A

Hans-Peter Martin is an experienced Austrian political journalist and author. Educated in both Austria and the United States, he was awarded a doctorate in law and political science at the University of Vienna in 1984. By this time he was already a bestselling author in German with books focusing on the pharmaceutical industry (*Bitter Pills* sold two million copies worldwide and *The Road to Health* two-thirds of a million). In 1986 he joined the leading German news magazine *Der Spiegel* where he worked as a foreign correspondent in Latin America and elsewhere. Currently, he is their bureau chief in Vienna. An associate member of the Club of Rome, he broadcasts frequently, including on the BBC World Service.

Harald Schumann is a respected German journalist and writer. He was educated in social science and environmental planning at Marburg and subsequently at the Technical University in Berlin. After working on the staff of the Berlin daily *tageszeitung*, he published the book *Food and World Hunger: The International Agribusiness and the European Community*. In 1986 joined the staff of *Der Spiegel*. In 1990 he moved to become deputy head of the German daily, *Der Morgen*, before eventually returning to *Der Spiegel* where he is now deputy bureau chief of the Berlin office. Together with Hans-Peter Martin, he was awarded the Bruno Kreisky Price for the best political book of 1997, *The Global Trap*.

The Global Trap

This book has had an extraordinary critical success since its first publication in German at the end of 1996. By 1997 some 250,000 copies had been sold and it remained constantly in the country's top ten bestseller list. It was rapidly translated into a clutch of European languages, and for many months headed the Austrian and Swedish bestseller lists. Currently, it is being translated into some 20 languages, among them French, Spanish, Portuguese, Korean and Chinese.

Public debate around the book has been intense in each country where it has been published because of its authors' provocative views on globalization, its implications for the future of national sovereignty and the alternative the authors put forward.

The Global Trap:
Globalization and the assault on prosperity and democracy

Hans-Peter Martin and
Harald Schumann

TRANSLATED BY
PATRICK CAMILLER

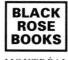

BLACK
ROSE
BOOKS

MONTRÉAL

The Global Trap: Globalization and the assault on prosperity and democracy was first published in English in 1997 by Zed Books Ltd, 7 Cynthia Street, London N1 9JF, UK, and Room 400, 175 Fifth Avenue, New York, NY 10010, USA.

Distributed in the USA exclusively by St Martin's Press, Inc., 175 Fifth Avenue, New York, NY 10010, USA.

Published in Canada by Black Rose Books, CP1258, Succ. Place du Parc, Montréal, Quebec, H2W 2R3, Canada.

Published in South Africa by Human Sciences Resource Centre, PO Box 5556, Pretoria 0001.

Published in Burma, Cambodia, Laos and Thailand by White Lotus Company Ltd, GPO Box 1141, Bangkok 10501, Thailand.

Published in Australia and New Zealand by Pluto Press, Australia, PO Box 199, Leichhardt, NSW 2040, Australia.

Originally published in German under the title *Die Globalisierungsfalle: der Angriff auf Demokratie und Wohlstand*.

Cover designed by Andrew Corbett.
Set in Monotype Baskerville and Univers by Ewan Smith.
Printed and bound in the United Kingdom
by Biddles Ltd, Guildford and King's Lynn.

Library of Congress Cataloging-in-Publication Data has been applied for.

A catalogue record for this book is available from the British Library.

Canadian Cataloging-in-Publication data

Martin, Hans-Peter
 The global trap : the assault on democracy and prosperity
Includes bibliographical references and index.
ISBN 1-55164-115-1 (bound)-
ISBN 1-55164-114-3 (pbk.)
 1. International economic relations.
2. International economic relations–Political aspects.
3. Democracy. I. Schumann, Harald II. Title
HF1359.M37 1998 337 C97-900738-0

ISBN 1 85649 529 9 cased
ISBN 1 85649 530 2 limp

South Africa ISBN 0 7969 1840 6 pb
Canada ISBN 1 55164 115 1 hb 1 55164 114 3 pb
Australia ISBN 1 86403 041 0 pb

Contents

vii

For our children
Ben, Manuel and Paul

A note of thanks

Thanks are due to all who have encouraged us with this book, especially those who, despite globalization stress and often unfavourable circumstances, found time for interviews and valuable suggestions:

Bella Abzug, Anil Agarwal, Carmen Bersch, Madhu Bhaduri, Boutros Boutros-Ghali, Andrew Braunsberg, Edgar M. Bronfman, Lester Brown, Richard Butler, Michel Camdessus, Barber B. Conable Jr., Markus Dettmer, Erich Dieffenbacher, Ricardo Díez Hochleitner, Julian Disney, Bénédicte Dupoux, Harald Ettl, Rainer Falk, Peter Felch, Caroline Fetscher, Michael Findeisen, Thomas Fischer, Chris Flavin, Hans Fleisch, Justin Fox, Hermann Franz, Fernando Gabeira, Adrienne Germain, Mikhail Gorbachev, Al Gore, Mathias Greffrath, William Greider, Peter Handke, Wilhelm Hankel, Andreas Hauskrecht, Peter Heller, Edmund Hillary, Heimo Hoch, Jeanette Hofmann, Ivan Illich, Pilar Isaac-Candeias, Jürgen Kautz, Hans-Ulrich Klose, Margaretha Kopeining, Hans-Helmut Kotz, Michal Kováč, Ferdinand Lacina, Claus Leggewie, Gerd Leipold, Gisela Leske, Roland Leuschel, Amory B. Lovins, José Lutzenberger, Andreas Mailath-Pokorny, Adam Markham, Inge Martin, Jack P. Martin, Dennis Meadows, Edgar Meister, Gregory J. Millman, Mahathir Mohamad, Valerie Monchi, Ward Morehouse, Klaus-Peter Möritz, Michael Müller, Rolf S. Müller, Rainer Münz, Kamal Nath, Wally N'Dow, Kum'a Ndumbe III, Wilhelm Nölling, Désirée Nosbusch, Bisi Ogunleye, Charles Oman, Yves Perreard, Erica Bo Petersen, Wolfgang Petritsch, Volker Petzoldt, David Pitt, Barbara Pyle, Werner Raith, John Rawls, Wolfgang Reinicke, Michael Renner, Wolfgang Riehle, Cesar Rodriguez Rabanal, Elfi Rometsch, Rüdiger von Rosen, Curt Royston, Jeffry Sachs, Nafis Sadik, Jochen Sanio, Reijiro Sawafuji, Waltraud Schelkle, Rosa Scheuringer, Anton Schneider, Bertrand

Schneider, Leonard Schrank, Alexander Schubert, Stirling D. Scruggs, Gordon Shepherd, Michael Snow, Bernd Spahn, Stephen Silvia, Patrick Slough, Roy C. Smith, Ulrich Steger, Marcel Stremme, Washington SyCip, Klaus Töpfer, Gilbert Trigano, Vincent J. Truglia, Ted Turner, Peter Turrini, Barbara Unmüßig, Herman Veltman, Günter Wallraff, Ingo Walter, Ernst Ulrich von Weizsäcker, R. Christopher Whalen, Simon Wiesenthal, Dieter Wild, Timothy Wirth, Michael Wortmann, Yun Ho Jin, members of the Contrapunkt journalists' group, and some others who helped us with information but are unwilling or unable to be named. A final heartfelt thanks goes out to Rüdiger Dammann, who always believed in the project.

Hans-Peter Martin and Harald Schumann
Vienna and Berlin

Updates by Hans-Peter Martin.

1 May 1997, Vienna

1. The 20:80 society. World rulers en route to a different civilization

'The whole world is changing into change, as it once was in an earlier life.'
Werner Schwab, in his posthumously published play *Hochschwab*

World-class dreams are at home in San Francisco's Fairmont Hotel. It is icon and institution, a luxury inn with a legendary *joie de vivre*. People who know it respectfully call it 'The Fairmont'; if you live there, you have certainly made it.

Like a cathedral of affluence, it stands on Nob Hill in solitary splendour overlooking the famous 'City', a Californian showpiece of all the superlatives, an unselfconscious mixture of *fin de siècle* and postwar boom. Visitors are suddenly hit by the view as they float outside in the glass lift to the restaurant in the hotel tower. A panorama opens before them of that brave new world in which billions dream of living: from the Golden Gate Bridge to the Berkeley Hills, middle-class wealth gives off a seemingly endless glitter. Between the eucalyptus trees, the swimming pools of invitingly spacious houses glisten in the gentle sunlight; every drive contains several vehicles.

The Fairmont is like a huge boundary stone between modernity and the future, between America and the Pacific Basin. On the slope facing the hotel, more than a hundred thousand Chinese people live closely packed together, while at its back Silicon Valley, the home of the computer revolution, beckons in the distance. Winners from California's earthquake of 1906, US World War generals, founders of the United Nations, the US presidents of the twentieth century – all have celebrated their triumphs in the plush expanses of a hotel that provided the dreamlike corridors for the filming of Arthur Hailey's *Hotel* and which has since been inundated with tourists.

In this site steeped in history, the man welcoming the world's elite

I

in late September 1995 is one of the few who has himself made
history: Mikhail Gorbachev. When the Cold War came to an end,
American patrons gratefully fitted out a foundation (with Gorbachev
of all people as president) on an abandoned military area south of
the Golden Gate. Now he has flown in 500 leading politicians,
businessmen and scientists from every continent – a new 'global
brains trust', as the last president of the Soviet Union and Nobel
prizewinner calls it, which is supposed to point the way to the 'new
civilization' of the twenty-first century.[1]

Such experienced world rulers as George Bush, George Shultz
and Margaret Thatcher are here meeting the new lords of the earth
– men of the likes of CNN boss Ted Turner, who has merged with
Time Warner to form the largest media business in the world, or the
South-East Asian magnate Washington SyCip. The idea is for them
to spend three whole days in intensive discussions with the global
players in computers and finance, as well as with the high priests of
theoretical economics from Stanford, Harvard and Oxford. Emis-
saries of free trade from Singapore and (naturally) Beijing also want
their voices to be heard when the future of humanity is at issue.
Kurt Biedenkopf, prime minister of the state of Saxony, takes care
of any German angle during the debates.

No one has come to brag and bluster. No one is allowed to stop
the participants from speaking freely, and the hordes of journalists
have been screened off at considerable expense.[2] There are strict
rules designed to minimize rhetorical ballast: those introducing a
subject for debate are given just five minutes, and no contribution is
supposed to last for longer than two. Well-groomed old ladies make
sure of this by holding up huge boards – '1 minute', '30 seconds',
'Stop' – in front of the billionaires and theoreticians, as if they were
Formula One racing drivers.

John Gage, top manager at Sun Microsystems, a rising star in the
computer business, opens the round of debate on 'technology and
work in the global economy'. His company developed the Java
programming language, and its shares are breaking all records on
Wall Street. 'Everyone can work for us as long as they like; we don't
need a visa for our people from overseas,' Gage tersely explains.
Governments and their various regulations for the labour world no
longer mean anything. He employs just who he needs, his current
preference being for 'good brains in India' who will work for as long

as they are able. From every part of the world, the company receives applications by computer that speak for themselves. 'We hire our people by computer, they work on computers, and they get fired by computer.'

The lady with the board signals '30 seconds' left. 'Quite simply, we get the cleverest ones. With our efficiency, we have pushed turn-over from zero to six billion dollars since we started out thirteen years ago.' Gage turns with a self-satisfied smile to the man sitting next to him at the table: 'You didn't do that anywhere near as fast, David.' Gage savours his little side-swipe for the few seconds remaining before the 'Stop' sign is raised.

The person he addressed is David Packard, co-founder of the hi-tech giant Hewlett-Packard. The ageing self-made billionaire doesn't bat an eyelid. He is completely focused as he asks the central question in response: 'How many employees do you really need, John?'

'Six, maybe eight,' Gage drily comes back. 'We'd be really stuck without them. It's all the same no matter where on earth they live.' The leader of the discussion, Professor Rustum Roy from Penn-sylvania State University, tries to dig deeper: 'And how many people are currently working for Sun Systems?' Gage: 'Sixteen thousand. All but a small minority are rationalization reserves.'

Not a murmur passes through the room. The prospect of pre-viously undreamt-of armies of the unemployed seems to go without saying for those present. None of the highly paid career managers from the company divisions of the future believes that there will be enough new, regularly paid jobs in any sector of the economy in the technologically demanding growth-markets of hitherto affluent countries.

The Fairmont pragmatists sum up the future in a pair of numbers and a concept: '20 to 80' and 'tittytainment'.

In the next century, 20 per cent of the population will suffice to keep the world economy going. 'More manpower won't be needed,' thinks Washington SyCip. A fifth of all job-seekers will be enough to produce all the commodities and to furnish the high-value services that world society will be able to afford. This 20 per cent, in whichever country, will actively participate in life, earnings and con-sumption – to which may be added another 1 per cent or so of people who, for example, have inherited a lot of money.

And the rest? Will 80 per cent of those willing to work be left

without a job? 'Sure,' says the American writer Jeremy Rifkin, author of *The End of Work*. 'The bottom eighty per cent will have almighty problems.' Sun manager Gage stirs things up again and refers to his business head, Scott McNealy. The question in the future will be 'to have lunch or be lunch'.

From this point on, the top-class group discussing 'the future of work' concerns itself entirely with those who will have none. The firm conviction is that these will include tens of millions who have so far probably felt closer to the everyday bliss of the San Francisco Bay Area than to the struggle to survive without a secure job. A new social order is being sketched out at The Fairmont – one of rich countries with no middle class worth mentioning – and nobody there disagrees.

The expression on everyone's lips is Zbigniew Brzezinski's 'tittytainment'. The old Polish-born warhorse, who was Jimmy Carter's national security adviser for four years, has continued to occupy himself with geostrategic questions. He thinks of 'tittytainment' ('tits' plus 'entertainment') in terms not so much of sex as of the milk flowing from a nursing mother's breast. Perhaps a mixture of deadening entertainment and adequate nourishment will keep the world's frustrated population in relatively good spirits.

Top managers soberly discuss the possible dosage and consider how the affluent fifth will be able to occupy the superfluous rest. The pressure of global competition is such that they think it unreasonable to expect a social commitment from individual businesses. Someone else will have to look after the unemployed. If they are to have a meaningful, integrated existence, this will have to come from the wide range of voluntary services and neighbourly help, in sports clubs and all manner of associations. 'A modest payment might actually enhance the value of such activities and so boost the self-esteem of millions of citizens,' argues Professor Roy. In any event, the business leaders expect that, soon, in the industrialized countries people will again be sweeping the streets for next to nothing or finding a meagre shelter as household helps. For futurologist John Naisbitt, the industrial age and its mass prosperity will eventually become no more than a 'blip in economic history'.

The participants in these three memorable days at The Fairmont imagined themselves to be on the road to a new civilization. But the route envisaged by the assembled experts from top management and

science leads straight back to premodern times. In the 1980s Europeans feared the coming of a 'two-thirds society', but that no longer describes how welfare and social position will be divided up. The new model is of a 20 to 80 world, a one-fifth society in which those left out will have to be pacified with tittytainment. All a wild exaggeration?

'The real hurricane'

Germany, 1996. More than 6 million job-seekers – more than at any time since the founding of the Federal Republic – can find no secure employment. The average net income of West Germans has been declining for the past five years. And this is just the beginning, according to reports coming from government, business and various research departments. The leading management consultant Roland Berger estimates that at least 1.5 million additional jobs will be lost in industry alone, 'probably including every second job in middle management'.[3] His colleague Herbert Henzler, head of the German branch of the McKinsey consultancy firm, goes even further in his predictions: 'industry will go the way of agriculture'; the production of goods will provide a living for only a few per cent of the population in work.[4] Similar trends are officially reported in Austria, where 10,000 industrial jobs disappear every year and unemployment is expected to reach 8 per cent in 1997, nearly double the figure for 1994.[5]

The explanations for this decline favoured by economists and politicians always culminate in the same word: globalization. Hi-tech communications, lower transport costs and unrestricted trade are constantly said to be turning the whole world into a single market. This sets up fierce global competition, including on the labour market, so that German companies will create new jobs only in cheaper foreign countries. From corporate bosses to the labour minister, the leading circles of the Federal Republic know only one answer: downward adaptation. Citizens are ceaselessly exposed to demands for sacrifices, as a cacophony of health insurance bureaucrats, economists, experts and ministers complain that Germans (and *a fortiori* Austrians) work too little, earn too much, take too much sick leave and have too many holidays. Newspaper and television journalists help out by arguing that 'Western society, with its high level of demands, is

colliding with the self-denial typical of Asiatic society', that the welfare state 'has become a threat to our future', or that 'greater social inequality is unavoidable'.[6] Austria's largest mass-circulation daily, the *Neue Kronenzeitung*, joins the tabloid battle with headlines such as: 'The Continent Has Been Living Beyond Its Means' or 'Europe Rocked by a New Wave of Cost-Cutting'.[7] Even the German president, Roman Herzog, makes speeches to the nation in which he argues that change is 'inevitable' and that 'everyone will have to make sacrifices'.

Herzog, however, has not got things quite right; by no means everyone is required to make sacrifices in times of crisis. Reduction in pay during sickness, the ending of protection against dismissal, deep cuts in all kinds of employers' social contributions, wage-cuts despite rising productivity – these are no longer just crisis management. Reformers operating in the name of globalization are now serving notice on the unwritten social contract of the Federal Republic, which has kept inequality within limits by means of top-down redistribution. The model of the European welfare state, too expensive in world terms, is supposed to have outlived its usefulness. The affected groups understand all too well: trade unions and welfare associations are raising an outcry throughout the country. Even the otherwise conservative IG-Chemie is threatening widespread strikes, and Dieter Schulte, chairman of the DGB trade union federation, warns of 'conditions' that will make the French mass strikes of December 1995 seem 'a feeble prelude'.[8]

The defenders of the social state are nevertheless fighting a losing battle. Many of their opponents' arguments are, to be sure, false. On balance, Germany's Konzerne create hardly any new jobs abroad; at most they buy up existing businesses in order to spread their workforce more widely and to cover regional markets. Nor is it at all the case that social costs have been rocketing upwards in Germany; in fact, they accounted for a smaller proportion of GNP in 1995 than they did twenty years before. What is really on target, however, is the constant reference to the policy of other industrialized countries. From Sweden through Austria to Spain, there is essentially the same programme of reducing public expenditure, cutting real wages and eliminating social services. And everywhere protest ends in resignation.

Internationalism, once an invention of social-democratic labour

leaders against capitalist warmongers, changed sides a long time ago. At a world level, more than 40,000 transnational corporations of varying shapes and sizes play off their own employees (as well as different nation-states) against one another. A 40 per cent capital gains tax in Germany? That's much too much: Ireland is happy with 10 per cent, while Malaysia and some states in the USA have done without anything at all for five or ten years. Forty-five marks an hour for skilled labour? Much too expensive: Britons work for less than half that, Czechs for a tenth. Only 33 per cent subsidization of new plant in Italy? Much too little: in Eastern Germany the state gladly contributes 80 per cent.

In a global pincer movement, the new International of capital is turning whole countries and social orders upside down. On one front it threatens to pull out altogether according to the circumstances of the hour, thus forcing massive tax reductions as well as subsidies running into billions of marks or the provision of cost-free infrastructure. If that doesn't work, tax-planning in the grand style can often help out: profits are revealed only in countries where the rate of taxation is really low. All around the world, the owners of capital and wealth are contributing less and less to the financing of public expenditure.

On the other front, those who manage the global flows of capital are driving down the wage-levels of their tax-paying employees. Wages as a share of national wealth are declining worldwide; no single nation is capable of resisting the pressure. The German model, in the view of US economist Rudiger Dornbusch, will be 'well and truly thinned down' by global competition.[9]

Share prices and corporate profits rise in double-digit leaps, whereas wages and salaries sink. At the same time, unemployment is growing in parallel with national budget deficits. No one needs special economic knowledge to grasp what is happening. For, over one hundred years after the death of Karl Marx, capitalism is again heading in the direction which that revolutionary economist so accurately described for his own time. 'The general tendency of capitalist production is not to raise but to sink the average standard of wages, or to push the value of labour more or less to its minimum limit,' he reported in 1865 to the general council of the First International in London, without dreaming that primitive capitalism would one day be brought under democratic control.[10] After the reforms of

the social-democratic century, however, a counter-reformation of
historic dimensions is opening up; the move into the future is a
backwards movement. Winners such as Siemens boss Heinrich von
Pierer triumphantly proclaim: 'The wind of competition has become
a storm, and the real hurricane still lies ahead of us.'[11]

The words chosen by Pierer and other standard-bearers of the
new globalism would make one think that it is all a natural outcome
of inexorable scientific and technological progress. But that is non-
sense. Global economic integration is by no means a natural process;
it is consciously driven by a single-minded policy. In every agreement
and in every new piece of legislation, it has always been the decisions
of governments and parliaments which have removed the barriers to
cross-border movement of capital and goods. From the lifting of
European currency controls to the continual extension of the General
Agreement on Tariffs and Trade (GATT), ruling politicians of the
industrialized West have systematically brought about the very situ-
ation with which they are now unable to cope.

Democracy caught in the trap

Global integration goes together with a doctrine of economic salva-
tion which a whole host of advisers are constantly bringing into
politics. The basic thesis, just a little simplified, is that the market is
good and state intervention is bad. Basing themselves on the ideas of
the leading representative of this school, the American economist
and Nobel prizewinner Milton Friedman, most of the neo-liberal
governments of the West made this dogma their guiding policy
principle in the 1980s. Deregulation instead of state controls,
liberalization of trade and capital movements, privatization of public
enterprises – these were the strategic weapons in the arsenal of
market-trusting governments and of the international economic
organizations under their sway, the World Bank, the International
Monetary Fund (IMF) and the World Trade Organization (WTO).
With these instruments, they fought a struggle for the freedom of
capital that is still going on today. Whether it is a question of air
travel or telecommunications, banking or insurance, construction or
software development, or even manpower resources, nothing and no
one is supposed to escape the law of supply and demand.

The collapse of the one-party dictatorships in the Eastern Bloc

gave further impetus and global penetration to this belief-system. Freed from the threat of the dictatorship of the proletariat, all the more effort was put into building the dictatorship of the world market. Suddenly the mass participation of workers in the gross national product appeared as a mere concession, designed in the context of the Cold War to take the ground from under communist agitation.

Yet 'turbo-capitalism',[12] which on a world scale now appears unstoppable, is destroying its own foundations as it undermines democratic stability and the state's ability to function. The pace of change and the redistribution of power and prosperity are eroding the old social entities more rapidly than the new order can develop. The countries that have so far enjoyed prosperity are now eating up the social substance of their cohesion even faster than they destroy the environment. Neo-liberal economists and politicians preach the 'American model' to the world, yet this is frighteningly similar to the propaganda of the old GDR regime which, right to the end, tried to learn the secret of success from the Soviet Union. Besides, social decay is nowhere more evident than in the homeland of the capitalist counter-revolution: the United States itself. Crime has reached epidemic proportions, so that in California – which describes itself as the seventh-largest economic power on earth – expenditure on prisons has overtaken the whole of the education budget.[13] Some 28 million Americans – more than 10 per cent of the population – have barricaded themselves inside guarded skyscrapers and housing estates. US citizens now spend twice as much money on private guards as their government does on the police.[14]

Europe and Japan, China and India are also splitting into a minority of winners and a majority of losers. For many hundreds of millions, globalized progress is no progress at all. To their ears it must have sounded like mockery when the G-7 heads of government, from the Group of Seven leading industrial nations, meeting in Lyons in late June 1996, issued the slogan, 'Make globalization a success from which everyone will benefit!'

The losers' protests thus confront governments and politicians less and less able to come up with any positive action. Whether it is a question of securing social justice or defending the environment, of restricting the power of the media or combating international crime, the individual nation-state always finds itself overstretched, and

attempts to coordinate international efforts just as regularly break down. But if governments, on every burning issue of the future, can do no more than evoke the overwhelming constraints of the international economy, then the whole of politics becomes a spectacle of impotence, and the democratic state loses its legitimacy. Globalization turns out to be a trap for democracy itself.

Only naive theorists or short-sighted politicians think that it is possible year after year, as at present in Europe, to deprive millions of people of jobs and social security without at some point having to pay the political price. Something will have to give. Unlike in the microeconomics of corporate strategy, there are no 'surplus people' in democratically constituted societies. The losers have a voice, and they will use it. There are no grounds for reassurance, as the social earthquake will be followed by a political one. Social Democrats or socially minded Christians will not be celebrating any more triumphs in the near future. Instead, it is becoming apparent how more and more voters really take seriously the stereotyped formulas of the globalizers. It is not we but foreign competition that is to blame – every second news broadcast says as much from the mouths of those who are supposed to defend the citizens' interests. From this (economically false) argument, it is but a short step to open hostility towards everything foreign. For a long time now, millions of newly insecure middle-class citizens have been seeking salvation in xenophobia, separatism and disconnection from the world market. The excluded are responding with exclusion.

In 1992, in his first try for the US presidency, the national-authoritarian populist Ross Perot won 19 per cent of the vote. Similar results have been scored by the French prophet of national rebirth, Jean-Marie Le Pen, and Austria's far-right populist Jörg Haider. From Quebec through Scotland to Lombardy, separatist parties are gaining in popularity. They supplement the canon of xenophobia with contempt for central government and dissociation from those in the poorer parts of the country who supposedly have their board and lodging paid for them. At the same time, a vagabond mass has appeared throughout the world in search of an escape from destitution.

Twenty to eighty – the one-fifth society envisaged for the next century by the Fairmont elite – is fully consistent with the scientific and technological thinking of the corporations and governments that

are driving forward global integration. But the world race to achieve maximum efficiency and minimum wages is opening wide the gates to irrationality. It is not the really destitute who are rebelling; rather, it is the fear of losing position – a fear now sweeping the middle layers of society – which is politically explosive to an incalculable degree. Not poverty but fear of poverty is the danger to democracy.

Once before, of course, the economic dissolution of politics led to global catastrophe. In 1930, a year after the great stock-market crash, the pro-capital London weekly *The Economist* commented:

> The supreme difficulty of our generation ... is that our achievements on the economic plane of life have outstripped our progress on the political plane to such an extent that our economics and politics are perpetually falling out of gear with one another. On the economic plane, the world has been organized into a single all-embracing unit of activity. On the political plane, it has remained ... partitioned.
> The tension between these two antithetical tendencies has been producing a series of jolts and jars and smashes in the social life of humanity.[15]

History does not repeat itself. Yet war is still the most likely safety-valve if social conflicts become insupportable, perhaps in the form of civil wars against ethnic minorities or rebellious regions. Globalization will not necessarily lead to military clashes, but it may do so if the unfettered powers of the transnational economy are not successfully brought under control. Existing political responses to the economic interlinking of the planet deny that this process can in any way be mastered, but there are ways and means of putting the steering wheel back in the hands of elected governments and their various institutions, without setting nations at each other's throats. Some of these ways will be presented and discussed in this book.

The foremost task of democratic politicians on the threshold of the next century will be to restore the State and the primacy of politics over economics. If this is not done, the dramatic fusing together of humanity through technology and trade will soon turn into its opposite and lead to a global crack-up. Our children and grandchildren would then be left with nothing but memories of the golden 1990s, when the world still seemed orderly and a change of course still seemed possible.

2. Everything is everywhere. Globalization and global disintegration

'The peasants belonged to the gentry, and the gentry belonged to the peasants; but now everything's separate, and you can't understand anything.' The man-servant Feers, in Chekhov's *The Cherry Orchard*

The world is becoming one. And in the beginning was the picture of the one earth.

Nearly three hours' flight from Beijing, but also three hours from Hong Kong and two from Lhasa in Tibet, lies Chengdu. At the most, the remote capital of Sichuan Province in the middle of the Middle Kingdom is known to lovers of spicy Chinese cooking; foreign travellers approach it only in the event of an unwelcome stopover. Yet Chengdu, with a population already of 3.4 million, is one of the fastest-growing megacities in the world.

Among the building sites for the new tower-block wastes, Mao's artistic poster painters show the new face of progress. Wrapped against the biting dust from the overcrowded but still untarred streets, gaudy pictures resembling giant TV screens tempt the passers-by. The bungalow is piglet pink, the grass bilious green, the swimming pool light blue, and the Chinese couple are happy with their oversized Cabriolet.[1]

On the other side of the world, deep inside Amazonia near the frontier between Bolivia and Brazil, the same promise dominates the pictures on street hoardings. The São Paulo construction company Mendes Junior widely advertises in the rainforest the North American type of well-kept, nature-destroying individual house. And in musty huts on the dried-up River Purus, young Caboclos – mixed descendants of Indians and black slaves – debate the exact bust measurement of lifeguard Pamela Anderson in the Californian TV series *Baywatch*,

as if she were a girl living just down the road. Meanwhile, timber traders use Hollywood videos to corrupt the handful of Indians left in the federal state of Rondonia, so that they can move into the reservations and fell the last mahogany trees.[2]

The power of moving pictures makes itself felt even among the Yanomami Indians, about whose distinctiveness the rock star Sting waxed so enthusiastic, as well as among young people in what is supposed to be the last Shangri-la, Bhutan. In this Buddhist eco-dictatorship at the foot of the Himalayas, the population are forced to wear a knee-covering smock at all times and to till the fields with medieval implements. The locals are much admired, even though they wear a leather jacket over their one-piece national costume and traffic in pirated American movies from India.[3]

The US TV soap *Denver Clan* has long been at home even in the Russian Far East. The director of Khabarovsk airport becomes in-censed when visitors think they have to explain what *Der Spiegel* is. Every week he can read extracts from it in a supplement to the regional daily.[4] At Copacabana, on the other hand, a beach-seller hoists the German flag at weekends out of conviction. The dark-skinned man is not descended from German nationalists; he simply admires 'the justice in Germany, where even ordinary people are not poor'.[5]

No doubt about it: if humanity had to vote today on a choice of lifestyle, it would know what to do. More than 500 active satellites are meanwhile sweeping the globe with the signals of modernity. Uniform pictures on a billion television screens nurture the same longings on the Amur, Yangtse, Amazon, Ganges and Nile. Even in areas far from electricity, such as the Niger in West Africa, satellite dishes and solar panels have plunged millions of people 'from their village life into a planetary dimension', as Bertrand Schneider, general secretary of the Club of Rome, puts it.[6]

The defensive battle of the Chinese regime against faxes, e-mail and TV broadcasts from the capitalist world serves not only to keep it in power but also to keep at bay a different concept of society. Where television pictures from the world of universal commodities are still frowned upon, as in North Korea and some Islamic countries, photographs and detailed reports do the rounds instead. Even in Iran, where American heavy metal is the most popular music among

middle-class teenagers,[7] the Ayatollahs no longer have their sovereign airspace under firm control.

Never before have so many people heard and known so much about the rest of the world. For the first time in history, humanity is united by a common image of reality.

If the nearly 6 billion inhabitants of the planet could really decide by referendum how they wanted to live, there would be an overwhelming majority for the kind of middle-class existence lived in a suburb of San Francisco. A qualified, informed minority would opt in addition for the social standards of the Federal Republic of Germany in the years before the Wall came down. The luxury combination of a Caribbean villa with Swedish welfare protection would be the dream to end all dreams.

Disney on top

Why has the Californian ideal of life imposed itself all over the world? Why did Disney come out on top? The size of the American market, together with the geopolitical position of the United States after the Second World War and its strength in the propaganda battles of the Cold War, played a central but not all-decisive role. To put it another way: Stalin wanted omnipotence, but Mickey Mouse achieved omnipresence.

The media mogul Michael Eisner, president and chairman of the board of directors of Walt Disney Corporation, takes care over his explanatory model: 'American entertainment offers a great variety of individual options, individual choice and individual expression. That is what people want everywhere.' Unperturbed, the Hollywood salesman adds: 'As a result of its unrestricted creative freedom, the US entertainments industry produces an originality that cannot be found anywhere else in the world.'[8]

His most outspoken critic is currently Benjamin R. Barber, director of the Walt Whitman Center at Rutgers University in New Jersey, who came up with the now classic formula 'Jihad vs. McWorld'. In his view, Eisner's thesis of diversity is

a downright lie. This myth blurs two crucial points: the type of choice and the alleged independence of people's wishes. In many American cities, for example, you can choose between dozens of car models but

you can't decide on public means of transport. And how can anyone take seriously the claim that the market only gives people what they want, when at the same time there is an advertising industry with a budget of 250 billion dollars? Isn't the MTV television station also just worldwide publicity around the clock for the music industry?

The decisive victory of the 'Disney-colonization of global culture' rests, according to Barber, upon a phenomenon as old as civilization itself: the competition between hard and easy, slow and fast, complex and simple. The first term in each of these oppositions is bound up with amazing cultural achievements, while the second corresponds to 'our apathy, weariness and lethargy. Disney, McDonald's and MTV all appeal to the easy, fast and simple.'[9]

Regardless of whether Eisner or Barber has the correct assessment of Hollywood's victory, its consequences are all around us. 'Cindy Crawford and Pocahontas stare out at you from every street corner, as Lenin's statues did in the former Soviet Union. The warbling of Madonna and Michael Jackson is the muezzin call of the new world order,' suggests Californian futurologist Nathan Gardela in reference to the monotonous field of vision of the contemporary world.[10]

In the great media empires the sun never sets. Hollywood is the international powerhouse supplying the most important raw materials for postmaterialism. Time Warner wants to merge with Ted Turner's Broadcasting Corporation and CNN to form the world market leader, and a fusion of Walt Disney and ABC television would be the second-largest corporate buy-up in American history. Sony owns Columbia Pictures, Matsushita sold the entertainment giant MCA in 1995 to the drinks multinational Seagram. Between Korea and the Persian Gulf, it is the Australian Rupert Murdoch who rules the roost. His Hong Kong-based satellite station, Star TV, straddles four time-zones and encompasses a half of the world's population. Stunning Chinese, Indian, Malaysian or Arab female presenters alternate between Mandarin and English as they bridge space and time on six separate channels. Now Murdoch is fervently seeking to open wide the People's Republic of China by participating in cable TV. The rulers in Beijing are still acting coyly, but they have already hinted to the industry which formula would allow the Australian to carry it off: 'No sex, no violence, no news.'

The media giants – which include the German Bertelsmann and his stubborn rival Leo Kirch, as well as self-promoters such as the

Italian potentate Silvio Berlusconi – are well equipped to provide that 'tittytainment' which the world's rulers ponder at meetings such as the one organized by the Gorbachev Foundation in San Francisco. Their pictures govern people's dreams, and dreams determine action.

The great thirst for monotonous 'screeching'

The more the market for pictures has moved across borders, the more restricted it has become. On average the US film industry spends 59 million dollars on a feature film – a sum which European or Indian producers cannot come close to matching.[11] It is also continually setting new standards in technology and equipment which competitors can only seldom achieve. The drain towards Hollywood and New York therefore continues to grow stronger.

The 500 television channels promised for every household will themselves bring only an illusion of variety. A few market leaders will reshape and recycle their commodities on several stations for different target groups, but the quest for the highest ratings will further the concentration process. Thus, broadcasting rights for major sports events can be financed only with huge income from advertising, and this can be secured only by the larger stations or international marketers. The only manufacturers interested in commercials and sponsoring are those which have a presence throughout the trans-mission area – above all, multinational corporations. Just ten big firms currently pay for nearly a quarter of all the TV advertising in Germany.[12] A ninety-second commercial that can be used in several continents costs as much as an average European feature film.[13]

Advertising agencies, for their part, use the settings of one and the same dreamland for their clients. German audiences have already grown so fond of New York and the Far West that, throughout the final game of the national football league championship in May 1996, the RTL station carried images from that distant yet apparently familiar world in nearly half of its advertising spots.[14] Nowadays, when the red sun sinks into the sea with a Beck's beer close at hand, this happens not in Capri but behind the Golden Gate Bridge. And Continental tyres no longer squeal close to German soil on the Nürburg racing track, but move stylishly across the gorges of high-rise Manhattan.

Feedback amplifiers are pushing global sameness ever further. A

logical end-product in the realm of culture would be a monotonous American 'screech' all over the world, such as the New York video artist Curt Royston has predicted.[15] Almost as confirmation, a young avant-garde stretching from Tomsk in Siberia to Vienna and Lisbon has for some years now been noisily imitating every detail of the New York scene of two decades ago: painstakingly lurid, intensely shrill, full of hellishly shrieking TV monitors – how boring.[16] The word is spreading only hesitantly that in an age when everyone is shouting, the alternative of stimulating quietness can be much more provocative and substantial.[17]

The 'three tenors' – José Carreras, Plácido Domingo and Luciano Pavarotti – also came within range of Royston's vision of global screeching during their world tour of 1996. In packed stadiums from Munich to New York, huge audiences could scarcely hear more than the basic melody of their classical favourites. The resulting hotch-potch, though otherwise remarkably uniform, everywhere contained something distinctive which was supposed to make the ticket-buyers feel they had had a unique experience. The many audiences, tuned in to their own cultural circle in one of four continents, would nevertheless melt into one during the encores. For the Japanese, the three global singers performed 'Kawa-no nagare nayomi', the soulful way of the eternally flowing river. By the never-blue Danube, on the other hand, which is now dammed just before the Vienna stadium where the tenors appeared, the hit drinking-song 'Wien, Wien, nur du allein!' rang in the overwhelmingly *nouveau-riche* ears of 100,000 Germans, Czechs and Hungarians.[18]

In their calculations of what appeals to different nations, the trio of bel canto enchanters may refer to the number-one captivator of people's throats, Coca-Cola. The soft-drinks giant serves up its brown-ish pop with different tastes in China and Japan, sweetened according to the cultural preferences and peculiarities of the region.[19] During the Olympic summer of 1996, Coca-Cola used its transcontinental commercials to offer itself 'for the fans', but in sultry Atlanta the understanding multinational posted up 'Cheering is thirsty work!' on the athletes' buses, in a direct appeal to the perspiring live spectators.[20]

In Europe, too, sport as a cultural product is rapidly being geared to a design-fixated fun society that cheers any lurid packaging. Fifa president João Havelange wishes that soccer matches, like American

football, had more commercial breaks,[21] while the German League is seeking a new identity more like that of America's National Basketball Association. Enthusiasm for an image is appearing in place of a sense of belonging to a culture in which one has grown up, so that Bayern München sells more logo-shirts in Hamburg than the two local league teams, HSV and St. Pauli. Sales of such items to fans already bring leading clubs more income than their total receipts, including television rights, used to earn them at the beginning of the 1990s. According to sports researcher Hans J. Stollenwerk, disputes are less and less likely to erupt between traditionally rival cities, and so 'they have to be artificially produced – even between players, or between player and trainer or trainer and committee'.[22]

Like a plough moving across the earth, the demand of billions for the globally advertised flow of commodities has firmly imprinted itself on the shopping streets of the world's big cities. The 'transformation of thirst into a need for Coca-Cola', as social critic Ivan Illich once scornfully described it, is now complete.[23] All the metropolises are dominated by the familiar names, from Calvin Klein through Kodak to Louis Vuitton. Ideas and products fall in with musical tastes and the supply of films in the few remaining cinemas. They become more and more alike, often at a speed that spells ruin for long-established national suppliers.

The latest victim is the imperial capital of yesteryear, Vienna. Countless shops whose original displays used to give the inner city a pleasant and distinctive character have had to close down since Austria's entry into the European Union at the beginning of 1995, especially as the strict rent controls were abolished at the same time. International chainstores are taking the best locations; cheerless snack-bars, provocative underwear firms and tacky drugstores are opening their sterile branches.

The age of cities

The urban middle classes of the flourishing economic centres move with undreamt-of ease around the shrinking blue planet, on business trips as well as on holidays. Already 90 million people regularly access the worldwide Internet, joined by another half-million each week.[24] A Viennese photographer born in Vorarlberg Province now knows New York's West Side better than Innsbruck; a London stock-

broker feels closer to his colleagues in Hong Kong than to a branch
bank-manager in Southampton. Both think of themselves as open-
minded cosmopolitans, far from any awareness that their global
'connections' are often very provincial and limited to their own
milieu. Journalists, computer experts or actors travel more often and
more intensely than diplomats or foreign affairs politicians: in the
morning they might still be in a small Hungarian town, dealing with
desperate customers or having a stimulating conversation; in the
afternoon keeping an appointment in Hamburg; in the evening visit-
ing a new but already nearly lost girl-friend in Paris; next day at
company headquarters somewhere, and then off to the USA or the
Far East. Anyone who needs a few seconds on awakening to recall in
which continent he has spent the night belongs to the front rank of
the club of world travellers. 'Watch out you don't meet yourself at
the airport check-in already on your way back!' – an old joke once
addressed to Hans-Dietrich Genscher as foreign minister, and now
made to such restless people by the few friends left to them. At the
same time, they are envied by many for their flexibility, their high
income, and even their 'cosmopolitan' way of life.

In the most famous hotel bars, however – Raffles in Singapore, the
Savoy in Moscow or the Copacabana Palace in Rio – the harassed
servants of the global players end up late at night with tears in their
eyes, while their old schoolmates (perhaps encountered by chance in
the street on a biannual tourist venture into the wider world) have
long been lying filled with wonder in their cheap beds. Lost to
everyone and to themselves, the career travellers then pour out that
crippling sense of emptiness and solitude which takes hold after the
eighth intercontinental flight of the year. The familiar surroundings
in which they take their rest are global indeed, but in the end also
monotonous and unbearable. All around the globe they find them-
selves cooped up in predictably hideous but confusingly similar
airports, chain hotels and chain restaurants, numbed by the same
choice of videos in air-conditioned yet musty hotel rooms. The souls
of the restless ones do not travel as fast as their bodies; the strength
to get involved in something really new and different, if they ever had
it, has long since departed. So they are everywhere and yet remain in
the same place, have seen everything yet see only what they have long
known – and in the process they collect bonus airline miles as those
at home collect telephone cards, postage stamps or beer mats.

Still, such mobility is indicative of a general trend as the world itself jets at the speed of sound into a stirring new future. Not long after the turn of the millennium, a thick web of electronic networks, digital satellite telephones, high-capacity airports and tax-free industrial estates will most probably join together thirty or so cosmopolitan conurbations, each with a population of 8 to 25 million. These metropolises are scattered across the planet like random spots of light, yet their inhabitants feel closer to one another than to those living in the respective hinterlands which previously shaped their own history.

Power, according to the Italian futurologist Riccardo Petrella, will 'lie with a league of traders and city governments acting on a world scale, whose main concern will be to promote the competitiveness of the global firms that they accommodate'.[25] Already each of Asia's major centres is straining to take the lead. Young people on every continent are growing up with an image of global cities, totally different from anything their parents knew. It is no longer Paris, London and New York which glitter with superlatives, nor Moscow or Chicago. Since March 1996 the tallest building in the world has cast its shadows in the Malaysian capital, Kuala Lumpur, and the largest number of construction cranes tower over the roofs not of Berlin but of Beijing and Shanghai.

Between Pakistan and Japan, a dozen boom-regions are pressing on to the stage of global competition and vying for roles defined in recent decades by the big cities of the West. Bangkok, for example, is trying to take over the role of automobile capital from Detroit. The Japanese producers Toyota, Honda, Mitsubishi and Isuzu have long been assembling their cars in Thailand, while Chrysler and Ford are converting their branches there into corporate bases for South-East Asia.

Taipeh sees itself as the successor to Silicon Valley, and already Taiwan is a world presence in the production of monitors, computer mouses and scanners. Malaysia hopes to prosper from hi-tech exports as the Ruhr once did from its steelworks. Bombay now turns out 800 feature films a year, four times more than Hollywood, and office rents there have overtaken the previous records set in Japan.

Shanghai is the main city contending with Tokyo and New York to become the nerve-centre of Asia's new supercities. 'By the year 2010 we want to be the international finance and business centre in

the West Pacific,' explains Hu Yangzhao, chief economist at the City Planning Commission. In the greatest urban redevelopment since Baron Haussmann's Paris of the nineteenth century, the old Shanghai will be almost entirely demolished and a new city put in its place. A quarter of a million households have already had to leave the inner city, to be joined later by another 600,000. Forty of the 100 largest multinationals have opened offices there: Siemens wants to help build the underground system; 220,000 motorcars will roll off the assembly-lines this year at Volkswagen-Shanghai, and from the year 2000 the figure is planned to be 2 million. The British Crown Colony of Hong Kong, which will revert to the People's Republic in 1997, is trying to come up with an answer. 'Geography is on our side,' argues the big banker Clint Marshall. Twenty billion dollars are going into a new airport, and just twenty kilometres away the thriving Chinese province of Guangdong is already supplying the global markets.[26]

China's economic take-off has become a commonplace, but it contains some sour-sweet surprises. Deng Xiaoping's 'socialist market economy' may become the world's second largest by the year 2000 – ahead of both Japan and Germany. Whereas Europe's scare-mongers used to worry in the 1960s about the advancing 'yellow peril' and nothing happened, the men from the Middle Kingdom are now really there. Workers from Shanghai's Meishan Metallurgical Corporation work nearly round the clock in Naples. They are dismantling a 24,000-tonne cast-steel complex from 100 hectares of closed-down plant belonging to the Italian Bagnoli firm. In the summer of 1997 the parts will be reassembled 14,000 kilometres away, in the Yangtse port city of Nanjing. Thyssen Steel, for its part, is dismantling a blast furnace that does not work to capacity and shipping it to India; and Austria's Voest-Alpine has offloaded an entire obsolete LD-2 steelworks from Linz to Malaysia. The Far East purchasers thereby acquire quality goods; they are the last to profit from the decades-long subsidization of Europe's steel industry that ran into billions of marks.[27]

Globalization is advancing with a speed scarcely imaginable before now. Economist Edward Luttwak describes the new age as the 'unification of the sloughs, ponds, lakes and seas of villages and provinces, regional and national economies, into a single global economic ocean, which exposes small areas to giant waves of competition instead of yesterday's little ripples and calm tides'.[28]

The whole world is a single market in which peaceful commerce appears to be thriving. Does this not realize an age-old dream of humanity? Should we who live in the hitherto affluent industrial heartlands not rejoice at the rise of so many developing countries?

No.

The Canadian prophet Marshall McLuhan's vision of a 'global village' has by no means come true. While pundits and politicians keep flogging this metaphor to death, it is becoming clear just how little the real world is growing together. It is true that more than a billion TV consumers almost simultaneously watched the boxing match between Axel Schulz and Michael Moorer in June 1996 at Dortmund's Westfalenstadion. And the opening ceremony at Atlanta of the last Olympic Games of the century, which was watched by 3.5 billion viewers, joined up the world more than any other event of the last thousand years. The world pictures of blows exchanged and athletes competing have not, however, given rise to any real inter-change, any real understanding between people. Proximity and simultaneity through the media are a far cry from any cultural solidarity, not to speak of economic equality.

The Olympic revelation

Even before anonymous (and therefore typically right-wing) terror threw the sharp light of US social discord over the televised games, the Olympic organizers in Atlanta made perfectly plain the emptiness of international cohesion. First they shamelessly degraded 85,000 visitors – who had come up with 636 dollars each to attend the opening celebrations – to the level of extras in a flow of exciting images. Coloured scarves, torches and boards had to be purchased and waved on command for the camera. The star of the evening soon became the word 'dream', which America's propagandists like to conjure up even more than their concept of freedom. Atlanta was a 'milestone in a dream', announced the kitschily sumptuous programme. 'The power of the dream', sang the *chanteuse* Celine Dion. And a line of verse by Edgar Allan Poe shone out for minutes from the advertising board: 'Dream dreams no mortal ever dared to dream before!' Finally, the historic words of Martin Luther King echoed through the ranks: 'I have a dream!'[29]

Whose dream are we talking about? Is it that, thirty years after

the black civil rights campaigner was murdered, the almost exclusively light-skinned suburban Americans in his hometown's splendid new oval stadium feel a smug tremor as his quivering, poorly recorded voice is played back on an elaborately prepared cassette? Or did Martin Luther King dare to dream that Atlanta's almost exclusively black-skinned homeless would be bussed clear of the city centre for the duration of the Olympics, so that images of American reality would not force themselves on camera crews from around the world?

Anyway, in this Southern metropolis, whose cleaned-up slums and overpowering skyscrapers make it feel as decadently rich as Malaysia's soaring capital Kuala Lumpur, the words black and poor have remained synonymous. It was with a kind of self-defensive cynicism that the socially aware television producer Barbara Pyle, a high-flyer from Ted Turner's media multinational in Atlanta, commented on the trend-setting record games of 1996: 'Before, there were a few poor black districts with cheap housing in among the CNN and Coca-Cola towers. They've been razed to the ground for the Century Olympics Park of the so-called "AT&T Global Olympic Village", and in future employees of the two corporations will be able to stroll undisturbed between each other's head office.'[30]

The one world is crumbling

Hi-tech city machines as full of themselves as Atlanta's now dominate the globe, though increasingly as isolated islands. The world archipelago of wealth may consist of flourishing enclaves, but in what have so far been the 'developing countries', the Kuala Lumpurs are no more than citadels of the global economy. Meanwhile, most of the world is mutating into a lumpen planet, rich only in megacities with megaslums, where billions of people eke out a meagre living. Every week the number of people living in the world's cities grows by a million or so.[31]

At the same time, 'our embarrassed indifference has changed into smug indifference,' warned François Mitterrand in March 1995. 'All interest in development aid has melted away. Every country, it seems, only looks after its own backyard.'[32]

A total of 358 people own as much wealth as 2.5 billion people own together – nearly half the world's population.[33] What the industrialized countries spend on the Third World is falling and falling:

0.34 per cent of Germany's economy in 1994, but already down a tenth to 0.31 per cent in 1995.[34] It is certainly true that private investment from the richer countries has outstripped official development aid, but only a few regions actually benefit from it. The investors' expected return on capital is, 'because of the risk', often as much as 30 per cent a year, a good example being water-pipe construction in India and Indonesia.[35] Despite the North's repeated talk of a sweeping reduction, the total indebtedness of developing countries has been going up and up to reach 1.94 billion dollars in 1996, nearly twice as much as ten years previously.[36]

'It's all over,' the Egyptian writer Mohammed Sid Ahmed concluded logically. 'The North–South dialogue is as dead as the East–West conflict. The idea of development is dead. There is no longer a common language, not even a vocabulary for the problems. South, North, Third World, liberation, progress – all these terms no longer have any meaning.'[37]

The refrain increasingly heard in Europe and the United States is that we ourselves have long been in need of assistance. Even in the booming conurbations, millions of voters feel that 'we' are the ones being swindled by the new order. Worrying types find new material in the crippling fears for their jobs and their children's future. Will the Western middle-class standard of living, which is still taken so much for granted, become in historical perspective no more than one big KaDeWe, that subsidized luxury store in West Berlin which caused a sensation in the communist East but which, for all the hype, was not at all representative of life in Western Europe?

As economic cleavages widen in society, insecure people look more and more for political salvation in separation and difference. Dozens of new states have had to have a place found for them on the maps in recent years, and a total of 197 national teams marched into the Olympic stadium in Atlanta. Italians and even Swiss are struggling over their identity as the very unity of the nation becomes an issue. Fifty years after the foundation of the 'Repubblica Italiana', up to 50 per cent of citizens in the regions between Ventimiglia and Trieste vote for the Lega Nord protest movement, whose leader Umberto Bossi calls for the relay stations of RAI radio and television to be blown up. Bossi even proclaimed an independent state of 'Padania' in September 1996. Prosperous countries are also crumbling in other parts of the world. In the Caribbean, for example, the hitherto

peaceful holiday islands of St Kitts and Nevis want to end their federation.[38]

Canada and Belgium are hamstrung by the quarrel between their linguistic groups. In the United States, whose waves of immigrants long ago accepted a common national language, millions of Hispanics down to the second and third generations now reject English. Tribalism is everywhere gaining strength, and in many regions it threatens to slide into violent nationalism or regional chauvinism.

Unlike the wars of the nineteenth and early twentieth centuries, most wars in future will be fought not between but within states. In 1995 a mere two out of fifty armed conflicts around the world followed the familiar pattern: the wars between Peru and Ecuador, and Lebanon and Israel. Yet the new conflicts within national boundaries receive little international attention. In South Africa, for instance, 17,000 people lost their lives through acts of violence in the year following the end of apartheid – more than during the thirty years of armed struggle against apartheid.[39]

As the tragedy of the African continent reaches its peak, the international community develops fateful mechanisms for repressing all thought of it. Nine of the twenty-one US missions for overseas aid that are due to be closed down by 1999 lie in that part of the world, which many have already given up for lost. 'Yet Africa is perhaps as important for future world politics as the Balkans were a hundred years ago, before the two Balkan Wars and the First World War,' says the American Third World specialist Robert D. Kaplan. 'Precisely because a large part of Africa is staring into the abyss, it gives a foretaste of how wars, frontiers and ethnic politics will look a few decades from now.'[40]

The cities between Sierra Leone and Cameroun – above all, Freetown, Abidjan and Lagos – at night are counted among the most dangerous in the world; 10 per cent of the population is HIV-positive in the capital of the Ivory Coast. In Kaplan's view, 'there is no other place on earth where the political maps are as deceptive, indeed as mendacious, as in West Africa.' Together with Rwanda, Burundi, and Zaire, other African countries are becoming the epitome of racial and civil war.

Since 95 per cent of world population increase is concentrated in the poorest regions, the question is hardly whether there will be new wars, but rather what they will be like and who will fight whom. In

1994, seventeen out of twenty-two Arab countries reported a decline in economic performance, yet in many of them the population will most likely double in the next two decades. Water will soon be running short in parts of Central Asia as well as in Saudi Arabia, Egypt and Ethiopia. In this context, Kaplan concludes: 'Islam will be attractive to the oppressed because of its militancy. This religion, the fastest growing in the world, is the only one geared up for struggle.'[41] Secessionists and religious zealots are thus winning ever greater popularity, from Morocco and Algeria to India and Indonesia.

In the summer of 1993 Harvard professor Samuel P. Huntington published an essay in *Foreign Affairs* under the now famous title, 'The Clash of Civilizations?'[42] According to Huntington's thesis, which received enormous attention, especially in the industrialized West, the future will be decided not by a confrontation between social theories and political orders, as in the days of the Cold War, but by conflicts of religious and cultural origin between civilizations. Ancestral fears that Europe would be overrun (by Huns, Turks or Russians, depending on the century) here found obliging corroboration. But was the Harvard strategist right? Will the democratic West eventually clash with the rest of the world, with an alliance of despots and theocrats à la Saddam or Khomeini, perhaps supported by efficient Confucian hired guns?

There is certainly more than reasonable doubt, especially in the new despatialized world of closely linked cities. The prosperous countries are punching holes in their own social fabric at a quite stunning rate and thereby provoking political tensions in the West. At the same time, a unified global culture is binding national elites together. But the main point is that resurgent Asia is anything but a homogeneous entity. Dissolution and fragmentation also threaten the Middle Kingdom. 'China is actually running up against a wall,' thinks Timothy Wirth, America's first secretary of state for global issues and a close collaborator of President Clinton's. 'China's disintegration could soon be the question dominating everything.'[43]

The Chinese peasants have had enough of their wretched life on the land. Just twenty years ago, they could hear nothing on state-controlled radio about the comparatively well-off cities. Even if they heard stories or actually wanted to go there, they were immediately prevented by the tight police controls on the main highways. Today, however, they enrol in the rootless army that disappears into the

slums in search of a way to earn a daily living, far from the watchful eye of the Communist Party or the neighbourhood committees. This vagabond mass is already more than 100 million strong; it is palpable evidence of the huge pressure weighing on the earth's most populous country.[44]

India, too, which even before the millennium will become the second country with more than a billion inhabitants, is being placed under ever greater stress. Bombay and New Delhi are replacing Mexico City and São Paulo in the headlines as examples of the nightmare city. Each already has more than 10 million people living within it, and the figure is due nearly to double again in fewer than twenty years. Soon Karachi, Pakistan's less widely noticed metropolis, will be *the* horror story in the international press. Its current population of just 10 million is likely to race up to 20 million by the year 2015.[45]

The New Delhi authorities often realize first from satellite photos where their metropolis is currently growing – unplanned, uncontrolled and unauthorized. By day the streets turn into a tunnel of smoke three metres wide and a hundred high. The whole city coughs in the fog from roaring *phut-phuts*, the cheap motorized rickshaws. A third of its children suffer from allergic bronchitis, which the usual medicines can at best relieve only for a short time. Some 2,200 people die each year in the traffic – a figure which, in proportion to the number of cars, is thirteen times greater than in the United States. Although New Delhi was famed as a 'garden city' as late as the 1970s, it has been described by a state minister as 'Asia's ecological black hole ... quite uninhabitable' for human beings.[46]

In Bombay, which in the view of columnist Sudhir Mulji has become 'the most expensive slum in the world' since India's economy opened up, taxis smell of sleep in the morning, as their drivers cannot afford the hours-long journey home. Every day 2000 tons of garbage have to be cleared from the streets; hundreds of thousands of toilets would be needed in theory, but the city authorities cannot provide even two-thirds of the necessary water.[47]

It is not at all the case, however, that the millions of people living in the countryside or in small towns flock like lemmings to the megalopolis. A study of New Delhi showed that most migrants decide to move only when friends or relatives already living there can offer them the chance of a job. Newcomers, then, are often in a radically

better position than the huge mass of city-born poor.[48] This obviously breeds tensions, which may set in train new, and this time unlimited, migratory movements.

How fragile a structure is even tightly ruled China was made plain to the German minister Klaus Töpfer during a working trip to Beijing. He dutifully reminded Prime Minister Li Peng that human rights had to be respected, even in the Middle Kingdom. Such rights can certainly be given to the people, replied the Chinese power politician. 'But would Germany be prepared to admit and provide for ten to fifteen million Chinese a year?'

This unexpected reaction left the missionary of Western democracy lost for words. Töpfer recalls being disarmed by the communist's 'unbelievable cynicism'.[49] But was that all it was? As a matter of fact, it raised the question which humanity at large, and especially those who have been the winners in Europe and North America, must be prepared to answer. How much freedom – or, to be more precise, which kind – is still possible on the blue planet with its population fast approaching 8 billion? What are the rules, what are the forms of society, that will allow the problems of ecology, hunger and economic life to be mastered?

A disturbing malaise has gripped the leading lights of world politics. 'Today we are living in the midst of a worldwide revolution,' former UN Secretary-General Boutros Boutros-Ghali hammers away in his addresses. 'The planet is in the grip of two vast opposing forces: globalization and fragmentation.'

Boutros-Ghali adds with deep uncertainty: 'History reveals that those caught up in revolutionary change rarely understand its ultimate significance.'[50]

We ourselves are the enemy

The model of civilization devised in Europe certainly proved in-comparably dynamic and successful. But it is not what is needed for the shaping of the future. A 'substantial raising of living standards' in the 'underdeveloped areas' through a 'great increase in their industrial activity' – as President Harry Truman offered the world's poor in 1949[51] – is not going to happen.

Precisely now, when billions of people sharing the same imagery from Bogota to Yakutsk are striving for Western-style development,

the salesmen of this promise are breaching the contract. They cannot keep their word even in their own countries (the United States and Europe), nor get a grip on the mounting social divisions. So who still thinks of ecologically sustainable growth and equitable distribution of wealth in the Third World? More and more, the self-satisfied dogma of development proves to be a weapon from the Cold War arsenal, a relic that seems fit only for the museum.

Sauve qui peut is the new watchword. But who are still capable of saving themselves? The victory of capitalism has by no means brought the 'end of history' that Fukuyama proclaimed in 1989, but rather the end of a project that was so boldly called 'modernity'. The times have started to change; it is not advancement and increasing welfare but disintegration, ecological destruction and cultural degeneration which are rapidly shaping the everyday lives of most of humanity.

The world's elite in San Francisco considered the prospect of a 20:80 society within the hitherto affluent countries, but that percentage distribution has long been the norm on a world scale.

The facts are well known, but the forces released by globalization will soon make them appear in quite a new light. The wealthiest fifth of nations dispose of 84.7 per cent of the world's combined GNP; its citizens account for 84.2 per cent of world trade and possess 85.5 per cent of savings in domestic accounts. Since 1960 the gap between the richest and the poorest fifth of nations has more than doubled – which confirms in figures the bankruptcy of any promise of fairness in development aid.[52]

At present, as we well know, an interest in environmental questions is seen as more important than concern for jobs or social peace, and yet not many of today's headlines suggest that the ecological health of the planet has in any way improved. The global pattern of resource use has remained the same since the UN's spectacular conference on the environment and development was held in Rio de Janeiro in 1992. The most affluent 20 per cent of countries use up 85 per cent of the world's timber, 75 per cent of processed metals, and 70 per cent of energy.[53] The implications are banal but brutal: all the world's citizens will never be able to attain such a nature-destroying form of welfare. The earth imposes its own limits on humanity.

The worldwide spread of power stations and internal combustion engines has already fundamentally disturbed the energy balance of

our ecosystem. The declarations of intent at the Rio summit sound like shawm-blowing from an age long past. The world community, meeting on the outskirts of the most beautiful metropolis on earth, declared its wordy support for 'sustainable development', for an economic course that will not leave the environment and natural resources in a worse condition for future generations. Carbon dioxide emissions were supposed to be reduced by the end of the millennium to the level they were at in 1990, at least in the industrialized countries. Germany intended to lower them by 25 per cent by the year 2005.

The paper promises are so much wastepaper, for it is thought that world energy use will actually double again by the year 2020. The emission of greenhouse gases will increase by 45 to 90 cent.[54] For years climatologists belonging to the Intergovernmental Panel on Climate Change (IPCC) have been exchanging the results of their research and warning of the 'noticeable human influence on the world's climate'.[55]

Climate change can no longer be prevented but can at best only be moderated, and it will claim innumerable victims. 'Global warming, together with such effects as storms or floods, is already a reality for us,' explains Walter Jakobi of the Gerling-Konzern, the largest insurer of industry in Germany. In the 1980s, insurance companies around the world had to cope with fifty natural disasters a year with damage amounting to at least 20 million dollars each; in the mid-1990s there are 125 such events every year. Reinsurers now calculate that a single violent storm over the US East Coast or Northern Europe might cost many times more, as much as 80 billion dollars.[56] Premiums have been going up accordingly, so that in flood-threatened regions it is more and more difficult for homeowners to negotiate insurance on reasonable terms. Some countries are already paying an incalculable price for climatic risks. In Bangladesh, for example, growing vulnerability to hurricanes deters many foreign investors.[57]

A marked rise in sea levels can also no longer be prevented. The age of cities, still only just begun, may thus come to an abrupt end before the middle of the next century. Four out of ten agglomerations with more than 500,000 inhabitants are situated near the coast, including three-fifths of all mega-metropolises.[58] The very existence of Bombay, Bangkok, Istanbul and New York is threatened, but only very few monster-cities will be able to afford the costly Dutch-style dykes that could keep them above water.

China too has reason to fear the storm tides of the next century: Shanghai, Hong Kong and dozens of other cities with a population over a million look out upon open seas. Yet Mao's heirs have learnt most of their lessons from the present century, and are copying (with or without permission) the achievements of the West. A fundamental choice of direction has been made; the billion-member nation is joining the long march to the automobile society. The pragmatic calculation can only be that if something has to heat up, it had better be the world's climate rather than the people's temper inside China. A single vehicle tranquillizes like opium.

'Even in China,' observed the Washington transport expert Odil Tunali, 'cycling is now seen as projecting an image of underdevelopment.' Currently a mere 1.8 million cars are on the road – 5 per cent of the German total – but in less than fifteen years there are expected to be 20 million.[59] The big international names are in a gold-rush type of fever, Volkswagen-Shanghai alone expecting to supply a third of all new cars. General Motors, Chrysler, Mercedes-Benz, Peugeot, Citroën, Mazda, Nissan and South Korea's Daewoo Corporation are all participating with production agreements and actual deliveries in China's breathtaking surge. India, Indonesia, Thailand and all the rest are going along with the new times.

'The Asian market will soon be as big as the total European and North American markets,' predicts Takahiro Fujimoto, auto industry expert at Tokyo University.[60] Latin America and Eastern Europe also report astounding growth-rates: Brazil's auto output has doubled in the 1990s, as has the traffic on the streets of Moscow. The citizens of the former Eastern Bloc long for nothing more than to draw level with their Western neighbours. The fascination with a car of one's own, which is gradually fading over here, is still undimmed in the new markets. The car is not simply a means of transport, but mainly a symbol of upward social movement and a proof of wealth, power and what counts as personal freedom. With exhaust fumes already beyond control, a billion cars – double today's number – are expected to contribute to a global seize-up by the year 2020.

Citizens of the European Union today waste the equivalent of roughly 1.5 per cent of GNP in traffic jams;[61] in Bangkok the figure is 2.1 per cent.[62] Journeys through Thailand's paralysed capital, the erstwhile Venice of the East, take so long that drivers carry portable toilets as a precaution. Companies in Japan routinely send three

lorries to clients by different routes, to make sure they keep delivery deadlines despite the hour-long motorway tailbacks.

So what? Dreams are still dreams even when they have long proved to be dead ends. So it is that the constant process of motorization has led with seemingly unstoppable logic to one last great blossoming. Nothing has come of all the efforts in many different lands to reduce global warming through more economical use of energy and curbs on motor transport. A bitter price is being paid for the fact that, in the 1980s, the industrialized countries never consistently discussed rational pricing of transport and petrol and never seriously tried to introduce a fair environmental tax. Now things are getting out of hand – and previously remote newcomers are able to profit in the global market from the ridiculously low price for oil. So long as environmental costs play no role, Chinese traders, for example, can ship toys by the ton halfway round the globe and still offer them at a better price than low-wage factories in the Czech Republic, not to speak of companies in the EU.

Meanwhile, the industrialization of the developing countries is advancing in a disturbing climate of ecological ignorance. China's cities throw up a colossal poison cloud that stretches more than a thousand miles over the Pacific. The inhabitants of Shanghai awake nearly every working day beneath a deep-orange cover of smog.[63] Near Chengdu, unfiltered black-and-white smoke streams for tens of miles from thousands of lime kilns and brick factories, worse even than in the notorious Katmandu Valley in Nepal, where the air affects the mucous membranes as it used to do only in the smog hells of megacities.[64] After an extensive trip to the Far East, the British architect John Seargant collected his impressions: 'I have seen the future of much of the Pacific Rim, and I am scared out of my mind. One quarter of the population of the planet, certainly about 1.2 billion Chinese, are about to transform their standard of living, and in the process, wreck a large proportion of the globe.'[65]

As we all know, China is in the best of company; we are part of it ourselves. Despite the increasing unpleasantness that goes with global warming, most of the population in the hitherto affluent countries think they can live really well. But the ecological factor also points to the coming of a 20:80 society. Few people will be in a position to afford scarce and expensive natural products. And those who can get control of them will certainly make a large extra profit.

In the chic ski resort of Lech am Arlberg, for example, a sneaking pleasure may be felt when another bad year is forecast for winter tourism in Austria.[66] For the 1450-metre-high village becomes even richer when there is no snow further down. Wedeling will then be as exclusive a sport in the Alps as polo-playing is in Britain. For the moment, it is true, a debt mountain weighs down many hoteliers who speculated with over-large investments; but the 1380 inhabitants of Lech have, with great foresight, staked out their claims to every inch of land and block any new arrivals. A bonanza is in store for their children and grandchildren. If, some time around the year 2060, they can just whiten the ski-runs beneath Kriegerhorn and Mohnenfluh with the aid of expensive artificial snow equipment, they will all be millionaires able to live on the return from their capital and to build a new life for themselves without any effort.

This may seem a repugnant example, but perhaps it explains one or two things. For if a broad political front against global warming has been so long in the making, this is partly because many millions of people may become winners from climatic change. On the other hand, it is wrong to think that all effort is pointless, that the apocalypse cannot be avoided. Such a conclusion only encourages others to turn a blind eye to the facts, and serves as an excuse for one's own inaction. It has become too easy to sit and wait for doomsday.

But that day of reckoning which ends all conflict is not going to come. Humanity must and will survive for a long time yet. The only question is how – that is, what percentage of people will be closer to affluence than to dire need, including in the industrialized countries. To be sure, 'the ecological fate of humanity will be decided in Asia,' as the head of Greenpeace International, Thilo Bode, strongly emphasizes.[67] Nevertheless, the prime responsibility for environmentally sustainable reconstruction lies with those who first created the commodity paradise and worship its images as so many idols.

To turn away from the conventional model of economic development, making all the necessary sacrifices, does not at all mean a 'doleful march into poverty'; indeed, it 'could lead to new forms of welfare,' argues Ernst Ulrich von Weizsäcker, president of the Wuppertal Institute.[68] As director of that well-established laboratory of the future, he set out his ideas in detail in 1995 together with North American energy experts Amory B. Lovins and L. Hunter Lovins. In Germany at least, their book was a surprise bestseller.[69]

While it is true that in the core regions of Europe the population is fully motorized and every household has at least one TV, thoughtful citizens are increasingly breaking free of these icons of modernity. Yet even there society is becoming more polarized. Since the effort to find a parking place now outweighs the pleasure of driving, the ideal of an egalitarian motorcar society is a thing of the past. Massive traffic jams also mean that it is far from the case that everyone is equal. Ownership of a car and a television used to confer status, but now it has become a luxury not to have to own a vehicle or to be dependent on television. Anyone who can afford it prefers to live in a quiet inner-city area close to a park instead of a hard-to-reach suburb. Anyone who has an exciting life gladly does without the flickering world of television appearance – and does not want to know about 'tittytainment'.

Such flights of fancy cannot take the place of the now imminent social change which has been outlined for so long by prophets ranging from Dennis Meadows (*The Limits to Growth*, 1972) to US Vice-President Al Gore (*Earth in the Balance*, 1992). In the early summer of 1989, environmental problems and climatic disaster were for the first time on the agenda of the G-7 summit meeting; it seemed to signal a major change in the rulers' thinking. 'The nineties will be the critical decade,' predicted the think-tank of the influential Washington-based World Resources Institute in a sensational statement.[70] 'In the next century it will already be too late,' echoed the biologist Thomas Lovejoy from the Smithsonian Institution in Washington. 'The decisive battles will be won or lost in the nineties.'[71]

A few months later the Berlin Wall came down, and optimists thought that the battle to save the planet would replace the ideological war between East and West.[72] At first this was certainly a tempting vision. After all, the Cold War had been fought at great expense and with great fanaticism, and these capacities were suddenly lying idle. However, anti-communism had been directed against a clear external enemy and had found support in human instincts going back thousands of years. 'But today's threat has no face; we ourselves are the enemy,' says Bertrand Schneider of the Club of Rome.[73]

Wheat as a world power

Along with the Club of Rome, Lester Brown is doubtless one of the best-known voices warning of ecological disaster. The Worldwatch Institute, which he founded in Washington in 1974, has become the most widely quoted private research institute in the world, and its yearly reports on 'The State of the World' are translated into twenty-seven languages. They are required reading for serious politicians, as well as for students in almost a thousand college and university courses organized each year in the United States alone.[74]

Brown is a much sought-after adviser; the world's big names solicit his company. So he simply had to be there at the Gorbachev meeting in San Francisco. He could be seen gliding in his trademark sneakers over the thick carpets and into the cosmopolitan corridors of the Fairmont Hotel.

The world-watcher is on the lookout for his close friends 'Ted and Jane', Ted Turner and his wife Jane Fonda. It is mainly at Brown's insistence that CNN produces remarkable eco-documentaries and that, instead of trendily poking fun at UN conferences of recent years, it has reported their main issues in considerable detail. In a few moments the CNN boss will welcome the guests at the opening reception of the elite conference. Nobel prizewinners such as Rigoberta Menchu are expected. Dozens of two-kilo tins of Malossol caviar decorate the counters, ready to sate everyone's appetite. In the adjoining kitchen America's star cooks – such as Square One chef Joyce Goldstein or Spago host Wolfgang Puck – are preparing their dainty evening menus.

Brown also seems interested in food, but of a quite different kind. The famous man is as excited as a young student who has just had his diploma thesis recognized: 'Did you know that China is importing wheat on a large scale for the first time in its history? Who will feed that gigantic country in the future? This will have huge consequences for us all.'[75]

A few days ago, Brown says, there was a meeting in Washington of agricultural experts, weathermen and specialists in the analysis of satellite photos. When they reached a corridor far away in the south wing of the Department of Agriculture, an armed guard locked and bolted a heavy steel door behind them. In the conference room where the scientists then met, the telephones were disconnected and

computer connections interrupted. Blinds prevented any visual contact with the world outside. The hermetically sealed group then spent all night sifting and comparing data from the various fields of operation. The meeting in the ministry, which so strongly recalled secret service practices or mafia films, was devoted to a weapon that might be capable of ruthless deployment within a few years: namely, world grain supplies.

As if training for the future, the US World Agricultural Outlook Board evaluates in a similarly conspiratorial manner documents concerning global crop forecasts and use of the chief grain varieties in more than a hundred countries. The secrecy is at present only supposed to stop leaks at any point before the end of the consultations. For in the hands of speculators, any conclusions about the world grain situation could immediately translate into fat profits on the computer-linked exchanges, so that the fate of countless agro-industrialists and commodity traders depends upon the forecasts of the Outlook Board.

Soon, Brown fears, the data series will lead directly to serious political conflicts, because individual countries must use every conceivable advantage in the struggle for food. In 1995 the stocks of wheat, rice, maize and other cereals were at their lowest level for two decades. In 1996 the grain silos contained supplies for only forty-nine days throughout the world, the lowest amount ever recorded. 'For the first time in its history,' the world-watcher estimates at The Fairmont, 'mankind must prepare itself – with no foreseeable limit in time – for a constant fall in the amount of food available per capita.'

Has the turning-point been reached, then, which Brown has tried for years to prevent with his tireless warnings? There is much to suggest that this is so. Stocks of maize are already lower than in 1975 and will probably shrink still further. Cassandras pronouncing on the question of world food have hardly been in fashion since Malthus's erroneous theories in the last century but, on the other hand, if present trends are to be reversed there will have to be a second 'Green Revolution' on a scale never seen before. Despite rises in yields through genetic engineering, as well as a further refinement of high-yield seeds and fertilizer technology, no one anywhere thinks that output can increase sufficiently to hold down the price of wheat. If the areas taken out of production in recent years in Europe and North America were cultivated again, they would still be a mere

trifle in comparison with surging world demand – according to the *Frankfurter Allgemeine Zeitung*, a paper beyond suspicion of playing Cassandra.[76]

At the same time, high-quality soil continues to be over-exploited. Since the 1960s, Japan, South Korea and Taiwan – the first Asian countries to make the leap to become industrialized – have given up a total of 40 per cent of their cultivable grainland to build thousands of factories, housing estates and highways. In Indonesia, 20,000 hectares of arable land are destroyed every year on Java alone – an area that could be used to feed 360,000 inhabitants. The population of this new addition to the development league is meanwhile growing by 3 million a year. China and India, too, are succumbing to the irresistible temptation to destroy agricultural land for their auto industries and their general economic boom. There is certainly a huge amount left unused on the planet, but it is no substitute. For either the land lying fallow is already too eroded, or it is in regions too dry, too cold or too inhospitable to make farming a worthwhile proposition.

Although the price of wheat already shot up nearly 60 per cent between May 1995 and May 1996, grain dealers are calmly awaiting further sharp rises on the exchanges. The UN's Food and Agriculture Organization in Rome calculates that it is already costing poor importing countries an extra 3 billion dollars a year.[77]

'When the cake stops growing,' says Lester Brown, 'the political dynamic changes.' Two hundred million tons of grain are currently exported per annum throughout the world, half of it from the United States. 'That means', Brown concludes his remarks in San Francisco, 'that in food too the USA will be the major world power in years to come – with the prospect that food will be misused as a means of political pressure.' Thus, according to the latest calculations, China will want to import roughly 37 million tons of wheat in the year 2000, more than the total of all US grain sales of any kind.

Globalization, then, is by no means just a question of 'American cultural imperialism' in the entertainment sector, as France's former minister of culture, Jack Lang, complained. The United States, as the 'mass culture superpower' (Lang), will not only decide which games are played but also hand out the bread.[78] Did Brzezinski also have this in mind when he, in front of Lester Brown and all the others, introduced the concept of 'tittytainment'?

There has been no outcry, or even constructive initiative, on the part of the US administration as mankind continues to live off its capital. While wheat prices soar, salination, erosion, air pollution and hotter summers have been having an ever worse effect on soil fertility in many parts of the world; not only new land but also water and fertilizer are running short. For Europeans, who have for decades been a reliable ally of North America on the other side of the great pond, none of this is any reason for apocalyptic cries of woe. The good news was in the papers on 9 December 1995, but it caused only a quiet sensation tucked away on the economic pages. The *Frankfurter Allgemeine Zeitung*, for example, drily reported: 'The European Commission has imposed a general tax on exports of wheat from the Community, in order to restrict the flow of EU wheat onto the world market.'[79]

Cruel wits might observe that, with the appointment of the new EU agricultural commissioner, Franz Fischler, an Austrian is once again preoccupied with the food situation on the European continent; cool calculators will realize that, with the introduction of the new tax, money will for once be coming into the EU's legendary kitty for agricultural subsidies rather than flowing out of it. Anyway, one result of the new wheat policy will be apparent to mockers and calculators alike. If the European Union no longer subsidizes exports of its food surpluses, but taxes them and makes them more expensive, things must be getting a good deal tighter out there in the rest of the world.

'Who will give the order to shoot?'

The story has got around, and now that it is known to everyone – peasants on the Kamchatka Peninsula, peasants in Tierra del Fuego, peasants in Madagascar, and all the poor young and young poor everywhere – can it really be true no longer? That there will not be a California or Germany for all, OK. But no California or Germany for anyone outside the EU, Japan and 'God's own country'? Really, no dream-life for anyone who does not already have anything?

Never.

The effects of forced uniformity can now be seen. Wherever tourists and television pictures put on display the living standards of the industrial heartlands, young people hungry for life are turning

their backs on their own country – which has nothing to offer but poverty – and getting ready to set off for the promised land. A good century ago, Europe first exported its sharply rising population and its armies of the poor to other continents. Eighteen million left Britain alone, six times the population of London, then the world's largest city.[80] Now that poverty is on the increase there, as it is in other EU countries, the time would seem ripe for another round of emigration. But where to?

Instead, people who are much worse off are jostling their way across the Rio Grande into the exalted United States, or across the Mediterranean into Europe and its jobs crisis. Already in the 1970s, 20 per cent of Algeria's labour force had taken the path of emigration, along with 12 per cent of Moroccans and 10 per cent of Tunisians of working age.[81] The EU eventually drew a circle around itself and started refusing visas and work permits. But the moat is too small for Fortress Europe to be completely sealed off. Even on a simple surfboard with a home-made sail, the Straits of Gibraltar dividing the rich from the poor can be crossed in a short enough time. EU heads of government long ago decided to arm their border guards. 'Millions will come,' expects Bertrand Schneider of the Club of Rome. 'Who will give the order to shoot to keep them out?'[82]

3. Dictatorship with limited liability. Playing pool on the world money market

'We wanted democracy, but we ended up with the bond market.' Polish graffiti

Michel Camdessus is undoubtedly a man of power. His speech lacks any superfluous flourishes, and his statements brook no contradiction. On G-Street in the north-west of the US capital, from his massive desk on the thirteenth floor of a forbidding reinforced-concrete building, the French bureaucrat governs one of the most controversial yet seemingly indispensable institutions in the world: the International Monetary Fund. Whenever governments try to get help from banks and finance ministers in other countries, because they are no longer paying off their debt and cannot overcome economic crises without international support, they turn to Camdessus and the 3000 employees of his world finance authority.

When dealing with the boss of the IMF, who has been in office for ten years now, the representatives of such major nations as Russia, Brazil or India are mere supplicants. In negotiations that can sometimes last for years, they must always commit themselves to draconian austerity programmes and a sweeping reduction in the size of their civil service. Only then will Camdessus submit the billion-dollar loans at favourable interest for approval by the rich donor countries – above all, the representatives of the United States, Japan and Germany. And only then will he add his signature releasing the money.

On the cold Monday evening of 30 January 1995, however, this tried-and-tested routine no longer works. About 9 p.m. Camdessus receives some news that sends shivers down his spine. From one minute to the next, he alone must take responsibility for heading off

a catastrophe that he previously considered to be all but impossible. Under enormous strain he grabs his papers and passes through his huge mahogany-tabled executive room into one even larger. In this conference room, where usually the twenty-four executive directors meet to decide on IMF loans, Camdessus sits alone with a telephone. 'I was looking for the answer to a question that had never posed itself before,' he recalled later.[1] Should he override the existing rules of the IMF and grant the largest loan in its fifty-year history without conditions, without an agreement and without the assent of the Fund's financial backers? Camdessus reaches for the receiver and, within a few hours, the power-conscious director of the world's largest credit institution shrinks to a mere puppet whose strings are held by people he does not even know.

Operation 'Peso Shield'

The crisis began when political Washington broke up for its winter holidays. Four days before Christmas, the Mexican government announced that its national currency would have to be devalued for the first time in seven years. A peso would cost 5 US cents (or 15 per cent) less than before. All around the world, but especially in the big banks on Wall Street and the mutual funds linked to them, panic spread among private investment managers, for they had put well over 50 billion dollars into Mexican government bonds, shares and debentures, having seen Mexico acquire a reputation as a financially sound country that had met all IMF conditions and put the government and economy on an even keel. Now foreign investors were faced with a massive loss in the value of their assets. Anyone who could was pulling money out of Mexico – as Mexican insiders had already been doing. In just three days, the peso lost not 15 but 30 per cent of its dollar value.

The Yuletide festivities were over almost before they had started for US Treasury Secretary Robert Rubin and White House Chief of Staff Leon Panetta, as well as for many of their colleagues. A crisis committee was formed from representatives of all areas of government dealing with foreign and economic policy – from the Federal Reserve to the National Security Council. Disaster was threatening one of the most important projects of the Clinton administration: that is, the economic stabilization of a country from

which millions of impoverished migrants were each year pressing their way into the United States. Rubin and Panetta therefore launched a rescue operation which the *Washington Post* soon dubbed 'Peso Shield' (in an obvious allusion to 'Operation Desert Shield' of the Gulf War).[2]

Three weeks of uninterrupted negotiations with the Mexican government seemed to bring a solution, at least for the time being. Mexico's President Ernesto Zedillo sacrificed his finance minister and promised an immediate rectification of government finances. President Clinton announced that his administration would stand by Mexico with loan guarantees to the tune of 40 billion dollars; no one need fear that the Mexican state would fail to repay its foreign creditors.

To the amazement of the crisis managers, Clinton's position was not enough to calm things down; in fact, the situation continued to worsen. Now investors not only suspected that dollars were pouring out of Mexico; they knew it. Moreover, it was unclear whether Clinton would actually get the money he had promised from the hostile new Republican majority in Congress. Although the Mexican central bank was every day buying half a billion dollars' worth of pesos, the exchange rate kept creeping down. This was a serious threat to Mexico, because it suddenly became unable to pay for imported goods. It was also a problem for the United States, where thousands of jobs depended on trade south of the border. The rest of the world hardly seemed to concern itself yet with the collapse of the peso.

A dramatic change came about on 12 January. On the very day when Clinton and Zedillo announced their financial closing of ranks, an eerie development occurred that hardly anyone had allowed for. In all of the world's major stock exchanges – from Singapore through London to New York – at least a dozen currencies simultaneously came under pressure. The Polish zloty fell in value at just the same speed as the Thai baht and the Argentinian peso. Suddenly, investors in every up-and-coming country in the South and in Central Europe, the so-called 'emerging markets', were selling off shares and bonds. Because they immediately changed the proceeds into hard currencies – dollar, mark, Swiss franc and yen – the exchange rate for the currencies in which the securities had been denominated fell together with the value of those securities. This happened in countries with

no economic links, such as Hungary and Indonesia. For the first time in their history, the heads of South-East Asian central banks assembled for a joint meeting. Driven by a dynamic for which they bore no responsibility, they had to make their currencies artificially more expensive by raising interest rates in order to keep investors happy. Argentina, Brazil and Poland followed suit.

From 20 January onwards, the end of the fourth week of the crisis, the dollar also went into free-fall. Even Alan Greenspan, the Federal Reserve Board chairman much admired for his nerves of steel, warned the US Senate that the 'worldwide flight of capital' into quality currencies such as the yen and mark was a threat to 'the global trend towards a market economy and democracy'. Together with Clinton's men, he urged Congress to approve the president's proposal and to give Mexico the necessary loan guarantees. Again the situation calmed down for a few days and the crisis of confidence in the high-growth countries of the South and East seemed to be nearing an end – until that chilly final Monday in January.[3]

Shortly before 8 P.M. on 30 January, Clinton's Chief of Staff Panetta received two telephone calls: one from Mexico's new finance minister, Guillermo Ortiz, and one from the leader of the Republican majority in the House of Representatives, Newt Gingrich. The Mexican reported that his country had exhausted its dollar reserves and was on its last gasp. If the flight of capital did not stop, he would have to limit the convertibility of the peso and at a stroke end Mexico's painful ten-year integration into the world market. Gingrich's message was hardly more optimistic. He explained to his political opponent in the White House that for the foreseeable future there would be no majority in Congress for the Mexican loan, and that the president would himself have to take all the responsibility.

Clinton and his team, Panetta later reported, therefore had no option but to adopt their 'Plan B'. The crisis committee had to use up the 20 billion dollars that were at the President's disposal for cases of emergency, as well as requesting assistance from other sources of finance. The first call for help went out to IMF headquarters in nearby G-Street. Michel Camdessus' hours of worrying had begun.

In an unprecedented forced ride over the previous fortnight, the IMF boss had whipped up 7.7 billion dollars for Mexico from its decision-making bodies – the largest sum permissible under the IMF statutes. But everyone knew that this would not be enough, that at

least another 10 billion would be needed to keep Mexico from bankruptcy.

Should he use the money placed in his safekeeping in this way? It was quite clear what the Americans and Mexicans wanted, and what they were pressing for; but was it in the interests of the many other contributors – including Germany, France, Britain and Japan – to add another 10 billion dollars to the emergency credit line? No time was left for the consultation required under the rules. It was 3 A.M. in Bonn and Paris, and the decision would have to be taken that night. Next morning the collapse of Clinton's plan would be made public in Congress.

Once again, Camdessus recalls, he thought of the warning 'calls from leading New York banks and investment managers' over the preceding days.[4] If the Mexican market collapsed, there would no longer be any respite. Fear of similar crises in other developing countries would set off a chain reaction that might end in a world-wide crash.

Camdessus got put through to nine successive government representatives on the IMF executive board who were in Washington at that time. To all he put the same question: 'In your view, should the IMF director act completely independently in an emergency?' Each one replied in the affirmative and expressed their confidence in Camdessus. Then he took a single decision, which Clinton learnt about when he returned to the White House from dinner shortly before midnight. The Frenchman disregarded all the Fund's rules, put his own job and the agency's reputation on the line, and informed Clinton that the IMF was good for another 10 billion, or 17.7 billion dollars in all.

A similar risk was soon being taken by Andrew Crocket, director of the Bank for International Settlements (BIS), the world association of central banks. It was already seven in the morning at the bank's headquarters in Basle when the US Federal Reserve asked Crocket whether it would take part in the support agreement. Yes, it would, but the maximum commitment it had ever discussed was 10 billion dollars. That was enough for the caller from Washington.[5]

Rubin and Panetta now coolly set 'Plan B' in motion. At 11.15 A.M. in Washington's Marriott Hotel, having slept for only four hours, their president caused a sensation as he addressed the annual gathering of state governors. With the help of the IMF, the BIS and the

Canadian government, but without the prior approval of Congress, Clinton annouced that a stand-by loan of more than 50 billion dollars had been made available to the crisis-shaken country on the southern border of the United States. Mexico would pay off all its debts.

In under twenty-four hours, then, half-a-dozen people acting outside all parliamentary control had used taxpayers' money from the industrialized West to launch the largest credit aid programme since 1951, exceeded only by payments under the Marshall Plan with which the USA had supported postwar European reconstruction. On behalf of all those who had contributed, Camdessus spared no superlatives to justify the coup. The Mexican affair, explained the French world-citizen to the leading lights of the IMF, 'was the first major crisis of our new world of global markets'. He had simply had to act, whatever the cost. Otherwise, 'there would have been a real world catastrophe'.

Numerous critics, however, interpreted the multi-billion dollar deal quite differently. Rimmer de Vries, an economist at the New York investment bank J.P. Morgan, which had not been involved in the Mexican boom, openly spoke of a 'bail-out for speculators'.[6] Norbert Walter, chief economist at the Deutsche Bank, remarked that it was 'not to be understood why the taxpayer should also have to guarantee that investors receive a high return' on the Mexican debt.[7] Willem Buiter, Professor of Economics at Cambridge University, concluded that the whole operation had been nothing more than 'a gift from the taxpayers to the rich'.[8]

This accusation does not, of course, contradict the arguments employed by Camdessus, Rubin and their colleagues. For the Mexico deal was both a disaster-aversion exercise (perhaps the boldest in economic history) and a brazen plundering of the tax coffers of contributor nations for the benefit of a wealthy minority. Naturally, speculators took advantage of the multi-billion-dollar credit, Camdessus admitted, but 'the world is in the hands of these guys'.

The Mexico crisis lit up with rare clarity the face of the new world order in the age of globalization. As never before, the main actors demonstrated the force with which global economic integration has changed the structures of power in the world. The government of the American superpower, the once omnipotent IMF and all the European central banks seemed guided by an unseen hand as they bowed to the dictates of a higher power whose destructive capacity

they were no longer able to evaluate: namely, the international money market.

From Bretton Woods to free speculation

In the stock exchanges and the dealing rooms of banks and insurance companies, in the investment and pension funds, a new political class has appeared on the world stage. It can no longer be shaken off by any government, any corporation, still less any ordinary taxpayer. Currency and security dealers acting on a world scale direct an ever-growing flow of footloose investment capital and can therefore decide on the weal and woe of entire nations, and do so largely free of state control.

Operation 'Peso Shield' was only a particularly clear instance. More and more often, politicians and electorates throughout the world see how the anonymous actors of the money markets are taking control of their economy, so that politics is left only with the role of impotent bystander. In September 1992, when several hundred bank and fund managers followed the example of finance guru George Soros and staked billions on the devaluation of the pound sterling and the Italian lira, the Bank of England and the Banca d'Italia could not prevent the fall in the exchange rate, even though they committed nearly all their dollar and Deutschmark reserves to purchases of their national currency. Both governments eventually had to leave the economically advantageous European Monetary System (EMS), with its fixed rates of exchange.

In February 1994, when the Federal Reserve put up base rates and the US capital market nose-dived as a result, the Bonn government could again only watch as German companies suddenly had to pay higher interest on their loans, even though inflation was low and the Bundesbank had set a low minimum lending rate which actually made quite cheap money available to the commercial banks. A year later, in the spring of 1995, the German and Japanese governments both showed themselves powerless before their electorates when the dollar fell to a record low of 1.35 marks and 73 yen, bringing export industries to their knees.

Numerous heads of government, driven into a corner by un-assailable dealers, have since given themselves over to helpless incantations and hollow abuse. Thus, British Prime Minister John

Major complained in April 1995 that it was quite unacceptable for things to happen on the money markets 'at a speed and on a scale which risks running beyond the control of governments and international institutions'.[9] His former counterpart in Italy, Lamberto Dini, who was once governor of the central bank, agreed that 'the markets should not be allowed to disrupt the economic policies of an entire country'.[10] In the view of French President Jacques Chirac, the whole finance sector should be condemned; its caste of traders were 'the AIDS of the world economy'.[11]

Yet the alleged conspiracy is not really a conspiracy at all. No cartel of profit-hungry bankers is at work. Nowhere do cabals meet in back rooms to weaken a country's currency or to drive up a stock-exchange index. What happens on the money markets follows a largely comprehensible dynamic that was actually made possible by the governments of the major industrialized countries themselves. In the name of a doctrine of salvation through totally free markets, since the early 1970s they have systematically striven to tear down all barriers which once allowed cross-border flows of money and capital to be regulated and therefore controlled. Now, like the sorcerer's apprentice, they complain that they are no longer in control of the spirits that they and their predecessors called into being.

The freeing of money from government controls began in 1973 with the ending of fixed rates of exchange between the currencies of the main industrial nations. Until then the rules of the Bretton Woods system – so named after the mountain village in New Hampshire where the Second World War victors met in July 1944 and instituted an international monetary order which assured stability for nearly thirty years – had been in operation. The value of all participating currencies had been pegged to the dollar, while the US bank of issue had for its part guaranteed to exchange dollars for gold. At the same time, currency dealing was subject to official controls, so that in most countries permission was required for the exchange and transfer of large amounts. The system was seen as an answer to the chaotic developments of the 1920s and 1930s, which had led to wild national defensive reactions, protectionism and finally war.

The rapidly expanding industries and the banks, however, saw such bureaucratic restrictions as a dampening device. In 1970 the United States, the Federal Republic of Germany, Canada and Switzerland gave up controls on movements of capital. The dam

then burst. 'Speculators' – that is, dealers who value a currency according to various investment possibilities – negotiated exchange rates among themselves, and the fixed-rate system fell apart.

This meant that all other countries which had stuck with controls also came under pressure. Their big corporations complained that they were denied access to foreign capital at favourable rates of interest. In 1979 the British lifted their last restrictions, and Japan followed a year later. The rest was taken care of by the IMF and the European Community. Guided by a firm belief in the capacity of a borderless economy to improve welfare, the EU regents launched the drive for a single market in 1988. In the course of this 'greatest deregulation programme in economic history' (as EU commissioner Peter Schmidhuber called it), France and Italy also freed up the circulation of money and capital in 1990, with Spain and Portugal holding out until 1992.

What the G-7 countries had decided for their own economic areas, they gradually pushed through in the rest of the world. The IMF, in which the G-7 countries have the main say, was the ideal instrument for this. Wherever the IMF potentates have granted loans in the last ten years, they have imposed the condition that the relevant currency be made convertible and the country opened up to international movements of capital.

Single-minded policies and legislation, on the part of mostly democratically elected governments, gradually put in place that autonomous 'money market' system to which political scientists and economists have come to ascribe a kind of higher power. Now there is no ideology, no pop culture, no international organization, no ecological interest even, which binds the nations of the world more closely together than the electronic network of global money-machines of the banks, insurance companies and investment funds.

Profit-chasing at the speed of light

This global freedom has enabled the business of the world finance industry to rocket in the last ten years. Since 1985 transactions in foreign currency and international securities have increased more than tenfold. On an average day, currency to the value of some 1.5 million million dollars now changes hands, according to the Bank for International Settlements. This sum – a figure containing twelve

zeroes – is almost equivalent to the total annual output of the German economy or to four times total world expenditure on crude oil.[12] Dealings in shares, corporate loans, treasury bonds and countless special contracts (so-called derivatives) have been moving in the same order of magnitude.

Just a decade ago, there was one market in Frankfurt for German government bonds, one in London for British shares and one in Chicago for futures, each coming under separate legislation. Today all these markets are directly linked to one another. All the current prices in every stock exchange can be called up at any moment at any place in the world, and trigger buying and selling at prices which are in turn immediately communicated round the globe as so many bits and bytes. It is therefore possible that falling interest rates in the USA will push up share prices on the other side of the world – in Malaysia, for example. If a commitment in US bonds becomes worth less, investors spread into foreign shares. The value of German government bonds may therefore go up if Japan's central bank lends more cheaply to Tokyo's finance houses, for these cheap yen credits, when exchanged into marks and invested in German securities bearing a higher rate of interest, guarantee a risk-free yield. For that very reason, anyone who wants to borrow money or raise capital – whether a government, a corporation or a housebuilder – immediately enters into worldwide competition with every other potential debtor. Neither the conjunctural position of the German economy nor the Bundesbank determines the rate of interest on the German capital market. All that counts is the judgement of professional money-multipliers who, in the words of *The Economist*, race twenty-four hours a day like an 'electronic army' in search of the world's best financial opportunities.

In their work, the profit-chasers move at the speed of light in a global data network with many branches, an electronic Utopia still more intricate than the complex mathematics which underlies individual transactions. From dollars to yen, then into Swiss francs and finally back to dollars – in just a few minutes, currency dealers can jump from one market to the next, from one trading partner in New York to another in London or Hong Kong, and end up with deals worth millions in three different places. In the same way, fund managers often shift their clients' billions in a few hours between completely different investments and markets. A telephone call or a

press on a key is enough to convert US federal bonds, for example, into British bonds, Japanese shares or Turkish government obligations denominated in Deutschmarks. Apart from currency, more than 70,000 different securities are already freely traded across frontiers – a fantastic market with infinite chances and risks.

Individual dealers achieve maximum output in handling the flow of information. One such man is 29-year-old Patrick Slough who, together with more than 400 colleagues, sits non-stop for ten hours a day in the great trading hall of Barclays de Zoete Wedd investment bank and manages the business of Swiss francs (or just 'swiss', for short).

His workstation is a modest-looking console three metres wide, surrounded by a babble of voices and bellowed orders in the dimly lit hall. Three screens and two speakers are mounted behind the small work-surface, constantly supplying him with new optical and acoustic data. At the top right presides the four-colour screen produced by Reuters, the market leader in finance electronics. Reuters records annual profits in excess of a billion marks, having evolved from a simple news agency to the main organizer of the electronic marketplace. It connects Slough, through special cables, satellite channels and its own mega-computer in London Docklands, to 20,000 finance houses and all the major stock exchanges around the world.[13]

The screen simultaneously displays the last three offers or supplies of 'swiss', the highest and lowest rates of the last few hours for all currencies, and the latest news from the currency world. At the same time, Slough can contact any other user by keying in a code and immediately conclude a deal. But he is not allowed to rely only on that; he must also keep track of the prices that his two independent brokers communicate to him through the speaker. Every couple of minutes he himself makes a bid, either by telephone or from his keyboard. If another broker-client accepts, a call soon follows.

Human price-finders compete with the electronic brokerage systems produced by Reuters and its rival EBS, which is owned by an international banking consortium. These too receive every bid and at once anonymously transmit it to the screens. In 'real time' and 'online', then, Slough can always find out from the EBS screen to his left what is the highest bid and the lowest offer for francs into dollars or marks that have been made within this system. The really important figures, which show up black on yellow, are the constantly

changing third and fourth decimal places. If Slough taps his 'buy' key, the computer displays the bidder's identity and automatically makes the connection.

On this Thursday in January 1996 'the market is very nervous', Slough complains. Before starting work, he studied the daily edition put out by the in-house information service of the economics department. The crucial event will be the meeting of the Bundesbank directors in Frankfurt. If it decides to lower the bank rate further, the dollar and franc should rise again. But it is doubtful whether the Germans can afford it; their debt mountain is too high, and the Bundesbank's fear of inflation is a permanent factor in the currency business. The in-house economist therefore guesses that the rate of interest will remain unchanged.

After half an hour, Slough tests the market by buying '70 marks' for 'swiss 575' at the Swiss UBS Bank. Using an electronic pen, he enters the deal at high speed into the house system through the dots on the console: 70 million marks for francs at 0.81575 francs per mark. Not long after, a loud 'Fuck!' escapes him: the price has fallen by a hundredth of a centime; he has lost 7000 francs, for the time being. But the 'Buba' – as the Bundesbank is known among professionals – is on his side. German interest rates remain unchanged. The mark is rising, and his loss changes in seconds into a gain twice as large. Slough plays safe by immediately selling and relaxes for a minute.

'Educated gambling', at high level with cast-iron rules, is how he describes the nerve-racking job. But he realizes that he is just a little foot-soldier blown around by the market. 'Even the biggest players' – the New York Citibank, for example – 'cannot make the market move on their own. It's just too big.'

Things are still easy for the currency dealer; only the present counts. At the other end of the room, his colleagues carry on the derivatives business. They deal in the future or, to be more precise, in what most market participants expect to be the price for shares, bonds or currencies in three or twelve months, one or five years. Their products are called swaps and collars, futures and options, dingos and zebras. Every month new ones arrive on the market. What they all have in common is that their price is 'derivative', based on rates paid now or later for real securities and currency.

To bet on the German economy, for example, there is no need to

buy German shares directly. Clients can also sign a futures contract on the German share index; a contract which, for a premium, promises payment of the difference if the index rises above an agreed level. The bank must in turn cover itself against this eventuality by means of a counter-contract or its own stock of shares. If the customer wishes, he can also insure himself with a further option against fluctuations in the exchange rate of the mark and swap the interest on his long-term deposits for short-term interest payments to the bank, or vice versa. The amazing effect of such deals is that they detach the risk of a rate drop or a debt default from the purchase of real securities or currency. The risk itself becomes a tradable commodity.

In the old days, this futures or risk business served only as a kind of insurance for the real economy. Exporters, for example, could use it to protect themselves against fluctuations in the value of their trading partners' currency. But since the capacity of computers became virtually unlimited, the derivatives trade has made itself completely autonomous and an 'age of financial revolution' (as the former BIS president Alexandre Lamfalussy euphorically described it) has dawned.[14] All the big financial centres have long had their own exchange just for the futures trade. Between 1989 and 1995, the nominal value of contracts doubled every two years and reached the unimaginable sum of 41,000 billion dollars worldwide.[15]

This figure alone signals the dramatic change in the nature of financial transactions, only 2 to 3 per cent of which now directly serve to protect trade and industry. All other contracts are bets organized among themselves by those who conjure with the market. Their formula is: 'I bet that in a year's time the Dow Jones will be 250 points higher than now. Otherwise I'll pay ... ' There is, of course, a big advantage over casino gambling in that only a small amount has to be put up front when the deal is concluded. The promised sum is actually seen only when the contract falls due, and then most players will have limited their losses through an offsetting contract. The actual market value of derivatives is therefore only a fraction of the nominal sums involved; but they have still radically transformed what happens on the markets, for even small shufflings of capital unleash ever-greater price movements, so that dealers' collective expectations themselves acquire a physical momentum.

With the derivatives trade 'the financial world has emancipated

itself from the real sphere,' argues the banker Thomas Fischer, who has himself ridden the market tiger for years as trading manager of the Deutsche Bank. Objective economic relationships, for instance between base rates and bond prices, are becoming less and less significant. What counts more is the expectation of 'what others will do. The point is not why such and such a price is increasing, but why it could increase in the first place' – and how such an increase can be anticipated. The evolution of German government bond prices, for example, is negotiated not by dealers in fixed-interest securities at the German banks but long before by brightly dressed jobbers at London's 'Liffe' futures exchange, where two-thirds of deals in 'bond futures' are transacted. Because of such mechanisms, the range of fluctuation of all prices (their 'volatility' in the jargon) has dramatically increased.

The big banks have done splendid business out of this latter risk, which was first generated by the derivatives trade itself. The Deutsche Bank alone makes nearly a billion marks a year from derivatives. The growing importance of the trade in its balance sheet illustrates the changed role of the banks in global finance. The management of savings and the granting of loans are no longer as significant as they used to be. Numerous corporations have long been their own bankers. There could hardly be a better example of this than Siemens, which earns more from its financial transactions than from its world-famous products. Hundreds of big companies meanwhile look after their credits by themselves issuing world loans. Except for the financial giants of New York and Tokyo, which really do operate on a global scale, most of the finance houses still have only the function of transmission belts for markets. Their trading departments provide only mercenaries for the electronic finance armies, while the commanders issue orders from quite different heights. They sit in the headquarters boardrooms of the investment trusts and pension funds. With a decade of double-digit growth behind them, they have become the real assembly points of world capital. America's mutual funds alone control 8000 billion dollars in savings and pension reserves, making them the largest source of the erratic and never-ending flow of capital.[16]

Lego models of the White House

In this business Steve Trent counts as one of the elite.[17] He and two other directors manage a so-called 'hedge fund', one of those special firms which regularly secure their investors a double-digit, now and then even a triple-digit, return through especially intelligent but also risky portfolios. Reddish-brown Carrara marble and elegant precious wood decorate the luxurious crow's nest on Washington's Connecticut Avenue at H-Street, from where Trent and his colleagues look out on the world. How emblematic it is of the new times! Not so long ago, this exposed spot in the US capital boasted an administrative office of the Peace Corps, which for years used to send socially committed Americans to various places around the world. When the US city centres started booming again in the 1980s, the expensive building was sold off to speculators and an aristocratic office block was erected which has since had architectural prizes showered upon it. The ground floor became home to the stylish Oval Room restaurant, so named in a conscious allusion to the legendary 'Oval Office' in the White House.

On the same floor as finance manager Trent, the staff of media giant Time Warner enjoy a heavily symbolic view. From their tinted windows, Bill Clinton's residence on Pennsylvania Avenue seems like a humble Lego house. Even the set of Treasury buildings, gigantic in comparison with the White House, shrink to a nice little dolls' home from the vantage-point of the finance and media magnates. At most, the marble-monster obelisk of the Washington Monument, recalling the ultra-rich first president of the USA, commands their respect.

Relaxed but concentrating in his multimedia office, Trent follows world events in order to steer his clients' 2 billion dollars into the right channels. He too has a Reuters display screen, as well as a 'squawk-box' or speaker with its black microphone that sticks out like a table-lamp between television and computer. Just under a hundred people around the world can listen to him – above all, his dealers on the Tokyo, London and New York exchanges. It would take him only seconds to shift billions around, discreetly but efficiently.

When Congress is in session at the other end of Pennsylvania Avenue, Trent always watches it live on TV out of the corner of his eye. When he describes his work, he does not sound like Patrick Slough in London; he does not talk of the profits earned in minutes

by the day's speculators on the stock exchanges and currency markets. Trent's remarks are more like the world situation reports that governments have their secret services and general staffs draw up for them.

Between five and ten times a year, he travels for a week or two to the world's most important markets and growth regions. There he makes inquiries about every conceivable aspect of economic life. Hardly any doors are closed to him; his conversation partners from industry, government and central banks know the inestimable value of such a pathfinder for the transnational flow of capital. In these conversations Trent is not looking for figures and mathematically grounded predictions. 'Everyone's got the latest data on computer,' he holds forth. 'What counts is people's mood, the conflicts beneath the surface.' And: 'History, always history. If you know a country's history, you can see better what will happen in an acute crisis.'

Calmly and precisely the speculator looks for the faulty estimates of computer-trusting competitors and the strategic mistakes of particular governments. He found one such gap in the autumn of 1994. The world economic situation was on the up and up, and things were also looking good for Germany, so the markets first banked on a rise in interest rates. 'That was crazy,' Trent says happily today. 'We knew Germany didn't have the problem of high labour costs under control, and we also knew that Germany's medium-sized companies would change every dollar they earned into marks to cover costs back home.' He therefore bet on a rising mark, a rapid worsening of the economic situation, and further falls in interest rates. He was right and pulled off 'one of the most successful speculative operations of recent years', when his fund made large-scale forward purchases of marks and mark bonds at a low price. Such contracts have to be honoured only three, six or even twelve months later, and these ones brought Trent increases in value to the tune of 10 per cent or more in just a few months.

Big money is only ever made by those who – in the manner of Trent's hedge funds – not only invest their clients' capital but use short-term loans to increase the size of the investment. The risk is high, but if things are well judged, a 10 per cent profit can quickly turn into 50 per cent for the investor. The fund manager can then pocket an extra year's income in a couple of weeks. A billion-dollar coup will eventually result if other funds and banks pursue the same investment strategy and, in this way, themselves contribute to the

evolution of prices that they have predicted. This must have worked out a number of times for Trent and his colleagues in recent years. The value of a share certificate in their fund soared by no less than 1223 per cent between 1986 and 1995, a twelvefold increase for shareholders.

The same happened in 1992–93 when 'speculators' (as German Finance Minister Theo Waigel called them) turned the European Monetary System inside out. Then too, most of the money staked by the professional multipliers was borrowed money. Again they achieved profits that would never be possible in the real economy. Only this time the opponents were not other market players but fifteen European governments, and the issue was not only money but, more than ever before, a power struggle between market and state.

A hundred million dollars a minute

A stable currency is a huge plus for any economy. It allows reliable calculations to be made by import and export businesses, and it lowers the cost of protecting them against fluctuations in the value of the currency. That is why West European governments agreed as long ago as 1979 to knit closely together the EEC currencies of the time, thereby making up for the loss of the Bretton Woods system at least within the European Community. This was supposed to make it easier for less developed regions to catch up, with gradual 'convergence' as the final goal. Exchange rates were guaranteed by the banks of issue, which at any time converted lire, pesetas or sterling into marks at a fixed rate. For years the EMS was also good business for financial investors. In weaker economies such as Italy, Britain or Ireland, higher interest rates for public or private loans prevailed than in Germany or the USA. But there was still only a small exchange-rate risk, as convertibility into marks and dollars was guaranteed.

This system fell apart as a result of German unification. Currency union with the East meant that in practice the federal government bought not only the GDR but also its bankrupt industry. The supply of marks in circulation skyrocketed without an equivalent counterpart in commodities and plant; higher inflation became a real danger. The Bundesbank met this by raising interest rates, and all other central banks in the EU had to fall into line if they wanted to keep

existing parities with the Deutschmark. This posed a macroeconomic problem, however, as high interest rates choked off investment. The Bundesbank suddenly came under fire all over Europe, and big corporations began to run down their holdings of lire, sterling and pesetas because many economists now considered these currencies to be overvalued. Nevertheless, the EU authorities hesitated to give up the EMS. The whole idea of European integration ultimately depended upon it, and they hoped that there would soon be an end to the crisis brought on by German unification and high interest rates. Two years later this aim was actually fulfilled. But two years is an eternity on the international money market.

Stanley Druckenmiller, head of George Soros's legendary Quantum Fund, could feel that this EMS crisis was his chance of a lifetime. Druckenmiller is the American dream personified.[18] A failure at university, he could not even pass a test to train in a bank in the 1970s. His reputation as a daring and unusual risk-taker, however, got him a job first as a share analyst at a small bank in Pittsburgh, then as asset manager for the Dreyfuss dynasty, and finally, in 1989, as Soros's successor at the top of Quantum. Since then, the Hungarian-born Soros has served only as the company's eye-catching public figure; his main activity has been as patron and promoter of economic restructuring in Eastern Europe. 'The man who moves the markets' – as *Business Week* once headlined Soros – is in reality Druckenmiller.

In August 1992 Druckenmiller was one of the first to realize just how precarious was the position in which the defenders of the EMS found themselves. Ministers and central bank governors from Stockholm to Rome were issuing almost daily assurances that they would keep to the fixed exchange rates. But it was also leaking out that the central banks of countries with a weak currency had already started to accept Deutschmark credits to replenish their reserves.

For the attacking forces in the EMS battle, information about the Deutschmark reserves of issuing banks was as valuable as knowledge in war about the food and water stocks of a besieged city. Once he had these data, Druckenmiller had an easy time of it. His strategy was simple. Each day he borrowed larger and larger sums in sterling and immediately converted them into marks in British banks – marks which the financial institutions were themselves requesting from the Bank of England. The more others imitated him, the more certain

he could be that the Bank would run out of reserves. At that point at the latest, when it would be the last purchaser still paying at the high exchange rate, the Bank would drop out and be compelled to release the pound for devaluation. Then Quantum could again buy sterling at a far lower rate and pay off its original loans. Even if the pound slipped by only 10 per cent, the operation could net as much as 25 pfennigs on every pound.

The British maintained faith in the Bundesbank until the second week in September. Theoretically it could have used its unlimited supply of Deutschmarks to defend the pound against any attack. To stem the ever greater tide of speculation, however, the Buba would have had to throw many billions of marks on to the market, and the guardians of the currency in Frankfurt thought that this would stoke up inflation. On 15 September German–British solidarity finally reached its limits. The Bundesbank president of the time, Helmut Schlesinger, casually let it drop at a press conference that the EMS required certain 'adjustments'. This expression did the rounds within a matter of minutes; it was like 'an advertisement to sell pounds', finance experts later commented in a report to the US Treasury.

In London Chancellor of the Exchequer Norman Lamont, who was bound by treaty and law to the freedom of capital movements, had only one weapon left. He could put up the rate of interest and make it more expensive for the attacking forces to get the money to play with. At eleven in the morning on the day after Schlesinger's betrayal, and again at two in the afternoon, he increased the official base rate by 2 per cent. But the profits to be expected from devaluation were far greater than the higher cost of interest. The only consequence of Lamont's defensive measures was that the speculators borrowed and exchanged still greater amounts. At four o'clock the Bank of England finally gave in, having gambled away half of its total reserves. Within hours the pound lost nearly 9 per cent of its value, and the attackers were able to pocket dream profits. Druckenmiller alone made a billion dollars for Quantum, Soros later announced.

Over the next few days the drama was repeated with the Italian lira and the Spanish peseta. To avoid the same fate, Sweden and Ireland took the ultimate measure of self-defence by raising their interest rates to 500 and 300 per cent respectively. But the speculators rightly interpreted this as a sign of weakness. They needed only to bide their time, knowing full well that both countries would not keep

it up for long if they did not want to see the life choked out of their economy. Sweden reached the end in November and returned to a normal rate of interest, whereupon the krone was devalued by 9 per cent. Ireland followed the next February with a 10 per cent devaluation.

The struggle over the EMS was not yet over. The 'franc fort', the strong French franc, was still going, and unlike in the other cases it was not thought to be at all overvalued. Early in 1993 Europe's second-largest economy was even better positioned than Germany's. Nevertheless, the profit-chasers had tasted blood the previous year; a declaration of political resolve in Bonn and Paris to maintain existing parities with the mark, and to save the EMS even without Britain and Italy, was enough to unleash new waves of speculation. For months the Paris central bank supported the franc whenever it was put to the test, and it urged colleagues in Frankfurt to ease the pressure on the monetary system by bringing down interest rates. When the Buba did not comply with this request at its directors' meeting on Thursday, 29 July, the waves became a flood tide. The next day, a German–French crisis meeting was hastily convened at the Finance Ministry in Paris, where Jacques de Larosière, governor of the Banque de France, demanded unlimited support from his partners in Frankfurt. While the delegations were still discussing the matter, they learnt of the de facto collapse of the EMS. A single figure demonstrated the superior strength of the worldwide offensive against the franc. For a while in the early afternoon, when the speculation was at its peak, the Paris central bank was losing 100 million dollars a minute. By the time trading ended for the day, Larosière's colleagues had put out 50 billion dollars and were in the red for more than half that amount.[19]

Helmut Schlesinger and his designated successor, Hans Tietmeyer, did not care to live with this debt and the expected further round of speculation, and so they advised the French to throw in the towel. The argument came back that the whole problem was ultimately caused by Germany. Until Sunday night Larosière and his government kept trying to put the Germans under pressure, to no avail. Around one in the morning, shortly before the exchanges opened in East Asia, the remaining EMS members let it be known that they had decided to allow all parities to fluctuate within a band of 15 per cent.

So ended the fourteen years of the West European stability pact,

after a dozen lost battles to defend it which, on a conservative estimate, had cost Europe's central banks and ultimately the taxpayers several hundred billion marks. Supporters of a free world market see nothing wrong in this, at least on the side of the money dealers and investors. Their most influential champion in Germany is the present Bundesbank chief himself, Dr/Dr honoris causa Hans Tietmeyer. In the view of the mark's supreme defender, currency rivalry is part of the free world of market economics in which all nations compete with one another. The 'free movement of capital' is supposed only to help along 'inexorable adjustments in economic policy', so that in the case of the collapse of the EMS, fixed exchange rates had simply become 'implausible' on the markets.[20] For the Buba boss and the many other true believers, if there is ever any doubt about who made a mistake the politicians are there to take the blame. The problem, Tietmeyer said at the World Economic Forum in Davos in February 1996, is simply 'that most politicians still do not realize how much they are already under the control of the money markets and are even ruled by them'.[21]

This is strong stuff. But it is fully in line with the theory of US economist and Nobel prizewinner Milton Friedman, which is nowadays accepted (and politically applied) almost everywhere in the world. The picture that many of these 'monetarists' have of the world is comparatively simple: optimum use of capital can be made only if it is free to move across national boundaries. Their magic word for this is efficiency. Guided by the pursuit of maximum profits, the world's savings should always flow where they will be best employed – and this will naturally be where they show the highest return. Money thus arrives from capital-rich countries in regions that offer savers the best investment prospects. Conversely, borrowers everywhere choose suppliers of credit who offer the lowest rate of interest; they do not need to bow to local banking cartels or to pay over the odds for the fact that there is too little saving in their own country. In the last analysis – or so the theory goes – all nations profit from the outcome, because the highest growth rates are combined with the best investments.

Monetarists, then, ascribe a kind of higher rationality to what happens on the money markets. The actors there are 'only umpires who punish policy mistakes with devaluation and higher interest rates', argues Tietmeyer's former colleague at the Bundesbank, Gerd

Häusler, who today sits on the board of the Dresdner Bank.[22] *The Economist*, for its part, was quite categorical in arguing that the money markets had become 'judge and jury' of every economic policy; there was nothing but good in the fact that national states had lost their power, for governments were no longer able to abuse it by imposing excessive levels of taxation and stoking inflation through high levels of debt. All this enforced a 'healthy discipline'.[23]

Is the money market without frontiers therefore a universal source of welfare and the guardian of economic rationality? Such a vision is not only misleading but also dangerous, for it obscures the political risk associated with it. The more dependent countries become on the goodwill of investors, the more ruthless must governments be in favouring the already privileged minority who have sizeable financial assets. Their interests are always the same: low inflation, stable external value of the currency, and minimum taxation of their investment income. Without being explicit, the true believers always equate these goals with the general welfare. But this is sheer ideology in the context of the global money market. The financial short-circuit between different countries forces them into a competition to lower taxes, to reduce public expenditure, and to renounce the aim of social equality – a competition which brings nothing other than a global redistribution from those at the bottom to those at the top. Rewards go to whoever creates the best conditions for big capital, while sanctions loom for any government that obstructs this law of the jungle.

Offshore anarchy

The abandonment of (border) controls on capital has therefore set up a dynamic which, by systematically nullifying the sovereignty of nations, has long been seen to have disastrously anarchic implications. Countries lose their right to levy taxes, governments lay themselves open to blackmail, and police forces lack the power to deal with criminal organizations because they cannot lay hands on their capital.

Nothing illustrates this anti-state tendency of the world financial system more dramatically than the development of so-called offshore financial centres. From the Caribbean through Liechtenstein to Singapore, a hundred or so centres are scattered around the world from which banks, insurance companies and investment funds manage

their clients' money and plan how to elude the grasp of the state in its countries of origin. The concept of safe havens for capital is everywhere the same: they promise low or zero taxation on foreigners' investments and make it a punishable offence to disclose the identity of account-holders, even if this is requested by government authorities.

The tax-haven market leaders are the Cayman Islands in the Caribbean, a 'dependent territory' of the British Crown. More than 500 banks are registered on the main part of the Caymans, where 14,000 inhabitants live in just fourteen square kilometres. Everything with a name in the financial sector is represented there, including the ten largest German financial institutions. Even state-owned banks such as the Westdeutsche Landesbank or the Hessische Landesbank are not above acquiring money that has winged its way to the Caymans.[24] Their European clients, of course, do not have to rely on the Caribbean to avoid paying taxes; the same services are provided in the Channel Islands of Jersey and Guernsey, as well as in the principality of Liechtenstein or the duchy of Luxembourg.

In recent years Gibraltar has risen to become one of the new magnets of capital (in reality, centres of fiscal crime euphemistically known as 'oases'). More than 100,000 rich people have already transferred their assets as a matter of form to the ape-inhabited 'Rock' at the southern tip of Spain. Men such as Albert Koch, owner of Marina Bay Consultants operating from the anonymity of a mailbox firm, can arrange everything a tax evader might need, up to and including the papers for an ostensible immigration. With its slogan 'Smart investors are heading for Gibraltar', the German Commerzbank also advertises tax flights to the South. The twenty employees of its branch in the Main Street of the British Crown Colony welcome all tax refugees who want to place at least 100,000 marks in a time deposit. An interest-bearing investment account requires a minimum of half a million. Branch manager Bernd von Oelffen is triumphant: 'Here banking secrecy is still for real.'[25]

The damage done by the offshore system can hardly be measured. There could not be more fertile soil for internationally organized criminals, and their ill-gotten gains have become virtually impossible to track down. It cannot be said for sure whether and how far the proceeds of crime filter through the offshore locations into above-board financial circuits. 'There is no factual material about that,'

confesses Michael Findeisen, who is in charge of coordinating the
official struggle against money-laundering at Germany's Banking
Inspectorate.[26] The Swiss Federal Police estimate that since 1990 more
than 50 billion dollars from illegal sources have been transferred to
the West from Russia alone.[27] The technical–financial bridgehead for
the various Russian mafias is the offshore centre of Cyprus, where
300 Russian banks maintain pro forma branches and report annual
turnover of 12 billion dollars.[28] These banks, maintains Findeisen,
also have access to the electronic payments system in Germany.
Contrary to the assurances of the German minister of the interior
and the banking lobby, the door is wide open for criminal money.
The same is true of Austria. Viennese security experts reckon that
200 billion schillings (very roughly 19 billion dollars) from mafia
circles have been deposited in the banks of the Alpine republic.

The danger of infiltration by multinational criminal organizations
pales, however, beside the gigantic losses to the public purse that
result from the legally organized flight of capital. Wealthy Germans
have parked more than 200 billion marks just in the Luxembourg
branches and investment funds of the German financial sector. The
Finance Ministry loses from this over 10 billion a year, roughly half
of the 'solidarity with eastern Germany' supplement that taxpayers
are required to pay. Fund managers invest most of the flight-money
again in Germany, perhaps even in government bonds. And so the
state becomes indebted to people who cheat it of taxes, and even
pays out interest that gives the creditors some extra tax-free income.

Luxembourg is only one of the channels through which the
national budget loses blood. If all the flight centres were added up,
the tax shortfall would easily come to 50 billion marks per annum,
which is approximately the amount of the new public debt added
each year. For all countries together, the losses represent an ongoing
financial catastrophe. Thus, according to IMF statistics, a total in
excess of 2000 billion dollars is managed under the flag of various
offshore mini-states, beyond the reach of the countries in which the
money was made. The Caymans alone have for the last decade been
reporting more investment by foreigners than all the financial in-
stitutions in Germany put together. And by no means all flight-money
is recorded. Year after year the international balance of payments
shows a deficit in the tens of billions. This means that the outflow of
money is still registered, but that – from a statistical point of view –

it never arrives anywhere, because many banks in offshore centres do not even issue data for statistical purposes. Already in 1987 OECD and IMF experts estimated that a further billion dollars were hidden in this black hole of the world economy.[29]

Grotesquely, all this is in no substantive sense connected with those unprepossessing political constructs which place their flags at the disposal of the world of finance and whose national sovereignty is at best on loan. Hardly anyone actually travels to the Caribbean or Liechtenstein with suitcases full of cash. And there is hardly any infrastructure there of the kind that would be needed to manage the money. Nor is any necessary. A mailbox and a general representative or trustee are enough; the rest is done by computers. For the flight-capital business is physically conducted in the computer networks of banks and corporations. Their head offices are in fact on German, British, Japanese or American soil. But the networked financial sector simply declares a lot of its hard-disk contents as extra-territorial.

It would therefore be a simple matter for the tax authorities and the police to block the channels of flight, without having to occupy any small countries. But that would be incompatible with the free movement of capital. So far the financial corporations have been able to prevent any attack on their 'secrecy' simply by arguing that it would lead them to transfer business elsewhere.

Germany saw a new performance of this farce in early 1996. Because of the mounting budget deficit, tax inspectors for the first time did some searching in the big banks. Jürgen Sarazin, head of the Dresdner Bank, immediately protested together with many of his colleagues. The operation, he said, 'would not raise the level of fiscal morality' but only damage Germany as a financial centre. As if to demonstrate its flight capacities, the Deutsche Bank later declared an annual balance sheet in which the company's results of 4.2 billion marks showed the second-highest profits in its history, but its tax payments were 377 million marks down on the previous year.

The Faustian pact

In this way, national states and their governments have become susceptible to blackmail. Under pressure from the organized finance industry, nearly everyone in the world follows the path that Sarazin from the Dresdner Bank and his colleagues again recommended in

1996: bring down taxes on wealth and capital, deregulate all financial services, and cut back spending on public services and social areas. For high taxes 'make people frustrated and only provoke resistance' that leads to tax avoidance. From one budget and tax law to the next, globalization has thus brought a consolidation of inequality, however different the national culture or social values may be.

The mechanics of this political alignment go well beyond state budgets. For the countries concerned, the act of joining the international financial system resembles what *Newsweek* called a 'Faustian pact'.[30] First it gives a government access to global reserves of capital. Countries can run up much higher debts for their investments than if they relied only on the money of domestic savers and wealthy individuals. The temptation has long been irresistible for every ambitious government. Even German unification could not have been financed without the money supplied by foreign purchasers of government bonds; more than a third of German public debt is now in foreign hands. But entry into the realm of world finance demands a high and inescapable price, in the shape of submission to an interest-rate hierarchy and to powers of which most voters have scarcely any idea.

The most influential of the discreet agencies operating in the money markets is located in a massive eleven-storey sandstone building at 99 Church Street in New York. In the shadow of the twin-towered World Trade Center, 300 highly paid analysts work for Moody's Investors Service, the world's largest and the most in demand. Above the doorway, a huge 12–square-metre relief covered in gold leaf explains the company's philosophy and interests: commercial credit is the invention of the modern world, and only the enlightened and best-governed nations are entitled to it. Credit is the life's breath of the free system in modern trade. It has contributed more than a thousand times as much to the wealth of nations than all the mines of the world.

Beyond this gilded creed lies a domain of power and secrecy that has no peer. Nowhere else in the world are the secrets of so many governments and companies so well guarded. No visitor from outside, whatever his rank, may enter the rooms where the staff work. Guests are first shown into a reception room with thick fitted carpets, and discussions take place exclusively in the elegant conference room on the eleventh floor.

Vincent Truglia, vice-chairman of the company founded in the early years of the century, starts by explaining what Moody's would not like to be. 'No, we don't pass judgement on whole nations; our rating is not moral and says nothing about a country's true values. No, we don't tell governments what they must do; we never give advice.'[31] In view of actual practice, however, such assertions vary between understatement and hypocrisy. For Truglia is in charge of Moody's Nation Rating, which ranks the countries of the world in order of creditworthiness. Grade 'AAA', the so-called 'triple A rating', is enjoyed only by financial top dogs such as the United States, Japan and stable EU countries like Germany and Austria. Already oil-rich Norway has to be content with the more restricted 'AA', because the 'long-term risks' of capital investment there are, according to Moody's definition, 'somewhat greater'. Italy, with its high level of debt, gets only a simple 'A', because it is 'prone to future weakening'. And Poland is really in the dumps, its 'BAA' indicating an expectation of only 'reasonable financial security'. In Hungary ('BA') even this is doubtful.

The rating has direct significance. Dealers at banks and investment funds automatically translate it into risk surcharges for the purchase of government loan securities. Moody's is at once the market's metaphor and its memory. Moody's never forgets, and it will forgive only decades later. Argentina, for instance, still cannot shake off its 'B-country' ranking, because it once had chaotic financial policies and triple-digit inflation and occasionally failed to service its debt on schedule. Today Argentina has the stablest currency in South America: its central bank has kept the dollar parity constant for the last five years, and the rate of inflation is no higher than in the USA. A rigid financial policy means that the economy is going through a severe structural crisis. Yet the people's sacrifices for the sake of currency stability are not being rewarded by the money markets. The government in Buenos Aires must still pay on fixed Deutschmark loans a rate of interest 3.8 per cent higher than 'triple A' Germany.[32]

For Truglia and Co., all this is simply a consistent application of economic criteria. As protection against bribery attempts, Moody's staff always travel in pairs – for example, to check government finances at the invitation of a finance ministry. Truglia stresses that every analyst must disclose his own investments once a month, and that no one is allowed to speculate in anticipation of a judgement he

will publish later. Even if governments do exert pressure, no consideration is shown for it. 'All we recognize are the investors' interests; we don't go in for politics.'

The outcome is political, however. The agency's ratings can cost a country billions in extra interest, influence its electorate, and affect its self-esteem. When the Canadian dollar was on the ropes in February 1995 and the markets were treating it as a 'Northern peso', Prime Minister Jean Chrétien tried to halt the outflow of capital through spending cuts and a new draft budget. Before the plan could be debated in the Canadian Parliament, however, Moody's deemed the cutbacks insufficient and announced that Canada bonds might be downrated to 'AA'. The opposition leader took obvious pleasure in accusing the government of an unsound financial policy. Chrétien's electoral chances plummeted, and the *New York Times* cynically commented: 'The man from Moody's rules the world.'[33] The same sequence of events occurred in 1996, when the agency placed Australia's credit status 'under review' shortly before elections were due to be held. 'Dark Clouds Over the Government,' headlined Sydney's largest newspaper. The Labour Party lost the elections.

A court without law

It is not only big bad foreign investors who rigidly apply the logic of the marketplace. Where the capital market has been international-ized, domestic owners of wealth are also promoted into a jury sitting in judgement on government policies. In the end, they too can invest their money somewhere else. In Europe no country learnt this more harshly than Sweden, a land once renowned for its model social policy which stood for the possibility of a socially just capitalism. Not much is left of that today. Since the late 1980s, more and more jobs and savings capital have been shifted abroad by Swedish com-panies and owners of wealth. Although tax receipts were declining, the government lowered the level of taxation on higher incomes. A soaring budget deficit then forced cutbacks in numerous areas of social provision.

Even that was not fast enough for 'the markets'. In the summer of 1994 the industrial tycoon Peter Wallenberg, main owner of Scania lorries among other firms, threatened to move his headquarters abroad unless the government (then run by a conservative alliance)

brought the budget deficit down. Björn Wollrath, the boss of Skandia – one of Scandinavia's largest insurance companies – went even further and called for a boycott of Swedish government bonds, which had so far been traded at the average European rate of interest. The next day, Stockholm's fixed-interest securities were unsaleable, the exchange rate of the krone nose-dived, and share prices followed its downward path. The government and all other borrowers of Swedish crowns now had to pay 4 per cent higher interest than Deutschmark debtors. As the country slid still further into debt, deep cuts in the budget became unavoidable. Today Sweden has less left for its poor than Germany.

Having been driven in this way to slash its social policies, the erstwhile model again enjoys a high currency and relatively favourable interest rates. But the threat remains, of course, as the Social Democrat Prime Minister Göran Persson came to feel plainly enough. In January 1996 he openly proposed the return of unemployment and sickness benefits to their previous level of 80 per cent of normal earnings. Two days later Moody's published a report suggesting that the stabilization of the Swedish budget had not gone far enough, and that social welfare programmes 'will probably be cut still further'. The very next day, the indices for government bonds and shares fell by 30 and 100 points respectively, while the external value of the krone spun downward.[34]

The scenario is similar in Germany for the dismantling of a welfare state that has so far used progressive taxation to keep social inequality within certain limits. The ruling conservative–liberal coalition has acceded to every major demand of industry and the banks for a recasting of the tax system. Twice recently it has cut the rate of tax on the profits of big corporations, and it has also reduced the top rate of income tax by 5 per cent. The number of exemptions for the self-employed has gone up by leaps and bounds, while the whole extra load resulting from German unity has fallen on mass taxation, especially income tax and VAT. The results speak for themselves. When Helmut Kohl took over as Chancellor in 1983, companies and the self-employed still shouldered 13.1 per cent of the tax burden. Thirteen years later, this figure had more than halved to 5.7 per cent.[35] In 1992 a high-ranking group of experts from the EU Commission in Brussels noted that German corporate taxation had fallen behind that of the USA, Japan and the European average.[36]

The Federal Republic of Germany, at least in fiscal matters, has thus long been bowing to the global assault on the welfare state, even before it could be punished with higher interest rates by the capital markets.

Meanwhile, even the United States government has been submitting to the judgement of those who direct flows of capital. When Bill Clinton entered the White House in 1992, he had promised the electorate a far-reaching programme of reforms: the run-down public schools would be turned into a functioning educational system, and every American would be insured against sickness. None of the projects could be implemented, however, without additional public spending. Immediately after the election, federal bonds began to fall as investment bankers forged an open front against the reforms. The reforms then gradually petered out after just a few months of the Clinton administration, long before he lost his majority in Congress. James Carville, Clinton's long-standing adviser, sighed in resignation: 'I used to think that if there was reincarnation, I wanted to come back as the president or the pope. But now I want to be the bond market: you can intimidate everybody.'[37]

Subordination to the money markets thus leads to an attack on democracy. It is true that every citizen still has a voice. Politicians must still try to reconcile the interests of all social layers in order to win a majority, whether in Sweden, the United States or Germany. But once the elections are over, the decisive factor is what economists euphemistically call the right of money to vote. It is not a question of morality. Even professional fund managers are only carrying out instructions by seeking the highest possible return on capital placed in their care, but their superior power now allows them to challenge every step forward in social equality that has been painfully achieved in a hundred years of class struggle and political reform.

Ironically, it is the overwhelming success of the social-democratic taming of capital which is today driving forward the global unshackling of capitalism. Only the constant wage increases and state-organized social protection of the last fifty years allowed the development of those middle layers whose savings now keep the money markets working. Never before in history have there been so many people with more income than they need for current living expenses. It is their savings that provide banks, insurance companies and investment funds with the raw material for their onslaught on

trade unions and the welfare state. Investment funds alone hold 7 trillion marks worldwide, according to the research department of the Deutsche Bank. Another 10 trillion are managed by the suppliers of savings schemes for provision in old age: insurance companies in the case of Germany, for example.[38] The well-paid middle-class citizen, then, is only too often victim and culprit, winner and loser, at one and the same time. While his life-assurance capital yields an increasing return, his disposable income goes down as a result of higher taxes. And even tomorrow the managers of the investment fund where he keeps his savings might, as large shareholders in his employer's firm, appoint a new board of directors which rationalizes his job out of existence – in the interests of the fund's investors.

The great majority of Swedes still have no wish for their society to be exclusively geared to the return on capital. Only this explains why the government balked at the dismantling of the welfare state. Even Canada's prime minister, Jean Chrétien, did not have the option in spring 1995 of cutting the budget by even more than he had proposed. A more important goal for him at that time had to be to keep the country from falling apart under the threat of the refer- endum over the secession of French-speaking Quebec. If he had cut the funds going to provincial governments, he would have only driven more people into the arms of the separatists and risked causing far greater economic harm to the country. Similarly, in 1992 it was not out of bureaucratic stupidity that the Italian government held out against devaluation of the lira, as many professors and speculators later mockingly suggested. Rather, it was trying to protect more than a million families who – on the banks' advice – had been buying their homes on mortgages denominated in the EU's artificial cur- rency, the Ecu. The collapse of the EMS meant that their Ecu income shrank by a third, or in other words that their mortgage repayments rose by more than 30 per cent, without so much as a lira's rise in the value of their property. The speculators thus played into the hands of the rightist 'Freedom Alliance', whose architect, the neo-fascist Ginafranco Fini, claimed to speak for the cheated borrowers.[39]

The money markets also provoke conflicts between nations which are more and more spinning out of political control. The currency and securities market, which true believers transfigure into a world financial court, hands down most unfair judgements. Indeed, it no

longer seems to recognize any laws and produces economic chaos instead of justice.

Profit-chasers in the various trading rooms always prefer big countries over smaller ones, quite independently of how their economy and their state finances are looking at a particular time. Countries such as Ireland, Denmark, Chile or Thailand pay as much as 2 per cent extra interest because they are small. Technically speaking, this leads to chaos. The smaller a market, the greater is the risk that it will find no buyers in a time of crisis. 'Then it's like a cinema when fire breaks out,' explains Klaus-Peter Möritz, foreign currency boss at the Deutsche Bank until 1995. 'Everyone wants to get out but there aren't enough exits.' This 'exit risk' actually carries a risk premium. But the principle is economic nonsense and makes investments more expensive.

At the same time, big countries have to fear the markets' judgement much less than smaller ones. The main beneficiary here is the United States; like no other country on earth, it helps itself to the savings capital of others. For more than a decade, US statistics have shown a negative balance of payments, which means that consumers, businesses and government together borrow far more money abroad than they themselves invest on world markets. Since 1993 the minus has been 10 per cent of GNP, making the USA the world's largest net debtor. Yet American companies or house-builders by no means have to pay punitive interest rates. The sheer size of its domestic market ensures that dollar investments are relatively safe and attractive. Besides, the dollar continues to be the world's reserve currency. Not only 60 per cent of hard currency reserves of all issuing banks, but also nearly half of total private savings, are held in dollars.[40] Even a Chinese peasant or a Russian worker will put anything they have left over into dollars, though in real terms America's economic output makes up less than a fifth of the world's total. Every government in Washington therefore knows that it has half the world on its side when the stability of its currency is at issue.

The dollar as a weapon

The dramatic imbalance does, however, make large parts of the world economy dependent upon the state of things in America itself. Since 1990 traders and economists have been pointing out that, in

the end, conditions in the dollar area alone determine the evolution of world interest rates. In the spring of 1994, for example, all the signs in Germany pointed towards a conjunctural downturn. According to current economic thinking, the resulting weak demand for credit should have led to falling interest rates, an indispensable condition for investment to recover. But the US economy still had rising growth, and interest rates suddenly shot up on the US securities market. Interest rates promptly rose in Europe too, above 7 per cent, which was further 'bad news' for the economy in general. A year and a half later Germany was again sunk in recession and the same story repeated itself, as US factories were reportedly working to full capacity. Even the Bundesbank's lowest base rate for a decade changed nothing. It is true that Germany's defenders of the currency lent more than ever to the banks and enabled companies to raise 7 per cent more in credits in 1995 than in the previous year; but the cheap capital immediately flowed out to foreign markets that showed a higher return. Helmut Hesse, member of the central banking council of the Bundesbank, soberly remarked that 'the capacity of issuing banks on their own to bring down interest rates' had unfortunately 'faded away'.[41]

The dependence of the dollar area puts Washington's finance and currency policy-makers in a powerful position, one which more and more often sets them on a collision course with other countries. Exchange rates are a gauge of the relationship of forces in the latent war for financial–economic supremacy. When the dollar fell by as much as 20 per cent against the yen and mark in the first four months of 1995, this threw the machinery of the world economy into chaos and triggered a new recession in Europe and Japan. Portfolio managers panicked and converted their investments into marks and yen, so that the fall was not limited to the dollar but all European currencies lost value against the franc and the mark. Suddenly the foreign income of German companies was worth much less than they had calculated. Daimler, Airbus, Volkswagen and thousands of others wrote figures in red and announced that in future they would prefer to invest abroad. Once again specialist magazines such as *Business Week*, *Handelsblatt* and *The Economist* described the 'impotence of central banks' in face of the vicissitudes of the trillion-dollar currency market, whose daily turnover is almost twice as high as the combined reserves of all central banks.

Objectively the rapid fall in exchange rates did not appear justified. The actual purchasing power of the dollar corresponded more to a value of 1.80 marks than to the 1.36 at which it was being traded. Moreover, for short-term loans on the money market, the interest rate was 1 per cent higher than for the now top-class mark and yen. Economists of every stripe were at a loss to understand. Marcel Stremme, currency expert at the German Institute for Economic Research in Berlin, even thought that 'there is no logical explanation' for the exchange rate of the dollar. The IMF's leading economist Michael Mussa could only remark that 'the markets are acting crazy'.

Illogical? Irrational? Insiders in the currency game see it very differently. Klaus-Peter Möritz, for instance, then head of currency trading at the Deutsche Bank, briskly interpreted the decline of the dollar as 'a conscious political strategy on the Americans' part' to overcome export weaknesses by making their products cheaper on overseas markets.[42] The exchange rate had thus become a weapon in the struggle with Japan and Germany for a share of the world market.

That sounds like a conspiracy theory, but it is also quite plausible. The great majority of global players in the money market are American institutions with a worldwide infrastructure. They evidently do not dance to the tune of the US government, but they bow most gladly to the aims of the Fed and its chairman, Alan Greenspan. Besides, the hardiest speculators do not cross swords with the world's largest bank of issue, because *its* dollar reserves are unlimited. 'It's enough for a Fed director to call up a Congressman and tell him that the US has no interest in stabilizing the greenback,' argues Möritz. The dealers soon get the picture and take care of the rest. This strategy is also indirectly supported by the two most powerful men in America. Thus, during the world dollar crisis in April 1995, President Clinton let it be known that the USA might 'do absolutely nothing' to stop it falling.[43] Shortly before, at a congressional hearing, Greenspan had held out the prospect of a drop in the base rate that never materialized.[44] In both cases there was an unmistakable signal to the markets that the central bank and the government wanted the dollar to fall. The Frankfurt professor of economics Wilhelm Hankel also sees the decline of the dollar as just 'clever US currency politics'. In a world of weak currencies plagued by inflation, the dollar is in

danger of becoming overvalued, so that by talking it down Washington's money-guards 'transfer the problem to other countries'.[45] This is clearly also how Helmut Kohl's advisers see things. Contrary to his usual caution with regard to the Big Brother across the Atlantic, the chancellor personally protested at Washington's obstructive currency policy and openly described it as 'quite unacceptable' – with pretty mediocre results.

The economic statistics for 1995 record the victory of the dollar strategists. In Germany the economy grew at only half the expected rate, and the weakness of the dollar was the spur for mass redundancies. Even harder hit was Japan, whose trade surplus with the United States shrank by three-quarters in just twelve months. The country sank from recession into deflation and the numbers without work doubled.[46] Greenspan and Treasury Secretary Rubin dropped their hard line only in autumn 1995, when they could be sure of the desired result. In September the central banks of the three countries again began to support the dollar with concerted purchases: the exchange rate slowly moved back up and was hovering around 1.48 marks by summer 1996.

The currency markets are therefore not at all crazy: they follow Alan Greenspan's baton. The cluelessness of experts, on the other hand, simply shows how their theories ignore the fact that, even in the cyberspace of world money, the actors are people who either wield or must submit to power and its accompanying interests. Not all central banks are equally impotent before the Moloch of the market. Rather, they are inserted into a clear hierarchy of size. At the top is the Federal Reserve. Next come the Bank of Japan and the Bundesbank, which in turn dominate their neighbours in the yen and Deutschmark zones.

Guerrilla warfare in the finance jungle

At least on the money markets, globalization so far means little more than the Americanization of the world. For trade professionals such as Möritz, that has its established routine. 'Maybe it is the price we have to pay for America's intervention for us in the Balkans.' Still, the harm that this dependence does to the economy is enormous, and not without risk even for the United States. The more ruthless the American giant is in exerting its supremacy, the more likely it is

that others will react. What can happen if a government feels cheated has already been shown by Malaysia. Under its long-serving prime minister, Mahathir Muhammad, it has developed along with Singapore into Asia's most successful rising economy. To top it all, Mahathir likes to keep on attacking the arrogance, decadence and imperialist designs of the West. In 1988 he seemed about to strike in the West's oldest home ground, the currency market itself.

Before, the Malaysian central bank, the Bank Negara, had had to take considerable losses. The high-interest-rate policy of the Reagan administration had for years been forcing up the exchange rate for the dollar. Then, at a secret meeting in the New York Plaza Hotel with the central banks of Japan, Britain and West Germany, the Americans had agreed on joint intervention to bring the exchange rate down again. There followed a chaotic fall of nearly 30 per cent. Negara boss Tan Sri Dato' Jaffar bin Hussein, who once worked for the Price Waterhouse accountancy firm, angrily noted that the dollar reserves that Malaysia had built up were now worth much less through no fault of its own. The Plaza agreement had fundamentally 'changed the stakes of the game', he said indignantly in a speech at New Delhi.[47]

From then on, he himself no longer respected the unwritten law that the first task of each central bank is to ensure stability; indeed, with backing from Mahathir, he turned this rule into its opposite as he embarked upon financial guerrilla warfare. Negara had all the privileges of a central bank – unlimited credit, optimum access to information, power as a supervisory body – and it used these to speculate successfully against the currencies of the G-7 nations. The Malaysians, with their huge, almost unlimited investments, had an easy time of it. The main operation was to sell a currency simultaneously to dozens of banks in tranches of 100 million or more, bringing about a collapse in the exchange rate that no one had been expecting. Once it had fallen enough, stoploss computer programs in the trading rooms suggested to the currency dealers that they should start getting rid of the currency themselves. Before the wave of selling subsided, Negara bought back and pocketed some sizeable winnings.

The attack on sterling in 1990 is especially well documented. In the space of a few minutes Mahathir's financial warriors dumped a billion pounds on to the market and caused the pound to lose 4 US cents. British banks protested and formed a defensive cartel against

future attacks, but Negara could rely on other countries to give willing support. Information about a Negara operation, if obtained at the right time, was worth its weight in gold. 'If they'd tried that at any of the world's organized exchanges,' a leading Fed official commented on such manipulation of the market, 'the culprits would have ended up in jail.'

On the global interbank market for foreign currency, however, there is no state with powers of enforcement. Instead, Negara was eventually thwarted by still bolder private emulators. When the European Monetary System collapsed, Jaffar made a wrong analysis of the situation. Surprised by the rapid British exit from the system, the Negara lost nearly 6 billion dollars in the course of 1992 and 1993. Jaffar, having to bear responsibility for what opposition leaders called 'Malaysia's biggest-ever financial scandal', lost his job. His successor has not been taking that kind of risk.

The Negara speculation confirms how prone the interlinked world of money is to tensions that it has itself caused. Because of the explosive growth of the markets, a country like Malaysia would today certainly be too small to threaten the stability of the system. But the 'dollar volcano', as Hankel calls it, throws up ever more greenbacks and thereby increases the amount of US currency circulating outside America. The issuing banks of Asia already control nearly half of the world's hard currency reserves: China's alone come to more than 70 billion dollars, as do tiny Taiwan's, while Japan's are more than twice as much again. Against the backdrop of mounting discord between the United States and its Asian trading partners, such figures offer 'excellent material for a financial thriller', warned *The Economist* in 1995.[48]

So far, it seems unlikely that anti-American states in Asia will use massive selling to undermine the dollar and hence the world financial system. These countries are still dependent upon the US market, and in some cases on its military protection as well. But things will not necessarily remain so. The growth dynamic is already shifting the balance of power in the direction of Asia.

Across the globe in Europe, however, the attempt to shake off the dollar's supremacy is becoming more like a crudely made soap opera without a happy end. The governments of the two largest countries in the EU – Germany and France – are battling to introduce a common European currency. But with their 'great hit', as Helmut

Kohl called it, they have set off a power struggle between market and state that will keep Europe on tenterhooks for a long time yet.

The euro adventure: struggles over monetary union

Since 11 December 1991, the small Dutch town of Maastricht has been assured of its place in history. It was on that Wednesday evening that the heads of government of the twelve EU countries of the time put their signatures to a treaty which will decisively affect the course of European history over the coming decades – the treaty, that is, on the formation of the European Union and the creation of a single currency for its member-states. The relaunching of Europe changed little in the political and administrative machinery of the West European confederation. This is why the agreement on a future monetary union (EMU) is evidence of a determination to lead which appears only rarely in modern democracies. Beginning in the year 1999, states the treaty since ratified by every parliament, a majority of EU member-states will join their currencies to one another at irreversible parities. Two years later, the old names for Europe's money are due to disappear in favour of an actual Community currency called the 'euro'. If everything goes according to plan, 1 January 2002 will see all assets, income, payments and taxes being calculated in euros, the value of which will correspond to the conversion rates already paid on the market since 1999.

The consequences of this step can hardly be overestimated. Countries that adopt the euro will leave behind them many serious disadvantages of the present monetary division. The interest-rate premium for small markets will cease to apply, as will the high bank charges for currency transactions. Most important of all, the entire trade between countries will be free of the expensive risk of sudden swings in the rate of exchange, and it will be possible directly to compare prices throughout the single market. At the same time, however, the countries within the union will be running an enormous political risk. They will no longer have independent banks of issue, whose past sovereignty will become a relic handed over to the future European Central Bank. This will bind member-countries of the EU to one another much more firmly than hitherto. No member of the monetary union will be able to reach for the emergency brake of

devaluation if its own export economy can no longer keep up with the rest. Nor will it be able to avoid aligning its financial, fiscal and social policies with those of the other member-states. If the monetary plan really does come off, then the creation of a genuine political union able to make swift but democratic decisions will become a matter of life and death.

It is now five years since the Maastricht Treaty was signed, and yet public discussion of the most ambitious political project in Europe's history, with all its far-reaching implications, is still carried on at a pretty mediocre level. EMU is by some supposed to ensure that 'war never again starts from German soil' (Helmut Kohl), or is by others held responsible for the fact that 'Europe is becoming divided again' (Britain's former foreign secretary, Douglas Hurd). Or else it is scapegoated as a 'threat to Germany's jobs' – as the top social democrat candidate in Baden-Württemberg, Dieter Spöri, maintained during the election campaign there in March 1996.

Amid the fog of propaganda and disinformation surrounding the EMU debate, a clear word rang out in Frankfurt on 18 January 1996. The European Finance Foundation, a banking lobby, organized a discussion with France's minister of finance, Jean Arthuis, to which anyone who was anyone in the financial sector received an invitation. Arthuis first presented some technical proposals and discussed a number of exchange-rate targets and transitional scenarios. Then, as the talk became more informal, he outlined the real aim of EMU. If the plan goes ahead, the euro may rise to become 'the world's leading reserve currency', supported by the world's largest domestic market with around 400 million citizens. On this basis, Europe might draw level with the United States. Beyond the management of exchange rates, Arthuis considered EMU 'a foreign-policy instrument' more important than any kind of import duty.[49]

The representatives of major finance in attendance reacted with a certain embarrassment. Despite the dollar crisis and the collapse of the EMS, the kind of state intervention that Arthuis envisaged against the free play of market forces counts as nothing short of sacrilegious among German financiers and economists. Yet it is precisely that – the rebuilding of the power of the state *vis-à-vis* the money markets – which is the real heart of the struggle over monetary union. EMU, as Paris politicians say with a hand in front of their mouth, stands for the end of the 'tyranny of the dollar'.

Should that day ever come, Europeans will have paid a high and painful price. For the market cannot be mastered unless it has first been calmed down. There is nothing else behind the so-called Maastricht criteria, which representatives of the Bundesbank dictated into the text of the treaty during the negotiation process. Only countries whose public debt is no higher than 60 per cent of their annual net product, and whose annual deficit is equivalent to no more than 3 per cent of GDP, will be allowed to join the EMU club. In addition, participating national currencies must have had a stable exchange rate with the mark over the three years before the entry date. The actual Deutschmark rates are arbitrarily chosen, simply corresponding to the levels expected for the year 1999 at the time of negotiations. But in the view of the guardians of Germany's currency, this was the only way of convincing dealers that the euro would from Day One be as secure as the mark and that speculative attacks would therefore not be worthwhile.

Convincing though the idea was in theory, it was fast overtaken by reality. Four years after the treaty was concluded, it is becoming a strait-jacket that does more harm than good. First, France was forced in 1994 to copy German monetary policy: an independent central bank was created whose governor, Jean-Claude Trichet, has since executed the 'franc fort' policy with an iron resolve. For four years French companies and private borrowers had to pay up to 3 per cent more in interest than their German counterparts, for no other reason than to defend the exchange-rate against constant waves of speculation, until finally in the summer of 1996 the interest levels became aligned in the two countries. During the same period, all EU nations began the process of reducing their deficit. If incomes had been rising, that would have been sound enough. But, with a brief interlude, the EU has been in recession since 1993, tax receipts have fallen dramatically, and even Germany was unable to fulfil the EMU criteria in 1995.

Meanwhile the economy drive has been flying in the face of any rational policy. When small firms and large corporations lay off millions of people in order to cut costs, public investment and employment becomes urgently needed. Austerity measures that further intensified the crisis therefore threw the whole EMU project into disrepute in France. In autumn 1995, for the first time in decades, the French unions jointly organized a month-long strike against the

government's austerity policy. Even industrialists such as Peugeot boss Jacques Calvet, or the by no means europhobic ex-president Valéry Giscard d'Estaing, were influenced by the storm of protest and called for changes to be made in the Maastricht plan. Opposition increased in Germany too. In agreement with the great majority of his colleagues, Heiner Flassbeck, a departmental boss at the German Institute for Economic Research, warned that the sweeping reductions in public expenditure could destabilize the whole of Europe, just as Chancellor Heinrich Brüning's cutbacks turned the crisis of the Weimar Republic in 1930 into a veritable catastrophe.[50]

In the summer of 1996, then, everything spoke in favour of delaying monetary union until better times, and at least for another two years. But the EU regents, with the eurovisionary Helmut Kohl at their head, no longer have any leeway to make such a decision. For it would be what has been eagerly awaited for years by all those fighting EMU in their own interests – namely, the dealer castes of the City of London and Wall Street. Michael Snow, for instance, New York head of currency operations for the giant Swiss bank UBS, does not conceal his hostility to EMU. 'It would take away our work and our chances of making a profit, so naturally we are against it.' Since summer 1995, Anglo-American and Swiss money institutions have systematically tried to make investors feel insecure, boldly warning in circulars and interviews of a possible loss in value of Deutschmark bonds, and palming off Swiss franc securities on to a lot of customers even though they earn next to nothing in interest. Greater damage was prevented only by the big German and French finance houses. They have supported the euro project, because a single currency would put an end to the niche markets that have long been the domain of numerous little banks in the other countries of the EU.

In this power struggle, the trading-room enemies of the euro have been betting on influential allies. In London, for example, the government and the City form a united front. Because they traditionally do not see themselves as doing what others do, but at the same time do not wish to be shut out, British ministers and civil servants would 'do anything' behind the scenes 'to make the project fail' (in the words of a high-ranking German politician specializing in monetary matters, who does not wish to be named). Still more significant for the mood on the electronic marketplace is the support that Bundesbank boss

Tietmeyer gives to the enemies of the euro, for he sees it as a threat to an independent German central bank, the holy grail of his monetarist faith. EMU is 'economically not at all necessary', he assured the financial world in March 1996 at a European symposium organized by the Foreign Ministry in Bonn.

With a monetary framework in constant danger of buckling in one way or another under the pressure of speculation, the European Community can move neither forward nor back. Any change in the Maastricht plan, thinks Hans Jürgen Kobnik, a member of the central banking council of the Bundesbank, 'would be mercilessly punished by the markets'.[51] 'Big funds are obviously already on their starting blocks, ready to take appropriate steps as soon as possible after any shift,' commented the in-the-know *Frankfurter Allgemeine Zeitung* in January 1996. What would happen is 'quite simple', according to Paul Hammet, London expert in capital markets for the Banque Paribas. If the single currency is put off, 'then Plan B would come into operation: buy Deutschmarks'. In this way an economic imperative – namely, postponement of cuts in public spending – is turned into its opposite by the electronic money-machines of the financial world. A rate of 1.35 marks to the dollar would then be expected, says Hammet. Once again Germany, the locomotive of the European economy, would be punished with a revaluation that would easily cost another million jobs.

Kohl and his partner Chirac, therefore, have nothing left but to stick to their project for the euro. Who joins the monetary union in 1999 will be decided in spring 1998; everything is going according to the treaty plan. Such assurances, issued almost weekly from Bonn, Brussels and Paris in the first half of 1996, are naturally little more than whistling in the dark. As the crucial date approaches, it is becoming more and more evident that no EU country other than Luxembourg will meet the entry criteria. If the europlanners nevertheless fix exchange rates in Europe in 1999, the EMU drama of 1992 will repeat itself on a grand scale. 'Market players will test the decision to see if it holds,' prophesied a Frankfurt banker. 'If enough people with enough money start to believe that EMU might not happen,' wrote the London *Economist*, 'they will almost certainly be proved right. Their prophecy would become self-fulfilling.'[52]

Taxing helps steering: the Tobin tax

EU governments, therefore, risk walking with their eyes open into another crushing defeat at the hands of the currency traders and their investment fund clients; it is an irresponsible playing with fire. If the monetary project collapses, the European economy will not be the only loser. The goal of European integration would not be trusted again for a very long time, and the old continent would lose what its nations need most urgently in the age of globalization: a capacity for joint action. This journey into a euro dead-end therefore indicates an astonishing ignorance on the part of the politicians responsible for it, as well as of their controllers in parliament. Their impotence in the face of the money markets is actually of their own choosing. Even without turning the clock back to a Bretton Woods type of world, they could instead have tamed the destructive power of the electronic dealers' army.

The American economist and Nobel prizewinner James Tobin developed a plan along these lines in the 1970s. The deregulated flow of capital, with its abrupt changes of direction and wild swings in exchange rates, was already damaging the material economy. Tobin proposed to 'throw some sand into the works' of the ultra-efficient international money markets, and to levy a tax of 1 per cent on all foreign currency transactions.[53] The figure may seem low, but it would have had a decisive effect. First of all, only in exceptional cases would it be worthwhile to play on interest-rate differences between different markets and countries. To swap a low-earning Deutschmark investment for better-remunerated dollar securities, for example, it would be necessary to reckon on paying 2 per cent of outlay to the tax authorities for the conversion into dollars and back again. In the three-month investments quite commonplace nowadays, that would pay only in the improbable event that the (annualized) difference between German and US interest rates was 8 per cent. If the investor wanted to leave the money longer, it would certainly earn a higher yield, but there would also be a greater risk that the interest differential, and hence the value of the investment, would meanwhile be eroded.

The advantage of Tobin's plan for the real economy is obvious enough. Immediately the central banks would again be able to control the rate of interest on their national market, in a way appropriate to

the country's economic situation. If there were a recession in Europe, for example, while things were really buzzing in the United States, Europeans would be able to borrow money as much as 8 per cent cheaper than the Fed.

Of course, the 'Tobin tax' – as it is known after its inventor – would not give governments the freedom to fix exchange rates at their discretion. Nor would that be sensible. If economies develop differently, their currency parities must also be able to change. Nevertheless, speculation would be drastically reduced in scale, and the evolution of exchange rates would correspond more to the real – or, in the jargon, 'fundamental' – economic data. At the same time, central banks would again be able to carry out their original function of stabilizing the exchange rate. Their intervention purchases, exempt from tax, would again carry weight because far less liquid capital would be on the move within the system.

Not the least argument for a Tobin tax on currency dealings is what it would itself bring into the public coffers. Even if the tax reduced turnover by three-quarters, experts calculate that (according to the rate at which it was set) it would produce a worldwide yield of 150 to 720 billion dollars.[54] Not only would that bring relief for overstretched budgets; it would also be a 'tax on Wall Street and for once not a tax on Main Street,' writes the professor of economics at Bremen, Jörg Huffschmid.[55] Theoretically and politically, there has for years been no argument against Tobin's proposal that is worth taking seriously. Indeed, it 'cannot be faulted theoretically,' in the view of Hans-Helmut Kotz, chief economist at Germany's Girozentrale, the central national savings institution. But the simple scheme obviously has one drawback: those who would be affected by it are resolutely opposed and, as in the case of ordinary taxes, they play off the nations of the world against one another. Kotz: 'New York and London will always block it.'[56] But if just one major financial centre were free of the tax, the currency trade would gravitate there. And even if the G-7 countries all introduced a Tobin tax, the financial sector could formally switch its business to offshore branches from the Cayman Islands to Singapore and so undermine the intended restricting effect. Failure is therefore 'programmed into' such a tax on currency transactions, an economist at the Deutsche Bank cheerfully predicts.[57] One of his American colleagues dotted the 'i's' on the threat. If the state starts interfering in the trade, 'we'll eventually

be financial organizations headquartered on a ship floating mid-ocean'.[58]

So far, governments everywhere have bowed to this logic. A bill incorporating a Tobin tax has twice run into the ground in Congress. The Germany Finance Ministry, too, though plagued by billion-mark holes in the budget, swallows without complaint the threatened flight by money-dealers. Tobin's proposal is 'no longer applicable today,' State Secretary Jürgen Stark says to justify the fiscal inaction against speculators. It would work only 'if it was [introduced] by all 190 countries in the world'.[59] A sensible scheme 'to limit the economically damaging volatility on the currency markets will be buried not because it is technically impossible, but because it contradicts the profit interests of the banking sector,' Huffschmid sums up.

Even such a transaction tax would not bring the unruly finance industry under control, so long as states compete with one another for its jobs and capital. But this does not mean that individual countries, and especially the European Union, have to remain completely powerless. Tobin himself, in a new study published in summer 1995, suggests that they could act alone[60] – only they would have to go a step further and impose an additional tax on the lending of their currency to foreign institutions, including foreign branches of their domestic banks. These could not be avoided. Those who want to speculate against the franc must first acquire francs. Even if they order them from a bank in New York or Singapore, it must ultimately refinance itself from France's banks, which would be in a position to pass on an extra tax to their customers.

The surcharge would hit unwanted speculation at source, where loans are made to finance the outlay. In practice, the freedom of movement of capital would thus be revoked through the roundabout means of taxation. Trade and the real economy would not be affected, however. The surcharge would hardly make any difference to foreign investment in industrial plant or to trade in goods, but it certainly would matter for the speculative deals running into billions of dollars which operate with minimal margins and can show a profit on exchange-rate shifts of a hundredth of a percentage point.

Ironically, the Maastricht Treaty explicitly allows for the re-introduction, if necessary, of controls on the movement of capital, but for bankers and true believers in the market, such a strategy is a vicious heresy. In their struggle for the cause of capital, they have

also long been able to rely upon most economics editors of the major media. The *Frankfurter Allgemeine Zeitung*, for example, fantasized that the Tobin tax would lead to 'an Orwellian state engaged in round-the-globe surveillance'.[61]

Nevertheless, there are a growing number of critics of the uncontrolled money market, including within the political elites. From Canada's finance minister through his counterparts in Tokyo and Paris to the central bank chiefs of South-East Asia or the Netherlands, serious politicians have for years been proposing ways to take the money markets in hand. The person to have gone furthest up to now is Jacques Delors, the former president of the European Commission. After the EMS crash in summer 1993, he demanded at the European Parliament in Strasbourg 'measures to limit speculative movements of capital'. Europe, he argued, must 'be in a position to defend itself. … Even bankers should not be allowed simply to do what they like. Why should we not lay down a few rules? Why should the Community not take the initiative?'[62] Those concerned wasted no time in making a sharply worded protest. 'What are things coming to when the man who introduced the single market is now calling for controls?' asked Hilmar Kopper from the Deutsche Bank indignantly. Together with the heads of the Dresdner and Commerz banks, he complained about the 'demonization of speculation' and insisted that all that was necessary was the right financial policy.[63]

For a long time, no government dared take a stand against such forces. Anyone advocating reforms was soon brought back into line. Yet the days of global financial anarchy are numbered; sooner or later the only option left will be to bring the capital markets back under strict state supervision. For the chaotic dynamic of the world of finance is too much even for its own actors. In their cyberspace of millions of interlinked computers, the mounting risks may be compared to those of atomic technology.

Derivatives: a crash from nowhere

No one had seen it coming; no dealer or fund manager was prepared. In the spring of 1994, things were not looking bad in the US economy. Companies were investing, consumption was rising, and Americans were building more homes than ever. To counter any overheating and to steady market fears of inflation, the Federal Reserve's

committee on the market, under its chairman Alan Greenspan, sounded a note of caution in the second week of February by raising the quite low interest rate for US banks by a quarter of one per cent. But what was intended as a gentle touch to signal the central bank's alertness became on the dealers' tables a slamming of the world economic brakes. From one day to the next, there was an unparalleled flight out of government bonds. While prices kept falling on the market for three long months, interest rates rose sharply – not by 0.25 per cent, as the Fed had planned, but by eight times more. Short- and medium-term loans in dollars became 2 per cent more expensive. The falling prices and rising interest rates soon impacted on European countries too, and a 'mini crash' on the capital market (to use the dealers' jargon) pushed the whole continent into recession. The central bankers had been used to 'driving monetary policy like an old Ford,' commented Gregory Millman, a finance expert and observer of the New York scene, but this time the market reacted like a racing car and 'its passengers flew through the windshield'.[64]

The worst hit were those who had covered high-risk speculative investments with 'Treasury bonds', because these no longer gave sufficient protection. Creditors started to terminate contracts. One of thousands to declare itself bankrupt was Orange County, California's richest district south of Los Angeles and hitherto one of the best-endowed public corporations. Nearly 3 billion dollars were missing from the previously well-stocked coffers. The finance industry and its clients bled all over the world, as the value stripped from long-term investments meant that their annual losses were the largest since the Second World War. Almost overnight more than 3000 billion dollars vanished into thin air.[65] The amazing thing was that no one knew what had happened.

At the Fed's New York headquarters in Liberty Street, a group of economists began tracking the missing billions. Their inquiries at various dealers led to a surprising conclusion: namely, that the key to the panic on the bond market lay in the mortgage trade.[66]

Unlike in Germany, mortgagees in the United States can repay their loan at any time if the market rate of interest becomes lower than the one specified in their mortgage agreement. Suppliers of the corresponding debentures insure themselves against this risk through the forward selling of fixed-interest securities. If the rate of interest drops and homeowners convert, the rising price of these options will

offset the lost income that the liquidated mortgages no longer bring. In the years of falling interest rates, the conversion business acquired huge proportions. Mortgage certificates simply became short-term investments, and purchasers accordingly insured themselves only with short-term options.

When the Fed then rang in a turnaround in interest rates, the market fell through the floor. Suddenly the managers of the giant US mortgage market tried to buy *en masse* long-term government bonds with five or more years to run. Neither the Fed nor the banks had made any allowance for that, as little was known at the time about the relationship between the mortgage and bond trades. Now an impulse to sell was coming from that corner of the market and soon drove prices down. Within hours the ill-starred 'stoploss' signal was appearing on every other player's computer screen; now they too had to sell. A self-reinforcing positive feedback set in as a world-wide wave of selling developed almost out of nothing. In this way, a previously unnoticed branch of the great capital-market river set off a veritable flood, and a slight course correction by the American central bank grew into a near crash.

The bond crisis of 1994 showed as never before the vulnerability of the finance industry to events and chain reactions that do not appear in any forecasts. This insecurity of modern hi-tech finance is crucially linked to the derivatives trade. The new freedom of movement given to capital in the 1980s only conquered the boundaries between national markets. The derivatives trade of the 1990s has been pushing this open-borders process to a climax. 'Derivatives', Deutsche Bank boss Hilmar Kopper said with obvious relish, 'make all capital markets interchangeable. They make long credit lines short and short ones long. They do what used to be only a dream for us.'[67]

Or a nightmare. Now, as in a system of communicating vessels, everything is linked to everything else, but each day it becomes more difficult to judge the exact relations between them. Yesterday's experience may already be invalid by tomorrow. Dealers can no longer even calculate what their own deals are worth. Just to be able to trade their 'structured products', the financial jugglers need price and risk-evaluation programs in which they have to trust blindly. The quality of these programs affects billions in profits and losses. The derivatives head at a German private bank reports that his current portfolio contains several thousands of these complex futures.

He proudly points to his program, which at any time can display the total value of the contracts. New data from dozens of markets are constantly entering into the calculations. 'There' – and he runs his finger down a hundred lines – 'I can see whether we are actually making a profit or not. Every day interest rates stand still, we lose 49,000 marks. A drop of just a hundredth of one per cent brings us in 70,000.'

It is still necessary, though, to find a buyer on the market for everything that can theoretically be sold. And that is not always assured. The more complex the relations between markets become, and the more factors determine the ups and the downs, the greater is the danger that prices will suddenly lurch into complete chaos. Just as the options held by mortgage dealers caused the world bond market to collapse, so tomorrow could other interdependences make themselves known.

The unpredictability of the derivatives market has already been the undoing of many a financial wizard and caused losses of hundreds or thousands of millions to many a serious business. The list of victims extends from the Frankfurter Metallgesellschaft, which was kept from bankruptcy only through billions in subsidies, through the world-league Procter and Gamble and the big Japanese bank Daiwa, to the German insurance companies Gothaer, Colonia and Hannoversche Rückversicherungs AG. The worst damage so far was done in February 1995 by the Englishman Nick Leeson, then only twenty-seven years of age. Operating from the Singapore Stock Exchange, his failed speculation with options on the Japanese Nikkei Index cost Barings Bank 1.8 billion marks and forced this oldest of British financial institutions into bankruptcy. This spectacular event made clear what banking supervisory bodies had known for years: namely, that the explosion of the derivatives trade has not only increased the risks for the money business, but also disabled security systems in the financial sector that took decades to put in place.

Meltdown in cyberspace

The losses of individual dealers and banks may, in principle, be a matter of indifference to the banking watchdogs. Danger threatens the whole system, however, when big banks and investment firms become insolvent. The plight of one institution can affect others

overnight and trigger a worldwide domino effect. 'Then the risk spills over to the exchanges, from there to the exchange rates and so into the real world,' worried Horst Köhler, president of the German association of savings banks, in early 1994. Such a mega-disaster is 'altogether possible'.[68] Trade would suddenly come to a stop, the whole system would collapse, and a global crash as on Black Friday, October 1929, would be unavoidable.

Köhler chose the right comparison when he spoke of the 'greatest supposable disaster', a technical term used by atomic engineers. For the so-called systemic risks in the money markets are quite like those of nuclear power stations. The probability of a major accident is small, but the potential damage it would cause is almost unlimited. This is why, for years now, the supervisory bodies in the banking sector of the industrial heartlands have been trying to get strict regulations accepted. Since 1992 it has been a basic rule from Tokyo to Frankfurt that every bank must have capital of its own equal to at least 8 per cent of all outstanding loans. If a big loan turns bad, this capital must be available to cover the loss. However, the derivatives trade carries this precaution *ad absurdum*. The open trading positions entered into by dealers do not usually appear at all in the balance-sheets, and, this being so, it is left up to the finance houses how high they assess the risk.

Since scandals and accidents became more frequent, many watch-dogs have been ringing the alarm. It is 'five minutes to midnight' was, for example, the warning given shortly before the Barings disaster by Arthur Levitt, head of the US Securities and Exchange Commission (SEC).[69] Wilhelm Nölling, who until 1992 was president of the Hamburger Landeszentralbank and a member of the Bundes-bank board of directors, called for urgent political measures to be taken internationally 'to defend the financial world from itself', and to afford suitable protection against a 'mega-disaster in the finance system'.[70] Felix Rohatyn, the New York banker and candidate for the vice-presidency of the US central bank, recognized that the 'deadly potential lurking in the combination of new financial instruments and hi-tech trading techniques may help to trigger a destructive chain reaction. The world finance markets are today a greater danger to stability than atomic weapons.'[71]

Jochen Sanio, vice-president of Germany's official credit super-vision office, sounded a similar note in April 1995. Barings was, in

his view, fairly small beer; the real headache would be a collapse of one of the global players. There are only a few houses like Goldmann Sachs, Merrill Lynch or Citibank, but they have most of the derivatives trade in their hands. Were one of them to be lost, 'the whole network might suddenly be put to a decisive test'. There is therefore a need for a world-networked 'registration office' at which big derivatives businesses would have to register, rather like the national bodies monitoring large loans. Only then could it be known in time if the accumulated risks on the market were too high. In Sanio's own opinion, 'the pressure to trade is too great'.[72] Even the finance guru George Soros, one of the greatest profiteers in the fast-moving, open-borders money business, has been urging a degree of caution. The financial system is not forearmed against major crises, he declared in January 1995 to a 3000-strong audience of top managers and political leaders at the World Economic Forum in Davos. In an emergency there would a threat of collapse.[73]

It is quite remarkable that, despite all these warnings, nothing (or almost nothing) has changed. The 'registration office' vanished from discussion, as did the call for stricter legislation. Instead, supervisory bodies in the large financial centres, which are coordinated by a standing group at the Bank for International Settlements in Basle, wrangled for two years with banking lobbyists over the methods to be used in the assessment of trading risks. This led in December 1995 to non-binding guidelines which leave the banks free to estimate the risks themselves. They are simply asked, with a please, to try multiplying the result by three, just as an experiment, and to put up capital of their own accordingly.[74]

The recommendation, perhaps to be given legal force after three years, has quietened debate for the time being, but it most certainly does not offer effective security. This was indirectly admitted by Edgar Meister, the man at the Bundesbank who heads its banking super-visory board. In January 1996, just six weeks after the Basle recommendation was adopted, he gave a lecture to the European Risk Management Round Table at a screened-off conference centre in the Taunus Hills, and pointed out dozens of weaknesses in their current calculations to the assembled risk-takers of the financial sector. Many models contain 'simplifying exclusions' and do not allow for 'violent swings on the assumptions'; they also improperly 'infer from the past to the future' and 'hardly make any allowance for

liquidity bottlenecks, as was the case with Metallgesellschaft and Barings'.[75] In other words, self-organized risk management fails precisely when it is most urgently required – in huge and unpredictable market movements. This was confirmed by Thomas Fischer, head of derivatives trading at the Deutsche Bank until summer 1995. 'It's getting bad when no one grasps what is happening right now,' says the experienced dealer. 'Then everyone wants to sell, and only few want to know' – the market becomes illiquid. 'In such situations, none of the models used for calculation is much good any more. Dealers reach their loss limit in three seconds, and nothing works any longer.'[76]

The risk of a crash is all the greater because of a particularly sensitive weak point in the system, which is usually passed over in embarrassed silence. The hi-tech architecture of the electronic marketplace is anything but perfect. With the rapidity of action on the trading tables and the exchange floor, business is by no means concluded there. To arrange a deal with the force of law, to transfer sums of money in payment, to make over the actual deeds – all this is done in the 'back offices' by hosts of assistants. But their system, unlike that of the dealers, works at too leisurely a pace for a sector that can push the whole world into bankruptcy in the space of a few hours.

Their main instrument is the Society for Worldwide Interbank Financial Telecommunications, or Swift for short. This organization runs the most efficient private communications network in the world, to which more than 5000 institutions are connected. Through a few dozen regional junctions and two huge computers at secret locations near Amsterdam and Washington, Swift handles each year the sending of more than 500 million instructions around the world. Only here, in code fully up to military standards, do the banks exchange for themselves and their clients the agreements that count as legally binding. Once the Swift communications are confirmed a second time, and only then, the real transaction takes place in the form of credits and debits between the various accounts which, as in the past, proceed entirely through the national bank-giro networks. In Germany, for example, Deutschmark credits never really leave the Federal Republic, but simply change owners in accounts of the registered banks. Anyone who wants to carry out a transaction in Deutschmarks needs a bank (or branch of a foreign bank) in

Germany. Because of the different time-zones, however, this all takes two or sometimes three days even for a simple currency transaction. In times of crisis, therefore, bank managers find out too late whether they can really have the traded sums made available to them.

Still more complicated is the process of settlement in the international securities trade. This is the business of Euroclear, a unique organization with headquarters on the Avenue Jaqumain in Brussels. Behind a glass-and-granite façade with no nameplate lies hidden one of the most sensitive nodal points of the world finance system. Only ten of the 950 members of staff are permitted to enter the top-security computer centre, whose generators and huge rooftop reserve-tanks can, if necessary, provide it with its own electric current and cool water. In addition, a complete parallel centre is up and running at a secret location, able to take over all operations at once if the main computer should break down. Every day a private tele-communications network belonging to the US corporation General Electric conveys the orders for 43,000 transactions to the computers, which receive messages by day and process them by night. Throughout, not a single share or bond certificate actually arrives in Brussels. What Euroclear operates is a system of systems that connects up the various national settlements organizations (in the case of Germany, the Dusseldorf-based Kassenverein where most German securities are kept safe). As many as ten different addresses may easily be involved in a single transaction: not only the actual parties but also the brokers, the national deposit centres, and the banks in whose accounts the relevant payments must be recorded. Thus, despite the state-of-the-art electronics and the worldwide networking, it all takes up to three days.[77]

In an emergency, the whole world of finance could come unstuck because of this delay. For while dealers have for a long time been trading with the proceeds of an earlier deal, things may already have come to a standstill at some other point in the river of data worth billions of dollars. According to Gerald Corrigan, chief international adviser at Goldmann Sachs and former president of the Federal Reserve Board of New York: 'A major break in the chain has the potential to bring large parts of the system to a halt, causing the much-feared financial gridlock in which market participants conclude that the safest thing to do, is to do nothing – hold back on payments, cling to collateral, and fail on securities deliveries.' The assets that

could be blocked in this way have become much too large. The volume of trade and the associated risks 'are growing much faster than the capacity of the banking system to carry them'.[78]

Such warnings make a meltdown in the stateless cyberspace of world finance appear far more probable than many of its actors would like themselves and their clients to believe. True, supervisory bodies and risk managers have installed countless safety devices, so that most dealers have to adhere strictly to specified limits. Almost everywhere they are allowed to deal only with partners whose creditworthiness has already been checked. Clearing centres such as Euroclear keep ready internal credit buffers and security reserve funds to overcome any liquidity bottlenecks. But neither technology nor internal checking can enable the security experts of the world finance machine to prevent what managers of other hi-tech systems most fear: human error. In isolated cases, that is hardly of any significance on the dealing tables and the exchange floors; one dealer's losses are another's profits. But mistakes are infectious in the global race for high returns. If well-known dealers of reputable banks and funds really stick their necks out, the herd instinct soon takes over. Greed then prevails over reason not in one individual but in thousands, and otherwise cool and calculating strategists can together outflank any safety regulations.

Nothing else lay behind the 'first major crisis of our new world of global markets', with which IMF boss Camdessus and the US government were wrestling in January 1995. When the Mexican government first devalued the peso and shortly afterwards could no longer keep up payments on its debt, many US finance managers complained that they had been led up the garden path over the true size of Mexico's dollar deficit, and that Mexico had kept the true figures secret for too long; otherwise they would not have pumped their billions into that once so-promising land of growth. Such statements, however, at best covered up for collective self-deception, or else were simply lies. Moody's and other rating agencies had had all the data at their fingertips, and indeed right through 1994 they had classified investments in Mexican bonds as 'high risk'. But in this case, even the managers of the biggest funds did not want to believe the sector's own watchdog. 'The profits were just too sexy,' confessed one of the dealers involved. Even for *tesobonos* (the dollar-denominated government bonds safe from any devaluation), the Mexican Finance

Ministry offered double-digit interest long before the crisis broke, thus drawing 14 billion dollars into the country from US investors. None other than the largest mutual fund in the world, the Fidelity Investment Group, which manages the savings of millions of Americans, temporarily became Mexico's largest creditor. So it was natural enough that the US financial sector panicked when the government's inability to pay became apparent in Mexico City.

Suddenly the much-vented scorn of state regulation and inflationary budget deficits lost all its sparkle. Spokesmen for every market explained to US congressmen and to the governor of the IMF that a worldwide domino effect would blow the system apart. They also dropped a reminder about the billions that Camdessus and Treasury Secretary Rubin had finally scratched together from tax revenue in their night-and-fog operation.

The peso crisis, however, revealed not only the weakness of governments in dealing with uncontrollable speculation, but also the impotence of market-makers when faced with their own weaknesses. The anarchistic, anti-state ethos of those who direct the flows of capital always turns into its opposite when it is a question of overcoming the disasters they have caused. The markets should indeed rule, but only as a dictatorship with limited liability. The international community remains responsible in times of crisis, but how many more Mexicos will that community endure? Another crash scenario has been around for quite a long time now. In order to put its ailing financial sector back on its feet, the Bank of Japan has since early 1995 been flooding the world with almost zero-interest yen loans and presenting canny investors with a fabulous bonanza. Funds and banks everywhere in the world borrowed cheap yen by the billion, exchanged them into dollars and netted a return of up to 6 per cent. Three hundred billion dollars from Japanese sources flowed into the acquisition of US bonds alone. But then came the fears of a sticky end. How was this money-roller going to be dismantled again? What would happen if the Japanese economy picked up and the central bank raised interest rates again? In August 1996 the yen boon is still holding; interest rates in Japan remain low. But analysts and central bankers throughout the world have been mulling over whether a bond-market earthquake might be in the offing as in 1994, only this time with its epicentre in Tokyo instead of Washington.[79]

The Brazilian situation is also causing unease on the markets. In

June 1996 the US economist Rudiger Dornbusch warned that there was a danger of something similar to the Mexican crisis. In Brazil, too, the government is sticking to an unrealistic dollar rate for its currency; the real, and excessively high, interest rates are drawing too much foreign speculative capital into the market. Brazil, mocked Dornbusch, 'is driving in the wrong lane with the expectation that there is never any traffic on the other side'.[80]

Year by year, then, the likelihood is growing that the unruly financial machinery will release, all over the world, waves of crisis that cannot be mastered simply through faith in the ordering powers of the market. The time may soon come when appeals to the state fall into the void. For the International of high finance is constantly undermining the very thing to which it desperately turns in times of crisis – namely, the capacity of national states and their international institutions to take effective action.

The financial sector is not alone in this respect. For the same branch is being sawn away by the second new group of self-appointed world rulers acting in the name of globalization: that is, the commanders of transnational corporations in every line of business. When the historic turn took place in 1989, they started a victory march which has been changing the world faster and more radically than any empire or political movement has ever done before. Yet this victory too has a bitter taste. And the triumphalist feelings will not last for much longer.

4. The law of the wolves. The jobs crisis and the new transnationals

At Dearborn, Michigan, the most highly valued engineers at Ford, the world's second-largest car manufacturer, work in the glow of numerous computer screens. They effortlessly demonstrate the symbiosis of man and machine. A chassis designer moves his cabled pen over the electronic drawing field on his work-table. A quick press here, a line there, and he can see on his monitor the outline of a new Ford model that may soon be catching the customer's eye in display rooms around the world. Suddenly a hollow, anonymous voice rings out from an inconspicuous speaker alongside the monitor: 'I like it; but what if we did it this way?' And the vehicle sketch changes on the screen as if guided by a ghostly hand – a little rounder at the top, even more stylish at the sides.

The helpful phantom is sitting in Cologne, at Ford's European headquarters. Either simultaneously or on successive shifts, people in Germany work with their colleagues in Dearborn to develop the same project. They put together European, American and also Japanese ideas or visual images. Silicon Graphics computers are everywhere: five laboratories spread over the continents form a single global studio for car construction, in which every virtual crash test, every aerodynamic calculation for every model, must be conducted within a common series.

Design by video and computer link-up across all oceans and time-zones is part of the most sweeping reorganization ever carried out at Ford. Since the beginning of 1995 regional subsidiaries no longer develop their own models, nor is one division's finished design then reworked by a second and adapted by a third. Ford boss Alex Trottman ordered instead that the old regional corporations should be

merged into two larger units, one serving the market in Europe and the United States, the other in Asia and Latin America. What seemed fraught with difficulties just a short time ago – the application of state-of-the-art computer technology – is now pushing open the gates for a globally integrated corporate machine. Whether in development, purchasing or sales, Ford is trying to avoid any duplication of effort by bringing everything online right down to the most far-flung provincial branch. The result is 'global cars', Ford's way of again setting the world standard for the most efficient production of automobiles. The new arrangements save billions in costs, and probably do away with several thousand highly skilled, well-paid jobs done by managers, engineers and salesmen. For the last world-marketed model, the Mondeo, Ford designers still needed two months and twenty international working conferences to complete the project. For the most recent model, the Taurus, fifteen days' work and three control sessions were all that was necessary before the board gave the green light for production to start – an efficiency leap of more than 100 per cent.[1]

The 'revolution at Ford', as *The Economist* calls it, is not due to the pressure of a financial crisis; in 1994, for example, the corporation earned 6 billion dollars in profits. Trottman and his team of top executives are simply doing what the most modern networked technology makes possible, and everyone else will follow suit, not only in the auto industry.

Sector by sector, job by job, the world of labour is indeed being revolutionized. Hardly anyone is spared. Politicians and economists look in vain for something to replace the blue-collar jobs that are disappearing at the Vulkan shipyards, the Dasa aircraft hangars or the Volkswagen assembly lines. Fear of redundancy has long haunted white-collar offices, and is spreading to sectors of the economy that used to be the most secure. Jobs for life give way to casual work, and people who yesterday thought they had a career of the future can find that their skills have turned overnight into so much useless knowledge.

Bleak times lie ahead, then, for the near-million employees of banks and insurance companies in Germany. Since businesses in the world of finance embarked upon open-borders competition, their staff have faced a future of a harshness that used to be reserved only for workers in the textile industry. Cash machines and

automated bank statements started the ball rolling. Now American and Japanese banks, insurance companies and investment funds are pressing for savers or borrowers on the European, and especially German, market. Since 1995 American Express, for example, has offered current accounts that attract a higher rate of interest than savings accounts, with no notice period for withdrawals. Customers can give all manner of instructions round the clock by telephone or PC, convert savings in minutes into higher-earning investments, or even have cash sent to their home. Fidelity Investments – the world's largest fund, based in Boston, Massachusetts – sells securities by telephone throughout the European Union from its branch in Luxembourg. This marketing ploy turns the traditional structures of the banking industry on their head. Dense branch networks, whose proximity to the customer used to be an advantage, have become an expensive luxury and a competitive disadvantage. With autonomous subsidiaries such as Bank 24 or the Advance Bank, behind which stand the Deutsche Bank and the Vereinsbank, all the big German financial institutions are going over to telebusiness. The launch period will be followed in the coming years by sweeping cuts in the number of branches.

Bank staff with a higher school-leaving certificate, special training and extensive work experience will therefore be needed in fewer and fewer numbers. Already not much is left of the traditional image of a friendly, well-paid bank employee living just down the road. At VB-Dialog, for instance, the direct banking subsidiary of the Bavarian Vereinsbank, the pay scale negotiated with the unions no longer holds. Instead of the usual 23 to 30 marks, the pay is only 16 marks an hour, little more than in the cleaning trade. The big Munich bank saves on holiday money for new employees, as well as on the Christmas bonus, and it requires staff to be prepared to work at any time of the day or night, including at weekends, with no extra pay. The highly trained experts who look after wealthy and corporate clients are also feeling the pinch, as are the trillion-mark jugglers on the electronically organized world money market. Five of the largest German finance houses have bought into investment banks in London and do most of their business with big-time clients there. German applicants, even inhouse, stand little chance of a job at either Kleinwort Benson (Dresdner Bank) or Morgan Grenfell (Deutsche Bank). Their employers prefer to rely on local manpower.

US finance professionals in Washington and New York pour scorn on what they see as antiquated, inefficient and above all unprofitable banking systems in Europe. 'The big-money managers in Switzerland', explains a leading Wall Street fund manager, 'grew up in a different world. Those people will all miss the boat if investors get 30 per cent a year with us and Swiss banks offer only 2 or 3 per cent.' In a few years' time, many big US speculators are convinced, they will also be attracting billions into their high-risk funds from previously cautious German, Swiss and Austrian savers. An insider graphically describes the strategy: 'When we first open a high-profile branch on Zurich's Bahnhofstrasse, Swiss customers will turn their noses up and treat us with suspicion. But when a gutsy neighbour of theirs drives round in a Porsche from a few years of investing with us, things will soon start to change.'

The consequences will be harsh. 'The banks are the steel industry of the nineties,' predicts Ulrich Cartellieri, a board member at Deutsche Bank.[2] Market researchers at Coopers and Lybrand business consultants agree that this is no exaggeration. In a study of the plans of fifty leading banks around the world, they forecast that half of all the people currently employed in the money business will lose their jobs in the next ten years. If that is projected on to the German financial sector, it means the loss of half a million well-paid jobs.[3]

Three Indians for one Swiss

What is just beginning in the banks and insurance companies has already engulfed one supposedly up-and-coming sector: the software industry. Although more than 30,000 young people were still studying computer sciences at German universities in the autumn of 1996, it already seems that a large number of budding computer experts will have little chance of finding something suitable on the labour market. Programmers in California's Silicon Valley have known for some time how quickly the value of their knowledge can depreciate.

Ten years ago, the chief planners at such companies as Hewlett-Packard, Motorola and IBM began to employ new specialists from India at lower rates of pay. At one point they were chartering whole flights to bring in the coveted temporary workers. 'Brain shopping' is what they called it. At first local software experts refused to accept the cheap competition, and the government supported them by

granting a visa only in exceptional cases. But that was not much help to American software engineers. Many firms simply relocated major parts of their data work to India. The New Delhi government laid on all the infrastructure – from air-conditioned open-plan laboratories to satellite links – at almost zero cost in ten specially designated zones. Within a few years the 'Electronic City' of Bangalore, a population centre of several millions in the Indian highlands, had achieved worldwide fame. Siemens, Compaq, Texas Instruments, Toshiba, Microsoft and Lotus – all global players in the computer sector – had set up branches of their own or were farming out development work to established Indian subcontractors. All told, the software industry in the sub-continent now employs 120,000 university graduates from Madras, New Delhi and Bombay, who in 1995 brought their companies more than 1.2 billion dollars in business, two-thirds of it from the export of their services.[4] At the same time, the boom has quadrupled Bangalore's motor traffic and made its air unbreathable, while the unrelieved mass poverty weighs upon people's minds. The city has therefore begun slipping down again, as the software-smiths prefer to get out and head back to Poona.

Ten years after the innocuous start was made in sending Indian workers to California, nothing is as it used to be at the original sites of the computer industry in the United States, Western Europe and Japan. In Germany, the three giants alone – IBM, Digital Equipment and Siemens-Nixdorf – have eliminated more than 10,000 jobs since 1991, partly, though not only, because of the construction of their branches in Bangalore. Many other companies which have to process huge amounts of data make use of the same special offer on the other side of the planet. Swissair, British Airways and Lufthansa have delegated a large part of their reservations to Indian sub-contractors, while Deutsche Bank is getting its subsidiary in Bangalore to build and maintain the computer systems used by its foreign branches. Indians have also developed the logistics for the container quays in Bremerhaven and tax programs for Intercope in Hamburg, which organizes its own telecommunications network. The motive for this expansion towards India is always the same: the staff there are well educated at English-speaking universities yet cost only a fraction of what their counterparts are paid in the North. Hannes Krummer, spokesman for Swissair, came up with a punchy formula for the electronic travel to India: 'We can hire three Indians for the

price of one Swiss.' The relocation of accounts preparation alone is supposed to have cost 120 jobs in Zurich and saved 8 million francs a year.[5]

This is just the beginning. Since 1990 a further million skilled computer people have been pushing on to the market from Russia and Eastern Europe. Already a firm in Minsk performs labour-intensive maintenance work by satellite for IBM Deutschland. The German company Software AG has programming done in Riga, and the Daimler-Benz subsidiary Debis sends programming work to St Petersburg. 'What is on offer there is even better than in India,' says Debis boss Karl-Heinz Achinger. Siemens's India expert, René Jötten, agrees with him: costs are already too high in Bangalore, and 'we're thinking of going somewhere else soon'.

Meanwhile, the hard-working and undemanding data-workers in East or South are facing even cheaper competition as the college computer proves itself simply unbeatable. Students of the computer industry, such as Karl Schmitz from the Society for Technology Consultancy and Systems Development, think that low-wage computer work is a 'passing phenomenon'. Ready-made software modules and new programming languages will soon make all work superfluous; future machines will make it possible for one programmer to produce as much as a hundred do today. It is a merciless prognosis for an occupation which has so far been considered at the forefront of progress.[6] If Schmitz is right, the present 200,000 jobs in the German software industry will be whittled down to a mere 2000.

At least computer experts can still hope that there will be growing demand for their guild. Everywhere in the world, telephone companies are focusing on the creation of high-performing networks, whose information superhighways will in turn boost business with multi-media services. The writing of application programs will still require a lot of work, and in 1995 German software businesses were once more expanding their staff. But the coming online boom will go together with the disappearance of many other service jobs in cyberspace. Archivists and librarians, travel agency assistants, retail salespersons, staff of regional newspapers and freesheets – all will become superfluous. Once the majority of households have a PC and a data telephone, and customers can choose in minutes from a world supply list without even leaving their home, large sections of the labour market will simply crumble away.

Millions sacrificed to the world market

Evacuate, streamline, terminate – the high-output, hi-tech economy eats away at the labour of the affluent society and makes its consumers redundant. An economic and social earthquake of unheard-of dimensions is now looming on the horizon. Whether in automobile or computer construction, chemistry or electronics, telecommunications or postal services, retail trade or finance, wherever goods or services are freely traded across borders, employees seem to be sinking inexorably into a morass of devalorization and rationalization. Just in the three years from 1991 to 1994, more than a million jobs were lost in West German industry.[7] And Germany is still not badly off in international terms. Elsewhere in the OECD (the organization of twenty-three rich industrial nations plus five poorer neighbours), the number of well-paid jobs shrank even faster.[8] In 1996 more than 40 million people in the OECD countries are looking in vain for work. From the United States to Australia, from Britain to Japan, mass prosperity is rapidly disappearing in the foremost countries of the world economy.

Even the profession which ought to write about the decline, and for which bad news always means 'good news', is coming to feel that times have changed: journalists and makers of documentaries, researchers and final editors are also being pressed hard by the world of 'tittytainment'. Ever fewer media people turn out ever more stories at an ever faster speed. Up-and-coming journalists can no longer even dream of fixed employment with a lavish expense account in the flagships of the print media and public service television. What used to be standard practice at *Der Spiegel* or *Stern*, at WDR or Bayerischer Rundfunk, is today reserved for people with long years of service and for a few young stars, while those starting a career have to make do with insecure flat-rate contracts or meagre payments per line. Even book publishers and serious video- and film-makers fall back upon cheap work. Flourishing houses hesitate before making new appointments, for it is not known what else might happen to a sector already hard hit by rising paper prices and flagging reader interest.

Huge redundancies are also in the offing in sectors which, only a short time ago, used to promise their staff lifetime employment whatever the ups and downs of the world economy. Massive 'down-

sizing' threatens not only in banking and insurance but also in telecommunications, airlines and the civil service. If the efficiency of the world leader is taken as the standard in each branch, and if future job losses in German or other European companies are estimated on that basis, then widespread layoffs will soon be happening everywhere in Europe (see pp. 104–7). Germany and the European Union offer rich pickings to the hungry wolves of global competition.

An end to the jobs collapse is not in sight. On the contrary, having studied surveys conducted by the World Bank, the OECD and the McKinsey Global Institute (the research group of the world-market leader in business consultancy), as well as numerous trade-sector and company reports, the authors of this book have reached the conclusion that a further 15 million white-collar and blue-collar workers in the European Union will have to fear for their full-time jobs in the coming years. That is almost as many again as the registered jobless in the summer of 1996.

In Germany alone more than 4 million jobs are in acute danger. The number of unemployed could more than double, from the present 9.7 per cent to 21 per cent in Germany, or from 7.3 per cent to 18 per cent in Austria. Presumably things will not work out quite like that, because it is thought that many of the secure jobs which go by the board will be replaced by part-time posts, temporary work on call and various forms of low-wage employment. Nevertheless, incomes in the new world of labour, in which millions of casual workers will be shunted from one short-time job to another, will be markedly lower than they have been under the present system of collective bargaining. The 20:80 society is drawing closer.

Everyone can feel the consequences, even if their own job still seems secure. Insecurity and fear for the future are spreading; the social fabric is tearing apart. Yet most of those in positions of responsibility deny that they are responsible. Governments or company boards act helpless and plead innocence. Voters and employees are told that the massive job losses – unthinkable just a short while ago – are the result of unavoidable 'structural change'. According to Martin Bangemann, for instance, Economic Commissioner of the European Union, large-scale production has no future in Western Europe if wages remain at a high level: 'China and Vietnam are already waiting as competitors whose wage costs can hardly be

The great shake-out: job losses threatened in major services

Banks Surplus employees at home and abroad on the payroll of German and Austrian finance corporations, calculated by reference to the productivity of the big American bank Citicorp in 1995 (company results per member of staff = 68,769 US dollars).

Source: Banks' own reports.

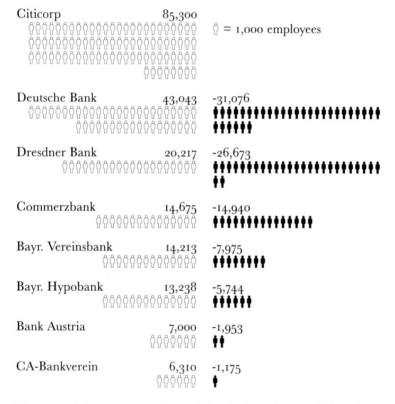

Citicorp 85,300

⚇ = 1,000 employees

Deutsche Bank 43,043 -31,076

Dresdner Bank 20,217 -26,673

Commerzbank 14,675 -14,940

Bayr. Vereinsbank 14,213 -7,975

Bayr. Hypobank 13,238 -5,744

Bank Austria 7,000 -1,953

CA-Bankverein 6,310 -1,175

The sum of the two figures for each bank gives what would have been the total number of employees in 1995.

Example: If Deutsche Bank had been as efficient as Citicorp, it would have needed 31,076 fewer employees than it actually had in 1995 to make the same profits.

Telecommunications Surplus employees in European telecom companies, calculated by reference to the productivity of the US telephone company Pacific Telesis in 1994 (296 main extensions per member of staff).

Sources: ITU World Communication Indicators Database; Sirius.

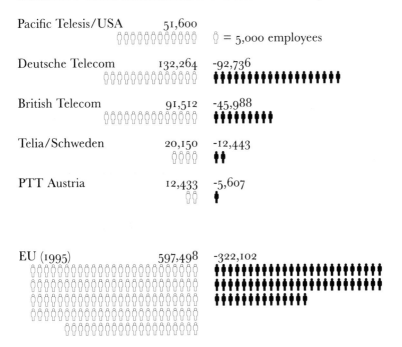

Pacific Telesis/USA 51,600
 ⚲ = 5,000 employees

Deutsche Telecom 132,264 -92,736

British Telecom 91,512 -45,988

Telia/Schweden 20,150 -12,443

PTT Austria 12,433 -5,607

EU (1995) 597,498 -322,102

The sum of the two figures for each firm gives what would have been the total number of employees in 1994.

Airline companies Surplus employees in European airline com-
panies, calculated by reference to the productivity of the US United
Airlines company in 1995 (2.2 million passenger kilometres per
member of staff).

Sources: Association of European Airlines, *Yearbook*; IATA, *World Air
Transport Statistics*; airlines' own company reports.

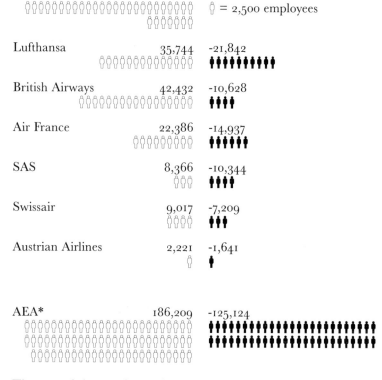

United Airlines	81,160	⚇ = 2,500 employees
Lufthansa	35,744	-21,842
British Airways	42,432	-10,628
Air France	22,386	-14,937
SAS	8,366	-10,344
Swissair	9,017	-7,209
Austrian Airlines	2,221	-1,641
AEA*	186,209	-125,124

The sum of the two figures for each firm gives what would have been
the total number of employees in 1995.

Note: * Association of European Airlines (Adria Airways, Aer Lingus, Air France,
Air Malta, Alitalia, Austrian Airlines, Balkan, British Airways, British Midland,
CSA, Cyprus Airways, Finnair, Iberia, Icelandair, JAT, KLM, Lufthansa, Luxair,
Malev, Olympic Airways, Sabena, SAS, Swissair, TAP Air Portugal, Turkish Air-
lines).

Insurance companies Surplus employees in European insurance companies, calculated by reference to productivity in the French Assekuranz company in 1994 (direct total gross premiums per mem ber of staff = 902,504 US dollars).

Sources: OECD, *Insurance Statistics Yearbook*, Paris 1996; *European Insurance in Figures*.

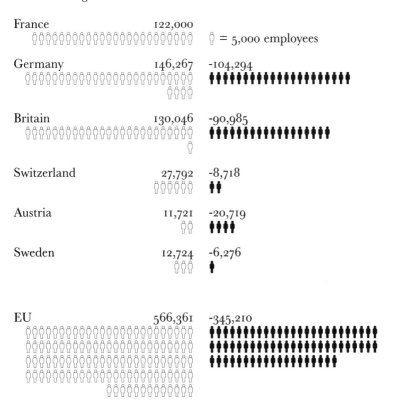

France 122,000

⍦ = 5,000 employees

Germany 146,267 -104,294

Britain 130,046 -90,985

Switzerland 27,792 -8,718

Austria 11,721 -20,719

Sweden 12,724 -6,276

EU 566,361 -345,210

The sum of the two figures for each country gives what would have been the total number of employees in 1994.

Note: * In France, banking and insurance are often combined in general financial companies that require far fewer employees for the selling of insurance policies and the investment of premiums. A similar integration is expected for the finance sectors of other European countries.

undercut'.[9] And the managers' paper, the *Wall Street Journal*, notes that 'competition in a brutal global economy ... is creating a global labour market. No job is secure any more.'[10]

Those who benefit from the open-borders economy are glad to make the crisis appear as a kind of natural process. 'Competition in the global village is like a flood tide; no one can escape it,' stated Edzard Reuter, then chief of Daimler-Benz, in 1993.[11] Three years and a million lost jobs later, Siemens boss Heinrich von Pierer repeats the message almost word for word: 'The wind of competition has become a storm, and the real hurricane still lies ahead.'[12] Economic integration across all borders does not correspond, however, either to a law of nature or to linear technological progress that admits of no alternative. Rather, it is the result of a government policy consciously pursued for decades in the Western industrialized countries, and still pursued there today.

From Keynes to Hayek: freedom struggle for capital

The road to the global economic circuit began when Europe was still having to tackle the consequences of the Second World War. In 1948 the United States and Western Europe agreed the General Agreement on Trade and Tariffs (GATT), which for the first time established a common international regime for trade between participating states. Through a total so far of eight rounds of negotiations, some stretching over years, the GATT members brought about a lasting reduction in tariffs to a level where they hardly figure in trade between developed countries. Since the successor to GATT, the World Trade Organization or WTO, was founded in Geneva at the beginning of 1994, governments haggle no longer over customs restrictions but over other barriers to trade, such as state monopolies or technical regulations.

The increasing freedom of trade has had a huge impact. For four decades world commerce in goods and services has grown faster than production, and since 1985 even twice as fast as aggregate output: in 1995 a full fifth of the recorded total was being traded across the world's borders.[13]

For a long time citizens of the industrialized countries could feel sure that economic integration was also increasing their prosperity.

But in the late 1970s an epochal shift in West European and North American economic policy began to push the world economy on to new terrain. Since the war, most industrialized countries had been following the principles that John Maynard Keynes developed in answer to the economic catastrophe of the interwar period. Keynes made the state the main financial investor in the economy, so that the budget could be used as an interventionist device to correct any tendency to under-utilization and deflation. In a downturn, government investment was supposed to boost demand and thereby avert a growth crisis, while in an upturn the public debt incurred during the previous period would be paid off through increased tax revenue and an inflationary boom would be prevented. Many governments also assisted industries that could be expected to deliver fast growth and demand for labour. Then came the oil price shocks of 1973 and 1979 which caused this whole edifice to totter. In many cases, governments were no longer able to bring the deficit and inflation under control. Fixed exchange rates could not be maintained.

After the conservative election victories in Britain and the US in 1979 and 1980, policy came to be guided by a completely different economic dogma: the so-called neo-liberalism or monetarism associated with Reagan's adviser Milton Friedman and Thatcher's mentor Friedrich August von Hayek. For these theorists the only role of the state was as nightwatchman, as guardian of order; the freer the hand of private business in investment and employment matters, the greater would be the growth and prosperity for all. Starting from this premiss, the mostly 'neo-liberal' governments of the 1980s in the West waged a kind of freedom struggle on behalf of capital. They dismantled controls over a broad front and greatly reduced the capacity for state intervention, using trade sanctions or other pressure to force unwilling partner-countries to follow the same course.

Three 'ations' – deregulation, liberalization and privatization – became the strategic instruments of European and American economic policy and the cornerstones of a state-decreed ideology. The radical free-marketeers ruling in London and Washington transfigured the law of supply and demand into the best of all possible principles of order. The further extension of free trade became an unquestionable end in itself. As this spread to international currency and capital movements, the most radical attack on the economic

foundations of Western democracies was carried through without meeting any noteworthy resistance.

It soon became clear who would bear the risks of the market from now on. Especially in labour-intensive sectors where a lot of the manpower was still untrained or relatively unskilled, companies of all shapes and sizes in Western Europe and the United States were facing competition from low-wage countries. The production of furniture, textiles or shoes, watches or toys, would be profitable in future only if it was extensively automated or transferred abroad. At the same time, Japan had become the first new industrial country to join the old phalanx of world-market leaders, and its aggressively cheap products were putting considerable pressure on the rest of industry. The old West first responded with defensive tariffs or forced through agreements on an ostensibly voluntary restriction of exports. But the supporters of free trade always had the upper hand politically and ideologically. They complained that such protectionism stood in the way of technological progress, and it was accepted that most of the defensive measures should be of only limited duration.

Away from labour-intensive mass production, forward to hi-tech manufacturing and the service society; this path was supposed to heal the wounds caused by international competition and automation. The hopes were never fulfilled. Despite a pick-up in growth, more and more people in every OECD country save Japan were no longer able to find well-paid work.

Prosperity through free trade: the unfulfilled promise

If things had gone in accordance with prevalent economic thinking, the labour market would never have evolved in the way that it has. Open-borders trade, apologists still tell us, means that all participating nations are winners. The usual reference, on the part of professors and politicians alike, is to the theory of 'comparative cost advantage' that David Ricardo devised in the early part of the last century. What he wanted to explain was why international trade also benefits countries less productive than their partners. The example he chose was the exchange of wine and cloth between Portugal and England. The fact that both commodities were produced in each of the two countries meant that the English had to expend more labour (or were

less productive) and that their goods may actually have been too expensive for export. Nevertheless, it could still be worthwhile for Portugal to sell wine to England and to buy English cloth with the proceeds; while England profited by selling cloth in Portugal and importing Portuguese wine. The reason for this was the ratio between the prices of the two products within each country's borders. For, as Ricardo's example showed, an hour's clothmaking labour in England produced the equivalent of what 1.2 hours' labour earned in Portugal's wine-pressing. In the case of Portugal, however, the ratio was only 1:0.8, so that wine was worth less cloth there than in England. It followed that for both sides there was a relative or *comparative* cost advantage. It was worthwhile for Portugal to put more manpower into wine-pressing and not to produce any cloth, and for England to make the reverse specialization. Trade would enable both nations to consume more wine *and* more cloth, without having to work harder.

Ricardo's theory is as simple as it is ingenious. It explains why commerce has always flourished between nations even in goods that both are able to produce. The only problem is that this has little to do with the world today. For Ricardo's brilliant theory of international trade rests upon an assumption that ceased to be valid a long time ago: namely, that capital and private business are not mobile and remain in their original country. For Ricardo, that still went without saying: 'Experience shows that the ... natural disinclination which every man has to quit the country of his birth and connections, and intrust himself ... to a strange government and new laws, check[s] the emigration of capital.'[14]

A century and a half later, Ricardo's basic postulate is completely out of date. Nothing today is more mobile than capital: international investment governs the flow of trade; billions moving at the speed of light determine exchange rates, as well as the international purchasing power of a country and its currency. It is no longer relative differences in cost that are the engine of business. What counts is absolute advantage in all markets and countries at once. Whenever transnational companies order production in the area with the lowest wages, without first having to worry about social spending or environmental costs, they lower the absolute level of their costs. This in turn brings down not only the price of goods but also the price of labour.

The difference is not a minor detail in an academic dispute

between rival schools of economics. The quest for absolute advantage
has fundamentally altered the mechanisms of the world economy.
The more easily production and capital were able to cross borders,
the more powerful and ungovernable became those often vast organ-
izations which today intimidate and disempower both governments
and their voters: the transnational corporations (TNCs). The UN
trade organization, UNCTAD, calculates that there are some 40,000
companies with headquarters in more than three countries. The
hundred largest alone account for a turnover of roughly 1.4 trillion
dollars per annum. TNCs today carry on two-thirds of world trade,
nearly half of it within their own company networks.[15] They are
right at the heart of globalization – and are driving it ceaselessly
forwards. Modern logistics and low transport costs enable them to
unify and concentrate production advances across every continent.
Well-organized corporations – for instance, the plant and machinery
giant Asea Brown Boveri (ABB), with its 1000 subsidiaries in forty
countries – are able, if necessary, to switch output of a product or
product-part from one country to another within a few days. It is no
longer nation-states and their various companies which offer goods
for sale in international commerce, afterwards haggling over the
distribution of profits within the country's borders. Now the workers
of the world compete over the labour they will be able to perform
within the context of globally organized production.

This process is overturning the rules of the erstwhile national
economies. First of all, it has speeded up the sequence of technical
innovation and rationalization to the point of absurdity: productivity
grows faster than aggregate output, resulting in what has been called
'jobless growth'. Second, the relationship of forces between capital
and labour has been totally transformed. Internationalism – once a
propaganda weapon of the workers' movement against war-
mongering governments and capitalists – has now crossed over and
is working for the other side. The employees' organizations, almost
entirely national in reach, are faced with a corporate International
that uses its trump card of cross-border relocation to face down any
demand. For capital investors and company managers, the promise
of prosperity through free trade may still hold. But for their workers
and employees, and even more for the growing numbers of the
unemployed, that is not how the sums work out. What was supposed
to be progress is turning into its opposite.

This trend had become unmistakable by the early 1990s at the latest. Yet it was then that, instead of applying the brakes, governments really stepped on the accelerator. The states of Western Europe launched their single market, and from Lisbon to Copenhagen they used the banner of 'Europe '92' to remove nearly all barriers to the movement of capital, goods and services. In reply the USA, Canada and Mexico set up a North American Free Trade Agreement (NAFTA) which, with the inclusion of the 100-million nation south of the Rio Grande, for the first time integrated a developing country into a trading bloc of this kind. At the same time, they were all negotiating the last round of tariff reductions within the framework of GATT, and in December 1993 many services were also thrown open to global trading.

All this was supposed to bring a veritable cornucopia for the countries involved. The more than thousand pages of the Cecchini Report, for example, which launched the EU Commission's single-market project in 1988, promised 6 million new jobs, deficits 2 per cent lower, and 4.5 per cent extra growth.[16] Similar claims accompanied the foundation of NAFTA and the WTO. The exact opposite has happened: the single market became, in the words of *Die Zeit*, a 'whip of competition' driving unprecedented rationalization throughout European industry. The jobless figures increased, as did the budget deficits, while growth actually slowed down.

In Austria, which did not join the market federation until 1995, employees are only now beginning to feel this as a constant pressure. When the German retail giant Rewe took over the Austrian Billa chain in July 1996, nearly half the country's food market came under the control of a single corporation operating Europe-wide. Since then, at least a third of the 30,000 or so employees of Austria's agriculture and food industry have been in fear of losing their jobs. Their products are scarcely competitive on the EU market. Rewe buyers pay producers in Austria only the low European prices; alternatively – the usual practice – they simply purchase better products on more favourable terms from their regular suppliers in other EU countries.

North Americans have been having the same experiences with NAFTA, whose promised blessings are still nowhere in sight. Yet governments in the WTO countries want to force transnational integration even further. Three more free trade agreements are in the

pipeline for 1996: China is due to join the World Trade Agreement; national telecommunications monopolies are supposed to come to an end; and the WTO countries are planning to harmonize at a minimal level their official regulations for incoming corporate investment, so that companies will have an even freer hand than they enjoy at present. WTO secretary-general, Renato Ruggiero, is even looking ahead to the worldwide dismantling of all customs barriers. Member-governments are asked by the year 2020 to give up all regional agreements and to turn the whole world into one free trade area – a plan which, judging by all previous experience, would considerably sharpen the jobs crisis.[17] And still most politicians in charge of the economy, from Washington to Brussels and Bonn, stick firmly to the scheme.

The global trap finally seems to have snapped shut. The governments of the world's richest and most powerful nations appear to be prisoners of a policy that no longer allows for any change of course. Nowhere do people feel this more acutely than in the homeland of the capitalist counter-revolution itself: the United States of America.

The bulldozer triumphant

It doesn't get much worse than this. Jack Hayes sits ashen-faced in his narrow kitchen and struggles to maintain his composure. He has worked for twenty-nine years as a lathe operator and mechanic at Caterpillar, the world's largest producer of construction machinery and bulldozers. He has been through all the ups and downs of his firm's history at its main factory and head offices in Peora, Illinois – including the terrible 1980s when 'Cat' nearly went bankrupt. Hayes voluntarily put in countless unpaid hours helping to redesign work routines, to install new computer-controlled machinery, and to train 'teams of quality' in the assembly halls that put the company back on top. Then in 1991, Hayes recalls, when turnover and profits reached an all-time high, management declared war on the work-force. Wages had to drop as much as 20 per cent, and two hours would be added to the working week. At first they weren't at all interested in talking. The situation was as plain as it could be to Hayes and his workmates of long standing. With their union, the United Auto Workers (UAW), they mobilized for a strike at all the company's US plants. That seemed only right: they had justice and

morality on their side. Why shouldn't the workers get a share of the rising profits?

Four years on, Hayes still does not know the answer. The organized Cat workers held a number of strikes, both walkouts and shopfloor sitdowns, keeping up their last action for more than eighteen months. It began as a normal strike against a management gone wild, but turned into the longest and most bitter labour struggle in America since the war, costing the union a good 300 million dollars in stoppage money to its members – and all in vain.[18] On the evening of Sunday, 3 December 1995, Hayes and his comrades heard it from UAW secretary Richard Atwood: 'The only people the strike's really harmed are our loyal members.' Caterpillar could not be hit, and the strikers would have to go back to work. A few days later, Hayes again had some work shifts behind him, on the new terms. But he does not understand how it could have come to that. 'Never,' he says shaking his head, never did he believe 'that the firm would treat us so rotten'.

The 'firm' in this case is Donald Fites, the man who took over as chairman of the board in 1991 and was feted like almost no other by America's business community. For Fites showed how it was possible to put an end to union power once and for all. Caterpillar could, under its chief executive, prove something which is hard to imagine in most industrialized countries: strikes, even if they last for years and are backed up by nationwide campaigns and demonstrations, can no longer force higher wages. Indeed, for a corporation organized on a world scale, they offer a welcome opportunity to save on labour costs and to boost company profits, if the top management acts with sufficient determination.

Until the early 1980s that would have been unthinkable. Caterpillar was a classic US company producing everything from the nuts and bolts down to final assembly in its own works. Its branches around the world handled things in much the same way. But in 1981 the Japanese rival Komatsu began to roll up the US market with dumping prices. The extreme undervaluing of the yen, assiduously promoted by the Japanese central bank, made the export offensive immeasurably easier. Caterpillar sank into the red, and its executive carried out a radical overhaul of production. Managers began to buy considerably more individual parts and component groups from small suppliers, often specially created for the purpose. The workforce was usually young and cheap at these new firms, because many of

them had been set up in Southern states where the unions are hardly able to organize. At the same time, the Cat management integrated overseas factories into production planning and invested 1.8 billion dollars in automation of the original plants. The unions played along so that the company could eventually become profitable again. The UAW even agreed on special cooperation to raise productivity, and bowed to the closure of many factories. This also meant a change in the composition of the workforce. In 1979 approximately 100,000 people worked for the corporation, of which nearly a half were UAW members. Eight years later, Caterpillar employed only 65,000 Americans, only a quarter of whom were in the union. On the other hand, the management reported that it had higher profits and a greater share of the construction machinery market than ever before.

Now came Fites's hour. Wages in Japan and Mexico were lower than in Peoria, he explained to his people, so any new hiring could only be at below union rates. The workers would have to be content with what they had: there would no longer be increases in real wages. When the UAW called for a strike, Fites countered by threatening to replace all strikers with new manpower. In the USA, too, labour law bans dismissals during a strike, but not the hiring of strike-breakers. Unions used to be able to count on the fact that there was not enough skilled labour around to keep production going in such cases, but recession, rationalization and cheap imports from overseas had thrown up an army of unemployed skilled workers who were only too happy to be taken on. Moreover, automation had reduced the number of complex tasks to a minimum. The threat issued by the Cat boss had to be taken seriously.

The United Auto Workers therefore tried to cripple production through slowdowns and working to rule. When Fites summarily expelled all union officials from his workplaces, the outraged workers again went on strike, this time sure of victory because such dismissals were illegal and Fites had no right in this case to try to break the strike by bringing in labour from outside. Now Fites played his most daring card. He sent office staff, engineers, the whole middle and lower management, and above all the 5000 or so part-time workers, into the assembly halls. At the same time, he ordered as much as possible from foreign subsidiaries – and got results. While pickets stood month after month outside the factory storerooms, Caterpillar was actually increasing output and sales. When the strikers finally

gave in, Fites imposed on them terms and conditions that had not
been seen for decades. These require them to work twelve hours a
day when necessary, including at weekends, and with no extra pay.
Fites triumphantly announced that his reorganization during the
strike had uncovered huge productivity reserves. A further 2000 jobs
are due to go.[19]

The American model: return of the day labourer

Fites's war on his workforce was spectacular, but the same can hardly
be said of the results. What Caterpillar imposed in its brutal way,
most other big US companies have also pushed through with subtler
methods. After Japanese but also European rivals had forced their
way into the American market for high-value consumer goods such
as automobiles and electronic home entertainment, nothing was ever
the same in the US economy. To raise productivity and lower costs,
corporations knew only one strategy: rationalization and real wage
cuts. 'Downsizing', 'outsourcing' and 're-engineering' are the methods
that all American employees will soon be facing, if they are not
already. The results seem to justify the sacrifices. In autumn 1995,
ten years after the great setbacks, America was said by *Business Week*
to have 'the most productive economy in the world'.[20] The govern-
ment is gleeful too. In his re-election campaign in 1996, President
Clinton drummed out the message that the US economy was in
better shape than at any time in the last thirty years. He even pointed
to labour-market statistics showing that, at the final count, far more
jobs had been created than lost – nearly 10 million during his first
term in office, or 210,000 a month. The jobless rate, at 5.3 per cent,
was lower than in any other OECD country.[21]

Truly America is again in front, but its citizens must pay a painful
price for it. The wealthiest and most productive country in the world
has also changed into the largest low-wage economy. America's 'local
advantages' are no longer its huge internal market or its brilliant
scientists, but only its cheap manpower. Fierce competition has
presented more than half the population with the new American
nightmare: continuing decline. In 1995 four-fifths of all male em-
ployees and workers in the United States earned 11 per cent less an
hour in real terms than they did in 1973.[22] In other words, for the

great majority, living standards have been falling for the last two decades.

In the old days of the 'golden 1960s', John F. Kennedy summed up the expectation of rising prosperity in a simple formula: when the river rises, every boat on the water rises with it. But the wave of liberalization and deregulation during the Reagan era produced a type of economy to which this metaphor no longer applies. It is true that between 1973 and 1994 per capita GNP in the United States grew by a full third in real terms. At the same time, for the three-quarters of the working population that have no managerial or supervisory responsibility, average gross wages fell by 19 per cent – to just 258 dollars a week.[23] And that is only the statistical average. For the bottom third of the pyramid, the drop in pay was more dramatic still: these millions of the population now earn 25 per cent less than they did twenty years ago.

Taken as a whole, American society is far from being poorer; indeed, the income and wealth totals have never been as high as they are today. But the statistical growth has all been to the benefit of 20 million households, the top fifth, and even within this group the division of the gains has been extremely uneven. The richest 1 per cent of households has doubled its income since 1980, and the half-million super-rich now own a third of all private wealth. The sea-change in the US economy has evidently paid off for the top managers of large corporations. On average, their already high net income has risen by 66 per cent since 1979. By 1980 they were already getting some forty times more than their ordinary employees. Now the ratio is 120:1, while the highest earners such as Anthony O'Reilly, boss of the food giant Heinz, make more than 80 million dollars a year or just short of 40,000 dollars an hour.

Most of these top people are being paid to drive labour costs down by all possible means. Simplest has been the low-tech clothing, footwear, toys and electrical goods industries, where most manufacturing has already departed from 'God's own country'. Manufacturers have turned themselves into importers, who either buy in Asia or maintain their own production sites overseas. Nowadays world-market leaders, such as the Nike sports shoes corporation or the toys giant Mattel, keep hardly any factories under their own management. They simply allocate orders to changing producers, from Indonesia through Poland to Mexico or even the USA, according to where the costs are

lowest. Over the Mexican border alone, US companies employ nearly a million people at starvation wages of under 5 dollars a day, in the so-called *maquilladoras* where social expenditure on such things as pensions or sickness benefit is unheard of. At first it was unskilled assembly-line workers who were most affected, but in the 1980s, recalls Joseph White, economist at the politically neutral Brookings Institution, 'there was no union official who was not told round the bargaining table that his members' jobs would drift down to Mexico if he demanded too much'.

The truth is that Corporate America no longer wanted to have anything to do with the unions. In every sector, top managers worked out strategies that would prevent their employees' interests from being represented. The green light came from President Reagan himself in 1980, when all union members working for the state-run air traffic control were unceremoniously dismissed. Then the government and Congress watered down labour legislation in a number of ways, so that chief executives and managers were able to take more radical offensive action than at any time since the war. One may definitely conclude, writes Lester Thurow, economist at the Massachusetts Institute of Technology (MIT), that America's 'capitalists declared class war on their workers – and they have won it'.[24]

The removal of whole areas of administration and production was the main instrument in the hands of the corporate bosses. Employees such as wages clerks, computer maintenance workers or construction technicians, as well as tax clerks, found themselves being shown the door in large numbers. They were told that in future their work would be taken over by subcontractors. Not long after, many found themselves working for the same company, only now at incomparably lower rates of pay, without sickness or pension rights, and almost always banned from organizing a union at the workplace.

Another favourite model is the conversion of employees into self-employed workers. Millions of people who used to be on company payrolls now do the same work as before as computer experts, market researchers or customer advisers, but they are paid per item or per contract and the whole of the market risk falls on their shoulders. The number of part-time and casual workers has also been growing apace. As companies introduced just-in-time production to order, thereby removing the need for costly stocks, they also came up with the idea of the just-in-time worker, who in earlier times used to be

simply called the day-labourer. More than 5 million US citizens are forced into such insecure conditions of work, many in two or three firms at once. Both inside and outside the company, then, managers have at their disposal a cheap reserve capacity to which they can turn according to the situation prevailing on the market. America's largest private employer is not General Motors, AT&T or IBM, but the temporary agency Manpower.

The change has encompassed nearly the whole world of labour. Between 1979 and 1995, 43 million people lost their jobs.[25] The great majority soon found another one, but in two-thirds of cases with far lower earnings and with worse terms and conditions. Large firms shrank in size, and the work was divided up among many legally distinct units operating in a number of different places. As we have seen from the example of Caterpillar, the newly fragmented organization of work also eroded the basis for union organization. In 1980 more than 20 per cent of all employees and workers still belonged to a union, whereas today the figure is 10 per cent. The United Auto Workers alone lost more than half a million members.

The removal of state controls and other counterweights gradually established in the US economy a 'winner take all' principle that is now permeating the whole society.[26] A social contract long taken for granted used to mean that if things were going well for IBM, General Motors or any other company, it was also good for their employees. Now this contract has been scrapped without notice. In the early 1980s, according to William Dickens from the Brookings Institution, the biggest US companies shared some 70 per cent of their profit potential with their employees,[27] and on average they paid more than the labour-market rate for the job. It was also common for the more profitable parts of the firm to subsidize the less profitable; not every sector had to generate the maximum return, so long as the corporation as a whole was in the black. The deregulated finance economy, however, changed this social strength into a management weakness. Clever brokers from Wall Street investment banks soon uncovered these 'inefficiencies' and opened up the speculators' El Dorado of the 1980s. Loan-backed hostile takeovers made it possible to strip and then sell off selected assets of such companies, shorn of all dispensable or 'overpaid' labour. This job-killer strategy became Hollywood-famous around the world with the film *Wall Street*, in which Gordon Gekko breaks up an airline company at the expense of the workforce.

To avoid such corporate raiding, most chief executives themselves became agents of restructuring. No one was spared. At IBM, for instance, chauffeurs of company vehicles were made self-employed, and personal secretaries had their pay cut in half. The staff of more than one IBM division received the alternative that the 14,000 employees of IBM France were faced with at Christmas 1994: either wage cuts or 2000 redundancies. (In that case, they agreed to give up a tenth of their earnings.) Between 1991 and 1995, IBM was thus able to push 122,000 people out of their job and to reduce total wage costs by a third. At the same time, the management board rewarded its five directors in charge of 'downsizing' with non-pay-related bonuses of 5.8 million dollars each.[28] The clear message, at IBM as everywhere else, was that 'shareholder value' was the only yardstick of corporate success; indeed, the IBM share price and dividend beat all previous records in the autumn of 1995. This logic explains why the staff at firms which make a regular profit must also be prepared for the worst.

The fear of difference

More and more firms, then, turn on its head the principle enunciated by Henry Ford that once gave American capitalism its vitality and helped it triumph around the world. In 1914, when the arch-capitalist doubled his workers' wage to 5 dollars a day, the *Wall Street Journal* castigated the move as an 'economic crime'. Yet Ford had merely revealed what would later become the logic of growth at the level of the national economy. If his cars were to be available to all as consumer goods, then potential customers had to earn enough to be able to buy them. He therefore paid his workers in three months the equivalent of the price of a Model-T Ford. Today many workers at the big auto corporations no longer achieve this ratio, especially if they are employed in Mexico, South-East Asia or the US South. Open-border trade and union defeats have 'overcome all restrictions', complained Robert Reich, the renowned economist and then Clinton's labour secretary. Now that companies sell worldwide, 'their survival no longer depends on the purchasing power of American workers', who are more and more becoming a 'frightened class'.[29]

Furthermore, MIT economist Lester Thurow thinks that the government's jobless figures in the USA are at best misleading, or

little more than propaganda. To the 7 million officially seeking work
in 1995 (a figure based merely on replies to questionnaires) should be
added a further 6 million who really need work but who have given
up looking. There are also some 4.5 million employees who, without
wishing it, are forced to work part-time. Combining just these three
groups, we already find that 14 per cent of the work-fit population
does not have regular employment. The ranks of this army swell to
28 per cent if people who work only periodically are included: the
10.1 million temps and on-call workers, as well as the 8.3 million self-
employed, often with a university education, who seldom have
sufficient work.[30] The distribution of income is in keeping with this
picture. According to the United Nations International Labour Office,
just under a fifth of all employees work at wages beneath the official
poverty level – the 'working poor', long established as a category in
American sociology. At the same time, US employees must today
work harder on average than their counterparts in other OECD
countries; they enjoy the least social protection, and they have to
change their job and home most frequently.

The American 'jobs miracle' so celebrated by European economists
is thus a curse for those affected by it. 'A lower jobless rate means
little', writes the pro-Wall Street *New York Times*, 'if a 15-dollars-an-
hour factory worker is fired and earns only half of that in his next
job.' *Newsweek*, for its part, talked of America's new competitiveness
under the title 'killer capitalism'. But a highly skewed distribution of
wealth is by no means a historical novelty for America, and it was
ultimately the quest for economic freedom that first led to the founda-
tion of the United States. Americans have never begrudged successful
businessmen their wealth, but something always used to be left over
for the rest. Before 1970 there was no long period in US history when
a large majority of the population had to soak up only losses, while
a minority increased its assets and income several times over.

The decline has huge consequences for every area of life in
American society, and it poses an increasing threat to political
stability. More and more Americans, even from the rich white elite,
therefore think that a wrong turn has been made. For instance,
Edward Luttwak – an economist at the Center for Strategic and
International Studies, one of Washington's conservative think-tanks
– has changed from a cold warrior into the sharpest critic of neo-
liberalism. 'Turbo-capitalism', as he calls it, is in his view 'a bad

joke. What Marxists argued a hundred years ago and was then absolutely wrong, is today a reality. The capitalists are becoming richer and richer, while the working class is being impoverished.' Global competition is putting 'people through the mill' and destroying the cohesiveness of society.[31]

It is not only dissident intellectuals such as Thurow, Reich and Luttwak who have been changing their views. People practically involved in economic and political life also visibly doubt the orthodox wisdom and wonder whether politics has not already withdrawn too much from the economy. Republican senator Conni Mack, for example, helped to introduce a lot of new legislation in his capacity as chairman of the Senate committee on the economy, but in the spring of 1996 he recognized that 'hard-working Americans are rightly full of scepticism'; 'they feel that something is rotten'.[32] And Alan Greenspan who, as head of the Federal Reserve, always condemned any redistributive elements in government policy, warned a congressional hearing that growing inequality had become a major threat to American society.[33] One spectacular about-face has been that of Stephen Roach, chief economist at Morgan Stanley, New York's fourth-largest investment bank. For nearly a decade Roach's books and studies had made a name for him as a management strategist. In chat shows, at universities, before Congress and at exclusive management seminars, he consistently advocated a shake-out of labour and a much simpler model of corporate organization. But on Thursday, 16 May 1996, all the corporate customers of his bank received a letter in which he publicly recanted as only Catholic reformers have done in the past. For years he had extolled 'productivity growth' as the 'new mantra for US businesses'. But now, he wrote: 'I must confess that I am having second thoughts as to whether we have reached the promised land.' The new US economy was based on something like 'slash-and-burn restructuring strategies', which destroy for short-term gain the soil on which people depend for a living. The strategy of downsizing and lean management was part of this pattern. If America's corporate leaders did not soon change course and build up manpower instead of de-skilling it, the country would lack the resources to keep up on the world market. 'Labour', he concluded, 'cannot be squeezed for ever. Tactics of open-ended downsizing and real wage compression are ultimately recipes for industrial extinction.'[34]

How to change from cutting to rebuilding? Critics such as Roach, Mack and Reich have little more to offer on this score than an appeal to top managers to consider the long-term social effects of what they are doing. But the genie is already out of the bottle. 'The sad truth is', commented the *Financial Times* on Roach's new initiative, 'that for shareholders and managers downsizing does pay off. Wall Street now simply prefers a dollar saved in costs to an extra dollar earned.' Shareholders clearly demonstrated this on the New York Stock Exchange, the very day after the circular from the Morgan Stanley economist. The management of the food corporation Con-Agra announced that in the current year it would lay off 6500 employees and close down twenty-nine of its factories. This news alone pushed the price of ConAgra shares so high that the company's stock-market value climbed by 500 million dollars in twenty-four hours.[35] The rapid feedback between the money market and top managers tempted by share options pushed ever onward the race for greater efficiency and cheaper labour. But even if the pursuit of short-term profit in the USA could be prevented from dictating the course of events – either through legislation or through the conversion of domestic investors of capital – it would still hardly be possible to reverse the loss of wages and purchasing power by American working people. For while the American elite has been rousing itself and pondering the alternatives, the transnationals have long since started the same race in other industrialized countries of the OECD. Europe and the advanced countries of Asia now seem to be inexorably following in the wake of the American Way of Capitalism, and the spiral keeps twisting downward for jobs and wages. Often this process is only indirectly triggered by actual competition on the commodity markets. The mechanism of the transnational network brings quicker results.

'What is still German at Hoechst?'

The auto industry clearly illustrates the breathtaking pace of global integration. The downsizing and 'lean production' of the 1980s was just the beginning. It shifted a still-growing part of production to outside suppliers of complete modules, such as axles, air-conditioning systems or dashboards. Thus, the newest American auto factories account for only a third of production; the rest is done by suppliers

who themselves have constantly to rationalize under the price pressure imposed by their customers. This latest dimension of the productivity drive has in turn launched the reductive integration of labour across all frontiers, not only those of states but also those of companies.

The only German cars fully manufactured in Germany nowadays are in the luxury bracket. The new Volkswagen Polo, though assembled in Wolfsburg, is more than half-made abroad. The list of supplier countries stretches from the Czech Republic through Italy, Spain and France to Mexico and the United States.[36] Toyota already produces more overseas than in Japan, and the American auto industry would collapse if it had to go without supplies from Japanese producers.[37] But even the replacement of 'Made in Germany' with 'Made by Mercedes' gives a misleading picture. For all the competition, designers have everywhere realized that they can save a lot of money if individual components are produced by companies working together. Instead of 100 different dynamos, German cars of whatever make now have only a dozen kinds of mini-generator. Nor do the integration and simplification stop there: Volvo uses Audi diesel engines produced in Hungary; Mercedes buys the six-cylinder engine for its new Viano minivan from Volkswagen; and even the noble Rolls-Royce packs BMW machinery beneath its traditional chassis.

At the same time, the big corporations are constantly forming alliances, joint ventures and mergers that maximize the efficiency gains. Volkswagen together with Audi swallowed up Spain's Seat corporation and the East European market-leader Skoda. BMW bought Britain's largest car manufacturer, Rover, and Ford took control of Mazda, Japan's fourth-largest. South of Lisbon, a factory run by both Ford and Volkswagen produces limousines that are simply sold under two different names. Ford calls it the Galaxy, and VW sells it as the Sharan. Fiat and Peugeot have the same practice. Chrysler has small cars built by Mitsubishi in Thailand which are then sold with an American brand name in the USA, while in the Netherlands they are jointly manufactured by Mitsubishi and Volvo.

The auto industry is thus spinning a worldwide web of its own, whose range and flexibility are worthy of its products. The actual producers are just another factor, pieces without rights that can be pushed to the sidelines at any moment. Between 1991 and 1995, more than 300,000 jobs were lost in the German auto sector alone,

while the annual output of vehicles remained roughly the same. There is no end in sight. 'We are planning to raise efficiency by six to seven per cent per annum between now and the year 2000,' reports Ford's European chief Albert Caspers. 'Today we still need 25 hours to make an Escort. By 2000 this should be down to 17.5 hours.' More cars, less labour, is also the watchword at Volkswagen. In just the next four years productivity is expected to rise by 30 per cent, according to the head of finance Bruno Adelt, with a shedding of 7000 to 8000 jobs each year. Over the same period, the VW board announced to shareholders, the yield on turnover will increase fivefold.[38]

The job losses due to transnational integration are alarming enough. Even more serious, however, is the fact that the old counter-strategies of national social and economic policy are having the ground removed from beneath them. Until the 1990s, the world's leading economies followed different growth paths. Japan cultivated the principle of lifetime employment, and victims of adaptation were spread around equally. Collective security came before a high return on capital, not only in the social scale of values but also in corporate practice. In France, technocrats conducted a national industrial policy with often remarkable results, so that the country climbed to a higher position in the world economy without a lowering of general living standards. Germany glistened with its highly developed educational system and its close cooperation between capital and labour. High standards of technology and labour, as well as a positive social climate, made up for the losses in less demanding sectors.

Today, all this no longer seems to count for much. Suddenly Japanese chief executives are becoming addicted to lean management and outsourcing, as if they were clones of their American counter-parts. Where layoffs are still frowned upon, the staff have their wages cut, are demoted to worse-paid jobs, or are moved to smaller branches and condemned to makeshift posts where they themselves hand in their notice. Straightforward dismissals – known in samurai-speak as 'beheadings' – are no longer socially taboo, however. At first it was only contract workers, unmarried women and young assistants who were affected, but now not even long-serving middle managers are exempt. Whole factories and administrative centres are brought to a standstill. 'Previously we used to share the misfortune around and relied on the government,' says Jiro Ushito, head of an

electronics firm. 'In future only the rules of the market will apply.'[39] The government still tries to cover up the consequences. Officially no more than 3.4 per cent of the active population is registered as unemployed, but the figure is plainly a lie. Anyone who looks for work for longer than six months simply drops off the record. An internal study conducted by the Economics Ministry shows that, if US registration methods (themselves not exactly accurate) had been used, the figure would already have been 8.9 per cent by 1994.[40] Today, critics estimate, one in every ten Japanese of working age is looking for a job. The government, once guardian of social stability, is itself driving the process onward. Deregulation and liberalization of trade are flattening whole branches, and only a fraction is left of the old trade surpluses. Tadashi Sekizawa, chief executive of Fujitsu, offers the simple explanation that the Japanese system 'moved too far from the international average' and that now things have to change.

The same argument is catching hold on the other side of the planet. France's big corporations have been laying off staff for the past five years. The high jobless figures, over 12 per cent, are not the only worry; 45 per cent of the gainfully employed have to make do with temporary contracts offering no protection against redundancy. In 1994, 70 per cent of new recruits were appointed on a temporary basis.[41] The unions are losing members, influence and, above all, prospects as the transnational market undermines their power base. The process affects nearly every EU country with the exception of Britain, where already in the Thatcher years government and employers worked together to drive wages and working conditions down to the level at which Portugal is today.

The systemic change is sharpest of all in wealthy Germany. Powerful evidence of this comes from the boards of the most profitable branch of German industry, the chemicals branch. Here the three giants – Hoechst, Bayer and BASF – reported in 1995 the highest profits in their history. Yet simultaneously they carried out further downsizing in Germany, having already axed 150,000 jobs in preceding years. 'We know people think that is contradictory,' admitted Bayer chief Manfred Schneider, but the high corporate profits should not hide the fact that 'Bayer is under pressure in Germany'.[42]

These two short sentences make it quite clear how Schneider sees things. Bayer, just like its rivals, is a German company only for

traditional reasons and because its headquarters are located there. On average, these scions of IG-Farben already do 80 per cent of their business abroad; only a third of their staff works in Germany. 'What is still German at Hoechst?' asks Jürgen Dormann, top manager of the Frankfurt-based chemicals giant. 'Our biggest single market is the United States, our Kuwaiti shareholder holds more shares than all our German ones put together, and our research area is international.' What does not function is the German limited company, because no money is earned there. That may be putting it too strongly, but it would seem to be true in comparison with the American or Asian divisions of the company. In the same breath, however, Dormann states that Hoechst naturally has a 'social mission' in Germany, 'because we see ourselves [also] as German citizens'. It's just that 'patriotism has been a little overdone' up to now.[43]

A high-flying manager in a globally organized business cannot afford the luxury of social responsibility – that is not only Dormann's problem. According to Article 14 of the German Constitution, 'property entails an obligation' and 'should serve the general welfare', but this too strikes most of his colleagues as no longer achievable. As it used to be the case only in the USA, managers organize their company by 'centres of profit' that either achieve maximum returns or are wound down. Hoechst is gradually divesting itself of the old chemicals business, and Bayer's Agfa group is facing a rehabilitation plan because its profits are only 3 per cent of turnover. The old concept of Deutschland Ltd is therefore breaking down, and a new, quite different corporate culture is taking over. In many big German companies, 'shareholder value' is now the magic formula of the hour – which, in the end, simply means the old idea of profit maximization to the benefit of the shareholders. The same goal lay behind the merger agreed in May 1996 between the pharmaceuticals giants Ciba-Geigy and Sandoz, which fills many Swiss with a sense of outrage because it threatens to bring mass redundancies. Even the Archbishop of Vienna, Christoph Schönborn, who taught for many years at the University of Fribourg, became involved in the debate. 'If two of the world's largest chemical corporations merge and create 15,000 job losses,' he said, 'even though both are in the best of shape, that is not a necessity decreed by the almighty God of the "free market" but is due to a few people's greed for dividends.'[44]

Shareholder value: the end of Deutschland Ltd

Adaptation to the American principle is not, however, just an evil capitalist caprice. The pressure on firms and their top managers comes from the transnational money market, the real power centre of globalization. The open-border trade in stocks and shares is a more powerful solvent of national ties than the networking of production. A third of Daimler-Benz shares, for example, are already in foreign hands. Forty-three per cent of the shares of its own main shareholder, Deutsche Bank, are held by foreign investors. Bayer, Hoechst, Mannesmann and many others are under majority foreign ownership. Most of these investors, moreover, are neither small shareholders nor banks and corporations that could become closely involved in the affairs of German industry. Those who have really bought into Germany are investment, insurance and pension funds from the United States and Great Britain. Their managements, trying hard to squeeze as much from these overseas commitments as they did from domestic portfolios, are quite intransigent in the demands they make on companies. 'The pressure of foreign shareholders on German companies is growing,' Bayer's finance chief Helmut Loehr says quite frankly.[45] Especially feared in the recent period have been emissaries from the Californian public employees' pension fund, which controls the investment of more than 100 billion dollars. Managers of the Californian Retirement System (Calpers), who already force their profit expectations on such mighty companies as General Motors and American Express, have increased their foreign investments to 20 per cent because 'the inefficiencies are now greater on international markets than on the domestic market,' explains Calpers strategist José Arau. For such controllers of world capital flows, the inefficient companies are those which have sections producing a return of less than 10 per cent on investment capital, which is entirely normal outside the United States. Especially in Japan, France and Germany, Arau and his team are now systematically bearing down upon uncooperative managers of big limited companies, 'in order to make these foreign companies aware of the shareholders' interests', explains one of the fund's consultants.[46]

Partly in response to such challenges, partly in anticipation of them, more and more 'hard hearts' are taking over the boss's chair in Germany, observes Frank Teichmüller, North German president

of the IG-Metall trade union. Ruthlessness in ordering layoffs and toughness in dealing with unions are what get them further in their career. Take Jürgen Schrempp, for example, who took over at Daimler-Benz in May 1995. Partly responsible himself for losses of almost 6 billion marks in the previous year, he now closed down the AEG division and the aircraft manufacturer Fokker and announced that the company would put 56,000 staff members on the street within the next three years. The cuts sent Daimler shares soaring by nearly 20 per cent, so that although shareholders had to forgo their annual dividend, they came out of it nearly 10 billion marks better off. The same man who was seen by his staff as a failure was feted by the *Wall Street Journal* and *Business Week* as a revolutionary who was breaking up Germany's cosy employer–employee relations and reorganizing the company around shareholder interests. Subsequently Schrempp (annual earnings: 2.7 million marks) got shareholders' representatives on the board to allocate to him, and to 170 other executives, share options that should appreciate enough to bring them in a further income of 300,000 marks each.

Many are the businessmen elsewhere who do exactly what the Daimler boss did by playing on stock-market prices. For years it was only exceptional cases such as the discontinuation of wage agreements at IBM or the splitting off of parts of Siemens which made the headlines, but since the spring of 1996 the whole German system of partnership between capital and labour has been falling apart. Almost overnight, trade unionists discovered that they were no longer fighting for an extra 1 or 2 per cent on their members' wages but for the very survival of the unions. One company after another is finding ways to get around existing wage agreements, or is simply pulling out of the employers' association. Agreements being negotiated between medium-sized companies and their works councils make trade unionists' blood run cold. The method of choice is nearly always straightforward blackmail. At the Viessmann boiler-makers in Kassel, for example, which is highly efficient with an annual turnover of 1.7 billion marks for a workforce of 6500, it was enough for management to announce that the next gas water-heater models would be produced in the Czech Republic. Thereupon 96 per cent of the workforce agreed without demur that they would rather work an extra three unpaid hours a week than risk the closure of a plant in Germany.[47] In Lübeck, too, the 'modernization' of the medical

equipment producer Dräger went ahead almost without a murmur. Yet hundreds of employees there – from packers and drivers to computer personnel and instructors – suddenly found themselves coming together again in an independent subsidiary where the old wage agreements no longer applied. For longer working hours, they now earn 6–7000 thousand marks a year less.[48]

While wages are being driven down in Germany and even in Sweden, the same methods ensure that they never rise in the first place in low-wage economies. Workers at Volkswagen's Czech subsidiary Skoda, for example, calculate that their productivity has gone up by 30 per cent since the takeover by the Wolfsburg auto giant, but their wages have hardly increased at all. 'If it goes on like this, even in fifty years we won't have the same terms and conditions as in Germany,' said the spokesman of the Skoda works council, Zdenek Kadleć, angrily. But Volkswagen boss Ferdinand Piëch calmly blocked wage demands presented by his Czech workforce. Skoda, he warned, must not lose its comparative local advantage, otherwise 'we would certainly have to consider whether production in somewhere like Mexico would not be more profitable'.[49]

Trade unionists nearly always try to oppose such attempts at coercion, but nearly always they lose the battle, because 'the employers manage to play workforces and production sites off against each other,' as IG-Metall chairman Klaus Zwickel complains.[50] Many officials, including Zwickel's deputy Walter Riester, still talk themselves into believing that legally enshrined workers' representation on company boards, as well as the existence of only one union federation, make it possible 'to avoid the disastrous development' that led to the defeat of America's unions.[51] Ordinary members speak a different language; they know from experience that union membership, while costing money, gives no protection in a crisis and can even harm their career. This realization, but above all actual redundancies and the splitting up of companies, has reduced the membership of the German trade union federation, the DGB, by a fifth since 1991. IG-Metall alone has lost 755,000 dues-paying members. It is true that more than half the haemorrhage is due to the collapse of East German industry, but even in the West there were just under a million fewer on the union books. In the end, blackmail can work in a case like that of Viessmann because only 10 per cent or so of the company's workforce are organized.

Since the beginning of 1996, German employers' associations have used the weakness of their erstwhile 'social partners' to launch one major offensive after another. Encouraged by the government in Bonn, the president of the Federal Association of German Industry, Olaf Henkel, called for the general agreement on conditions of employment to be terminated in every branch, so that the percentage of wages paid in case of sickness could be lowered. A month later Werner Stumpfe, president of the Metal Employers' Association, made the first attempt to curtail the right to strike. His association will in future negotiate across enterprises only in matters relating to wage percentages and the length of the working year. Everything else – length of the working week, holiday pay, sickness benefit, and so on – is supposed to come under the responsibility of works councils. His aim is to strip unions of the right to organize industrial action on such issues, because 'strikes are no longer in keeping with the times' and affected companies 'would lose their share of the market'. Stumpfe is obviously not aware that his proposal is directed against a basic constitutional right.

Henkel, Stumpfe and their colleagues have also refused to accept the introduction of a minimum wage in the building and construction trade, even though the relevant employers and unions have jointly called for one. Given the right to free collective bargaining in Germany, federal legislation on a minimum wage can come into force only with the consent of the employers. And so, by withholding this, the company representatives have accepted that the German construction industry should face its worst spate of bankruptcies since the war, unable to counter wage-dumping on the part of foreign suppliers. Up to 6000 German construction firms will go to the wall and 300,000 jobs will be lost, according to the Central Association of the German Construction Trade.[52]

Deregulation: method in the madness

Fund managers and company chairmen are obviously not the only ones pushing jobs and wages onto a downward path; the third group of actors comprises the various national governments. In the OECD countries, most ministers and ruling parties continue to believe that once state intervention is whittled down sufficiently, prosperity and new jobs will follow. In the name of this programme, from Tokyo via

Washington to Paris, all state-run national monopolies or oligopolies are being razed to the ground. Competition means everything, jobs are nothing. But as they privatize the mail and telephones, electricity and water, air travel and the railways, as they liberalize international trade in these services and deregulate everything from technology to labour protection, governments are intensifying the very crisis that they were elected to tackle.

In the USA and Britain, this contradiction has long been plainly visible. The classical model was the deregulation of American air transport. For reasons of safety and control, a state-organized cartel allocated routes in the 1970s to individual companies, with competition being the exception rather than the rule. Airlines made sufficient profits and usually offered their staff lifetime employment, but prices did remain relatively high. Those who had more time and less money travelled by bus or rail. Then the Reagan administration turned everything upside down. Prices came crashing down, but so did numerous companies. Both the air travel and the aircraft industry became highly unstable; the result was mass redundancies, hostile takeovers and asset-stripping, as well as chaotic conditions in the airports. Finally, no more than six major airlines were left. With fewer staff than twenty years ago, they sell more flights than ever before, and flying has never been so cheap. Only the good jobs are lost for ever.

This concept found enthusiastic support in the 1980s among the managerial elite of Western Europe, but nowhere except in Britain was there a political majority behind it. It was thus the EU Commission in Brussels which became the true order of radical marketeers, and its officials crafted most of the European legislation in close collaboration with consultancies and lobbies dependent upon private industry.[53] With virtually no public debate, the privatization and deregulation of all state-run sectors became the one solid component of the great single-market plan. The former European commissioner Peter Schmidhuber logically described it as 'the greatest deregulation project in the history of economics'. 'Europe 1992' began by unleashing a huge wave of concentration in the private sector, which cost at least 5 million jobs. In a second phase, the countries of the EU now have to free up state-protected sectors and monopolies, with further job cuts built into the programme.

As in the United States, air travel was the first in line. When the

EU lifted controls on all cross-border flights in 1990, prices began falling and with them the fortunes of all state airlines. (The only exceptions were British Airways and Lufthansa, but in fact they had both already been privatized.) The smaller West European airlines – including Alitalia, Austrian Airlines, Iberia, Sabena and Swissair – were hardly competitive under the new conditions. Amid constant battles with the workforce, one rehabilitation plan followed another, usually with the help of millions in government cash injections, but there is still no prospect of success and so far a total of 43,000 jobs have been lost.[54] From April 1997, airlines will also be allowed to offer flights within any single EU member-state: British Airways, for example, will be able to fly between Hamburg and Munich. In anticipation of this new efficiency drive, a second great wave of redundancies is already rolling through the industry. Lufthansa alone is seeking to save 1.5 billion marks in wage costs over a five-year period. And along with an unspecified number of layoffs, the airline boss Jürgen Weber announced a pay freeze, longer working hours and shorter holiday entitlement.[55] Only four or five 'mega-carriers' (to use the industry jargon) are likely to remain by the end of the battle for market share over the skies of Europe.

 This state-inspired job-killing is itself a politically confused programme in conditions of raging unemployment, but the wider plan makes what has been done to air transport appear a minor laboratory experiment. From the beginning of 1998 the whole of the EU's internal trade in telecommunications will be decontrolled, bringing a new El Dorado for investors and well-capitalized corporations.[56] From Helsinki to Lisbon the former state monopolies must be 'made fit' for competition, while private international consortia prepare to storm a market worth billions whose double-digit growth rates and possible annual profits up to 40 per cent are enough to justify any outlay. What this means in the end can be seen from a comparison between Deutsche Telekom and America's AT&T. In the trading year 1995 the US market leader notched up profits of 5.49 billion dollars, with a staff of only 77,000. Deutsche Telekom, with almost the same annual turnover of 47 billion dollars, had 210,000 employees on its payroll and declared profits equivalent to only 3.5 billion dollars.[57] By 1998, agreed the former Sony manager and present Telekom boss Ron Sommer, 60,000 members of staff will be laid off with the help of redundancy payments and early retirement. To

keep the company competitive, however, some 100,000 employees will have to go by the year 2000, a shake-out with no precedent in postwar Germany.[58] At best a fraction of these jobs will reappear in the rival consortia being formed around the electricity corporations VEBA and RWE (partnered with AT&T and British Telecom), for these newcomers can count on their own telephone networks alongside power routes and on the considerable staff reserves which they are at present profitably regrouping. Furthermore, the legislature assured them that they could use the Telekom distribution network on favourable terms and initially concentrate on the ultra-lucrative conurbations that require less labour to supply.

The governmental men of action, however, no longer want to be the ones who actually increase unemployment. In November 1996 the federal government announced that it would sell off Deutsche Telekom in several tranches on all the world's major stock exchanges. Any residue will be taken care of by the hunters for shareholder value in the big mutual funds. The same drama is repeating itself all over Europe, inexorably pushing still higher the EU's jobless figures. And while the telecom businesses are still arming against future rivals, politicians are setting in motion the next round of liberalization.

In the spring of 1996 the US Congress decided to lift controls on the American telephone market, allowing the three national suppliers, AT&T, MCI and Sprint, to compete at every level with the seven previous regional monopolies. Two of these regional companies promptly merged and unleashed a wave of redundancies, while AT&T announced that a further 40,000 jobs would be axed. British Telecom, for its part, intends to take another big step towards a job-free profit machine. Since it began to be privatized in 1984, nearly 50 per cent of its staff – representing 113,000 jobs – have been shown the door. By the year 2000 they will have been joined by a further 36,000. Britons and Americans, then, are prepared for the total worldwide competition for which politicians have been busily clearing the way. At the Geneva headquarters of the World Trade Organization, government delegations have been negotiating since autumn 1995 over the details of a world free-trade agreement in telecommunications. If it actually comes into force – and the corporate lobbies are fighting their corner hard – there will be only four or five giants left in the world, predicts Professor Eli Noam of New York's Columbia University.[59]

For the true market-believers in Washington, Brussels and most European capitals, telecom deregulation is by no means the end of the story. If the EU Commission has its way, the postal services with their 1.8 million employees will join in by the year 2001. The electricity monopolies are also due to go. After the British, the German federal government also wants to push this through as a solo effort, as do a number of American states.

If European politicians are serious in regularly declaring that unemployment is their greatest concern, then their actions can only be described as methodical madness. Well may one doubt whether they still know what they are doing. On 1 January 1996, for example, Ron Sommer restructured Deutsche Telekom's scale of charges: trunk calls became cheaper, local ones more expensive. That makes sense in terms of making the company more competitive and its shares more attractive. In the newly competitive environment, there is no longer any reason why frequent business use of long-distance should subsidize mainly individual conversations in the locality – indeed, the first aim is to woo corporate clients with low prices for calls around the country and abroad. Hardly had the new charges come into operation when the popular press and politicians jointly staged a display of public anger against the evil Telekom, which was seen as making lonely telephone-dependent grandmothers pay for discounts to fat-cat businessmen. Led by CSU Post Minister Wolfgang Bötsch, the same politicians from every parliamentary party who had approved the new charges now demanded a special price for calls to friends and relatives. Sommer could do nothing more than complain that such populism was 'outrageous'.[60]

The political carnival of indignation and hypocrisy was not only absurd, it also showed that most people in government can no longer see the consequences of the globalization policy upon which their laws are based. 'The decision to liberalize certain branches where public services have been on offer is not at all an ideological decision; it expresses a *natural* readiness for adaptation to economic and technological developments,' insists Karel van Miert, the current EU commissioner on issues relating to competition.[61] His very choice of words, however, betrays the ideology that can always be detected when politicians invoke nature as they divide out public property, tax receipts and economic benefits. Lobbyists such as Dirk Hudig, who represents the interests of British industrial corporations in Brussels,

speaks a plainer language. The princely sums paid for public services in Europe are, in his view, a result of the inefficiencies of state corporations that serve their employees more than their customers; the productive part of society can no longer carry this burden on its shoulders.[62]

Sounds logical. Higher costs for telephone, transport, electricity or business travel are a competitive disadvantage for the European economy. Individual consumers also pay excessive prices to the monopolies and have endless trouble with the often poor quality of service. No doubt the majority of companies in question operate below optimum efficiency, and yet they offer job security on a wide scale in times of crisis. If millions of citizens are marginalized or have to fear for their jobs and their future, then deregulation becomes a mad political race. Most governments stick to it because their experts firmly believe in neo-liberalism and promise that lower costs for hi-tech and service sectors will help to create new and better jobs.

But the miracle never happens. It will be no different with the long-awaited successes of the privatized communications industry. The multi-media boom predicted to result from cheap access to information superhighways will first and foremost be another job-killer programme. The more customers are able to make online travel bookings, banking operations and all manner of purchases, the fewer jobs there will be in banks and insurance companies, travel agencies and the retail trade. Nor is there any sign that the job losses will be anywhere near compensated by work on the programs and computers that are organizing the world of the future. In the few employment-intensive branches of the coming multi-media industry – in films and entertainment, for example – Germany and Europe will have only a weak global position; such is the conclusion drawn by the Roland Berger business consultancy, a subsidiary of Deutsche Bank. Policies that revolve around entry into the computer age do not therefore hold out any great promise.[63]

Deregulation is carrying efficiency mania to self-destructive lengths. Nevertheless, most experts at the leading institutions of the world economy – whether the OECD, the World Bank or the IMF – continue to urge worldwide integration. Their optimistic assertions may be challenged by the problems now coming to a head in the highly developed countries, but they are still unanimous in claiming

that the open-borders market shows the Third World a way out of poverty and underdevelopment. 'For many developing countries, globalization improves the chances of closing the gap with the industrialized economies,' write, for example, Erich Gundlach and Peter Nunnenkamp of the Kiel World Economy Institute, the neo-liberals' academic stronghold in Germany.[64] For its part, the *Frankfurter Allgemeine Zeitung* – the newspaper spearheading capital's freedom struggle – argues that 'only through globalization will the world's 6000 million citizens share in the fruits in which only 600 million people from the old industrial heartlands participated well into the eighties'. It is a strong argument, but is it correct? Are the poor of the South really the ones benefiting from the North's welfare losses?

5. Comforting lies. The myth of locational factors and the fairness of globalization

He sits there silent, hands folded between knees, lips pressed tightly together. Never did Jesús González imagine that he would end up here. For years he slaved his way up to become an electrician and eventually found a sought-after job in Mexico's flourishing motor-vehicle industry, with a regular salary and apparent security. Shock absorbers for Mexican motor-cycles and tractors were assembled in his factory; it looked as if nothing could go wrong. But suddenly everything collapsed: first the currency, then trade, and finally the national economy. His firm went bankrupt. Now the thirty-year-old father of a family spends his days on the pavement of the noisy Avenida San José in the centre of Mexico City. He sits on an empty metal crate and advertises himself as an *electricista* in scrawled writing on a sheet of cardboard. He hopes some casual work will come his way, but he no longer looks forward to better times. The crisis, he says, 'will last much longer than we thought'.

In Mexico in 1996 the case of Jesús González is quite normal. Every second Mexican of working age is either jobless or under-employed as a day labourer in the parallel economy. Per capita output has been declining for the last year and a half. Political unrest, strikes and peasant uprisings send shock waves through the country. This is not at all what the government and its US advisers had planned. For ten years, three successive presidents obediently carried out the prescriptions of the World Bank, the International Monetary Fund and the United States government. They privatized most of state industry, removed obstacles for foreign investors, abolished import duties, and opened up the country to the international finance system. In 1993 Mexico even concluded the North American Free Trade Agreement (NAFTA) with the United States and Canada, which

envisaged the country's full integration into the North American market within ten years. The international community of neo-liberals had found a model pupil, and the venerable club of wealthy nations seemed to recognize this when it welcomed Mexico into the OECD in 1994.

Early on, the whole thing actually seemed to be working. Numerous transnational corporations opened or expanded production sites in Mexico. Exports rose annually by 6 per cent, and the public foreign debt that brought the country to the point of collapse in 1982 began to decline. For the first time, Mexico also experienced the growth of a small middle class which had money to spend, founded new companies and paid its taxes. But it was still only a tiny part of the economy and of the population that really profited from the miracle. The new, dynamic growth industries in the chemicals, electronics and automobile branches were highly import-dependent and offered relatively few new jobs. Older large industry was transferred from the public sector into the hands of a few big shareholders. A mere twenty-five holding companies controlled a corporate empire that produced half of Mexico's GNP.[1] At the same time, however, the rapid opening up to the United States exposed major sections of the economy to outside competition. A flood of imports overwhelmed the country, and labour-intensive, medium-sized companies were brought to their knees. Fifty per cent of businesses had to close down in mechanical engineering, as well as in the previously stable textile branch. Real economic growth fell below the rate of increase of the population. The forced capitalization of agriculture, which was supposed to boost exports and to help in defying giant American competitors, had disastrous consequences in practice. Several million farm labourers lost their jobs to machines and fled into the already overflowing cities. From 1988 imports grew four times faster than exports, piling up a trade deficit that was as high in 1994 as that of all other Latin American countries combined.[2] By then Mexico's growth strategists had no way of turning back. To humour voters and to keep imports cheap, the government made its own currency more expensive by means of high interest rates. Not only did this stall the domestic economy, it also drew into the country more than 50 billion dollars in short-term investment from North American funds. In December 1994 the inevitable finally happened: the pumped-up boom collapsed and the peso was devalued. Fearing the

anger of US investors as well as a worldwide crash, Washington's Treasury Secretary Rubin and IMF boss Camdessus fixed up the largest emergency loan of all time (see Chapter 3). This certainly saved the foreign investors, but it also plunged Mexico into an economic catastrophe. To regain the confidence of international markets, President Ernesto Zedillo ordered a further round of shock treatment. Real interest rates above 20 per cent and drastic cuts in public expenditure set off the worst recession for sixty years. Within a few months 15,000 companies went to the wall, some 3 million people lost their jobs, and the purchasing power of the population sank by at least a third.[3]

After a decade of neo-liberal reforms, the 100-million nation south of the Rio Grande is worse off than before. The state is destabilized by the most varied protest movements, from the Zapatista peasant guerrilla warfare in the south to the million or so organized middle-class people who cannot pay the sky-high interest on their loans. Social scientist Anne Huffschmid, who knows Mexico well, insists that it is truly a country on the threshold – the threshold not of wealth but of 'ungovernability and civil war'.[4]

The balance sheet of the NAFTA adventure is therefore also negative for the mighty neighbour to the north. When US assembly plants moved down south, the Clinton administration could still argue that exports to Mexico from domestic industry were creating 250,000 extra jobs in the United States itself. But the economic collapse has affected Mexican demand for North American goods, so that the US trade surplus of 1994 has turned right round in Mexico's favour. Nothing is left of the high hopes of job growth in the United States. What have grown are the profits of every company that has lowered its wage costs with cheap labour from Mexico. The devaluation of the peso even meant that many US corporations, but also many German and Asian automobile and electronics companies, acquired an additional advantage on the world market. Jobs in such firms offer a basic existence to many Mexican families, but they are no-where near compensating for the losses caused by the collapse of the domestic economy. There is again a rise in the number of Mexicans who illegally, and often in hair-raising circumstances, cross the Rio Grande to scrape a living in the USA, although NAFTA is supposed to stop precisely this kind of migration.

The Mexican experience, then, shows that the idea of a welfare

miracle resulting from a totally free market is a naive illusion. Whenever a less-developed country tries, without subsidies and without tariff protection, to compete with the powerful industrial economies of the West, the prospect of failure is never far off. Free trade simply means the law of the jungle – and not only in Central America.

Europe's Mexico is Turkey. Hoping for a stimulus to rapid modernization, the government in Ankara signed a customs union treaty with the European Union which came into force at the beginning of 1996. Turkish industrialists expected more exports to the EU to follow. But the modernizers on the Bosporus, like their counterparts in Mexico, underestimated what the opening of the economy would mean for their internal markets. Now that goods from the whole world can be imported into Turkey on conditions laid down by the EU, cheap overseas products are well and truly in the race. In just half a year Turkey's trade balance sank into the red. It is true that exports rose by 10 per cent, but imports soared by 30 per cent. Fearing for the country's currency reserves, the new government led by the Islamic Welfare Party immediately introduced import duties of 6 per cent. The customs treaty with the EU permits such protective measures, but only for a period of 200 days. Turkey is stuck in the trap.[5]

Again it seems that more harm than good results when a hopeful developing country, itself weak in capital, joins without protection a free trade zone of highly developed industrial nations. This knowledge is, of course, anything but new. Unlike European and American true believers, many rulers of the world's poorer countries realized it years ago and embarked upon a far more sensible course towards prosperity.

Dragons instead of sheep: the Asian miracle

Foreigners have long enjoyed coming to Penang. In the nineteenth century, its maritime climate and fertile soil lured British colonizers to establish a strongpoint on this island facing the Thai–Malaysian west coast. And today business is thriving in the capital, George Town. Tourist sights and trade in plantation fruits no longer draw people from afar, but light-skinned visitors from Japan, Europe and North America jostle one another as they wait beside the luggage belt in the airport arrivals lounge. Penang's new attraction is its industrial zone. Texas Instruments, Hitachi, Intel, Seagate and

Hewlett Packard make it known through huge publicity boards that no big electronics corporation can afford not to have its own production site here. 'Silicon Island' is what Malaysians proudly call their former bathing resort. Its factories have turned this South-East Asian country into the world's largest exporter of semiconductor products and now provide work for 300,000 people.

Penang is only one of many stunning signs of the economic revolution that the former agricultural country has been experiencing over the last twenty-five years. Malaysia has long ceased to be a developing country. Since 1970 its economy has grown by an annual average of 7 to 8 per cent, industrial output by more than 10 per cent. Today, not 5 but 25 per cent of the active population work in industry, which accounts for a third of Malaysia's total product. Between 1987 and 1995, the per capita income of this nation of 20 million doubled to reach 4000 dollars a year. By the year 2020 it is expected to have quintupled and reached the level of the United States.[6]

Malaysia is not the only country engaged in this spectacular drive to catch up and attain prosperity. South Korea, Taiwan, Singapore and Hong Kong – described early on as Asia's 'tigers' – were five to ten years ahead in reaching Malaysia's level. Finally Thailand, Indonesia and southern China have made the leap and, as the new 'dragons', are recording the same successes. All over the world, economists and industrialists feted the miracle of the Asian economic model, living proof that the market offered a way out of poverty and underdevelopment. However, the Asian boom has little to do with the *laissez-faire* capitalism of most OECD countries. Without exception, the rising economies of the Far East adopted a strategy which is effectively scorned in the West: namely, massive state intervention at every level of economic activity. Instead of letting themselves be led like lambs to the slaughter of international competition, as Mexico did once again, the dragons of state-managed construction from Jakarta to Beijing have developed a wide range of instruments with which to keep control of development. For them, integration into the world market is not the end but only a means that they use cautiously and after careful consideration.

In all the high-growth economies of Asia, the opening to the outside world follows the aircraft-carrier principle invented by the Japanese. High duties combined with technical specifications block

imports in every branch where the planners think their own country's firms are too weak to face international competition, and where they wish to protect existing levels of employment. Conversely, the public authorities and the government boost export production with every means from tax incentives to cost-free provision of infrastructure. Manipulation of the exchange rate is an important element in this strategy. All Asian countries copy the Japanese model and, through central bank intervention, keep the external value of their currency artificially lower than the rate that would correspond to real purchasing power inside the country. Thus, at the official rate of exchange, average wages in South-East Asia have only a fortieth of the value of West European wages, although they are the equivalent of an eighth when measured by their purchasing power.[7]

The engineers of Asia's growth do not intervene only in short-term capital flows on the money markets; direct investment by transnational corporations is also subject to precise conditions. Malaysia, for instance, systematically organizes the involvement of its own public and private firms in the branches of foreign companies, thereby ensuring that a growing number of local workers acquire know-how of use on the world market. To raise the general skill levels of their population, all the governments in question invest a sizeable part of the budget in the creation of an efficient education system.

Where that is not enough, further agreements on licences and patents assure the transfer of technology. Requirements concerning the share of local businesses in production for the world market ensure that sufficient profits remain in the country and flow into the development of nationally based companies. The best-value car in Malaysia is thus the Proton, which has Mitsubishi involvement but is 70 per cent locally produced. Despite protests from auto corporations in the OECD countries, Indonesia is pursuing the same strategy in collaboration with two South Korean firms. All these ventures serve a common end. The governments retain economic sovereignty and ensure that both local and foreign capital fulfil politically defined goals. Anyone who does not cooperate is out in the cold.[8]

Success shows the Asian planners to be right. Nearly all the booming East Asian states started out like Mexico, as mere positions on a supply line controlled by world corporations; their rulers never lost sight of the need to protect the domestic economy and its future growth, financing this through the exports of local branches of the

transnationals. Gradually they have created their own big corporations, half public and half privately controlled, which are now entering the world market in their own right. Not only South Korea has its mighty *chaebols*, the conglomerates like Hyundai or Samsung which each span several branches from autos through computers to ships. Even Malaysia, comparatively small with its population of 20 million, already has six multinationals of its own. The biggest, Sime Darby, has 200 subsidiaries and employs 50,000 people in twenty-one countries. Its equity capital is already worth more, for example, than that of Asia's leading airline company, Singapore Airlines.

Globalization of the world economy, then, does not proceed in accordance with a single principle. While the old centres of prosperity call for the state to withdraw and for market forces to be given greater scope, the emergent economies do the exact opposite. The same corporate strategists who in America or Germany brusquely reject any government interference in their investment decisions are quite willing in Asia to subject billion-dollar investments to the conditions imposed by state bureaucrats who quite shamelessly describe their work as central economic planning. The profits to be had from double-digit growth sweep all ideological reservations aside.

Fair trade: protection for the poor?

The Asian miracle does, of course, have its darker side. The boom goes hand in hand with corruption, political repression, massive environmental destruction, and often extreme exploitation of a labour force with no rights (most of it made up of women). Take Nike, for example. Its expensive trainers, costing up to 150 dollars a pair in Europe and the USA, are stitched and punched by some 120,000 workers in the contract companies that supply Nike in Indonesia, for a wage of less than three dollars a day. Even in Indonesian conditions that is a starvation wage, but it complies with the legal minimum applicable to more than half the country's 80-million labour force.[9] To make sure that it keeps this advantage, the military regime headed for the last thirty years by the dictator Suharto nips every workers' protest in the bud. For example, when Tongris Situmorang – a twenty-two-year-old working for Nike in Serang – mobilized his workmates for a strike in autumn 1995, local army men simply shut him up for seven days in one of the factory's storerooms and kept an

eye on him around the clock. Still, he was later released and all he lost was his job. Others, such as the two women trade unionists Sugiarti and Marsinah, who are celebrated throughout the country, paid with their lives for their courageous action. Their dead bodies, mutilated by torture, were found on the rubbish tip of the factories where they had tried to organize a strike. Industry Minister Tungki Ariwibowo points to the competition that has long been developing even between countries with the lowest wages. The rates are no higher in China, Vietnam and Bangladesh, he says by way of justifying state-authorized exploitation. If the minimum wage is increased, 'we cannot compete on wages with them'. His government's strategy is to bring production of the highest possible value into the country.[10]

By now, neighbouring Malaysia has left that stage behind. Its move up the chain of world production brought full employment and rising wages for many Malaysians, because the government at least permitted company trade unions. But it is still far from being a free country with basic democratic rights. The regime headed by Prime Minister Mahathir Muhammad, who has been in power for the past fifteen years, imposes strict censorship on all the media. Strikes and assemblies are forbidden. Opposition parties are no more than window-dressing in elections held for the sake of world public opinion. The growing economic strength of a rising middle class goes together with often inhuman working conditions for the underclass, not to speak of the million or more immigrant workers from poorer countries in the region who can be squeezed dry in any way whatever. After three years, with no exceptions, they must anyway leave the country and make room for new cheap labour. And so Siemens has to pay local skilled workers relatively well in its Malaysian microchip factories, but not the 600 Indonesian female assembly-line workers who are treated by the world corporation as so many possessions. For 350 marks a month, they slave away six or even seven days a week and at night are locked up like prisoners in the factory's own hostel. The local Siemens boss even keeps their passports, to make sure they do not slip away unobserved at the end of their three-year term.[11]

The workforce is treated with even fewer scruples in many of the 150,000-plus joint ventures through which investors from all over the world assure their stake in the explosive development of China's socialist market economy. More than a million women workers have

to stitch, punch or pack on the work-benches for fifteen hours a day, or more in exceptional circumstances. 'People are forced to work like machines,' says a local newspaper. Often they must pay a deposit worth several months' wages when they first start work at the factory, and it is not returned to them if they leave the company without the management's approval. At night they are crammed together in narrow and often locked dormitories which become death-traps in the event of a fire. Even the central government in Beijing has admitted that labour legislation is being ignored; the first six months of 1993 alone witnessed more than 11,000 fatal work accidents and 28,000 fires.[12] Yet those who rule in the name of the Chinese working class prevent any resistance, above all in the special economic zones for foreign investors: 'those who complain or attempt to form unions are likely to be sentenced to three years in a labour camp and there are currently hundreds of trade unionists in prison.'[13]

When faced with East Asia's (by Western standards) unacceptable campaigns to capture world-market shares, most governments in the West exercise astonishing restraint. West European heads of government last displayed their artificial blindness in early March 1996, when they met their counterparts from eight leading Asian nations in Bangkok to promote mutual economic relations. While one speaker after another in the conference hall conjured up visions of international understanding, representatives of more than 100 grassroots organizations at a counter-conference protested against the inhuman working conditions in Asia's factories, and 10,000 Thais pitched camp in front of their prime minister's office to highlight the unequal distribution of the country's growing wealth.[14] None of the European guests said a word about all this in public; the German chancellor and the British prime minister, for example, preferred back-room wooing to land mega-deals for companies that still bear a German or an English name. At the same time, Daimler-Benz chief Jürgen Schrempp spread it around that Germany must be prepared 'to learn from Asia', and that a study had been produced for the German Trade and Industry Congress in which the Indonesian dictatorship was praised for its 'political stability' and 'especially good investment conditions'.[15]

Such ignorance conveys a fateful message: namely, that health and environmental protection, democracy and human rights must take second place whenever this serves the world economy. 'But we

cannot allow that authoritarian regimes should be seen as a necessary condition for economic success', argues John Evans, general secretary of the TUAC international trade union organization, which represents employees at the OECD in Paris. 'Only in democracies can the distribution of profits be argued over.'[16] Like most trade unionists everywhere in the world, Evans has for a long time been in favour of trade sanctions against countries which violate human rights and environmental norms.

The Clinton administration in the United States, which was elected with union support, has also formally endorsed this demand. At the end of negotiations to establish the World Trade Organization, the US representative called for a social and environmental clause to be included in the treaty, whereby countries whose export goods had demonstrably been produced under conditions violating the minimum standards of the International Labour Organization could be brought before the WTO and, if necessary, have punitive duties imposed on them. A number of countries – and not only the ones directly affected – stood out against such a clause, but their opposition could have been overcome, because they had a lot to lose if the protective duties and trade barriers scheduled to disappear under the new treaty remained in place. In the end, the proposal came unstuck mainly because the EU countries, with the exception of France, were opposed to it. The governments of Germany and Britain – countries where, as *Le Monde Diplomatique* bitterly put it, 'people believe in free trade as children do in Father Christmas'[17] – stood out for their especially vigorous rejection. And so a unique opportunity to introduce a world trading code went by the board, even though the negotiations had dragged on for a total of seven years.

There is really no sound argument against enforcement of the kind of minimum standards just mentioned. Leading ILO norms – such as the ban on child or forced labour and on ethnic or sexual discrimination, and the guarantee of trade union freedoms – are already written into UN conventions that nearly every state ratified long ago. The threat of trade sanctions would give some teeth to these agreements. Men such as German Economics Minister Günther Rexroth, or WTO Secretary-General Renato Ruggiero, insist that 'neoprotectionism could then slip in by the back door' of social regulation, that wealthy countries might use it as a pretext to keep out cheap competition from the South. This is just what all the

representatives of developing countries maintained at the Geneva talks: that a social clause in the WTO treaty would again merely deny a share in prosperity to the poor of the South.

The argument has at best only propagandistic value, however, and in the mouths of European politicians it borders on hypocrisy. When the interests of influential associations and capitalists are at stake, the EU Commission and European governments are rather less prim about their trade policy. Whenever Europe's companies did not establish in time a base for themselves in a low-wage production site, the Commission has so far always imposed high anti-dumping duties at the request of the branch association concerned, above all on imports from Asia. From Chinese ball-bearings through Korean video-cameras to Russian basic chemicals – the trade watchdogs in Brussels, even after the WTO agreement, imposed punitive duties on well over a hundred product categories, using the dubious argument that suppliers would sell the goods below their true value in order to acquire an unfair market share.

The introduction of minimum social and ecological norms would be nothing new in principle – it would just be a question of fairness for workers in developing countries and for the population who have to suffer the poisoning of the environment. The view of rulers there that trade union freedoms or a ban on child labour would make the poor poorer still is no less mendacious. On the contrary, the un-democratic elites of the South would find their own trade profits in danger if they came under pressure from major sections of the population to share the fruits of economic success. Protectionist abuse of import restrictions allowed under WTO social clauses would also be easy to prevent if the competent UN institutions were assigned to identify human rights violations.

Protectionism for the rich?

Just and reasonable though they would be against authoritarian regimes, trade sanctions would still contribute little to a reduction of competitive pressure from the South. Many trade unionists hope that they would help to contain joblessness and the downward pressure on wages, but this is a mistake. The cost advantages of low-wage countries do not stem only from political repression or exploitative practices on the part of companies and government officials. The

rising exports of a relatively small number of successful developing countries are based first of all upon the generally lower living standard of the population, with fewer demands made on income by food and housing. In addition, the emergent capitalist economies have not so far needed a social security system, because family structures are still largely intact. 'Our social system is the family' – such is the usual reply of Asian politicians when asked about provision for sickness and old age. An even more significant factor is the currency dumping that makes the exports of booming states unbeatably cheap. The Siemens microchip factory in Malaysia, for example, would still be profitable even if it had to pay its female assembly-line workers 700 marks a month and the country had free trade unions. It would still be worth producing Nike sports shoes in Indonesia or Bangladesh even if the minimum wage were doubled. The enforcement of minimum norms is necessary and would help to bring greater social justice in the South, but it would hardly protect existing jobs in the North or lead to the creation of new ones.

Many French economists, in keeping with their country's tradition of protectionism, therefore call for selective restrictions on trade. For instance, Gérard Lafay, an economic adviser to the French government, has proposed that Asian exporters should be charged anti-dumping duties that at least offset the artificial undervaluing of their local currencies. But the customs revenue should not, in his view, flow into the state coffers but be credited in European currency to the corresponding exporters; this might finance imports from Europe and produce a better balance in trade and exchange rates. The idea sounds plausible, but it has a number of problems. The gates would be thrown wide open to the arbitrary raising of duties. No one could objectively determine what was a fair balance, and whether the affected country would find itself denied access to the markets of the North on which it has to depend for its development.

Furthermore, it is questionable whether a shield against low-wage competition could ever prevent the galloping devaluation of labour power in the highly developed nations. No doubt, growing imports from the East and Far East have caused losses in labour-intensive sectors of industry. In footwear and textiles, computer technology, precision engineering and related sectors, all the countries of the Europe/North America/Japan triad have been losing jobs to newcomers in the world economy. This is the main reason why demand

has been falling for unskilled labour and routine assembly-line tasks. In a wide-ranging empirical study, the British economist Adrian Wood has shown that since 1980 industrial labour has fallen off by an average of 15 per cent in the triad countries as a result of increased trade with the emergent economies.[18]

Macroeconomically, this trend has so far resulted in excellent business for most of the affluent countries of the North. For as imports grew, so too did purchases made in the other direction. After all, the newly rising economies have to buy everything they cannot produce themselves, from factory equipment to telecommunications satellites. And no other OECD country has benefited from this as much as Germany, which proportionately to GNP is still the world's leading exporter. It even runs a trade surplus both with South-East Asia and with the new market economies of Eastern Europe, but the bulk of the export earnings go straight into capital-intensive, science-oriented sectors such as machinery and equipment, chemicals, electronics and precision technology.

This shift is the main cause of the work crisis. Most German companies, but also French and Japanese ones, are doing very well out of globalization. What is constantly falling, however, is the percentage of their income which goes to the labour force in their country of origin. General prosperity is not on its way out; rather, an ever smaller share of the economic product accrues to wages and salaries. Even in Germany, which until recently was thought to have achieved a balance, the share of wages has fallen by 10 per cent since 1982. At the same time, the distribution of total wages among different occupational groups has become more unequal. Hard-to-replace specialists, or skilled providers of services for which there can hardly be cross-border competition, still have every expectation of rising incomes. The great majority of the remainder, especially the unskilled, are slipping further and further down.

This process can only in small part be put down to the emergent industrial economies of Asia or Central Europe. Most of the big downward changes in the labour market are due to the rapid interlinking of the OECD countries themselves, which in the 1990s still account for more than two-thirds of cross-border investment in the world. It is true that companies from the North are increasing their investment in the developing countries, but over half this capital transfer goes into the extraction of raw materials and into service

enterprises such as hotels and banks, where the relocation of labour is hardly a factor. Above all, cross-border takeovers and investments are accelerating between the rich countries. Whereas direct foreign investment in the developing countries rose between 1992 and 1995 from just under 55 billion to 97 billion dollars per annum, the corresponding figures within the OECD shot up from approximately 111 billion to 216 billion dollars per annum.[19] Just as before, then, the club of the rich corners for itself most of the booming world trade.

These figures illustrate the extent to which both capital and trade have become integrated within the OECD countries. But the resulting surge of competition among the world's most prosperous nations means that for years productivity has been growing faster than economic output as a whole; technological change induced by competition is making more and more work superfluous. Thus, it is not cheap workers in the South and East who are to blame for unemployment and a downward pressure on wages. At most they are instruments and lubricants for the rationalization and wage-cutting spiral to keep moving within the world of the OECD.

The neo-liberal school of economics has filled whole libraries with studies which seek to show that the jobs crisis is due not to transnational integration and competition but only to advances in technology and managerial methods.[20] This is a purely academic distinction, however. In the real world the two phenomena are in-extricably bound up with each other, because only global integration confers upon technological progress that penetrative force which is today driving millions to the margins of society. Trade barriers and import duties would be a blunt weapon indeed against this process, so long as the protectionism was directed wholly against low-wage economies. Only if a country shielded itself against competition from other highly developed economies would it be able to rebuild its labour-intensive industries. But then it would lose all its own export markets, because competitors would pay it back in its own coin – a strategy for chaos. The price for a reversal of structural change would be a huge loss of prosperity, even if employment levels were somewhat higher.

Whenever economists and pundits urgently insist that citizens will have to tighten their belts because new armies of cheap labour are pressing on the market, they keep quiet about the fact that total output is continuing to rise in the richest countries of the world. The

average profit on invested capital still comes in, and even faster than before. So it is not at all the case that poor countries are robbing the rich of their prosperity.

Actually the reverse is true. Economic globalization brings an ever greater share of the (growing) prosperity produced on a world scale to the privileged layers in North and South – wealthy owners of property and capital, highly qualified professionals – at the expense of the rest of the population. Bundesbank statistics on the sources of private income reflect the fact that Germany too, despite its strong unions and high social transfers, has long been subject to this trend. In 1978, 54 per cent of disposable income in West Germany was allocated to wages and salaries. The rest went half to income from interest or profits, and half to pensions or social benefits. Sixteen years later, in 1994, the share of after-tax wages and salaries had fallen to just 45 per cent. Now a full third of national income goes to the paid non-labour of those who benefit from interest and corporate profits.[21]

In this light, the conflicts arising from world economic integration concern nothing more, but also nothing less, than the distribution struggle which is as old as capitalism itself. The only amazing thing is that market mystics still manage to deny this simple truth, both to themselves and to the general public. In Germany, for instance, the debate on 'locational factors' is becoming more and more grotesque and producing wrong-headed policies on a grand scale.

The German model: lies about locational factors

Helmut Kohl was full of praise. 'The unions have shown themselves to be exceptionally cooperative and ready to discuss,' he flattered German employees' representatives. Their 'alliance for jobs' had had 'positive results'. Klaus Zwickel, chairman of the IG-Metall union, was a 'fine fellow-citizen who really gets things done', and IG-Chemie deserved his 'deepest respect and gratitude'. The objects of his ardour were assured of his support in difficult times. 'I am a disciple of Ludwig Erhard. This party will never follow a policy geared only to the market; social conditions are also part of it, and so there is not going to be any social dismantling.'[22] That is how the chancellor still spoke in April 1996, for everyone to hear on a peak-time television programme. Just two months later in Bonn, those who had been given

such gushing praise organized the largest trade union demonstration since the war, to protest against the self-same chancellor and his policies. Well over 300,000 people came in seventy-four special trains and 5400 coaches, some of them travelling for as long as seventy hours to express their opposition to the erosion of social gains, unemployment and state-orchestrated wage cuts. If the government keeps to its programme, declared the head of the DGB trade union federation, Dieter Schulte, 'this republic will go through conditions that will make France seem like a feeble prelude' (a clear allusion to the similar upsurge by French trade unionists half a year earlier). This time, Kohl found different words for his once so cooperative partner: he was a 'professional grumbler and sower of doubts', whose 'one and only aim is to defend vested interests' and 'to gamble away Germany's future'.[23]

The times are changing in Germany. Throwing off all disguise, the conservative–liberal government now aggressively endorses everything that the country's capitalist elite has been demanding for years. 'We are too expensive,' says the chancellor, but the 'we' refers only to those who draw their income as workers and employees. One expression is certainly doing the rounds, and that is 'vested interests'. The prime minister of Saxony, Christian-Democrat prophet Kurt Biedenkopf, has even identified 'a whole mountain of vested interests' that have to be 'blown up'.[24] These are: the continued payment of wages during sickness, child benefit, protection against dismissal, unemployment benefit, public job-creation, the five-day week, annual leave of thirty days, and much more besides which has long made up the social component of Germany's market economy. No doubt, most German employees still have it good in international terms – a condition which brought the country worldwide admiration and envy, and once enabled its political parties to make the 'German model' a major theme of their election campaigns. But then, in the light of global competition, social gains became vested interests. 'For growth and employment' is the title of the government programme published in April 1996, and Kohl and his ministers are now clearly getting down to the dispossession of those with vested interests. Their axe is lifted against the whole range of achievements in social protection and wage levels. Even women who expand their vested interests by getting pregnant and becoming unable to work will in future be punished with loss of pay.

The aim is easy to see. Since the global economic machine leaves less over with which to pay for work, people who rely on wages and social benefits will have to divide the smaller total among themselves, so that everyone can get something and the jobless figures can come down. Germany is supposed to learn from America, where a larger proportion of people have work but only at the price of lower wages, minimal social benefits, longer working hours and worse working conditions. One of the spokesmen for higher returns on capital in Germany puts the case crisply enough: 'A 20-per-cent reduction in gross wages is necessary to have full employment again.' It is Norbert Walter, former director of the World Economy Institute in Kiel and now head of economic research at the Deutsche Bank, whose management board is regularly rewarded with share options for its careful attention to 'shareholder value'.[25] A few years ago, the bank's economist would have found himself in political limbo if he had made such a proposal; today he knows the government is behind him. For this, Walter and his comrades-in-arms can thank a campaign waged over many years in all the media, in which no distortion or falsification was too crass if it helped to secure victory.

One of the central arguments in this propaganda battle is that Germany's welfare state has become too expensive. Or, as Walter puts it, too many citizens have the 'fully comprehensive mentality' and prefer to draw social benefits instead of getting down to work. To be sure, a lot needs reforming in Germany's social security system. The 152 different forms of social benefit are to some extent chaotically organized: their administration is very costly, and they often favour bogus claimants, while the really needy do not even get enough for a roof over their heads. More than 8 million people are already below the poverty line, and there is not sufficient money to reintegrate them through training and job creation. What is not true, however, is that the welfare state has become more expensive. Nearly a trillion marks were paid out in 1995 for all areas of social expenditure – eleven times more than in 1960 – but the national income had meanwhile increased by the same amount. Thus, total social spending in 1995 cost the Federal Republic just over 33 per cent of GNP. In 1975, twenty years earlier, the figure for West Germany was almost exactly the same: 33 per cent.[26] If East Germany were left out of the equation, the percentage would actually be 3 per cent lower today.

What has dramatically changed is the way in which these costs are defrayed. Nearly two-thirds of social expenditure is financed out of the contributions made by wage- and salary-earners. But as their share in the national product is continually falling as a result of unemployment and slow earnings growth, the contributions have had to be enormously increased over the years in order to pay for pensions, unemployment benefit and medical treatment. Four million unemployed means an annual loss of 16 billion marks for the pension funds alone. The crisis of Germany's welfare system, then, is almost entirely due to the jobs crisis and not, for example, to exorbitant demands made on it by a lazy and mollycoddled population. Given the country's wealth (but also the need not to make labour unnecessarily expensive), it would have been logical to use fiscal policy in such a way that exempt categories such as civil servants, the self-employed and high-earners would also start to pay social contributions. The Kohl government, however, is actually moving in the opposite direction. As the East German construction programme got under way, it plundered the coffers of the welfare state for all manner of expenses that had nothing to do with their designated purpose; from compensation to victims of repression at the hands of the ruling SED, to retirement money for laid-off civil servants of the GDR. Administrators working for the competent federal authorities calculate that, if the pension, unemployment and sickness funds were simply freed of financial burdens they were never meant to have, social contributions could be immediately reduced to 8 per cent of wages.[27] Even those who complain loudest about the bloated welfare state feel perfectly free to make use of contributors' money. Thus, from 1990 to 1995, Germany's companies and personnel departments sent three-quarters of a million employees into early retirement, rejuvenating their labour force at the expense of the people's contributions. The extra cost for the pension funds was 15 billion marks a year, equivalent to 1 per cent of total wages.[28]

A no less dubious way of getting people to lower their sights is the persistent claim that labour costs are higher in Germany than anywhere else. In fact, international differences in hourly wage rates mean no more than differences in new house-building costs between the Frankfurt city centre and a suburb of Perleberg. What really counts on the world market are unit wage costs, or the product value created with one unit of labour. By making a world com-

parison of these data, the economists Heiner Flassbeck and Marcel Stremme from the German Institute for Economic Research (DIW) in Berlin came up with some astonishing results. Calculated in local currencies, unit wage costs rose by a total of 97 per cent in West Germany between 1974 and 1994, but by a full 270 per cent for an average of all OECD countries.[29] The German efficiency machine certainly worked well, then, and this is precisely what has allowed German companies to keep their noses in front in many markets. Similar conclusions were drawn in July 1996 by economists from the Munich Ifo Institute, one of the six economic research centres from which the federal government takes advice. 'The average real income per employee has not risen anywhere more weakly than in Germany,' Ifo experts reported to the Economics Ministry in Bonn. 'Similar figures are to be found only in the USA. The data support the postulate of moderate German trade unions, and confirm that high hourly wages with short hours of actual labour are justified by productivity.'[30]

Of course, no country can go on for decades selling more in the world than it imports, without certain consequences. In Germany's case, the result is that the Deutschmark has constantly gained value relative to other currencies. The cost discipline reaffirmed in every new round of wage bargaining has always soon been eaten up by the loss in value of earnings denominated in other currencies. Thus, German export products earned 10 per cent less in 1994 than in 1992, because the crisis in the European Monetary System and the Federal Reserve's cheap-dollar policy kept pushing the mark up and the dollar down. If these exchange-rate shifts are taken into account, then the evolution of costs has remained roughly parallel in Germany and in other industrialized countries, reported DIW researchers. The German Economy Institute in Cologne, which is close to the employers' associations, has likewise calculated that, in dollar terms, German unit wage costs in the processing industries are today roughly in line with American costs.[31]

Against this background, it was really audacious propaganda when Olaf Henkel, ex-chief of IBM and president of the Federal Association of German Industry, sounded off in autumn 1995 about the high price of German employees. Because German companies are investing billions of marks a year abroad, he noted, jobs are likely to go with the capital. Or, as he put it: 'Jobs are the Germans' biggest

export success.'[32] The idea hit the public like a bomb and was soon
on millions of lips, but, nevertheless, was quite wrong.

In support of his thesis, Henkel made the following calculation.
Since 1981 German companies have invested 158 billion marks in
foreign subsidiaries. During the same period the number of people
employed by them abroad has risen by 750,000. Therefore Germany
has 'exported' nearly 70,000 jobs a year. The reality is quite different.
A country that has trade surpluses over a number of years must
inevitably export more capital than it imports. For the same reason,
and during the same period, Japanese corporations invested 100
billion marks more than German ones in their overseas subsidiaries.
Most of this investment flows not into low-wage economies but into
other industrialized countries. The most important areas for German
expansion abroad are Britain, Spain, the United States and France.

More important, however, the supposedly additional jobs are a
purely notional quantity. This has been shown conclusively by
Michael Wortmann from the Berlin Institute for External Economics,
which has studied the foreign investments of German companies
over the last ten years.[33] It is true that the labour force of German
companies abroad increased between 1989 and 1993 (by 190,000
according to Bundesbank statistics), but in the same period, German
investors bought up foreign companies that employed just over
200,000 people. The 'exported' jobs, then, had already been there
for a long time. Many corporations have, of course, also set up new
factories: BMW is building in South Carolina, Siemens in the North
of England, Bosch in Wales, Volkswagen in Portugal and China.
But at the same time, German world-market strategists operate with
newly acquired foreign companies in the same way that they do in
Germany itself: they rationalize, evacuate and concentrate. Many
foreign purchases also simply serve the purpose of clearing the
market, so that acquisition is soon followed by shutdown. When all
is said and done, German companies create just as few jobs abroad
as at home.

The debate about German competitiveness is, as we see, teeming
with inconsistencies, contradictions and deliberately misleading
formulations. The effect on politics is disastrous enough. Firmly
believing in the locational rhetoric of radical free-marketeers, the
government is encasing the country in an austerity programme that
does more harm than good. Among public-sector employees alone,

some 200,000 jobs are due to vanish by the year 1998. As the funds for job creation in Eastern Germany dry up, another 195,000 people will join the dole queue. Purchasing-power on the domestic market will further decline as a result of cuts in social benefits. According to Holger Wenzel, head of Germany's main retail trade association, lack of custom will cause 35,000 jobs a year to disappear from shops and department stores.[34] 'Unemployment feeds on itself,' warned Wolfgang Franz, one of the five 'wise men' working on the economy for the central government.[35] Nevertheless, ministers protest that there is no alternative to the austerity drive, and point to the burgeoning deficit in the public accounts.

This too is a threadbare argument. Obviously tax revenue declines with a rise in unemployment. Those administering the budgetary hole never mention the fact that they themselves have deliberately reduced the size of the revenue. Each year, more and more exemptions from federal and individual state taxes are granted to companies and the self-employed, while a blind eye is also turned to the transfer of assets to tax havens. Several reductions in taxes for joint-stock companies, together with a flood of advantageous write-offs, reduced the fiscal burden on corporate profits from 33 per cent in 1990 to 26 per cent in 1995, revenue to the state from this source falling by 40 per cent.[36] In 1980 taxes on profits still accounted for a quarter of state revenue, and if this were still the case today, the public coffers would have 86 billion marks more in them than they do – one and a half times more than the finance minister accumulated in additional debt in 1996. Nor should it be forgotten that the austerity programme itself will bring a further reduction in tax receipts. With the ending of taxes on private wealth and commercial capital, 11 billion marks will cease to flow into the treasury.

All this is supposed to make it easier to create new firms and jobs in Germany. Even in corporate taxation the different states will be competing with one another – this is how Finance Minister Theo Waigel justifies tax reforms designed to lower revenue. But the hope that higher profits will almost by themselves translate into higher growth and more jobs was refuted a long time ago. Between 1993 and 1995 corporate profits in the Federal Republic increased by an average of 27 per cent, but the rate of investment remained constant.

Breaking out of the downward spiral

Contradictions in Germany's concern about locational factors illustrate the basic fallacy of a policy which makes global competition an end in itself: that is, it leaves perspective out of account. The unbridled race to carve up the world (labour) market devalues labour power in ever faster cycles and – like the race between the hare and the tortoise – unfolds out of sight of the great majority of the population. Some cheaper competitor is always there already, or will be by tomorrow at the latest. Those who 'adapt' only force others to adapt elsewhere and soon find it is their turn to move again. No matter what they do, this is a game which most employees can only ever lose. The only ones with an advantage are the wealthy and those with (currently) high-priced skills – roughly a fifth of the population in the old industrial heartlands. Even professional champions of neo-liberalism such as the OECD headquarters in Paris can no longer deny the trend towards a 20:80 society. There are simply too many income statistics that show a widening gap between rich and poor.

The downward spiral is not fated to continue, however, nor is this anyway likely. Possible counter-strategies have been devised in great number. At the heart of any change of course must be the attachment of greater value to work. Even liberal economists do not dispute the enormous opportunities that an ecological reform of the tax system could open up. If energy use were gradually made more expensive over the longer term, this would not only counter the threat to the environment, it would also increase the demand for labour and slow down the deployment of technology for automation. Rising transport costs would set new limits to the transnational division of labour. The travelling warehouse of suppliers' components, in the form of endless lorry tailbacks on the motorways, would no longer be a paying proposition.

In a model computation that carefully sets out its own premises, the German Institute for Economic Research has demonstrated that an eco-tax increasing by small amounts every year on heating oil, petrol, natural gas and electricity could lead within a decade to the creation of more than 600,000 extra jobs in Germany. The minimization of energy use would be achieved largely through technical improvements to buildings and decentralized production of the energy itself, which would create employment for many people.[37]

Still more labour would be used if the consumption of raw materials were made more expensive. In this regard, the product researcher Walter Stahel has published a remarkable calculation under the arresting title 'The Speed Trap or the Tortoise's Victory'.[38] Higher prices for resources would give long-life products a clear cost advantage over the disposable and short-life competition – which would tend to promote labour. Using the example of auto production, Stahel shows that it has long been possible to produce cars whose chassis and engine block last twenty years instead of the ten usual today. In a ten-year model, the purchase price is on average 57 per cent of total costs, only 19 per cent being accounted for by repairs. Over twenty years, however, the consumer's outlay on the new car falls to 31 per cent of total costs, while repairs take up 36 per cent. Assuming that the amount spent on the car remained the same as in the first case, the value of the robotized factory labour would thus be proportionately lower and the value of the labour-intensive maintenance work proportionately higher.

In other spheres, too, there is no shortage of things to be done. In the health system, in the overcrowded schools and universities, in the restoration of devastated landscapes or dilapidated satellite towns, there would be more than enough work. Private enterprise and the market can do nothing alone. Only if the state, and principally the local or district authorities, are able to invest in such programmes, will the corresponding jobs be created.

The necessary funds would have to be available in the budget. Cross-border movements of capital could be taxed without any harm to the economy, providing a lucrative source of finance that would not make labour more expensive. Even more would come from a ban on the transfer of assets to tax havens such as Liechtenstein or the Channel Islands, which serve as a black hole in the world economy where more and more wealth each year is able to escape taxation. Such a reform would also counteract the tendency to upward redistribution of income.

The objection to ideas of this kind is obvious. Precisely because of their entanglement in the global economy, most nation-states – at least in the wealthy North – are no longer in any position to carry out such fundamental reforms. Every party in the German Bundestag is theoretically in favour of eco-taxation, but any initiative is dropped as soon as a representative of the industrialists hints that higher

energy prices would drive thousands of companies abroad. So it is that democracy turns into theatre of no consequence.

The key task for the future is therefore to win back a capacity for political action, to restore the primacy of politics over economics. For it is already becoming clear that things cannot go on like this for much longer. Blind adaptation to world market forces is inexorably propelling the old affluent societies into a state of anomie, a collapse of the social structures on whose functioning they have to rely. But markets and multinationals have nothing to offer against the destructive power emanating from a radical and growing minority of the declassed and the excluded.

6. Sauve qui peut: but who still can?
The disappearing middle classes and the rise of radical seducers

'Will the whole world turn into one big Brazil, into countries with complete inequality and ghettoes for the rich elite? With this question you take the bull by the horns. Of course even Russia is becoming Brazil.' Mikhail Gorbachev at the Fairmont Hotel, San Francisco, 29 September 1995

Delayed, but with a provoking lack of haste, the Canadair jet of Lufthansa flight number 5851 to Berlin-Tegel rolls towards the runway at Vienna-Schwechat. At the window seat in row 16, the thirty-year-old Peter Tischler is stretching out as best he can. He wants to appear 'real cool', but his body gives him away: he can't take any more. He stares vacantly ahead at the little folded table and starts to talk.[1]

He got up at five o'clock on that Friday morning in July 1996, then raced in his hired car through Moravia and the East Austrian wine district to catch the 09.05 flight to Berlin. There he has an appointment before noon, and it will be evening before he reaches home in Eitorf near Bonn. At the weekend he is due to go to Spain, and on Thursday he has to be in the United States. Flying comes as naturally to him as riding a tram does to others. Does this mean he has an enviable life?

Tischler knows the world, but no one knows him. He is not a manager or a tennis professional but a kind of mechanic of the age of globalization – or, to be more precise, he corrects programming errors in computer-controlled die-casting systems. He is harassed and frustrated, and he does not mince his words.

'Is it all really worth the effort?' he asks. 'I work 260 hours a month, including nearly 100 hours' overtime. Out of a salary of

8000 marks I am left with just 4000, because I'm counted in tax band one.' He has no time for a family: 'The state fritters away my money, and nothing will be left for my pension.' His employer, the highly specialized mechanical engineering firm Bartenfeld, has been chalking up handsome profits, but recently a quarter of all jobs have been eliminated. 'It's really no fun any longer.' Without being asked, Tischler blames this joylessness on 'the *Aussiedler* [ethnic Germans from Russia and Eastern Europe] and the Turks'. Besides, 'I cannot comprehend why we spend like this on Russia and development aid and even still fork out a packet for the Jews.' This 'selling out of our country and our firms is completely crazy'. As someone with 'a wealth of international experience', he knows who he will be voting for: 'The Republikaner, of course' – even if unfortunately it is 'not yet the right party'. He shouldn't be saying this 'out loud', but 'a lot of citizens have started arming themselves'.

Change of scene. A different airport, a similar life, a quite different reaction. It is a close July afternoon in 1996, and Lutz Büchner, Lufthansa's deputy flight manager in Frankfurt, is trying to soothe an incensed regular flyer who arrived at Gate B 31 twelve minutes before take-off and was not allowed on board, because a few weeks ago the minimum check-in time was raised from ten to fifteen minutes. Büchner calmly explains the new regulations and shows understanding for the traveller who is in such a hurry. 'You can feel the pressure growing all around. Even people you would never have expected to react like that fly off the handle at the slightest thing that goes wrong.'[2] Still, Büchner convincingly declares, 'I feel glad when I come to work each morning. I'm right behind this company.' A few days before, however, he was standing with 1000 colleagues outside the entrance to the airport, because good economic results had not prevented Lufthansa from announcing another eighty-six redundancies.

Like the stressed-out computer expert Peter Tischler, the thirty-five-year-old Büchner does not have any children, 'because unemployment could soon hit me too'. Naturally he is prepared to make 'personal economies and take a cut in pay, if that will make our jobs safe', but the downward spiral of globalization will not remain unanswered: 'There's going to be a rebellion, no doubt about it.' Büchner is an 'absolute pacifist': 'Of course I'll get involved, but I'm not going to get myself shot at a demonstration. Before that, I'll move with my Greek girlfriend to a little island in the Aegean.'

The modern radical Peter Tischler and the distraught yet peaceable Lutz Büchner are two well-placed, unassuming citizens who represent prototypes of future developments in Germany, perhaps even in Europe. Can the shape of ordinary politics around the end of the millennium be glimpsed in these two characters? Either hit hard or clear out: is that becoming the key choice? Even if history does not necessarily repeat itself, there is much to suggest a revival of conflicts such as those which dominated the European continent in the 1920s.

The social cement that holds societies together has become brittle and cracked. The impending political earthquake is a challenge to every modern democracy. This is most obvious, though surprisingly little investigated, in the United States of America.

The loneliness of Charlie Brown

'Why is Europe committing suicide like this? Don't you see that in the end you'll have to adapt to economic trends and global changes?'

The Washington business consultant Glenn Downing, who blared these sentences with complete conviction to a guest from the suicidal continent, has been a conservative since childhood and currently prefers to invest in Siberian crude oil.[3] His daughter Allison, a law school graduate, is part of the ambitious staff of a Republican congressman. The previous evening, on the last Saturday of September 1995, she had a stylish church wedding, and Daddy Downing is in a buoyant mood: 'At last something is happening.' He is alluding cheerfully to Newt Gingrich, the radical leader of the Republican majority in the House of Representatives, and to the new 'American Revolution' which is the greatest hope of the US Right since the days of Ronald Reagan.

There has got to be an end to talk of falling wages. The Democrats are to blame for all that, 'because the statistics are quite simply falsified, with no proper account taken of inflation'. Those who talk of the 'decline or even collapse of the American middle classes' are simply making fools of themselves, as are those who suggest that both partners in a white middle-class couple must work hard to get near that standard of living envied throughout the world which was still taken for granted in the 1970s. In those days, men had a secure well-paid job, and their wives stayed in their suburban homes as grass

widows, whether or not they had children. If they did casual work it was usually out of boredom, not at all because they needed to.

The Downings still live like that, in Reston, Virginia, amid the woods of prosperous Fairfax County, not far from Dulles airport and the headquarters of the CIA. 'Just look around you,' says the corporate adviser standing self-consciously on the new terrace, which he personally laid with fresh bricks in time for the family party, reddish brown for the five continents, bright red for the oceans, and the whole world level, completely flat.

Less than a year after Allison's wedding, in the summer of 1996, it becomes clear just how much the investor has lost touch with reality. The ideal world of the white middle classes no longer exists. To be sure, Downing's thirty-year-old daughter is full of loving solicitude for her nearly sixty-year-old father. 'People of his generation no longer have such a clear grasp of social changes,' she explains in the presence of her husband Justin Fox, who grew up in a sheltered Californian suburb near Berkeley.[4] 'There's no way we can afford our parents' lifestyle: a house like the one Dad bought a little before I was born would cost 400,000 dollars today and is simply beyond our means.'

All the same, Justin Fox has been making considerable strides in his career: he has become a 'writer-reporter' on the thriving business magazine *Fortune*, and the young married couple now live in Manhattan. Allison gave up her job in the capital and earns a meagre 1100 dollars a month as electoral agent for a Republican candidate to the New York State Assembly. But Justin's fortnightly pay slip shows no more than 1157 dollars after deductions. Just the rent on their cosy but diminutive apartment on 39th Street comes to 1425 dollars a month, nearly half their combined income, without counting electricity or the telephone. Justin Fox's gross salary is 45,000 dollars a year. 'It's nowhere near enough,' says Allison, but she is not discontented for all that. 'Just look around at people still younger than us who are finishing college at twenty-two or twenty-three. Often they can only get a job serving in a bar or driving a motor-bike for a messenger service.' Allison's husband makes a terse journalistic comment: 'The middle class is dying out.'

Out of concern for their future, the remaining US middle classes of the 1990s are putting out their savings in stocks and shares. Downing and Fox invest in Coca-Cola among others, and they were

discreetly happy enough when the Olympics were held under the sign of the soft drinks giant. During the sixteen days that the games of the century lasted in Atlanta, Coca-Cola shares were up 4.2 per cent on Wall Street.[5]

Twenty million US households take part in stock-exchange roulette, investing in at least one of the 6000 and more speculative funds which may juggle with as much as 6 trillion dollars worldwide. Whereas, twenty years ago, 75 per cent of private savings in the United States were held in savings accounts or fixed-interest securities – as is usually the case in Europe today – the proportion has turned right around in the 1990s. Three-quarters of savings are now speculated on the stock exchange. In this way, savers give fund managers the power to exert pressure everywhere for wage cuts and downsizing, often in the very companies that have so far given work to these small investors.[6]

For every individual, though, 'stock speculation becomes the rule of prudence,' one of Fox's fellow-journalists opens his essay in the influential US *Harper's Magazine*.[7] Fifteen years after the beginning of Reaganomics, the contribution by Ted C. Fishman from Chicago throws more light than endless statistics or analyses upon the economic situation and mental state of this politically thin-skinned, and almost exclusively light-skinned, prosperous layer of the population.

> Although I am a thirty-seven-year-old, white, Ivy League-educated, married man and thus, by any reckoning, enjoy nearly every advantage one may have in American society, I do not expect, necessarily, to be able to retire with sufficient wealth to maintain my present standard of living. […] I see the stock market as the only way I can possibly accumulate what I will need to retire. So, with 51 million others, I'm a player. I invest in four mutual funds every month and have holdings in several others, the mix of which I 'adjust' occasionally.

Things are not as they were in the 1980s, however. Then, writes the Chicago essayist, 'those markets rode on a certain Reaganesque optimism: people who had money were going to be allowed to make a lot more of it, at least for a while. This market runs on fear.'

'I need all the friends I can get': these black letters could often be seen on the back of the gaudy orange T-shirts that Californian high-school kids liked to wear in the 1970s. On the front, emblazoned across the chest, was the cartoon character Charlie Brown from 'Peanuts'. The kids of that time have since become anxious parents,

their carefree laughter has mostly disappeared, and friends – well, friends are harder to find than ever. For America's famous competitive society is devouring its children; the scant incomes of the baby-boom generation mean that there is not much comfort for the Peanuts star.

Every day millions of families feel their temperature rising together when the Dow-Jones index moves a few points, and not infrequently they will discuss the bottom-line conclusions for hours with their fund managers and stockbrokers. Nearly every gambler knows that only a few will strike it rich in the end, often at the expense of friends who have put their money on dud shares or bonds. So it has gotten real lonely around Charlie Brown.

If college graduates like the Downings, Foxes and Fishmans feel so cornered that they think their future prosperity can only be secured through stock-exchange speculation, what of all those other Americans who are no longer so young or privileged or healthy, or who are simply not fair of skin?

Several million of the 18.2 million office-workers, for example, must reckon that their jobs will be lost to college computers over the coming years, according to a *New York Times* report in early February 1996.[8] On the same day when the early-morning newspaper placards were displaying this latest shock report in front of houses and offices, the weeks-long strike of New York maintenance workers – liftboys, cleaning ladies, home-helps, and so on – was entering its decisive phase. The employers' association had demanded a 40 per cent reduction in the starting wage of all new employees. Janitors, previously well paid, would thus earn a mere 352 dollars a week.[9] The service employees' union was not prepared to accept this, fearing that, if it did, long-serving workers would soon be dismissed and replaced with cheap new labour. Then the employers jointly decided to hire more than 15,000 strikebreakers by night, who were only too grateful for every nine dollars an hour.

In New York, which always used to be thought of as a 'union city' that sends scabs packing, the public outcry this time failed to materialize – even when a lot of workers did not get their jobs back and all resistance ended with a settlement that knocked 20 per cent off the starting wage. Too many US citizens have themselves been floored by the argument that the hungry on the streets would be better made use of in the labour force.

Of course, the United States has never seen itself as a homogeneous society, or even one that stands together. But this? The attack on the whole middle class is fresh kindling for a fire that has already swallowed up large parts of the world's leading society. Unresolved racial conflicts, well-known drug problems, equally well-known crime rates, the collapse of once-famous high schools where teachers work for a wage that not even a home-help would accept in Germany. There seems no end to the disintegration, and so the revolution of those at the top continues against those at the bottom.

Are you doing better, Europe? Certainly any smugness would be quite out of place anywhere between Lisbon and Helsinki. The investor and business consultant Glenn Downing is fortunately wrong to think that the old continent – the Europe from which the planners of the American dream originally came – is heading for suicide. But how is Europe to hold its ground when the American nightmare-come-true suddenly swings around like a boomerang?

The end of German unity

The abandonment of the idea of involving the broadest possible middle class in affluent national economies goes hand in hand with growing social disintegration.

In Germany at least a quarter of the population has said farewell to prosperity; the lower middle class is subject to creeping pauperization. The society which is still the wealthiest in Europe is letting its youth in particular go to the dogs, and a million children already live on social assistance.[10] The Bielefeld researcher Wilhelm Heitmeyer warns:

> One of life's tasks for young people is always to exceed, or at least to preserve, the status of their original family. But that is very difficult nowadays, because practical opportunities on the labour and education markets are extremely tight. This uncertainty about future prospects is gradually seeping through to every milieu. And violence is one possible way of coping with the stress and the competitive struggle.[11]

Since 1989–90, statisticians in Germany have recorded a sharp rise in crime among children and young people. As opposed to current explanations in terms of 'declining moral standards', Heitmeyer

argues that 'the young people in question do not reject but, on the contrary, overfulfil the ideals of a "radical free-market society"'.[13]

'Pinching, robbing, kicking for instant enjoyment' – this is how the Berlin *tageszeitung*, with its usual snappiness, characterizes the younger generation's feelings about life. 'There are rivals round every corner.'[13] 'Parents are neglecting education' is how Wilfried Penner, SPD chairman of the Bundestag home affairs committee, explains things. But millions of parents would reply: how much time do we have left for education, we who are forced to earn double and are completely stressed out? And anyway, how many children still grow up with both their parents?[14]

A major educational offensive, necessary though it undoubtedly is, could not over the coming years prevent millions of well-placed members of the German middle class from falling into a new mediocrity. Not even the cleverest little boys and girls can take their school-leaving exam that early.

The gulf between rich and poor is growing wider: high earners want to have less and less to do with popular layers that seem to them ever more aggressive. German unity is crumbling, even though geographically it has only just been achieved. Instead of 'prosperity for all', as Ludwig Erhard pointed the way in 1957 in a book with that title, we are now seeing everywhere the 'revolt of the elites', as the American historian Christopher Lasch called it in his last work, posthumously published in 1995. The separation of the rich is becoming the norm, Brazil the model.

The betrayal of the elites: Brazil as world model

The guests squeeze herbal cheese from a tube onto savoury biscuits; the thin beer is in pre-iced aluminium mugs on the folding table. Magnificent steaks sizzle on the charcoal barbecue, while the eight-year-old son in a 'Miami National Football League' T-shirt runs from the garden into his room to fetch the golden-yellow plastic goblet he won at his school's last judo competition. A weekend idyll in an unprepossessing North American suburb?[15]

When evening comes, the father of the family, Roberto Jungmann, cycles round the neighbourhood with little Judoka and still littler Luisa, past freshly planted eucalyptus trees and villas decked out

with alpine wooden balconies or postmodern façades. Street ramps slow the already voluminous traffic; in front of the garage exits, rubbish sacks stand in long-legged metal baskets to stop the dogs getting at them. 'It's paradise here,' says Roberto's wife Laura. The paradise, measuring 322,581 square metres or nearly as much as forty-four football fields, is called Alphaville and lies in the west of Greater São Paulo. Surrounded by metre-high walls that have spot-lights and electronic sensors to pick up every movement, it is an ideal retreat for residents who are scared of criminals and ruffians in the centre of the metropolis, and who want to live like average families in Europe or prosperous parts of the USA, without having to face the social reality of their own country.

Twenty-four hours a day, private security officers moonlighting from the military police cruise round Alphaville searching for in-truders, on motor-cycles or in police cars equipped with warlike signal lights just like the ones they used in *The Streets of San Francisco*. If just one cat manages to sneak into the ghetto of affluence, the guards immediately race to the scene of the incident.

'The system has to be perfect,' says interpreter Maria da Silva, 'because a whole lot of people with guns live right close by.' Only 'really rich people' can afford several guards of their own. For the middle layers, claims property developer Renato de Albuquerque, 'Alphaville is a model with a future.' Lawyer Jungmann is visibly content: 'My son can romp around here all day without my having to worry.' For children under twelve are not allowed through the steel railings at the entrance unless their parents accompany them or give special authorization, while minors in general have to carry written permission from their parents.

Every visitor must show identity papers, and is admitted only after telephonic consultation with the respective ghetto-dweller. Large vehicles are thoroughly searched, and guards feel deliverers and building workers all over their bodies in case they have stolen something.

The rule of the militia in whose hands the residents gladly place themselves is almost without bounds. Domestic servants – who in Brazil are by no means a privilege only of a small upper class – can be employed only if the quasi-colonial soldiers give the go-ahead. Nannies, kitchen helps or chauffeurs – all have their previous life closely checked against military police records. 'Anyone who has ever

stolen something or carried out a robbery stands no chance,' affirms co-developer Yojiro Takaoka.

The property tycoon of Japanese descent insists that the real Alphaville has nothing to do with Jean-Luc Godard's eponymous science-fiction film of more than thirty years ago, which prophesied an ultra-technologized world of total surveillance. The name was dreamt up by a Brazilian architect, this being a case, then, of a transcontinental Freudian slip.

Takaoka sells plots of land 'only to people who have no blot on their reputation'. The price per square metre is 500 marks – which few can afford, not only in a Third World country like Brazil.

The idea of consistent social apartheid is, according to Takaoka, 'a solution for our problems', and an alarmingly successful one at that. More than a dozen Alphaville-style 'islands' (as residents call them) have already been completed, and many more are either under construction or on the drawing board. Takaoka's partner, Albuquerque, estimates that some 120,000 people may be living in Alphaville and the neighbouring ghetto of Aldeia da Serra, in an area roughly totalling 22 square kilometres.

Industrial companies, offices, shopping malls and restaurants have sprung up in the vicinity and are also kept under close watch. But the state police, notoriously corrupt and incompetent, hardly ever shows its face. It is 400 security men, six-shooters at the hip, who defend this beautiful oasis. The ghettoes are also ringed by special units carrying .12 Taurus sawn-off shotguns, 'to hit five or six people at once,' as José Carlos Sandorf, head of security in Alphaville 1, willingly puts it.

Inside the ghetto walls, the guards are allowed to shoot at any stranger, even if he is unarmed and is threatening no one. 'In Brazil,' says Sandorf, 'if you shoot an intruder on your own property, you are always in the right.'

'In effect it is a defensive civil war on the part of those who have the money and the power. In Europe, violent criminals spend their days behind high walls, but here it is the well-off who do so,' maintains Vinicius Caldeira Brant, a sociologist at the Brazilian Centre for Analysis and Planning, CEBRAP, who repeatedly suffered at the hands of the military regime in power until 1985. But Alphaville is 'a market necessity,' says Takaoka in justification. 'We create the conditions for heaven on earth.'

If the Alphaville guards seldom use their Colts nowadays, declares boss Sandorf, 'this is because the mob knows how good security is here'. Only at his second employer's, the military police, are there no cobwebs in the gun barrels, for the law on the streets is: 'The more you can do, the less you complain.' And what if one day the hungry were to rise up around Alphaville? 'I hope I'm on duty that day,' comes back Sandorf with something like relish in his thin smile. 'Then I can line them up in my sights.'

Alphaville – a world model? Since the consequences of globalization tear the social fabric even in countries that have so far known prosperity, there are more and more copies of these perfidious enclaves: in South Africa around Cape Town and in the wine district of Stellenbosch, for example, where divisions based on race and wealth are still cultivated after the official end of apartheid; obviously in the United States, where high walls surrounding property à la Beverly Hills and private security guards have become status symbols from Buckhead near Atlanta to Miranda near Berkeley; in France, but also in the coastal areas of Italy, Spain and Portugal; or in New Delhi and in the guarded condominiums and tower blocks of Singapore. Even islands once used to hold political prisoners and fighters for social justice are now being converted into refuges for those who have been left with their wealth and do not wish to pay the bill for their arrogance. The enchanted Ilha Grande, off the east coast of South America, is one such example.

Nor are Brazilian values alien to the new Germany. In its search for investors, the country's oldest sea resort, Heilgendamm, has fallen under the Cologne-based property group Fundus. In the days of Kaiser Wilhelm, before it started to decay, the celebrated 'white city' near Rostock on the Baltic, with its two dozen classical villas, was the favourite summer resort of the aristocracy. Today, spruced up with 150 to 250 luxury dwellings plus an enlarged and renovated Grand Hotel, it is becoming the new exclusive refuge of an upper crust and men from the world of high finance who often prefer the shadows to sunlight. The condition Heilgendamm has to meet is that it should lay more roads and allow strict access restrictions. New fences to be put up in the former GDR? 'The main thing is that something is happening here at last,' says Günter Schmidt, whose lease is running out on an atmospheric but dilapidated café that survives mainly on the custom of students who still find accommoda-

tion in Heilgendamm. 'Special ladies and gentlemen naturally have a special need for security – otherwise they simply won't come.'[16]

This is how the 20:80 society would eventually look. But today, long before it is fully established, there are already stirrings of resistance which paint the past in rosy colours and bear markedly authoritarian features.

Prosperity chauvinism and irrationality: the modern radical Peter Tischler

'They'll be astounded,' the German radical Peter Tischler keeps threatening on the way to Berlin, and he means nearly everyone down below. 'We take in 200,000 *Aussiedler* a year, and the French, the Spanish, are all laughing because we do it. The boat is full, but now they are coming from the East. They get everything paid for them, while we have to toil and sweat. Where I live, the Germans from Russia have some pretty fancy property. We'd have to put down security at a bank, but they get it paid for them by the state.'

The rage of the patriotic computer expert against the homeward-bound Germans passes seamlessly into a more familiar xenophobia. 'The number of foreigners is much too high, and now unemployment is rising. There's too big a burden on social security, and a lot of it comes from people signing on and doing work on the side. They'd better watch out that things don't get really dangerous in Germany.'

They? 'The government people, and the foreigners too, of course,' explains Tischler. 'It's hardly surprising that Germany has all these problems now as an economic location. I wanted to set up as a young entrepreneur, but the state demands so much that you can forget about it. With the conditions they make, you might as well keep right out of it.' At the same time, he thinks he knows why German companies are going through a patch of turbulence: 'We buy much too much abroad for production here in Germany, and so the quality suffers as a result. There are hardly any German products any more.'

Until the late 1980s things were still moving upwards: what we need is to plug into the strengths of those times. Germany as the world's master-exporter would give politicians something to work on, 'and they'd have to think about the citizens again'. It's completely

unacceptable that 'Kurds can simply block the motorways'. Tischler had been going to catch a flight to Algeria from Dusseldorf airport, 'and they never wait for me there'. The globetrotting computer man does see a solution: 'I'd have brought in the border guards or the special forces and had it cleared in five minutes.'

As a voter, Tischler does not really feel at home with the Republikaner, despite all their well-known slogans. 'The problem, unfortunately, is that we don't have a real party in Germany.' Everything would be different 'if we got someone like Jörg Haider in Austria'.

And so, as the plane flies through Alpine–Prussian air space, Tischler describes the features of a radical modern civil movement. It would 'bring order back to our country. A party like that could easily get 20 to 30 per cent of the vote'. When he finally feels the ground under his feet again in the German capital, he has a deeply contented look on his face for a number of minutes. Although the Lufthansa flight connects two cities within the European Union, meticulous border guards sit in their booths in the narrow arrivals hall. 'I like it that they still check your passports here,' says the otherwise hurried systems analyst, 'even if I have to wait an hour.' There are no more delays after passport control. The orderly citizen quickens his pace to be on time for his appointment.

Fundamentalist saviours: scientology, Ross Perot, Jörg Haider

The stature of Helmut Kohl in Germany may still obscure what can no longer be ignored in nearly every other industrialized country. More and more voters are turning away from their traditional representatives. As if guided by an invisible hand, they withdraw their support from parties of the centre and seek refuge with the right-wing populists. The old political institutions are crumbling, again most visibly in the United States. US citizens have usually been quite reticent at election time: even in 1960, the spectacular presidential contest between Kennedy and Nixon drew no more than 60.7 per cent to the polls. In 1992, only 24.2 per cent of those entitled to vote actually cast their ballot for the winner, Bill Clinton, while the right-wing populist Ross Perot at his first try won 10.6 per cent – or 19 per cent of all valid votes cast.

In the summer of 1996, as four years earlier, Perot was lying far behind in the opinion polls. But this time he could rely upon the well-oiled apparatus of his own Reform Party, which consults its members via the Internet.[17] The Greens, for their part, having been disappointed by Clinton's anti-minority and anti-ecological populism, officially named a candidate of their own for the first time in a presidential election. He is the consumers' champion Ralph Nader, who wants to start 'building an aggressive political force of the future'.[18]

As these candidates pick up support in elections, the integrative capacity of two two big American parties declines still further – and a lot of space is thus created for markedly irrational decisions and decision-makers. A few years ago, for example, it would still have been unthinkable in the world's main country of immigration that the Republican and Democratic candidates should vie with each other in excluding immigrants. But in August 1996 the former football star Jack Kemp had almost to beat his breast while recanting his relatively tolerant position on illegal aliens, as the price for his nomination as Bob Dole's vice-presidential candidate.[19]

Sensitive political observers warn in alarmist tones about current changes in what has so far been the world's most stable parliamentary democracy. 'We are in a prefascist situation,' says the prominent Washington journalist and author William Greider, who has often shown himself to have a sharp feeling for political trends.[20] In 1987, for example, his *Secrets of the Temple* spelt out how the US central bank 'governs the country', and in 1992 he was on the *New York Times* best-seller list with his *Who Will Tell the People?*, which analysed his country's dubious political system under the sub-title *The Betrayal of American Democracy*.

There are far-right Republicans closely linked to the neo-Nazi spectrum and bomb-planting militias, then the 'crazies' who call for 'independent states' against the central power in Washington and are often nothing other than losers in the prosperity stakes, and finally the sects such as Scientology, which experts regard as a 'new form of political extremism'. All this adds up to a most unwholesome brew.[21]

'Fascism springs from certain trends in the economy and in financial policy. Any authoritarian American politician with some credibility who promises to give the people bread, mixing this in with racist overtones, will soon be riding high,' prophesies Greider.

This nearly happened in 1996 when Pat Buchanan, the nationalist advocate of protectionism, won one victory after another in the Republican primaries to choose a presidential candidate. The Giessen political scientist Claus Leggewie, who now teaches at New York University, thinks it is 'not exaggerated to detect echoes of early types of European fascism in Buchanan's programme'.[22] Buchanan's popular attack on big business practices, with its elements of anti-Semitism and xenophobia, went too far for the Republican establishment and the excellently organized Christian Coalition (which, with its 1.7 million members, has become a central force in the Republican Party). In the end, therefore, Buchanan's challenge was blocked.

Nevertheless, 'the 'Buchanan movement' recalls contemporary European national-populists such as Jörg Haider, Umberto Bossi and Jean-Marie Le Pen, who also present themselves as outsiders, crusade against immigrants, and clamour for sweeping privatization and moral cleansing. Leggewie takes the parallel further: 'What for them is Vienna, Rome, Paris or Brussels, is for Buchanan Washington. And he too makes use of tax-revolt ideas.' The strengths of these new Rights are not yet the people who represent them, but the seductive power of their ideas. As the US election campaign neared its peak in 1996, Buchanan himself was no longer an issue, but his themes were still playing a major role.

Authoritarianism follows in reaction to an excess of neo-liberalism as a wild fire spreads on parched fields. New Zealand, for instance, which started its deregulation early on, now has to contend with an irrational, racist counter-movement, 'New Zealand First', whose leader Winston Peters made a major breakthrough in the elections of autumn 1996. Neighbouring Australia, not much used to international attention, hit the headlines in mid-August because the new conservative government was planning such draconian labour laws and public spending cuts that aborigines, workers and students stormed parliament.[23] The xenophobes are on the advance even in Sweden, which used to be so open to the world, as well as in Switzerland, Italy, France and Belgium.

As these examples show, fundamentalism is not just a problem confined to Islam. 'We all have our Zyuganovs,' wrote a commentator in the *International Herald Tribune*, alluding to the backward-looking Russian communist Gennady Zyuganov.[24] But again it is the Austrians who have gone furthest down this road. Since 1986 the

far-right populist Jörg Haider has been galloping forward at a rate which (he makes bold to think) will carry him into the president's office by the end of the millennium. Only his verbal slips, which awaken memories of the 1000-year Reich in the 1000-year-old Österreich, have so far been damaging enough to hold him back, if only for a short time.

The professional populist, still looking youthful in his mid-forties, profits like none of his co-thinkers around the world from Austria's specially cultivated insularity. When it joined the European Union in January 1995 – a move which Haider vehemently opposed, even though there was no alternative – the Alpine republic was exposed to the powerful subjective shock of adapting to European standards of efficiency. At the same time, it is like the rest of the EU in having to grapple with the consequences of globalization. For the majority of Austrians, who in case of doubt always tend towards escapist denial, this is a twin challenge that puts them under intolerable pressure. 'We shall be elected by the natural-thinking people,' says Haider, without realizing that the chosen one will land his electors in even more difficult straits. For the enchanter is also a radical free-marketeer who boasts of having learnt from the neo-liberal Jeffrey Sachs at Harvard University 'how one prepares the economy for global challenges'. In the election campaign of autumn 1996 the streets of Vienna were lined with placards: 'Vienna must not become Chicago', 'Like this Vienna will remain our home', and, most force-fully, 'Election day is when you make them pay' (Wahltag ist Zahltag). The Social Democrat under-secretary Karl Schlögl admitted: 'We are in a dangerous situation'. And Peter Marizzi, secretary of the once-red party, predicted: 'It will be a disaster.'[25]

First projection: return of the imperial and royal capital

If one had to predict who the future winners will be, on the basis of present trends and an analysis of early votes, then the former imperial and royal capital Vienna would be well out in front. It is true that the metropolis which, at the turn of the last century, was the seventh-largest on the planet is today far down the list of 325 cities with a population over a million. But soon it may be able to profit as much from its compact dimensions as from its past grandeur.

If the climate-induced rise in sea levels expected by 2050 at the latest will threaten most of the world's monster cities, and if mountainous areas everywhere will have to face mudslides that beggar description, the Viennese birthplace of modernism will come out of it all nicely, having a temperate continental climate despite global warming, no sea in sight, and only the gently rolling hills of the much-sung Wienerwald, which has already been defended once against the Turkish armies.

The regents of today have learnt from the mistakes of the Habsburgs. Unlike in the turmoil of the last *fin-de-siècle*, the influx of unwanted aliens has been stopped before it could really get going. No unwashed Bosnian masses, no hordes of gypsies or even black African black-marketeers will disturb the idyll of the new Viennese upper classes, in a part of the city just next to where more than 100,000 Jews sought refuge a century ago from still worse poverty and fresh pogroms in Eastern Europe.

No need to worry about Jewish expulsions this time, it really wouldn't pay off, hardly any are left there any more – this is the sort of malicious gossip that can now be heard around the pub tables, and by no means only in the capital. But Vienna's anti-Semitism, its ultra-efficient export product, has a contemporary and no less promising successor in the shape of xenophobia without foreigners.

The grand coalition of Social Democrats and People's Party that still rules Austria gave wise forethought to these matters as early as 1994, not only, of course, from fear of what the Haider vote so clearly revealed about the popular mentality. The Council of Ministers, with its customary unanimity, adopted a set of laws that put the country behind everywhere else in Western Europe in its policy for the integration of immigrants. Each year, just a few thousand foreigners unable to wave an EU passport – most of them highly qualified managerial types or professional sportsmen – receive a one-off work permit.

That does not matter at all for Haider; on the contrary, xenophobia has finally become accepted in polite society. Politics too is being Haiderized, even without the man himself in power. Thus, when Social Democrat Interior Minister Caspar Einem, a direct descendant of Germany's Chancellor Bismarck, dropped a bare hint of generosity on the question of uniting families, his advisers had to justify themselves like schoolchildren before their Social Democrat

chancellor's closest confidants, as if Einem had just taken it into his head to argue that heroin dealers should go scot-free.

At the elections of October 1996, the Social Democrats were clearly in danger of losing the absolute majority on the Vienna City Council that they had held for decades. With this in mind, their transport spokesman in the capital, Johann Hatzl, saw legal action as the way forward: 'I can perfectly well imagine our establishing from a review that someone with a residence permit [that is, a foreigner legally living in Austria] regularly incurs fines for speeding or parking offences. That also shows a lack of will to integrate. The residence permit should then be withdrawn.'[26]

Despite such purges, the worsening economic situation means that unsightly poverty and tiresome aggression cannot always be prevented, even on the part of non-foreigners. In the 'golden red' 1920s, the Social Democrats made an effort through housing development to turn the Gürtel (the near-circle of streets around inner Vienna) into a 'proletarian ringroad' to rival the splendid old Ring itself. The road has since become a transport nightmare, with prostitutes, mainly from Eastern Europe, lined up along the parking lane. Haider instinctively fumes against the 'slummification' of this and adjacent areas, whose cheap housing is mostly inhabited by immigrant workers from south-east Europe. The city hall is now pushing an 'urban Gürtel plus' initiative designed to upgrade the area.

Visionary it certainly is not. As Hatzl and Haider see things, a hi-tech wall running along the *Gürtel* would replace the original Ring which protected the city until 1850 against the Turks and other interlopers. In the imperial metropolis so rich in tradition, not only would this provide secure jobs for the period of crisis; Vienna would also have a pilot project that commanded the whole world's attention. The now so politically turbulent capital, which never wanted to be a city of movement, might thus soon have in its healthy core that peace and quiet which has always been so valued in its history.

A welcome is extended, however, to all kinds of refugee money. For decades, banks protected by strict secrecy have been entering it in their books, in branches that enjoy a picturesque location within the restored inner city. According to an Austrian television report, on the occasion of the murder of a shady Georgian businessman in the city centre, the few select Russian visitors spend more money in Vienna on an average day than the whole flood of German tourists.[27]

The guests from Russia are especially prized by estate agents (who used to prefer offering villas to Saudi millionaires) and by jewellers. Sales of precious stones are breaking all records in the lavishly refurbished boutiques of leading dealers.

'Luxury is socially presentable everywhere in the world and no longer has to cover itself up: it is accepted and respected, and is even at the centre of public interest. This is one of the key trends of the 1990s. With its boutique renovation in Vienna, Cartier is at the forefront of this trend.' The missive in which Cartier Joailliers imparted this information to its customers in July 1996 was rather self-importantly affixed to the advertising panel outside its branch on the noble Kohlmarkt, just next to Demel's, the sweet-smelling but ill-famed imperial confectionery.

The letter was torn down several times, as if it had something wrong with it, and the wall was even smeared with crude anti-capitalist graffiti. Sauntering passers-by expressed their indignation. Eventually, then, the Cartier manageress had to repaper the whole panel with expensively printed company paper. Laser-backed surveillance of the city walls, together with smart cards encoding personal data and efficient controls at passageways and underground stations, would put an end to such nuisances once and for all. Thoughtlessly, the elegant underground trains also extend into the outer districts. Stupidly, they do not provide an escape route to the airport. Reasonably enough, however, rents and house prices inside the Gürtel are already so high that local residents tend to be Cartier customers rather than work-shy graffiti-scrawlers.

Speed, speed, speed: turbo-capitalism is too much for everyone

No, one wants to scream, no and no again. May such a rebirth of Vienna be only a dream, a bad or at worst a successful Hollywood thriller, but not something real, not the actual shape of things to come! Let it be a false prediction of the kind usually made before elections. May it all prove to be a fantastic distortion, a hallucination caused by the excessive speed of globalization which leaves hardly any time for sober thought.

It is precisely speed, 'the acceleration of the process of creative destruction', that is 'the new feature of market economics in present-

day capitalism', argues the economist Edward Luttwak, who has coined the term 'turbo-capitalism' to refer to this.[28] The 'horrendous pace of change', argues the Romanian-born American who has also made a name for himself as a historian and military strategist, is becoming a 'trauma for a large part of the population'.[29]

Luttwak is close to the Republican Party, but he attacks its leaders head on when, like presidential candidate Bob Dole, they evoke 'family values' yet pursue the opposite policies. 'Whoever thinks that the stability of families and communities is important cannot at the same time speak in favour of deregulation and globalization of the economy, for these pave the way for rapid technological change. The break-up of American families, the visible collapse of communities that have given a meaning to life in many parts of the world, the unrest in countries such as Mexico, are consequences of the same destructive force.'[30]

For Luttwak, an 'already classical example of the consequences of turbo-capitalism' is the deregulation of air transport in the United States, which has certainly led to cheaper ticket prices but also to waves of redundancies and to 'chaotic, unstable airline companies'. This development 'would be an interesting subject for sociological study. How many divorces, and therefore problem children, may it have caused? How much economic stress may it have brought for the families of airline employees?'[31]

There is another, no less weighty, consequence of the tremendous speed. In the framework of global competition, the supply of commodities changes so fast that even a thirty-year-old finds alien the consumption world of a teenager. Many people cannot grasp how to use electronic entertainment and computers. Millions of employees have to retrain virtually from the beginning more than once in their working lives. Those who want to get on must show proof of 'mobility', of a willingness to move home at frequent intervals. 'It is completely crazy,' says Robert Weninger in the Herrengasse, a street where Karl Marx made fiery speeches against exploitation during the revolutionary year of 1848. 'It used to be enough to repair one burst pipe a day, but now it has to be at least eight. In building work as well, some people have to do many times more than they used to.'

At this speed, many are inevitably left behind, either unable or unwilling to keep changing their picture of the world and to perform at maximum their whole life long. Basic career choices or company

decisions are often taken in a dangerously hectic manner, while politicians are always expected to deliver an instant reaction. Party preferences may change even in the polling booth and render obsolete the most up-to-date forecasts. Passing moods and impressions thus become the foundation of far-reaching decisions. Weninger, who operated as a plumber for twenty-five years, could no longer find work and is now a casual caretaker for the security firm Group 4. He always used to vote for the Social Democrats, but since 1994 it has been 'Jörg Haider, of course. He really should be tried out.'[32]

In self-defence, 'I develop in times like these a sympathy for certain kinds of inefficiency or even sloppiness,' says Ehrenfried Natter, an economist and organizational consultant in Vienna.[33] The 'pauses for breath' which the cautious West Austrian thinker Franz Köb encourages as an individual 'slowing of time' have suddenly become the global talk of the town.[34]

'Globalization leads to a speed of structural change that more and more people are unable to cope with,' notes even Tyll Necker, the long-serving president of the Association of German Industry (BDI), who nevertheless still points with pride to his 'major in-volvement in the debate on locational factors' in Germany.[35] Now the once so self-important industrial leader considers that 'a serious discussion of the effects of globalization' is 'long overdue'. The present dynamic is putting everyone under intolerable pressure – by no means just ordinary voters, but also the global players who are supposed to be invulnerable.

7. Perpetrators or victims?
The poor global players and the welcoming
back of compulsion

'I know, ladies and gentlemen: everything is very complicated, just like the world in which we live.' Austrian Chancellor Fred Sinowatz in his government statement, 1983

Personal protection against assassination is still as disturbingly erratic as the weather. Someone who wants to attend a world-level UN conference on the East River in New York receives, after intensive questioning, a photographic identity card welded into a plastic holder. Then he must join a long queue to go through the meticulous checks, before finally entering the headquarters of the United Nations that Le Corbusier laid out fifty years ago as so open and inviting. Each body is searched, each pocket probed by attentive hands. The fear of attack is present everywhere.[1]

If you can refer to a personal appointment with the secretary-general, however, you glide through the obstacles as if you were a ghost. All you have to do is mention his name; the duty guard does not want to see any proof of identity, and after a quick call to the executive floor the way is clear. On the thirty-eighth floor of the UN skyscraper, the guest is greeted by the unimaginative insignia of power, a cold sterility and rooms so big that they dwarf human beings. There is not a single armed guard.[2]

Boutros Boutros-Ghali lives dangerously open to attack. Like so many world celebrities, he looks much smaller and frailer in real life than he does on the television screen; permanent conflicts surrounding his global commitment have left behind visible traces. It is 22 July 1996. He has been on his feet since three in the morning, trying once more in vain to arouse the world community before all it can

do is react to the consequences of the latest outbreak of fighting. It has been reported to him that at least 300 Hutu civilians have been murdered in Burundi, and that further massacres are looming. Yet France remains silent and the US too; after all, the Clinton administration is in the middle of an election campaign.

For some time, globalization has been Boutros-Ghali's central theme. In order to talk about it, he extends his fifteen-hour day with yet another hour's work. 'There are not just one but several globalizations – of information, for example, of drugs, of epidemics, of environmental effects, and above all of finance. A major complication has appeared, because these different globalizations are proceeding at very different speeds.' He is slowly warming up as he speaks. 'Take an example. It is true that at global conferences – most recently in Naples – we talk about things like transnational crime. But that is an extremely slow reaction in comparison with the speed at which crime itself has been globalized.'

The varied and non-synchronized global changes, continues Boutros-Ghali, 'enormously complicate the problem and may give rise to dangerous tensions'. The future of democracy has become his greatest worry. 'That is the real danger. Will globalization be steered by an authoritarian or a democratic system? We urgently need an agenda, a world plan for democratization.' That is true for every member-state of the UN and for their relations with one another. 'What use is it to us', asks the man at the top of the United Nations, 'if democracy is defended in a few countries, while the global system is directed by an authoritarian system, therefore by technocrats?'

As a result of globalization, 'individual states have less and less capacity to influence things, while the powers of global players – in the realm of finance, for example – grow and grow without being controlled by anyone.' Are the major heads of state, Boutros-Ghali's constant interlocutors, aware of this? 'No,' he shakes his head in resignation. 'As leaders of their country, they are still under the impression that they have national sovereignty at their disposal, and that they can cope on a national level with globalization.' He adds diplomatically: 'Of course, I wouldn't want to cast doubt on the political leaders' intelligence.'

Then the Egyptian secretary-general of the UN, who also had fourteen years' experience as a member of government in Cairo, comes out with the following: 'In so many spheres, the political

leaders no longer have real sovereignty of decision-making. But they have the idea that they themselves can still resolve the central questions. I mean, they have only the fancy, only the illusion, that this is so.'

The old complaint that the stress of everyday business keeps politicians from thinking about long-term problems is, in Boutros-Ghali's view, true everywhere in the world. 'In a very, very poor country somewhere in Central Africa, changes in the price of cocoa or seed-corn are as important as whether it rains or not. No one there is aware of the globalization process. In a powerful country like Germany, on the other hand, which is currently preoccupied with the unification of two states, political leaders think that globalization is comparable to environmental problems, that it is possible to wait and solve it at some later date.'

A principal witness and victim of this fateful strategy is Klaus Töpfer, for many years German minister of the environment and currently minister of regional planning and urban development. 'At best we criticize after the event and, if in doubt, are happy to look the other way because we get scared of the dramatic nature of the task.' It is a July afternoon in Bonn, just after he has returned from Berlin and shortly before his flight to New York.[3] 'Subconsciously perhaps one looks away because the question of how we are to solve everything is becoming almost too difficult.'

At the UN conference on the environment held in Rio de Janeiro in 1992, Töpfer had the image of a sought-after mediator between North and South. At the time the US administration, usually so dominant in international debates, was amazingly lacking in direction, for suddenly it could no longer rely, as Töpfer put it, on the 'counterforce ways of proceeding acquired in bipolar negotiations' during the Cold War. Four years after his marvellous performance at Rio, which earned him praise even in the *New York Times*, the world negotiator can only shake his head at the ruins spreading before him.

In spring 1996 he spent some time at the elite Dartmouth College in the woods of New Hampshire. 'What incredibly impressed me there (I won't say frustrated) was that students and even lecturers and professors see two possibilities with the approach of global warming. Either the scientific prognoses are wrong – which would be fantastic. Or they are right – in which case we can no longer prevent

the consequences, because it is psychologically impossible to pass on the costs to citizens. Socially and politically, then, the necessary economic restructuring cannot be carried through.'

With such calculating and perhaps not even cynical views, a generation of young scientists and future managers from all over the world are entering the third millennium AD. The leading CDU politician Töpfer is, after all his experiences, 'really very surprised how quickly the global character of the problems proved to be something for a sunny day, a challenge you get down to only when there are no other problems. I thought the results of the Rio conference would have more prophylactic power in relation to the crisis. But all these conventions and agreements fell very quickly into a box marked: Open in a good economic situation.'

High politics closes people's eyes. Nothing goes on without the US superpower, but in the United States nothing at all is going on. 'The woeful tale of the energy-tax discussions is still very fresh,' remarks Töpfer, referring to the bungled attempts by Bill Clinton and his team in spring 1993 to make at least a start on an ecological tax. In Rio in 1992, at receptions on terraces high above Copacabana, Al Gore appeared as a well-informed senator offering marvellous hopes. But since he became vice-president later that year, the 'ways to equilibrium' that he advocated in his best-seller have remained a completely dead letter. With the Clinton–Gore team back in the White House thanks to their populist appeal, the knowledgeable vice-president will soon have to cultivate his own image to be in the running for the top position in the year 2000. But Töpfer is still pessimistic: 'I don't think anyone in America would stand a better chance for the presidency by developing an ecological image.'

Meanwhile, at the UN World Population Conference held in September 1994 in 5000-year-old Cairo, encouraging vistas opened up for the world just five years after the fall of the Berlin Wall. Speaking before delegates from 155 countries, with a pathos that Americans usually sink into only when acclaiming their own country, Al Gore praised the South Indian state of Kerala for its judicious health system. No matter that the government there had for decades been run by enemies of the American system, by communists even.

'What's more, the population growth-rate fell to near zero,' said the vice-president in a tone of amazement.[4] He even self-critically admitted that successes such as Kerala's and 'insights from developing

countries are given much too little attention'; now he wanted to 'outgrow borders'. Hollow words?

The assembled world community listened and kept silent. Gore could finally bathe in warm-hearted applause when, like an excited boy, he told the conference of a Sunday morning four years before. He had sat with his youngest son in front of the television, to experience together the release 'of the brave and visionary Nelson Mandela', another radical scorned for years in America.

Hardly had the attractive vice-president departed when Clinton's close associate Timothy Wirth took command of the US delegation. The Harvard and Stanford graduate was already a veteran liberal congressman when the president appointed him the first secretary of state 'for global affairs'. 'Everything is possible,' Wirth enthused in Cairo and smiled at the 'bizarre coalitions'.[5] He was even in high spirits as he talked of a meeting with government representatives from the enemy country Iran, 'which now fully supports our position on family planning'.

The contrast with Rio 1992 could hardly have been more striking. Whereas George Bush's Republicans liked to play at ignorant stone-walling beneath the Sugar Loaf Mountain, Clinton's Democrats cultivated an image of themselves as flexible slave-drivers beside the Nile. They seemed to be coping almost playfully with the confused new world free of blocs. There has to be a population policy, they argued; it is beneficial to everyone, poor as well as rich. The speeches were so convinced and convincing that local Islamic fundamentalists could no longer gain a hearing even among their Egyptian compatriots.

Suddenly it was the long-hated Americans who were showing competent and liberal leadership on human issues, in a way that corresponded to the new realities in the world. Gore and Wirth, both tried and tested global activists, abstained from superficial great-power affectations, and no one could escape their charm and bustle. 'For a long time it was not realized that the aphorism "Think globally, act locally" is fast becoming reality.' The feeling was gradually growing that responses are possible through new international institutions instead of at a purely national level. 'The new world order is being drawn up at UN conferences of this kind,' announced Wirth. Operations such as those in Bosnia and Rwanda were, in comparison, only 'firefighting operations'.

A few months later, there was hardly an intellectual who showed more clearly than Wirth what U-turns the US administration could perform out of opportunism towards its insecure electorate. After Gingrich's Republican extremists swept into Congress in November 1994, Wirth was only a shadow of his former self at the negotiations to prepare the World Social Summit in Copenhagen in January 1995. Lacking enthusiasm and saying little, he threw out proposals made by various groups and constantly referred to 'the Republican majorities in Congress that make our international commitment so difficult' – nothing but practical constraints, instead of bold (if also open to attack) leadership.

In the style of the new masters of Congress, Wirth called an end to the ritual whereby 'around midnight on the last day of a UN conference, a heap of money is placed on the table to be shared out'; that was 'old thinking'. In 1996, consistently enough, the Clinton administration waged an ignoble propaganda campaign against the United Nations and, without any grounds, demanded the replacement of Boutros-Ghali in order to placate its own uninformed, anti-UN electorate.[6]

Breathless reaction instead of considered action, costly repairs instead of prudent avoidance of false paths: this is all that can now be expected of high politics, in the view of the global players. Michel Camdessus, who, as head of the IMF in Washington, is a key link between the political world and the realm of the money markets, stresses that 'people must know that their own action, but also their inaction, always carries world-wide consequences'.[7] This is how he justifies his night-time Mexico coup in January 1995, when he tried to overcome 'the first crisis of the twenty-first century' by lending out 18 billion dollars provided by contributors to the IMF (see Chapter 3). Camdessus is also convinced that 'in a globalized world, one can no longer afford not to adapt'. He leaves no doubt that Wall Street and its fund managers are the ones who call the shots: 'The world is in the hands of these guys.'

'These guys', as he calls them, flatly reject his view. No, they argue, we are not in the driving seat either; no, we do not bear the responsibility either. 'It is not us, it is the marketplace,' comes the unanimous refrain – from Michael Snow, who is fixing a high-risk 'hedge fund' on New York's Park Avenue for the Swiss bank UBS,[8] to the multi-billion-dollar speculator Steve Trent in Washington, from

whose exquisite crane's nest of an office the White House looks like a Lego model.[9]

'Think of Belgium or Austria, for example,' suggests Trent. 'It is always the national investors who wander off with their money and cause problems in their own country. If the risk is low and the expected yield is high, it is Austrian and Belgian insurance companies and banks who will put more and more of the money saved in their country into Argentina, for example. And why will they act like that? They do it for Austrian investors and their Austrian clients. It is not American financial institutions, but rather individual decision-makers, who will make the best possible decision for them. So you really cannot hold us responsible, as a globally speculating firm, for any resulting collapse of a national currency or any major outflow of capital. We only ever operate in the markets of major countries or with major currencies.'

Vincent Truglia, vice-president of Moody's Investors Service, offers an even simpler justification.[10] 'Our advisory service with its three A's has become a market metaphor. We cannot allow ourselves any emotion towards individual countries or firms. In my work I think only of those aged grandmothers who have invested their money in funds. They rely on getting the highest possible return, whether because they have no other regular pension or simply because their grandchild can go to a good college only with earnings from the fund to pay the high tuition fees. So when I help these grandmothers, I am helping everyone who invests.'

The new self-satisfaction of fund and industry investors around the world can have powerful effects on a small country. This was seen by the Austrian economist Ferdinand Lacina, who was Europe's most experienced finance minister until he withdrew from governmental politics in April 1995. 'The investment fund managers are largely non-political,' considers Lacina, 'and yet market liberalization is an ideology.'[11] All too often this has meant that 'everyone who is verbally for competition very soon comes to think that the market has been wrecked, and that state help and subsidies are necessary, as soon as real competition occurs'.

Even if subsidies are frowned upon within the European Union, 'a lot is now done through tax breaks. Before an investor decides for a particular location or an industrial enterprise builds a new plant, it will always be made very clear indeed whether any taxes have to be

paid and, if so, how tight the squeeze will be.' Whereas steel companies, for example, used to establish themselves for decades at a particular production site and created thousands of jobs, such decisions in the microelectronic age – at Siemens, for example – 'often last only for a few years and bring only a couple of hundred jobs'. Globalization, with its 'increasing levels of stress', has greatly restricted national sovereignty, admits Lacina, who now runs giro operations at the Austrian Savings Bank. 'But which politician will readily concede that he is in fact governed by practical constraints?'

Certainly not Mikhail Gorbachev. With the fall of the Wall he opened up the last third of the world to the open-borders market, yet he unswervingly believes in his own comeback and in democratic socialism. He savoured the applause like a sovereign at that memorable conference at the Fairmont Hotel in September 1995. California was the last major area in the world to discover the fundamental changes that had been taking place in the East, and now it is the last place where Gorbachev is still feted as a hero. 'The international system is not stable,' spells out the last president of the Soviet Union, in a suite at the Fairmont paid for him by US sponsors.[12] 'Politics lags behinds events. We act like a fire-engine that goes off to various fires in Europe and the world. We are all too late in what we do.'

Then the near-legendary figure, who seems like an eight-cylinder Jaguar revving to go but without the necessary wheels, attacks the growing 'social polarization which leads only to division, and which eventually becomes so great that class struggle is unavoidable. Instead of that, we need social partnership and solidarity.'

The keyword 'partnership' makes an impression even on US media mogul Ted Turner, who like Gorbachev is also holding court at the Fairmont. Visibly satisfied with himself, Turner points out that his CNN television devotes countless air-minutes not only to the spectacular events of the day but also to the issues that will shape the future of the 'one world' for which he calls. At the World Population Conference in Cairo in 1994, for example, he gave evidence of how much he takes birth control to heart. His global broadcast whipped up the conference into a 'historic event'. No titbit from the negotiations was too banal not to merit yet another special 'Beyond the Numbers' broadcast with a budget of millions.

As criticisms were made of the evident manipulation, CNN staff tried to drown them out with the dangerous argument that it was all

in the service of a 'damned good cause'. At official UN receptions, people close to Turner drunkenly disputed with long-serving CNN producers over who had brought Ted and his Oscar-winning wife Jane Fonda onto the Green straight and narrow. In personal conversation, the man who figures in *Forbes* magazine's list of the 400 wealthiest people on earth can leave a lasting impression that he has grasped what is at stake in today's world.[13] 'The big billionaires are busy getting rid of middle managers before the day when they can make pension demands on the company. We are in the process of becoming like Mexico and Brazil, where the rich live Hollywood-style behind fences. Many of my friends employ an army of bodyguards for fear of being kidnapped.'

The angular-featured self-made billionaire, sitting in his modestly protected CNN Center in Atlanta, becomes indignant that the mega-rich spend proportionately far less per annum than simple millionaires for social and ecological purposes. 'That is monstrous,' says Turner. 'The federal government is broke, the individual state governments are broke, and so are the city governments. All the money is in the hands of those few rich people, and not one of them is giving anything away. That's dangerous for them and for the country. We might have a new French Revolution here, with another Madame Defarge knitting as these guys are brought to the town square on ox carts and "boom", off with their heads.'

The cable-television visionary parted with 200 million dollars in 1994 in favour of several universities and environmental initiatives, but he did so with a heavy heart. 'My hand was trembling as I signed the papers, because I knew I had taken myself out of the race to be the richest man in America.' Instead of being glad to give, he felt a gnawing fear of social downgrading – perverse if humanly understandable. Turner, who has also made a name for himself as a sportsman, believes that 'this *Forbes* 400 list is destroying our country, because it means that the new super-rich don't open their wads of banknotes'. He would like to start a new ranking of the most generous givers, and at the same time implement a wealth-disarmament treaty. 'If each of us gave away a billion, we would all slip down the list together.'

Turner would still certainly remain well near the top; his business is flourishing in Atlanta and Hollywood, and soon he will be able to feed news and documentaries through the huge new HBO cable

channel, which was the subject of speculation at the Atlanta Olympics in July 1996 during a CNN lap on the margins of the women's cycling race. Turner is at most concerned about the future of his media empire, as his footprints have got too big for his carefree children. The market has triumphed – which is good for everyone: All else is a question of adjustment.

'We will only make real progress, though, when we realize that changes are unavoidable.' This is the course set in Europe by Tyll Necker, for many years president of the Association of German Industry.[14] Also on the bridge of the corporate ship plying the seas of world competition is Hermann Franz, a member for thirteen years of the Siemens board and now its chief executive. Year after year the giant company records remarkable profits: 1.27 billion dollars worldwide in 1995, which was 18.8 per cent up on 1994. And yet the fifth-largest world corporation in Germany is slimming its labour force by another 383,000 employees.

'Look,' says Franz in the baroque rooms of the company's headquarters on Munich's Wittelsbacherplatz, 'an hour's work of a woman producing Volkswagen harnesses costs forty-five marks in Nuremberg. In Lithuania it's not even one mark fifty, and the factory buildings are provided free of charge. So we really have to think about Volkswagen and produce as cost-effectively as possible.'[15] Presumably the Siemens top man is troubled by scruples and dissatisfaction about the new social question, for he admits that 'there will be frictions'. Then he immediately adds: 'Industry is not responsible for them, though.' Franz is therefore becoming a prisoner in the net that he himself has helped to mesh. With his eyes open, he drives social divisions forward and yet feels himself to be only an obedient executor of world-market laws. Siemens operates on a world scale with its headquarters in Germany, 'but we have a duty to all our employees throughout the world'. If the EU tried to protect itself, the company would (with a heavy heart) have to move its headquarters to the United States or the Far East. There are new opportunities especially in the East, enthuses the global player. As long ago as 1993 Franz was predicting radical changes in Germany: 'We must all realize that labour has become too expensive here, even if many employees are not yet aware of this.' And so, 'we will say goodbye to many simple industrial activities in Germany. Instead of bank and coffee machines, more people of flesh and blood will again

have to work here' – at correspondingly reduced, often extremely low wages.

These are striking sentences, particularly in Germany, and they reveal a dull sense of unease among managers in the lands of Europe. In small circles of intimates, they ponder more and more often the incalculable risks that they run – or rather, think they have to run – in what the British economist Susan Strange calls the new global 'casino capitalism'. China, South Korea, Indonesia, Saudi Arabia; all these hopeful markets must be opened up, economic leaders insist in public, if the chance for further growth in turnover and profits is not to be missed. Yet no one can sleep soundly any more in the Middle East and Asia sweepstakes.

'The main problem is that cultural systems are so different throughout the world,' top manager Anton Schneider begins his analysis. Schneider is a 'dairy boy', the son of a master cheese-producer from the Bregenzerwald area, the triangle of land where Switzerland, Germany and Austria meet. He grew up with six brothers and sisters, became a sharp-witted left-wing trade union economist, and then began at the international Boston Consulting firm a remarkable career as an industrial rehabilitation expert. This took him in 1995 to the top position in the ailing Cologne-based KHD or Klöckner-Humboldt-Deutz Corporation.[16]

'What some call fair play and fair treatment is for others culturally incomprehensible. A Korean, for example, will pursue a definite protectionism completely as a matter of course and tell the world that this is fair play – something that we are unable to grasp. The Saudis are also impossible to understand: they are members of the new World Trade Organization, the WTO, and also have good support from the Americans, but their values are nevertheless completely different. That is the basic mistake in this scheme of one market fused together on a world scale.'

In north-west Europe and the United States, according to Schneider, 'over a period of two hundred years, a comparatively purist Protestant capitalism and a market economy have become generally accepted, with rules that we all keep in principle. Perhaps it is looser in the Catholic parts, but they also go to confession there. In the Asian–Buddhist regions, on the other hand, our rules and regulations are not taken very seriously; land and family count for much more.'

Globalization brings together players from all firms and nations, as in a world football championship. To stay with the metaphor, however, this means that in the world of big economic decisions there are not yet even common rules of the game, let alone agreed referees. 'That is just how things are,' confirms the KHD chief. 'Many cultures bring quite different rules with them into the game. I don't want to judge which ones are better or worse. But anyway, many new players and teams do not at all know and understand what we understand by fair competition.'

Schneider then draws his conclusions. 'I think nearly all big European firms see themselves as driven by economic globalization. Or who seriously believes that any big European corporation feels happy about its investments in China? Not a single one does, because each knows that there is no legal system there which protects our rights. Nor is that true only of China. If there is no investment protection, no know-how protection, then you forget about it all. Every joint venture being signed nowadays has a maximum life of thirty years. After that, everything belongs to the Chinese.'

Why this worldwide commitment, then? 'We've got to do it,' replies the captain of industry. 'We want to participate in these markets and so we climb aboard on the terms offered us. We have to get into the markets. For naturally it is better for me to be in than for the competition to be there. But it doesn't make anyone feel happy.'

Fear is a poor counsellor, and chief executives know this as well as popular wisdom. However one acts, serious mistakes appear inevitable. If a top manager, faced with more than understandable concerns about how things are going, simply presses on regardless, he soon runs the risk that re-engineering, outsourcing and downsizing will destroy more than they save. But if he runs away from modern times and just defensively tries not to do anything wrong, he is already doing nearly everything wrong.

What, then, are the global players of politics and finance, economics and the media: just people driven by events, or wilful perpetrators of them?

8. Who does the state belong to? The decline of politics and the future of national sovereignty

'The only things organized between states in Europe are crime and capitalism.' Kurt Tucholsky 1927

'If the industrialists have put all the money abroad, that is called the seriousness of the situation.' Kurt Tucholsky 1930

In early March 1996, 250 tax inspectors searched for incriminating documents in the foreign business and tax department of the Commerzbank in Frankfurt. The head of the fourth largest German bank, one of the big names in the world of high finance, soon found this getting on his nerves. Martin Kohlhaussen complained that he and his bank were victims of a state-organized conspiracy: the search was a 'deliberate operation against our bank, our clients and ourselves,' he wrote in a house report to his colleagues. No board member had 'infringed current legislation': 'Our bank has nothing to reproach itself with. We are all being unjustly treated as criminals.'

Kohlhaussen actually knew better. On the very day when his denials were being used for PR, his fellow board-members Klaus Patig and Norbert Käsbeck composed a letter to Frankfurt's Tax Office III in which they admitted serious violations in the hope of avoiding prosecution. The balances declared to the revenue authorities contained a number of 'inaccuracies', they said. 'Valuation adjustments relating to demands apportionable to corporate sites abroad probably did not enter with fiscal effect into the foreign results.' Or in plain language: the bank reduced its official domestic profits, and hence its tax liability, by several times offsetting losses from foreign subsidiaries against the profits of the German parent company. Because they were all too clumsy in the way they went about it, the

196

loss transfer was not in this case admissible for legal purposes, reported *Der Spiegel* shortly afterwards, referring to the tax inspectors. The bank, it was said, had been making false declarations for a whole decade since 1984; in 1988 alone its tax people had undercalculated by 700 million marks the Commerzbank profits liable for tax, and over the years a total of half a billion marks had eluded the tax authorities.[1]

This was the first time that the tax inspectors of the state of Hessen brought solid evidence into the public domain, but insiders and finance authorities had been reporting similar cases for years. In the context of global integration, transnational companies operated within a legal grey area that made it easy to keep the taxing of profits to a minimum. With the spectacular raid in the heart of Germany's banking capital, the German finance authorities marked the provisional highpoint of their two-year offensive against tax evasion by individual citizens and firms. In more than forty branches of such renowned institutions as the Dresdner Bank, the Bayerischer Hypotheken- und Wechselbank, and the US Merrill Lynch bank, they impounded material relating to the accounts of several thousand customers suspected of having transferred their assets to Luxembourg, Liechtenstein and elsewhere in order to avoid taxation. Finally – or so it seemed to many observers – the time when the authorities had adopted a *laissez-faire* approach to the permanent tax holiday organized by the banks was over. Helmut Kohl even announced his *Schadenfreude* on hearing of the investigations, because one German *Land* where tax evasion was treated as a trivial offence had 'already lost its future'.

The chancellor judged the danger well, but this is no cause for rejoicing. However often and deeply the tax authorities check and investigate, they cannot win the war that remained dormant for so many years over the taxation of unearned private income and corporate profits. For only poorly informed individuals or particularly audacious managers use illegal methods to avoid paying tax; well-run businesses and money-managers do not find that necessary. Without any breach of the law, the jungle of the transnational money market allows the tax burden to be massively reduced, in some cases even below 10 per cent.

'You won't be getting any more from us!'

How does it work? Germany's big corporations have been giving demonstrations for a long time. BMW, for example, the country's most profitable auto company, still reported in 1988 profits of a good 545 million marks to the tax authorities. Four years later, they had fallen to a mere 6 per cent of that amount, just 31 million marks. The next year, despite rising total profits and unchanged dividends, BMW actually declared losses on its domestic operations and got a refund of 32 million marks from the tax office. 'We try to make spending originate where taxes are highest, and that is inside the country,' BMW finance director Volker Doppelfeld explained frankly. Analysts of the sector calculate that in this way, between 1989 and 1993, the corporation saved paying more than a billion marks to the state.[2]

The electrical engineering giant Siemens has moved its head-quarters abroad. In 1994–95, out of total profits of 2.1 billion marks, the sum raised by the German revenue did not even reach 100 million marks, and in 1996 Siemens paid nothing at all.[3] Daimler-Benz, for its part, tersely mentions in its business report for 1994 that tax on profits mainly 'fell abroad'. Even Kohlhaussen from the Commerzbank reported at the end of March 1996 that his experts had now learnt how fiscal obligations can be legally circumvented. As if in defiance, just three weeks after the inspectors swooped on his office, he produced a balance that as good as mocks ordinary taxpayers. In 1995, it shows, the bank's trading profit doubled to reach 1.4 billion marks, but its payments to the state fell by half over the same period to less than 100 million marks.[4]

The dramatic shrinking of taxes is not a speciality of large corporations: numerous medium-sized firms manage to do the same. By systematically exploiting differences between national tax systems, they can internationally optimize their overall liability. The simplest method is what experts call 'transfer pricing', which is based on a cross-border combination of subsidiaries and branches. Since they trade with one another in unfinished products, services or even just licences, the firms are able to charge costs to one another in almost any way they please. The expenditure of internationally active companies is therefore always highest where tax rates are also highest. Conversely, subsidiaries operating in tax havens or low-tax regions

always make exorbitant profits, even if all they have there are an office with a fax connection and a staff of two.

State inspectors have no means of controlling this practice. Often it cannot be proved whether the prices in intra-firm trade are too high or not, because comparable market prices scarcely exist for many of the items in question. The authorities can dig deeper only when the corporate planners cheat too brazenly. In high-taxing Japan, for example, numerous transnational corporations went much too far in the early 1990s with their attempts to massage the figures. In autumn 1994 the Finance Ministry in Tokyo recovered the equivalent of just under 2 billion marks from more than sixty companies – including such world leaders as Ciba-Geigy and Coca-Cola – because the transfer prices entered in their books were far too high. One of the firms in question was the German pharmaceuticals giant Hoechst, which was accused of having overcharged its subsidiaries some 100 million marks between 1990 and 1992 for deliveries of raw materials.[5]

Such little coups on the part of irritated tax officials naturally do not dent organized tax avoidance. Where transfer pricing no longer brings in enough, various other tricks can help out. 'Double-dip leasing', for instance, can serve a number of purposes. Companies take advantage of different national tax write-offs on new equipment, so that the costs of purchasing machinery, power stations or aircraft are used to reduce their tax liability in two countries at once. Also very widespread is the 'Dutch sandwich' method, which combines a subsidiary in the Netherlands with a company location in a tax haven such as the Netherlands Antilles or Switzerland. The two sets of tax laws can then be used in such a way that nine-tenths of the company's profits are taxed at a rate of just 5 per cent.

Governments and legislatures around the world naturally try to counter these and similar practices by improving their control methods and by closing tax loopholes. Usually this does not have much effect. 'In the end, any movements can be disguised through the complexity of the firm's structure,' promised a tax lawyer who looks after a worldwide circle of clients. In this field 'it is like in a hare and tortoise race,' agrees the leading tax expert at the German economics ministry, Johannes Höfer. 'The really good tax advisers are always a step ahead of the Revenue.'[6]

In recent decades, then, companies operating across borders have been able to draw nearly the whole world into a 'tax system

competition', as Bonn's finance undersecretary Hansgeorg Hauser puts it. Because individual countries compete with one another for investment, and because their tax inspectors are so clearly impotent, the only thing left for them is to fall in line with the lowest existing level. The downward trend began in 1986, when the US government set a new standard by reducing the tax on profits for joint-stock companies from 46 per cent to 34 per cent. In the years since then, most other industrialized countries have had to follow suit.

Meanwhile, competition has assumed grotesque forms among the countries of the European Union. Since 1990 Belgium has proposed to companies active in at least four countries that they establish so-called coordination centres, centralizing all kinds of services such as advertising, marketing, legal advice and especially finance. They are expected to pay tax there not on the profits they make, but only on a small part of their local company earnings. The model has become a winner, with a list of beneficiaries ranging from the oil multi-nationals Exxon and Mobil to the tyre producer Continental. Opel saves on taxes by having its finance headquarters in Antwerp, Volkswagen has sent its financiers to Brussels, Daimler has put tax avoiders into the suburb of Zaventem, and colleagues from BMW have accommodation in Bornem. Thanks to Belgian generosity, finance branches in the heart of the EU have generally become the most profitable subsidiaries. Thus, according to its balance sheet, BMW supposedly made a third of its total profits in the Belgian branch, without a single car being produced there.[7] Even more attractive is the tax break that the Irish government offers to anyone who has their financial business run from an office in the Dublin Docks. Out of every pound that is formally earned through a branch in Ireland, only 10 pence go to the Irish public purse. This is why tiny branches of nearly 500 transnational companies can now be found in the glass palaces surrounding the former harbour – 'just addresses', as the head of the German–Irish Chamber of Commerce underlined. Alongside Mitsubishi and Chase Manhattan, all the big German banks and insurance companies are represented there, and even the Kassel-based Evangelical Credit Cooperative has a fortune handled here. The German inland revenue estimated that by 1994 German companies alone were using the Ireland trail to hide away some 25 billion marks.[8]

The consequences of open-borders tax tourism are plain to see,

and yet the whole question remains taboo in political debate. Together with monetary policy, including the management of interest and exchange rates, a further key area of national sovereignty is gradually being lost in the transnational economy: namely, the power to set rates of taxation. The German Institute for Economic Research in Berlin has calculated that, contrary to the appearance of high taxes, the *average* effective rate of taxation on corporate and self-employed profits actually fell in the Federal Republic from 37 per cent in 1980 to just 25 per cent in 1994. Nor is this just a German phenomenon. In the tax competition, the rate for companies is on its way down not only in certain countries but everywhere in the world. In 1991 the Siemens empire still paid nearly half its profits to the 180 states in which it had branches. Just four years later, this proportion had shrunk to 20 per cent.

It is no longer democratically elected governments which decide the level of taxes; rather, the people who direct the flow of capital and goods themselves establish what contribution they wish to make to state expenditure. As is well known to so many global players, at the end of April 1996 Daimler-Benz chief Jürgen Schrempp painfully spelt things out to the parliamentary experts on the state budget. By the year 2000 at the latest, he mentioned in passing at a dinner with Bundestag deputies, his company will no longer pay in Germany any taxes at all on profits. 'You won't be getting any more from us.' The representatives of the people could only listen in embarrassed silence, when finance director Manfred Genz later explained in detail about the settlement of profits with foreign countries and about investments in Eastern Germany.[9]

Black holes in the state coffers

The shrivelling of public finances as a result of the open-borders economy is not only apparent on the revenue side. The new transnational also steers a growing part of public spending into its own coffers. Competition to pay the least goes together with competition to extract the most generous subsidies. Here the cost-free provision of land, including all necessary road or rail connections plus electricity and water, is already the minimum expected throughout the world. Wherever a corporation wants to build a plant, its cost-planners can also count on all manner of public donations and subsidies. The

Korean giant Samsung, for example, in building its new electronics plant in the North of England with an investment value of a billion dollars, is able to draw on a good 100 million dollars from the British Treasury. That is already a very handy sum, but countries and regions that want to become sites within the Mercedes-Benz network must put up considerably more. The taxpayers of France and the EU are already committed to direct subsidization of a quarter of the cost of the new Mercedes plant in Lorraine, which will produce its planned small car. If the anticipated tax breaks are also taken into account, the public contribution – without any voting rights – will come to a third of the total outlay.[10] That is by no means uncommon. Once one is outside the conurbations, such a level of subsidy is more or less the European norm. But depending on the level of unemployment and of political disorientation, there seems to be no upper limit. In 1993, for instance, Mercedes-Benz paid only 55 per cent of the start-up costs for a new plant in the comparatively poor state of Alabama. Beside this, the ten-year tax holiday that General Motors stipulated in 1996 in Poland and Thailand appears decidedly modest.

The present record for investment-steering through tax breaks was set by the federal government in Eastern Germany. For example, the American electronics corporation Advanced Micro Devices is being refunded 800 million marks – or 35 per cent of its planned outlay – for a new microchip factory in Dresden. In addition, the federal government and the state of Saxony are providing loan security to the tune of a full billion marks, and a banking consortium of which the state government is part has contributed a further 500 million marks. At the final count, then, the corporation does not have to put up even a fifth of the total outlay; almost the entire market risk falls on the taxpayer's shoulders.[11] Things are the same at the Opel and Volkswagen plants in Chemnitz, Mosel and Eisenach. Modernization of the Baltic shipyards under the direction of the Bremen-based Vulkan and the Norwegian giant Kvaerner – which is tantamount to a refoundation – is planned to swallow up 6.1 billion marks. Following the bankruptcy of the Vulkan combine, which put part of the subsidies into its ailing West German companies, another half a billion will presumably have to be found. Clearly the attempt to entice international corporations with generous subsidies can turn into a black hole for public finances, as the Kohl government first really discovered in the case of the chemical industry in the old

GDR industrial region around Buna, Leuna and Bitterfeld. It was there that the chancellor himself stumbled into the trap.

'Think of our families!'

When Helmut Kohl landed by helicopter in Schkopau on 10 May 1991, it was initially just one election fixture like so many others. At the House of Culture in the Buna plant, he tried to enlist people's trust and 'to demonstrate hope', but then he experienced at close hand the despair of a population facing impoverishment. 'Think of our families!' called out a worker just behind the first barrier. In the room inside, the chair of the Buna works committee urged him to press on with privatization so that at least the remaining 8000 jobs could be saved out of the former 18,000. 'Please get things moving, please don't disappoint us!' the spokeswoman begged the chancellor. This evidently got under the skin of the elephant of German politics. Brought up himself in the BASF company-town of Ludwigshafen, he could not oppose what the chemical workers were demanding. Throwing away his prepared speech, he said it 'went without saying' that their trust would not be betrayed. He personally gave his word 'for the preservation of this production site'.

It was well meant and humanly understandable, but it was also one of the costliest mistakes of Kohl's time in office. For the federal government was now open to all kinds of blackmail. Despite Kohl's promise, the boards of the three German chemical giants pointed to the state of the old works and firmly said no. In their place, however, some managers of the US corporation Dow Chemical saw that fortune was smiling on them. Bernhard Brümmer, once head of Dow's Gulf Coast operation, was managing the business of the former Buna combine for the Treuhandanstalt (the trust responsible for selling off East German industry), and so a former Dow man had all the necessary information at his fingertips. At first, the board of the world's fifth largest chemical company merely signalled an interest and made some vague offers. Then, in a bargaining marathon lasting a year, the corporation's lawyers really took the Treuhand representatives to the cleaners. The chancellor's promise had condemned them to work something out, and they became more and more entangled in a thicket of pledges and assurances. Finally, on 1 June 1995, the three largest enterprises of the old Buna combine

passed under the name BSL Olefinverbund into the ownership of
Dow Chemical; the firms' lawyers had in their hands a contract
promising them a risk-free deal worth billions of marks. The cor-
poration itself would pay a mere 200 million marks out of the
expected outlay of 4 billion marks, and even that would be only in
the form of an interest-bearing loan from the parent company. At
the same time, BVS – the successor to the Treuhand – had to
undertake that it would make good all BSL losses until the end of
1999, up to a maximum of 2.7 billion marks. Since the company
would probably start with a loss of 3.2 billion marks carried forward
on its balance sheet, Dow would not be liable to pay any taxes at all
for the foreseeable future, even if profits were to come rolling in. For
thirty years, the company could have all toxic waste cleared from the
soil at public expense, and would also have a pipeline laid on to
Rostock's international port. What was expected in return proved to
be almost laughable. Dow promised no more than 1800 jobs, and
then only until the year 1999. Nor was it much of a problem for
Dow managers if the figure turned out to be lower. For each job less
they would have to pay a penalty of 60,000 marks – a pittance in
comparison with the sums involved.

At the end of the day, then, the Federal Republic will probably
find itself subsidizing every job at BSL to the tune of more than 5
million marks – which makes a crazy total of nearly 10 billion marks.
Even if the public money were used to build skyscrapers in the
middle of the Thuringian Forest, it would give more people a liveli-
hood. Invested in urban renewal, the tourist industry and higher
education, the same investment would certainly bring Eastern
Germany a step closer to levels in the West. That the public heard
anything at all about the grotesque terms of the Buna deal is thanks
only to some *Spiegel* journalists who spent months investigating the
story behind the contract. With information from BVS staff, they
showed that Dow Chemical would, without any risk, make a profit
of at least 1.5 billion marks, even if the whole venture failed.[12] When
the story broke, there was hardly a voice raised in protest. But then
which leading politician would have been likely to object? Kohl may
have done badly in Buna, but nearly every politician responsible for
economic affairs has had similar experiences – and in the end every
job does count.

In every *Land* in Germany, the research and development minister

is just as undiscriminating with the tax revenue entrusted to him. In 1993 Daimler-Benz, for example, which no longer pays any taxes itself, pocketed more than 500 million marks in federal research money. More than a quarter of the total spent in federal grants for science was thus allocated to a single firm which, with the subsidized results, can start making money tomorrow at the other end of the earth, without creating so much as one new job in Germany. Siemens has also made a nice profit through the policy insecurity resulting from the new rules of the game in the global economy. For years supporters of the old national industrial policy – men such as Konrad Seitz, former head of the planning department at the Foreign Ministry – warned that Japan and the United States were threatening to monopolize the production of microchips, the raw material for the computer age. The German federal government and the EU Commission then worthily invested several billion marks of research money in European electronics corporations, especially Siemens – all to no avail. Today the Munich-based corporation is developing next-generation chips together with its ostensible rivals, IBM and Toshiba. From 1998 Siemens will even have a joint factory with the US technology firm Motorola in Richmond, Virginia, where the top-performing 64-megabit computer chip, developed with support from the EU, is due to start production.[13]

The ruinous and often senseless subsidy-auction reveals how politicians and governments have lost their way in the labyrinth of the global economy. 'The pressure of international competition drives governments to offer financial inducements that cannot be justified by objective economic criteria,' concludes the UN trade organization, UNCTAD, which is currently investigating subsidy practices around the world. Ways must be urgently found 'to prevent such excesses'.[14] Yet the political executives of world-market integration, driven to show voters that they are doing something about unemployment, do not realize that in the long run their costly incentives to companies are doing their country nothing but harm. As they raid the budget to maintain the national share of the world economic cake, they impose a microeconomic logic which is leading the macroeconomy towards disaster. Even if one leaves out of account the traditionally subsidized sectors – agriculture, mining, housing and railways – it is cautiously estimated that subsidies to industry are costing more than 100 billion marks a year in Germany alone.

The scale of this transfer of wealth significantly affects the structure of the state. Neo-liberal prophets at Kiel's World Economy Institute employ a metaphor from biology to define the new role of the state as the mere 'host' for the transnational economy. This implies, of course, that the companies interlocking across borders have an increasingly parasitical character: their goods are transported on publicly funded roads and tracks; their employees send their children to public schools; and their managers enjoy performances in state-supported theatres and operas. For these and other facilities, their only contribution is through the tax on the income and consumption of their factory and office workers. But since incomes from work are tending to decline under the impact of competition, and many wage-earners are actually near the threshold for welfare supplements, one country after another is facing a structural crisis of public finances. State budgets are subject to the same downward pressure that bears on the incomes of the population, but in the highly organized industrial economies, the demands on the state are moving up rather than down. New technologies make infrastructural maintenance ever more expensive, environmental damage calls for ever greater restorative measures, and the growing average age of the population requires more money to be spent on pensions and medical services. As a result, the politicians in charge often have no choice but to cut spending in areas where no powerful interest groups prevent it: that is, in social security, cultural facilities and public services, from swimming-baths to schools and universities. The state thus becomes an agency of bottom-to-top redistribution. Impressive evidence of this is the draft budget legislation presented in summer 1996 for the coming year by the German federal government. If this is approved, the income coming into private and public budgets will be cut by 14.6 billion marks, while companies and the self-employed will have their tax burden reduced by the same amount.[15]

In the United States and Britain, whose governments early on initiated the 'retreat of the state', it can be seen what happens when public finances are slashed for the benefit of the free-market economy. Money is everywhere lacking for the upkeep or even the completion of public infrastructure. Proportionately to GDP, the state in the USA invests a mere third of what Japan spends on its roads and railways, its schools, universities and hospitals.[16] In Washington, for example, the majority of schools are fit only for demolition. The

mayor states that 1.2 billion dollars would be necessary to bring the buildings back into shape – more or less the same as the amount which the city police says it needs to maintain its technical equipment and its fleet of cars. Congress refuses to pay up. Schools can carry on meaningful business only if volunteers lend a helping hand, while the police force has to carry out repairs at its own expense if it is to go on functioning.[17] In Britain too, the European model of neo-liberalism, the social and educational system is approaching the level of a developing country. Every third child there grows up in poverty, and 1.5 million children under the age of sixteen have to work because of the lack of social support. Whereas four-fifths of eighteen-year-olds on the continent are undergoing higher education, fewer than half of young people that age are still learning something in Britain. At the same time, illiteracy rates show a sharp rise. Already a fifth of all twenty-one-year-olds – according to a representative sample – are unable to do simple sums in their head, and a seventh can neither read nor write.[18]

In comparatively rich Germany, where prosperity has for long been shared around and citizens expect comprehensive provision from the state, this process has only just begun. A sign of things to come, however, is the rude awakening in the richest, and also most indebted, city in the republic, Frankfurt am Main. In 1990 the Social Democrat mayor of the day, Volker Hauff, still declared: 'Frankfurt's wealth is there for all.' Six years later, the city treasurer Tom Königs, a member of the Greens, can do nothing except take this promise back step by step. While areas of social spending so far protected by law cost three times more than they did, Frankfurt's main source of income, the trade tax, actually brings in less than in 1986, despite the 440 bank branches operating in the city and economic growth of more than 20 per cent. Now thirty out of forty-six neighbourhood centres are scheduled to close down. Half a dozen swimming-baths are either up for sale or down for closure. There is no longer any money for social projects such as meeting-places for local residents or im-migrants; music schools and museums are being 'downsized'. The season at the Theater am Turm is a mere six weeks, and the director of the opera is threatening to cancel performances because of grant cuts. So far the sacrifices have not been all that great, but Königs is full of dark forebodings: 'There is a risk that it will become much more difficult to achieve a social balance.' If the trend continues,

'the peaceful coexistence of classes, nations and lifestyles in Frankfurt will blow up in our faces'.[19]

Open-border crime

The forced cuts in public spending demote politicians to mere proxies who refer to the higher powers of economic progress to absolve them of responsibility for acute poverty. This undermines the foundations of the democratic state. Nevertheless, chronic financial problems are only one among many symptoms of the decline of politics. Along with monetary and fiscal sovereignty, another conquest of the nation-state is also starting to shake: the monopoly of violence. For just as banks and corporations profit from the removal of legal fetters on the economy, so too do the criminal multinationals. Throughout the industrialized world, the police and judiciary report that organized crime is growing by leaps and bounds. 'What is good for free trade is also good for criminals,' an Interpol officer soberly notes.[20] According to a group of experts set up in 1989 from the seven largest industrial nations, the turnover of the world heroin market went up more than twentyfold in the two decades up to 1990, while the cocaine trade increased more than fiftyfold.[21] Someone who knows how to sell drugs can tap into any other illegal market. Duty-free cigarettes and other contraband, weapons, stolen cars, illegal immigrants – these are outstripping drugs as the main source of income in the criminal economy. The smuggling of immigrants alone, a modern form of the slave trade, is estimated by the US authorities to have brought in profits of 2.5 billion dollars a year to the Chinese 'triads'.[22]

In Europe, the explosive growth of cigarette smuggling testifies to the new power of the illegal traders. Up to the late 1980s, the evasion of tobacco duty was mainly an Italian problem, but in 1990 a number of tightly knit organizations branched out into the European single market. Two years later, 347 million untaxed cigarettes were confiscated in Germany, and by 1995 the figure was up to 750 million. Tax inspectors estimate that this represents some 5 per cent of the total cigarette trade, and the Cologne-based Tax Crime Department puts the annual loss of revenue at 1.5 billion marks in Germany, or somewhere between 6 and 8 billion marks in the EU as a whole.

The smuggling boom is not due to police shortcomings. There is quite precise knowledge of the organizations and their outlets, states

public prosecutor Hans-Jürgen Kolb, head of the economic crime task force in Augsburg, which has been studying the business since 1992.[23] The goods usually originate in US tobacco factories, whose quite regular exports to Europe are temporarily stored in the duty-free ports at Rotterdam or Hamburg, or in their Swiss counterparts, the so-called 'free stores'. There it is not only legal West European importers who do business; large quantities are also ordered for export to Eastern Europe or Africa by limited companies registered in Cyprus, Liechtenstein or Panama. The cargo then sets off in sealed lorries for its journey across EU territory, but it never reaches its destination, being swapped for dummy goods before the next border crossing. If a shipper is under observation and the driver suspects something, his clients tell him by satellite phone to continue with the original transport until he has crossed enough borders to shake off the pursuers. Since a profit of at least 1.5 million marks per lorry is quite common, it is no problem to sacrifice or pay duty on the occasional load – for the police, faced with a huge increase in the volume of trafficking, cannot hope to control more than a fraction of the trade. Sometimes an astonishing number of contraband cigarettes are seized, but that hardly affects the illegal business itself, as it is always only small-fry couriers or distributors who are arrested. The real organizers are respectable businessmen who cannot be touched. 'We know the names of these people, but we can't get at them,' complains Kolb. Liechtenstein or Panama are certainly not within reach, so international police cooperation ends there at the latest.

What worries investigators much more is the fact that they are no longer able to seize the assets of criminal corporations. However efficient the police and judiciary are at their work, the collected proceeds remain untouchable in the unlegislated space of the global money market. Tax evaders are not the only ones to shelter behind the banking secrecy of capital-flight zones, which the international finance community fights tooth and nail to defend. It is no accident that the most important tax havens have developed along the main routes of the drugs trade. This is how Susan Strange sums up the function of offshore sites for the underground economy:

> Panama and the Bahamas are well known for their financial clearing of the transactions in cocaine between Latin America and the United

States. Hong Kong plays a similar role for the heroin coming from
South-East Asia towards the West, while Switzerland, Liechtenstein or
Gibraltar shelter the illegal proceeds of the heroin produced and
exported by traffickers from Turkey and other Middle East countries.[24]

At the same time, the strictest laws against money-laundering are
unable to halt the infiltration of legal sectors by criminal investors.
'If you want to launder ill-gotten gains, you can do it without a
problem almost anywhere in today's world,' is the frank admission of
banker Folker Streib, who used to work for the Commerzbank in
Asia and Africa and now heads its Berlin branch.[25]

The consequences are frightening. Experts reckon that organized
crime is now the fastest-growing branch of the world economy,
bringing in profits of 500 billion dollars a year. In a study for the
German Crime Department, researchers from the University of
Münster predicted that by the year 2000 Germany would witness a
35 per cent rise in crimes such as trafficking in human beings, illegal
casual labour, receiving of stolen cars, and protection rackets.[26] As
their stock of capital increases, the criminal cartels acquire ever
greater power to corrupt legal businesses and state agencies, or even
to take them over. The weaker the state, the greater the danger. In
Russia and Ukraine, Colombia and Hong Kong, legal and illegal
business activity pass smoothly into each other. No one can tell any
longer which parts of the state apparatus still defend the rule of law,
and which have been contracted by one set of criminals to wage war
on their rivals. Even Italy, despite some spectacular arrests, has not
yet won its battle against the mafia. The capital of the old bosses has
been transferred without a hitch to unknown heirs who have only to
modernize their organizations. By June 1996, just 2.2 billion marks
had been seized out of the estimated total wealth of 150 to 200
billion marks in the hands of the big four Italian syndicates. Even
then, mafia lawyers are suing the state for the return of two-thirds
of that sum, on the grounds that it was earned from legitimate
business.[27]

Operating from base countries with support from the banks, the
criminal networks are gradually spreading into the rich, apparently
still well-functioning, parts of the world. In Germany too, contract
killing is no longer an exotic crime. In the war between the rival
Vietnamese gangs that organize sales for the cigarette mafia in East-
ern Germany, nineteen people died in Berlin in just the first half of

1996. Here too the border between legality and illegality is becoming blurred. Even serious banks and corporations can become mixed up in crooked dealings without the knowledge of senior management. If a rival company controlled by criminals uses illegal methods, employees are soon tempted to follow suit. Name-your-own-price bribes also help to lower inhibition thresholds. In an anonymous survey of executives, conducted by the KPMG auditing firm in several hundred companies from eighteen countries, nearly half the respondents said that they considered the growth of economic crime to be a major problem.[28]

In all four corners of the world, the state and politics are visibly in retreat. Even anti-trust legislation, once the bedrock to protect the market economy from entrepreneurial conspiracies against consumers or taxpayers, is today losing its efficacy; it already means next to nothing on the global markets for air travel, chemicals or film and broadcasting rights. How can it still be checked whether the three big Euro-American alliances formed between Lufthansa, British Airways and Air France and their respective US partners have fixed things in advance, if they have first driven to the wall all smaller rivals on the transatlantic routes? And what of such media moguls as Leo Kirch, Rupert Murdoch and the three giants Time Warner/ CNN, Disney/ABC and Bertelsmann/CLT? Who is to prevent them from fixing higher prices whenever they like and carving out zones of influence?

Environmental politics is also falling by the wayside. In the competition to persuade companies to provide jobs, governments have generally abandoned or postponed the aim of ecological reform. In summer 1996, most climatologists viewed the flooding disaster in China and America's third successive drought of the century as harbingers of catastrophe due to the concentration of greenhouse gases in the atmosphere. Yet nothing is done; even the appeals of many environment ministers sound tired and unconvincing.

The list of ways in which the state abdicates in the face of world-market anarchy could be extended almost indefinitely. Governments throughout the world are losing the capacity even to steer their country's development. At every level the system failure of global integration is becoming apparent. As the flow of goods and capital has become available worldwide, regulation and control have remained a national responsibility. Economics is devouring politics.

Contrary to a widespread view, however, the growing impotence of the state is not at all due to an overall shrinkage of its apparatus, or even – as the Japanese visionary and former Asia-chief of McKinsey's, Kenichi Ohmae, suspects – to the 'end of the nation-state'.[29] For the state and its government remain the only body that citizens and voters can sue for the recovery of justice, responsibility and improvement. It is also a delusion to think, as *Newsweek* suggested in a cover article, that the league of world corporations could assume the functions of the state.[30] It has never occurred to the most powerful chief executive to take responsibility for things happening outside his corporation. That is not what he is paid for. Company heads are the first to demand state intervention when there is a fire. And so, instead of a general dwindling of public administration, the opposite is actually occurring in many places. Incapable of far-reaching reforms, ministers and civil servants are forced to get on with a kind of surrogate politics. German environmental law, for instance, now contains more than 8000 provisions – not because of a national penchant for perfect rules, but because the people in charge must protect citizens from health risks, while being powerless in the face of the general trend that is damaging the environment. The result is endless bureaucratic ballast. The same is true of tax legislation. Since a socially just reform cannot be implemented for economic reasons, politicians of all parties have created a forest of exemptions and reductions for this or that group in which tax officials have long lost any view of the whole.

The reaction of politicians to the crime threat follows the same pattern, albeit with far riskier methods. Unable to touch the capital power-base of what Bavaria's undersecretary of the interior Hermann Regensburger aptly called 'market-oriented criminal groups', they resort everywhere in the world to the strengthening of the police apparatus.[31] Despite the vigorous protest of data protection officials, a grand coalition of Christian and Social Democrats agreed in Bonn in June 1996 to legalize 'extensive bugging' with police approval. From now on, tax inspectors can eavesdrop on citizens in their own homes, even when they merely suspect them of being involved in organized crime. The state of Bavaria introduced its own 'veiled inspection' a year earlier, enabling the police to carry out at any time or place 'inspection checks independent of particular suspicions or incidents' and to arrest any citizen on mere suspicion. The extended

powers of surveillance give some idea of the direction in which things are heading. If the anarchic pressure arising from integrated markets can no longer be politically restricted, then the consequences will have to be combated with repressive means. The authoritarian state is becoming the answer to politicians' impotence in the face of economics.

It is obvious that any counter-strategy has to be based upon international cooperation. Committed scientists, environmentalists and politicians have long been calling for a closer interlinking of national policies across borders. The number of intergovernmental meetings and agreements has increased many times over. Western Europe, with the treaties on the single market and European Union, has even established a form of transnational legislation. A long series of UN conferences – from the Earth Summit in Rio de Janeiro in 1992 through the World Population Conference in Cairo in 1995 to the meeting on the future of cities in Istanbul in 1996 – signal a continuous internationalization of politics. Little by little, it would appear, a kind of worldwide coordination of governments is taking shape. As former UN secretary-general, Boutros Boutros-Ghali specifically appointed a commission of leading statesmen and women, which in 1995 presented an extensive programme for 'global governance'. At the heart of this was to be the democratic reform of the UN Security Council and the creation of a complementary 'Economic Security Council', which would help to make it more capable of action.[32] At the same time, private political initiatives have also taken on a global dimension. Greenpeace and Amnesty International have extended their struggle for environmental protection and human rights to nearly every country on the globe, and in many places they are as well known as Coca-Cola and the MTV music station. In summer 1995, the ecologists' victory over Shell and the British government in the case of the sinking of the Brent Spar oil platform was widely interpreted as a new form of supranational politics, a kind of consumers' democracy achieved through a worldwide media presence.

Is global cooperation to preserve social and ecological stability therefore becoming more of a reality? Are just a few more efforts required for a breakthrough to global governance? Judging by the number of scientific conferences and publications on the matter, we would seem to be on the threshold of the new era. But a look at the results achieved so far soon brings us back to earth.

Global governance: a useful illusion

When some 500 diplomats from 130 countries gathered in late March 1995 at the Congress Centre in Berlin to negotiate a treaty on world climate protection, hope was definitely still in the air. Environmentalists and delegates ran excitedly along the corridors of the spaceship-style concrete labyrinth and collected government support for an initiative on the island states that are in danger of sinking beneath the Pacific or Indian ocean. Japan, Germany, Scandinavia and many others were prepared to sign an accord binding the industrialized countries to reduce their emission of greenhouse gases by a quarter; it seemed that the threat of climatic disaster could be averted. But at least one person attending the conference had known better all along. His angular flabby-cheeked head on a slender body, his underlength trousers and well-worn health shoes gave him the look of an innocuous backwoodsman. Appearances were deceptive. Donald Pearlman, lawyer at the Washington firm Patton, Boggs & Blow, was the most important figure at the Berlin intergovernmental conference. Each morning he waited outside the main hall and whispered to his confederates their instructions for the day.

Pearlman made an essential contribution to the fact that, after a two-week negotiating marathon, all proposals for environmental protection evaporated into a single obscure declaration. The man with the bulldog face had no mandate himself. The Washington lobbyists' handbook shows his chambers representing the chemical giant DuPont and the three oil corporations Exxon, Texaco and Shell. Already in November 1992, their expertly organized resistance had broken the early ecological momentum of the Clinton administration. According to Christopher Flavin, vice-president of the Worldwatch Institute also present in Berlin, their campaign of 'systematic disinformation' convinced the American public that the climate peril was not yet a proven fact.

The United States cannot, as the main contributor to global warming, openly oppose the protective convention demanded by most other countries, and so the oil and coal industries had to find other ways of operating internationally. This was Pearlman's job and he accomplished it with great finesse. For three years, he travelled to each of the twenty or more preparatory sessions held in various parts of the world, and managed to line up the representatives of

the Arab oil states against any protective measures. His biggest problem was the climatologists, who were largely in agreement with one another about the impending danger. The oil lawyer therefore got scientists from Kuwait and Saudi Arabia on to the UN committee in charge of summarizing the present state of knowledge for the Berlin conference – scientists who challenged many views that had previously been beyond dispute. Meanwhile they even submitted some of Pearlman's handwritten notes as amendments and engaged in 'endless hairsplitting', Dutch climatologist Joseph Alcamo angrily reported. From his draft for a concluding report, all that remained in the end was a non-binding document without any clear statement. Pearlman was triumphant that there was 'no scientific consensus' on the climate danger. In the ensuing intergovernmental negotiations, the oil states got it agreed that decisions could only be taken unanimously, so that the adoption of an effective UN convention on the climate receded into the distant future. A follow-up conference in Geneva in July 1996 also ended without any tangible result.

The depressing snail's pace of climate diplomacy is the main weakness in the fine idea of global governance. Attempts at worldwide coordination among the various groups of states seem to confer effective dominance, and a de facto veto right, upon well-organized lobbies and individual governments. If one of the protagonists refuses to go along with something, then it is guaranteed to grind to a halt. At the same time, governments whose voters are willing to see the introduction of reforms are given a welcome argument to excuse their own lack of action.

This does not mean that worldwide cooperation is bound to fail by its very nature. The history of 'global governance' has also known some spectacular successes. The world community reacted quite rapidly and effectively, for example, to the discovery of the hole in the ozone layer above Antarctica in autumn 1995. Within two years, industrialized and developing countries negotiated a UN convention which, together with the Montreal Protocol signed in 1987 and two further rounds of tightening-up, bound all member-states to cease the production of ozone-destroying chemicals by the year 1996.

The central banks of the leading industrialized countries have established, within the framework of the Bank for International Settlements, a kind of provisional regime for the protection of the money markets from themselves, a set of minimum standards to which

global financial players are expected to conform. First, they must maintain capital of their own to a value of at least 8 per cent of the money they have out on loan; otherwise, they lose their licence and access to the network. These capital reserves have lowered the risk of another debt crisis of the kind which, in the early 1980s, brought American big banks in particular to the brink of collapse. Whatever the backsliding in individual cases, the nuclear non-proliferation treaty is also testimony to the fact that worldwide cooperation can work very well. No crime is more vigorously suppressed than dealing in the technology or materials for nuclear mass destruction.

All these instances do, of course, have one thing in common. The respective international agreement really happened only when the government of the United States took the driving seat. This was not enough by itself to guarantee success, for Russia, Western Europe and the major countries of the South can also apply the brakes. But all are in one way or another dependent on the good will of the United States, if for no other reason than the importance of the American market. It has long been the case that, although America may not be everything, nothing adds up to anything without America.

America, show the way?

Globalization, understood as the unfettering of world-market forces and the removal of economic power from the state, is for most nations a brute fact from which they cannot escape. For America, it is a process that its own economic and political elite deliberately launched and keeps in motion. The United States alone could compel the Japanese government to open its market to imports. Only the government in Washington could force the Chinese regime to close thirty video and CD factories that were making billions from copyright and product piracy. Again, it was only the Clinton administration that could talk the Russians into supporting the military intervention in Bosnia which put an end to the Balkan carnage. A 10-billion-dollar loan, coming at just the right time for Boris Yeltsin's election campaign in summer 1996, was the quid pro quo.

The last remaining superpower is thus the last nation which has still preserved a large degree of national sovereignty. Across the whole spectrum of commercial, social, financial and monetary policy, it is ultimately Washington's politicians and their advisers who set the

rules for global integration, even if they are often not themselves aware of it. Neither a quest for colonial supremacy, nor actual military superiority, but the sheer size of the American economy makes the USA the last factor of order amid the chaos of global entanglement. It is therefore quite possible that an American government will also eventually be the first to break out of the global trap. Already today the American model of total subordination to the market is nowhere criticized more severely than in the United States itself. If, between California and New Hampshire, enough people come to the conclusion that the retreat of the state is ruining their country too, then an abrupt change of direction might take place from one day to the next. The fact is, of course, that the welfare state which is now being crushed to pieces in the planetary economic machine was also first established in the USA. When the last globalization drive ended in catastrophe in the 1930s, it was the New Deal government of Franklin D. Roosevelt which invented the welfare state in order to bring poverty under control. It cannot be excluded, then, that in a couple of years' time the proverbial American pragmatism will discard the doctrines of free-market radicalism as swiftly as it made them a dogma in 1980.

'America, show the way!' is all too often the unspoken idea guiding European politics, when the great questions of the future of humanity are at issue. But in order to defuse the explosive situation brought about by the borderless market, Europe can hardly count on American leadership. Up to now, every US government has opposed any argument that economic integration should proceed at a slower pace and be brought back under state control. The Group of Seven, the only institution of any real weight involving global cooperation between governments, has therefore degenerated into an inconsequential talking shop. It is true that, at the summit of the seven heads of government held in Lyons in June 1996, French President Jacques Chirac called for 'controlled globalization'. Together with the German federal chancellor and finance minister, he spoke firmly in support of ending the ruinous competition over tax rates and of bringing the world money markets under tighter control. But thanks to American and British opposition, the final communiqué was an innocuous text in which the summit princes merely instructed the OECD bureaucracy to come up with a proposal next year.

In the same way, the US Congress and the Clinton administration

have long sabotaged any attempt to enlist the help of UN institutions in making the fusion of markets and nations governable once again. American politicians regularly make ill-considered denunciations of the UN as a rampant, useless bureaucracy that never actually achieves anything. They thereby do an injustice to most of the 9000 or so UN staff, who spend more than 70 per cent of the meagre annual budget of 2.4 billion dollars on humanitarian aid and the deployment of UN peacekeeping forces. In fact, the accusation mixes up cause and effect. While the US representative on the Security Council takes part in ordering new blue-helmet assignments and aid operations, his government breaks its obligations under international law by withholding contributions to the UN budget and running up a debt of 1.3 billion dollars.[33] Constantly on the verge of bankruptcy, the UN apparatus inevitably functions worse and worse.

American politics, marked as it is by populism and demagogy, can hardly be expected to show the world a way out of the global trap. Nor is that only a bad thing. For the American refusal offers a historic opportunity to the countries of Europe, such as they have never had before. The European Union could become a reality, and its rulers could themselves take the helm of world economic policy in their hands.

The opportunity for Europe

If one were to compare the diaries of ministers, undersecretaries and other top political figures in the fifteen countries of the European Union, the result would be rather astonishing. With the exception of weekends and holidays, there would be no day in the year when at least one, and usually ten or twenty, fifteen-member groups did not meet in Brussels to push along some piece of draft European legislation. From food controls to minimum wages in the construction industry, from immigration policy to the fight against drug-related crime, nothing happens in European politics any more without Brussels. Legislative integration within the EU has long reached a level that would have seemed unattainable just two decades earlier. This growing harmonization forces member-states to co-ordinate their activity ever more closely in nearly every area of public life.

To a considerable degree, the man who has been German federal

chancellor since 1982 is to thank for the fact that this process has come so far and overcome the obstacles in its path. Helmut Kohl's greatest success is not the achievement of German unity but his unwavering insistence on the Europeanization of national politics. It was only in December 1991, however, that he first showed how serious he is, when he initialled the Maastricht Treaty that is supposed to effect the transition from the old EC to the European Union. Against massive opposition from the Bundesbank, his own party and a large section of the conservative elite, he joined forces with France to put the old dream of monetary union on the European order of the day. With a sure instinct for power, Kohl and his then partner François Mitterrand recognized the significance of this step long before their voters or even the majority of their advisers; they understood, that is, that a common currency could become the key to political unification of the continent and bring an end to American dominance. For even if it only comes into effect in 2001, EMU will make it possible for Europe to win back a major part of state sovereignty in the realms of monetary, financial and fiscal policy. Europe's interest and exchange rates will then be much less dependent on the US market than they are today.

The cornerstone has thus already been laid for a politically unified Europe. If the member-states also find their way to a common economic and social policy, the distribution of roles on the world arena would permanently change. Supporting itself on a market with more than 400 million consumers, a politically united Europe would have no less weight than the United States of America. A European Union truly worthy of the name could insist that the tax havens be cleared, demand the enforcement of minimum social and ecological standards, or raise a turnover tax on the capital and currency trade. If there is any chance at all of binding together the world economy both politically and socially, then this is the way.

For all the speed with which Kohl and his partners have pushed the technical and organizational side of unification, they have so far failed to turn the EU into a political unit really capable of action. The EU apparatus, and its methods of opinion formation and resolution adoption, have remained stuck at the level of mere inter-state diplomacy. Most citizens are right to see the current EU project as an undemocratic monstrosity in which technocratic rule appears to be replacing their nation-states.

A simple analogy will clarify the bizarre make-up of the European confederation. Let us imagine that in Germany all laws were passed not by the Bundestag, the federal assembly, but by the Bundesrat, which consists of delegates from governments and ministries of the individual states of the republic. Let us also assume, however, that each delegate was neither subject to directives from his or her respective parliament, nor in the end accountable to it. All negotiations took place behind closed doors, and delegates were also supposed to maintain secrecy about how each one had voted. Elected members of parliament had no say in draft legislation. Instead, matters were submitted for decision by a central body of 12,000 people under no parliamentary control but advised by a whole army of industrial lobbyists. Only cynics would apply the label 'democratic' to such a system. Yet that is exactly how European legislation is made week in, week out, in Brussels.

There, in a standard marble-and-glass office block at Rondpoint Schuman, leading ministerial bureaucrats from EU states gather nearly every day according to the business on the agenda. Often a number of committees are sitting at the same time. As soon as ministers, undersecretaries, ambassadors or lower-ranking representatives enter the building, they constitutionally acquire a second identity. From administrative officials, they become mandate holders of the most important legislative body in Europe, the Council of Ministers. They modify and adopt proposals from the central authority, the EU Commission. Whatever this structure approves as a 'guideline' or 'decree' is legally binding on all fifteen member-countries, regardless of the will of each national parliament. The only function left to parliaments is to acclaim the entry of such texts into the national statutes. In this manner, the executive of the EU states is more and more writing its own laws outside of public view. At least a third of German legislation of the last decade has followed this scheme of things.

As the division of powers is in effect cancelled in favour of rule from Brussels, the seeds are laid for popular discontent with the whole project of European union. Already elections to the so-called parliament in Strasbourg are a recurrent flouting of sovereign power on a massive scale. Whichever party people vote for, none of the rulers seated in the Brussels stalls will have to give up their seat. Whole interest groups are systematically excluded from the EU decision-

making process. Against the 5000 or so lobbyists internationally organized on behalf of industry, the trade unions, environmentalist and consumer-protection groups in Brussels cannot even hope that publicity will have an effect. A bad press is no more unpleasant than bad weather for the eurocrats.

This continuation of democracy with technocratic means may be comforting to the government apparatuses, as officials are spared the trouble of public debate. As a form of government, however, it is drawing Europe further and further into a dead end where there is no scope for action. The supposed strength of the EU administrators is in reality their greatest weakness, for without democratic legitimacy no majority decision can be reached on important issues. The EU system suffers from the same defect as global governance: it always fails when governments do not agree. No one can force all fifteen countries to act at the same time. Any reform project that does not have the support of transnational industry has long since run into the sand. Meaningful environmental, social and fiscal policies are no longer developed at a European level, but neither can national parliaments any longer take steps to counter the destabilizing power of the markets; the mantra of international competition nips in the bud any attempt to go it alone. So far, economic integration has brought not the United States of Europe, but only a market without a state in which politics accentuates its own loss of power and produces more conflicts than it can solve.

Market without state

This system is bound to collapse. No oracle is required to see that, with the ministerial committee principle, it will not be long before the log-jam of reforms becomes quite intolerable. The more social tensions intensify in France, Italy, Austria, Germany and elsewhere, the more will governments be compelled to find emergency national solutions when the EU offers no perspective. The weakness of the Europe of governments is paving the way for all those populists who promise their voters that politics can once again be made national. Even if prophets of national rebirth such as Le Pen, Haider or Fini do not win a parliamentary majority, they will put the governing parties under enormous pressure. The 'national reflex', as elite EU officials mockingly call resistance to their regime, will be ever more

difficult to control, however irrational and economically pointless it may be to quit the European association.

Conflicts will arise between member-states (at the latest when monetary union is established) that will be impossible to resolve through the existing EU constitution and its back-room law-making. If, for instance, one country cannot keep up in the race to increase productivity, its economy will inevitably sink into crisis. In the past, the central bank could still soften the impact by devaluing its national currency and supporting at least the export sectors. This buffer will no longer exist after EMU. Instead, harmonization transfers will have to be made from the prosperous countries to regions in the grip of poverty. But while this kind of regional aid has been standard practice within national states, how is the Council of Ministers supposed to organize it on a European level? Tax revenues could hardly be used for this purpose without democratic legitimation, without a broad degree of understanding among the population. This could be achieved only if decisions made by the Brussels council were dragged into the light of public scrutiny, and if voters could be sure of bringing some influence to bear through the ballot box. Only then would the aspiring law-makers in the ministerial committees be compelled to explain to their voters why the welfare of the Greeks, for example, cannot be a matter of indifference. Up to now, the same obstacle has also stood in the way of a common police authority. However urgent the need is for Helmut Kohl's 'European FBI', it is unimaginable that the present system could accommodate an operational police force that carries out investigations across the whole area of the EU. Unless it were controlled by a parliament and by independent courts, it would itself only become entangled in mafia-like structures.

In the immediate future, then, the regents must face the question of how the Europe they are concocting is actually to function, and how it is to be democratized. It is often wrongly assumed that the key to the opening of Europe, as far as its citizens are concerned, is to be found in the European Parliament in Strasburg. Theoretically, the 626 Euro-deputies already have all the necessary powers to transform the present debating chamber into a genuinely democratic monitoring and legislative body. If there were a majority in favour, they could discharge the EU Commission tomorrow. By blocking the budget or the ratification of all international treaties, they could also force the Council of Ministers to comply with any demand.[34] If the

MEPs in Strasbourg were really serious in their call for a democratic Europe, they would immediately be able to assume the appropriate jurisdiction. One simple measure would suffice, from one day to the next, to make negotiations within the ministerial committees accessible to the public. No minister would dare to have the police remove deputies who had been elected with as many as half a million votes. But if the zest for democracy has not gone that far, it is because the hundred or so home-country parties represented in Strasbourg do not take seriously the problem of European democracy. Most deputies are still tied to the apron strings of their national governments, and in case of conflict it is the latter which give clear instructions on how to vote.

This record of parliamentary self-effacement suggests that Europe is not yet ripe for democracy on a continental scale: the Union is not really a state, and the focus of politics is overwhelmingly national. The Speaker himself, Klaus Hänsch, justifies the subordination of MEPs to governmental princes – and in so doing, he certainly speaks for the great majority of his colleagues. Even the German constitutional court argued in its ruling on the Maastricht Treaty that the EU is only a 'confederation' or 'association of states' (Staatenverbund) which lacks a 'European nation' (Staatsvolk). Therefore it is 'first and foremost the nations of the member-states which must give democratic legitimacy through their national parliaments to the decisions of the EU'. The lack of a common language, explained constitutional judge Dieter Grimm, already means that 'for a long time to come there will not be broad public discussion at a European level', and without real political communication across Europe, any Euro-parliament will always 'break up into national particles'. In this the EU is 'fundamentally different from the founding of the German Reich' in the last century, or from the constitution of the United States of America. For the time being, then, the 'rapid transfer of powers from the nation-states to the EU' should be 'slowed down', and the various national parliaments need to exercise 'stronger influence on the positions that the governments adopt in the Council of Ministers'.

This sounds plausible enough, but the proffered solution is not really one at all. For whether or not there are many languages or one European nation, markets and powers in Europe have long been inextricably intertwined with one another. The real European

revolution was the creation of the open market, which for better or worse fuses the participating countries together. Monetary union will further strengthen this mutual dependence. If Helmut Kohl and his partners want to make the EU capable of action, then all they need do is take the first step themselves. Two changes would be enough to put on its feet the EU's whole decision-making process. First, the commissions would have to decide by qualified majority voting (which happens at present only in matters of detail); the weighting of votes would ensure that smaller member-states had ample influence. Second, ministers would have to discuss and decide on laws in the full light of public opinion. Immediately a democratic dynamic would be unleashed throughout Europe, turbulent and contradictory but no longer to be suppressed. Germans, for example, would suddenly have to face the fact that youth poverty in Spain was also their problem. Or people in the Netherlands would realize how short-sighted their government was in protecting the right of Dutch hauliers to send an endless convoy of forty-ton lorries across its neighbours' motorways. And everyone would find out which finance ministers are responsible for the fact that companies and high-income individuals are paying hardly any tax. Soon political alliances would centre not on national territories but on common interests, and it would only be matter of time before the European Parliament became the main locus of power in the continent. That democratic processes are possible on a European scale became clear to citizens after the signing of the treaty in Maastricht. Since, exceptionally, voters in France and Denmark were required to give their approval, a truly European debate took place in the run-up to the two referendums – a debate which is still going on today. Whenever politically aware citizens from different EU countries meet one another, they now have a common theme about which they can argue the pros and cons, because their respective governments were forced to justify in public what they were doing.

Before there could be a democratic reform of the EU, however, the other main question affecting its future would have to be settled: namely, the membership of the United Kingdom. So far, British governments have played an unhappy role throughout the history of European integration. They have blocked any progress in environmental protection, especially the introduction of a Europe-wide tax on energy use. All attempts to harmonize the social policies of member-states have foundered on the rock of British resistance.

Whitehall is opposed to a common foreign policy, as well as to trade arrangements that also protect the interests of employees. Legal advisers in the City of London ensure that it is impossible to control the money markets. The sabotage of Europe reached its peak in June 1996, when John Major responded to the ban on British beef exports (imposed because of the BSE crisis) by blocking all out-standing decisions on the EU agenda. For twenty-three years British governments have violated Article 5 of the Treaty of Rome, which prohibits every member-state from 'taking measures which jeopardize the goals of this treaty'.

Ironically, most of the British hostility to EU integration stems from a deep-rooted sense of democracy. 'Democracy is at home in our country,' says John Major, echoing those of his fellow country-men who are not happy with the EU project because they are willing to bow to majority rule only in their own country, not in Europe taken as a whole. What these Euro-critics fail to see is that the national sovereignty they so ardently defend is already a thing of the past. Nevertheless, the fundamental mistrust that most Britons and British politicians feel towards European union has to be accepted as a fact, even if it is now and then expressed in chauvinist reproaches against their continental neighbours.

Conversely, the other EU countries will very soon have to confront British voters and politicians with the need to decide whether they want to cooperate, or whether they would not rather withdraw from the confederation. Once it has to consider the risks of the latter course, the British debate on Europe might possibly be conducted along more rational lines. Certainly for British industry it would be a 'nightmare' to withdraw from the EU, as Niall FitzGerald, head of Unilever and spokesman on Europe of the Confederation of British Industry, warned his fellow-countrymen.[35] Adrift from the continent, Britain's last trump-card – its role as a low-wage, weak-union zone of the European single market – would rapidly lose its value. But if the political integration project does not succeed, and there is much to suggest this, Europe will be able to move ahead only without Britain. For with the British brakes applied, all the other EU countries would also have to renounce any intervention in the economy; the grotesque result, hardly worth striving for, would be the adaptation of the whole continent to the British model. None of the other large EU countries has such low incomes, such a run-down educational

system, and such a massive polarization between rich and poor. These features are better qualifications for the 51st state of the USA than for a member of the European Union, where a majority of voters and politicians at least still strive for a greater social balance.

A democratic union underpinning a new European sovereignty which begins to tame the destructive power of the markets – this would seem to be no more than a Utopian vision. What will happen if the nations of the old continent do not take this path? There is need of a countervailing state power against the corporations, cartels and criminals, one which can support itself on the will of a majority of citizens. In the borderless market, however, no European state can achieve that alone. The European alternative to the Anglo-American style of *laissez-faire* capitalism will either develop within a democratically legitimate union, or it will not happen at all. Helmut Kohl is right to insist that European unity is a matter of life and death; it will determine whether there is to be war or peace in the twenty-first century. But he is wrong when he argues that there is 'no return to national power politics and traditional concepts of equilibrium'. Apologists for just such a return appeared a long time ago throughout Europe, and every further global twist to the downward spiral of incomes, job security and social equality provides them with millions of followers. Either the European Union succeeds in developing to the point where it can restore a balance between market and state, or it will eventually fall apart at the seams. Not much time is left to decide between these two outcomes.

9. An end to disorientation. How to get out of the dead end

'International technocracy can be effectively challenged only on its own preferred ground of economics, and only if its mutilated form of knowledge is countered with one more respectful of people and of the realities they face.' Pierre Bourdieu, professor at the Collège de France, speaking to strikers at the Gare de Lyon on 12 December 1995

How much democracy can the market tolerate? Until a few years ago there seemed little point in asking this question. For it was in the democratic societies of the West that the market economy enabled more people to lead a life without great material worries. Market plus democracy was in the end the victorious formula that forced the party dictatorships in the East to their knees.

The end of the communist regime, however, brought not the end of history but an enormous speeding up of social change. A good billion people have since been swept into the realm of world-market economics, and the integration of national economies has only now truly begun. But what the founders of the postwar welfare states had learnt through bitter experience is again becoming ever more apparent: namely, that market economy and democracy are by no means inseparable blood-brothers who peaceably increase the well-being of all. Rather, the two central models of the old industrial nations of the West continue to be in contradiction with each other.

A democratically constituted society is stable only when voters know and feel that everyone's rights and interests count for something, and not only those of people at the top of the economic ladder. Democratic politicians must therefore insist on a balance in society and limit the freedom of the individual for the common good. At the same time, however, if the market economy is to flourish, it absolutely requires entrepreneurial freedom. Only the

prospect of individual gain releases those forces which create new wealth through innovation and investment. Entrepreneurs and share-holders have therefore always sought to impose the rule of the strong – strong in capital, that is. The great success of postwar politics in the West was that it found the right balance between these two poles. This is precisely what lay behind the idea of a social market economy, which assured West Germans of peace and stability for four decades.

Now that equilibrium is being lost. As it is no longer possible for the state to direct activity in the world market, the pendulum is swinging ever further to the side of the strong. With astounding ignorance, the engineers of the new global economy throw overboard the insights gained by those who first made it a success. Constant wage cuts, longer working hours, reduced welfare benefits, and in the USA the abandonment of a whole system of social protection, are supposed to make nations 'fit' for global competition. Most corporate bosses and neo-liberal politicians consider any resistance to this programme as a futile attempt to defend a status quo that can no longer be maintained. Globalization, they say, is as unstoppable as the industrial revolution was in its day. Anyone who opposes it will go under in the end, as those machine-wreckers did in nineteenth-century England.

Forward to the 1930s?

The worst thing that could happen would be that the globalizers are right in making this analogy. The beginning of the industrial age was one of the most terrible periods in European history, when the old feudal rulers joined with the new capitalists and overwhelmed with brute force the old order of values, the guild rules of craftsmen, and the customary rights of country people to a poor but secure living. Not only did this cause untold misery to millions of people; it also called forth uncontrollable counter-movements whose destructive power eventually shattered the emergent system of international free trade, and discharged itself in two world wars and the communist seizure of power in the Eastern part of Europe.

The social historian Karl Polanyi, who was born in Vienna but emigrated to the United States, shows in detail in his brilliant work *The Great Transformation* how the subjection of human labour to the laws of the market, and the resulting dissolution of the old social

structures, forced the states of Europe to lurch ever deeper into irrational defensive measures. The 'freeing' of trade, he argues, did not put an end to state intervention; on the contrary, it enormously 'extended the scope of regulation'.[1] The more often the market and its conjunctural crises produced waves of bankruptcies and mass revolts, the more the rulers of the day found themselves compelled to limit the free play of market forces. At first, they repressed only the various working-class protest movements, but later they moved to shield the markets especially from overseas competition, and other countries immediately responded in kind. By the turn of the century, and even more in the 1920s, the daily business of governments was not free trade but the development of protectionist policies. In the end, without actually intending it, they stepped up trade and currency wars to the point where the already highly integrated world economy was plunged into the great depression of the 1930s.

Polanyi's description of responses to the freeing of market forces should not, of course, be schematically applied to today's global hi-tech economy, but his main conclusion does still hold. The economic liberals dominant in the nineteenth century thought that their societies could be shaped by an international, self-regulating market system. For Polanyi, this was a dangerous 'Utopia' that carried the seeds of its own downfall, because *laissez-faire* policies constantly threatened to destroy social stability.

The same Utopia of a self-regulating market is entertained today by all those who have raised the banner of unlimited deregulation and dismantling of the welfare state. According to sociologist Ulrich Beck, their 'market fundamentalism is a form of democratic illiteracy'; the supposed modernizers forget the lessons of history when they refer to the law of supply and demand. For the taming of capitalism through basic social and economic rights was not some act of charity that can be abandoned when the going gets rough. Rather, it was the answer to deep social conflicts and to the breakdown of European democracy in the 1920s and 1930s. Beck writes: 'Only people with a home and a secure job, and therefore an assured material future, are citizens who will adopt democracy and make it a living reality. The simple truth is that without material security there is no political freedom, no democracy, and therefore a threat to everyone from new and old totalitarian regimes and ideologies.'[2]

For this very reason, the contradiction between market and

democracy has been regaining its explosive force in the tormented 1990s. The tendency has long been apparent to anyone with the eyes to see it. The wave of xenophobia among the European and American population is an unmistakable sign that politics has for years had to take into account. Refugees and immigrants have had their human rights considerably curtailed through ever harsher laws and surveillance in nearly every European country as well as in the United States.

The next round of exclusions is directed against economically weak groups in society: receivers of income support, the jobless and disabled, the young. These people experience more and more the withdrawal of support or fellow-feeling on the part of those who are still 'winners'. Themselves threatened with relegation, peaceful middle-class citizens turn into prosperity chauvinists who are no longer willing to pay for losers in the game of world-market roulette. Politicians in this area of the New Right, mainly concentrated in the FDP in Germany, have managed to convert popular resentment against 'welfare scroungers' into the idea that provision for old age, sickness and unemployment should again become the responsibility of individuals. In the United States, where half of all citizens (much more among the lower strata) do not bother to vote, the new social Darwinists have even captured a parliamentary majority and are dividing up their country according to the model of Brazil.

By an inexorable logic, women will be the next to be hit. In Germany, Christian Democrat politicians have already decided to punish pregnant women who report sick by withholding their pay, and single mothers dependent on benefits have to wage a daily struggle to survive. In Britain the liberal *Financial Times* has developed a line of argument justifying the further exclusion of women. The most dangerous problem arising from the growth in inequality – a male commentator explained in razor-sharp prose – can be seen among poorly educated young men who turn to crime and violence in the absence of job opportunities. Most of them have to endure competition from female employees, who now occupy nearly two-thirds of unskilled posts in the country. The best way to proceed, then, would be 'by curtailing the participation of women, who are relatively unlikely to become dangerous criminals'. The future maxim of economic policy will have to be: 'More Jobs for the Boys'.[3]

The prosperous parts of the world are thus storing up a potential

for conflict that individual countries and their respective governments will soon no longer be able to defuse. If a change of direction is not taken in time, there will inevitably be a social defence reaction in Polanyi's sense of the term. And it seems likely that it will again take a protectionist form geared to the separate nations.

The more alert company directors and economists recognized the danger a long time ago. Tyll Necker, president of the Association of Germany Industry for many years, is not the only one to worry that 'globalization leads to a pace of structural change that more and more people are unable to cope with. How can we steer this process in such a way that markets open up but change remains under control?'[4] Percy Barnevick, head of the mechanical engineering giant Asea Brown Boveri, which has 1000 subsidiaries spread over forty countries, issued an even stronger warning: 'If companies do not rise to the challenge of poverty and unemployment, the tensions between the haves and the have-nots will lead to a marked rise in violence and terrorism.'[5] Another man who sees the writing on the wall is Klaus Schwab, who, as founder and president of the World Economic Forum at Davos, can hardly be suspected of any social romanticism. In his view, present trends are 'multiplying the human and social costs of the globalization process to a level that tests the social fabric of the democracies in an unprecedented way'. The spreading 'mood of helplessness and anxiety' is the harbinger of a 'disruptive backlash' in what is now becoming a 'critical phase'. 'All this', he concludes, 'confronts political and economic leaders with the challenge of demonstrating how the new global capitalism can function to the benefit of the majority [of the population] and not only for corporate managers and investors.'[6]

This is precisely what the apostles of the market cannot demonstrate. It can easily be shown how the growing international division of labour helps to boost world economic performance. World market integration is economically very efficient. But in the absence of state intervention, the global economic machine is anything but efficient in distributing the wealth so produced; the number of losers far exceeds the number of winners.

This is precisely why there is no future in the policy of global integration pursued so far. Worldwide free trade cannot be sustained unless it is underpinned by a socially responsible state. Of course, Bonn is not Weimar, and the nations of present-day Europe – with

the exception of the successors to Yugoslavia – are incomparably more peaceful at home and abroad than they were seventy years ago. No communist movement is struggling to overthrow the existing system, and nowhere in Europe do generals or armament producers plot the conquest of neighbouring lands. But the danger from the anarchic development of transnational markets is the same as it was in those times. Again a world stock-market crash is in the air, as gamblers on the electronic marketplace of world finance know better than anyone else. And again democratic parties are in crisis in one country after another, because they do not know how and where they can take the rudder back under control. If governments do nothing but ask their population, in the name of progress, to make sacrifices from which only a minority stand to gain, they will have to reckon on being voted out of office. With each percentage point added to unemployment or subtracted from wages, the risk grows that politicians at a loss to know what to do will again reach out for the emergency cord of protectionism, triggering trade or currency wars that result in economic chaos and leave every country worse off than before. For this to happen, it is not at all necessary that nationalists or other sectarians should first win elections. No: today's ruling free-traders could well become tomorrow's protectionists if they think they can get enough votes out of it.[7]

This may happen, but it does not have to. For we today have the inestimable advantage of historical experience, from which we know that a single nation cannot escape the global trap on its own. We must therefore seek and use other exits. To avoid sliding back into economic nationalism, it is necessary to regulate the single market by means of a revived welfare state, so that the huge gains in efficiency mean something to every citizen. Only thus will it be possible to maintain the broad measure of support for a market system open to the world.

It is an illusion to hope that, if only the right party is elected in Germany or France or any other European country, a political act of will can restore economic and social stability. There is no going back to the time of the 1960s and early 1970s, when national governments could use fiscal policy to decide relatively independently what degree of distribution was right for their country, and plan investment so that the teeth were drawn from conjunctural crises. Economic integration has since gone much too far to allow that. In the global

race for shares of the world-market cake, the individual nations drive on a multi-lane expressway and, until the great crash, can turn around only by risking their own destruction.

Nor is it desirable to turn around. For worldwide economic integration also contains immense opportunities. The fantastic growth of productivity could just as well be used to free more and more people from poverty, and to finance an ecological conversion of the society of waste in the hitherto prosperous parts of the world. But then the main task would be to steer the world-market race away from its suicidal course into social paths congenial to democracy, and to replace the globalization of injustice with development in the direction of greater social equality.

Blueprints and strategies to halt the trend towards a 20:80 society are already in existence. The first major step would be to limit the political power of actors on the money markets. If a turnover tax were to be placed on currency dealings and foreign loans, the G-7 central banks and governments would no longer have to bow un-conditionally to the inflated demands of money-dealers. Instead of slowing investment through excessive interest rates and fighting an inflation that does not even threaten to happen, they could jointly lower central bank rates as a way of beginning to extend entre-preneurial freedom and to promote growth and employment.[8]

It is essential that this is combined with an ecologically oriented tax reform which makes the use of resources systematically more expensive, and improves the position of labour by reducing social security contributions. This is the only way to stop overexploitation of the ecological base of all economic activity, which robs future generations of their chances in life.

There is also a broad consensus about the need to improve the scope and efficiency of the education system. If it is true that industrial society will give way to the information society, it is a permanent scandal that more and more young people in Europe and America do not receive a proper education and that the universities are becoming increasingly run down, simply because companies and high-income brackets deprive the public purse of its fiscal life-blood.

If more people are to be given an education, and if more jobs are to be created through public investment in such projects as an environment-friendly transport system, then new sources of revenue will have to be tapped. For this reason, income from interest should

no longer be exempt of tax, and a higher rate of VAT on luxury items might ensure that the tax burden is spread more fairly.

The dangerous world policeman

All these proposals, however, are premissed upon something that is manifestly not yet the case: namely, the existence of governments capable of introducing reforms in the teeth of the new transnationals, without being immediately punished through a flight of capital. The only country that could still make a turn single-handedly is the economic–military superpower, the United States. For the time being, the chances of an American initiative to tame market forces for the benefit of every society in the world must be pretty close to zero. What is more likely is that US governments will increasingly turn to false protectionist solutions and seek to obtain other commercial advantages for their own country.

This would not be a break with tradition. For the selfless America that helps the rest of the world to solve its problems has never existed in reality. US governments, whatever their colour, have always almost exclusively pursued what they take to be the national interest. So long as the 'evil empire' had to be combated in the East, the national interest included a stable and prosperous Western Europe that could hold up to communism the more attractive side of capitalism. Now, however, Europe is no longer needed for that in Washington. If the expulsion of foreign goods and services from the American or other major markets can bring gains to established companies in the United States, future governments will certainly not shrink from giving a political helping hand to market forces. The Clinton administration gave the world a foretaste of coming trans-atlantic conflicts at the time of the dollar crisis in 1995. A further shot across the bows came in August 1996 when the US president, on the pretext of the struggle against terrorism, signed a law to ban from the American market all European and Japanese companies (especially in the oil and construction sectors) which have business links with Libya or Iran. The EU states soon found themselves having to threaten appropriate retaliatory measures.

Precisely because the American welfare state is in ruins and does not protect its citizens from crisis shocks originating in the world market, the 'backlash' against globalization is also likely to come

from the country that has so far backed subordination to the total
market everywhere in the world. It is not only as global policeman
that the North American giant is becoming more and more un-
predictable; it also falls short as a guardian of world free trade.[9]

The European alternative

The countries of Europe can and must start acting together against
this danger, but the solution does not lie in opposing a Fortress
Europe to the coming Fortress America. One of Europe's strengths
is precisely that it knows the disaster that could follow if the different
nations launch into protecting their economies from one another.
The aim, rather, should be to counter destructive Anglo-American
neo-liberalism with a potent and viable European alternative. A
political union, joined together by a common currency and a painful
but past history, would carry no less weight in world politics than the
USA and the rising powers of China and India. Economic size is the
one major power factor on the global markets that America's trade
strategists have been demonstrating for many years. But a united
Europe, resting upon a market of some 400 million consumers, would
have the capacity to develop a new economic policy first internally
and later externally too, one that was closer to the principles of John
Maynard Keynes and Ludwig Erhard than to those of Milton Fried-
man and Friedrich von Hayek. In the unfettered global capitalism,
only a united Europe could push through new rules providing for a
greater social balance and ecological restructuring.

All the more fateful is it, then, that the many convinced Europeans
in central governments from Lisbon to Helsinki have so far pursued
only technocratic paths to unity and excluded voters from any say in
the future shape of the continent. The consequence has been a
Europe of the big corporations, in which anonymous officials, advised
by ubiquitous industrial lobbyists, pour a market programme of
American-style social division into the cast of EU legislation, and
citizens receive no serious information about its advantages and
disadvantages. With the completion of the single market, the coun-
tries of Europe have again become incapable of reform. Mutual
dependence means that it is no longer possible for them to act alone,
but the democratic legitimacy is lacking for majority decisions. The
sine qua non for a viable European federation is therefore a rigorous

democratization of its decision-making processes. Only when the backroom legislating of the ministerial committees is dragged into public view, only when each EU law is debated in national parliaments at which foreigners are also allowed to speak, will the European alternative have a real chance of success. A capacity for reform will revive only if the awakening is at once European *and* democratic.

This does not at all imply the construction of another overweening European bureaucracy that regulates everything and everyone. Indeed, the opposite would be the case; Europe's recovery of the primacy of politics over economics would stop the hydra of bureaucratism from sprouting new heads. If, for example, the outlines of fiscal and financial policy were decided at a European political level rather than by a consensus of officials, they would end the chaos whereby international tax havens cost member-states hundreds of billions of marks a year in lost revenue. The same would be true of the rampant apparatus erected to defend all manner of subsidies – an apparatus which has become uncontrollable only because the EU, unable to take decisions on such matters, cannot bring about a simple financial harmonization of national budgets.

Those who argue that a united Europe does not have the support of EU citizens are getting things the wrong way round. Democracy is not a condition but a process. All that is certain is that the EU of technocrats meets with little support from voters, and rightly so; for years it has been hollowing out the national democracies of individual states to the point where they have become a laughing stock. It is also certain that a huge majority of Europeans will not willingly follow the Anglo-American path of tearing their own society apart. If a democratic European Union is the only way to secure social stability, state sovereignty and a sustainable ecology, then large political majorities are assured for this project, at least in France as well as in Southern Europe and Scandinavia.

Is there the political strength to lead the Union out of its bureaucratic dead end? Not yet, but there may be soon. Already millions of European citizens, in their workplace and neighbourhood or in countless social and ecological initiatives, support alternatives of one kind or another that seek to preserve social cohesion in the face of world-market madness. Whether in Greenpeace, a community centre or a local women's refuge, in a trade union or a church, whether through help for the aged and disabled, through solidarity

actions for developing countries or the many immigrant support groups, people everywhere are daily making considerable sacrifices for their civil commitment to the common good. There is such a thing as civil society, and it is stronger than its many activists realize. Employees' organizations, too, must not let themselves be persuaded that they are wrong to rebel against the devaluation of work, or that they are simply delaying the inevitable. Justice is not an issue for the market to resolve; it is a question of power. The mass strikes in France, Belgium and Spain therefore point in the right direction. Even if they partly served to defend the interests of privileged public employees, they were still a legitimate protest against bottom-to-top redistribution. That is also how most people there understood them, otherwise there would not have been such widespread public support. Similarly, the trade union demonstrations in London, Bonn and Rome are a sign of the strength that can be built up throughout Europe, until governments are no longer able to ignore them.

The same goals are pursued by numerous activists and representatives of the major Christian churches. More passive members may turn their back on them, but they offer to committed young people invaluable space for their own social initiatives. The repeatedly high level of participation in Germany's Evangelical Church congresses is a sign of the widespread need for orientation and solidarity in the high-performance society.

Meanwhile there is also a ferment among Europe's economic and political elite. Many feel deeply uneasy at the idea that the old continent will become more and more American, even if they admit it only with hands covering their mouths. A few bold ones have even begun to speak out publicly for a change of course. For example, Rolf Gerling, a billionaire and major shareholder of Europe's largest industrial insurer, has joined with other representatives of his financially strong sector to fight for an ecological restructuring of the industrial heartlands. 'Our image of the world is being turned inside out,' he says, predicting an epochal change 'such as the one from the Middle Ages to modern times'.[10] He wants to invest some of his capital in helping companies with real 'products of the future' to make their initial breakthrough. Far more than in Germany, influential industrialists in Latin Europe are doubtful about the direction in which their country is heading. When President Jacques Chirac said that the globalization process must be brought under control, he

echoed the growing displeasure of French business leaders at having to cut wages and jobs although they had no wish to do so. In Italy, too, the former Fiat chief Umberto Agnelli warned that 'if the social costs [of adapting to the world market] become unsustainable,' then a 'fortress mentality' will again develop in individual countries of the EU.

In nearly every country of Western Europe, then, there is enough social energy for a stand against market dictatorship and in favour of democratic reforms, running counter to individualist currents and the New Right. So far, this has nowhere resulted in a real power to shape politics. But will things remain so? The weakness of the European alternative is not a lack of voter support but its fragmentation among different national or regional initiatives. In the age of transnational economics, a reform perspective that ends at a country's borders is no longer worthy of the name. Why should it not be possible to rally many millions of committed citizens in a credible alliance and to offer them an all-European perspective? The European Union belongs to us all, not only to the officials and technocrats.

The outcome of the globalization debate in Germany will not be the least factor in determining whether there is still time for the Union to be appropriated by its citizens, before it collapses again into national particles. In every party there are enough politicians who suspect that the world market cannot go on much longer developing in the way it does at present. On one thing at least Helmut Kohl and his SPD counterpart Oskar Lafontaine are agreed: namely, that the European Union offers the only chance of restoring the state's capacity for action. It is not in their hands alone, but it does also depend on them whether their parties break out of the national cage and fill their mentors' European vision with democratic life. If they and their political friends really fought across frontiers to democratize the Union, pan-European civil society might really become the hope they so urgently need. It should also be possible to win support for this from the liberals, or at least those who see themselves as defenders of civil rights. For if organized crime continues to grow on the fertile ground of the stateless European market, their arguments against an apparatus of police surveillance will no longer look so appealing.

No less threatened is the chief concern of Europe's largest Green Party: the ecological restructuring of industrial society. It is certainly

true that the rich countries 'will have to give up some of their prosperity' to the rest of the world, as the Green tax spokesman Oswald Metzger expressed his party's position in the Bundestag.[11] The countries of the North that have so far revelled in extravagant consumption will not be able to avoid major changes for which quite considerable sacrifices will be required. Only the replacement of the throwaway economy with one geared to services and solar power, only city planning that centres on human beings and stems the avalanche of cars, will offer any chance of creating for the countries of the South the ecological space they need for their own development. But globalized redistribution in favour of countries strong in capital does not bring us one step nearer that goal; indeed, it pushes it further into the distance. The wage cuts suffered by workers and employees, as well as the reductions in transfer payments, are of no help at all to developing countries; they simply benefit the wealthy or highly skilled fifth of society who have seen their incomes rise from interest or employment, while the rest of the population have had to make do with less. Once most voters live in fear that they will soon be among the losers, ecological reform programmes have no chance of gaining a political majority if they so much as hint at belt-tightening. An enlightened middle-class citizen holding down a good job may possibly leave his car in the garage – a prosperity chauvinist, never.

In many parts of the EU, political reformers eager to preserve social cohesion are quite capable of winning a majority at the ballot box. But if they take seriously the goals contained in their programmes, they will really have to face up to the challenge of the international economy and develop instruments and institutions within a European framework that give politics the power to shape things once again. Helmut Kohl's Europe will deliver free of charge the monetary union that is the key to European construction. The possibility will thereby open of imposing agreed social rules in the control centre of globalization, the international finance market. At the same time, however, the countries of the Union will bind themselves so closely to one another that they will either invent democratic forms of common legislation or go under. The use made of this opportunity will greatly depend upon whether national politics awakens from its European slumber and starts to dream of reforms that go beyond national boundaries.

One of America's critical economists, Ethan Kapstein, who is also director of the Washington-based Council on Foreign Relations, expressed how much is really at stake: 'The world may be moving inexorably towards one of those tragic moments that will lead future historians to ask, why was nothing done in time? Were the economic and policy elites unaware of the profound disruption that economic and technological change were causing working men and women? What prevented them from taking the steps necessary to prevent a global social crisis?'[12]

For citizens of the old continent, this means that they must decide which of the two great currents of the European legacy will shape the future: the democratic current that goes back to the Paris of 1789, or the totalitarian current that had its victory in Berlin in 1933. The answer will be decided by us voters, most of whom are still democratic in our convictions. If we no longer hand the initiative to the market Utopians who are paving the way for the New Right, then Europe will begin to show that it can do things better.

Ten ways to prevent the 20:80 society

1. A democratized European Union capable of taking action Individual European countries within the highly integrated single market are no longer capable of reform. Nor can the EU confederation, in its present form, decide and implement such deep changes as an ecological tax because ministerial commissions – the real legislative body in the EU – lack the democratic legitimacy for majority decisions. If all ministerial commissions were open to the public, if the EU Commission itself were chosen by the European Parliament, and if foreigners were allowed to speak at all national parliamentary debates on every EU law, then European democracy could become full of life and alliances for political reform could become possible across national boundaries.

2. Strengthening and Europeanization of civil society The more the growth of material inequality threatens social cohesion, the more important it becomes that citizens should themselves defend basic democratic rights and strengthen social solidarity. Whether at the workplace or in the local community, by helping out in playgroups or in the integration of immigrants, there is scope everywhere to oppose the exclusion of the economically weak and to push for alternatives to free-market radicalism and dismantling of the welfare state. Cross-border cooperation and networking could give much greater reach to the commitment made by millions of people. It is everyone's right to take part in shaping the future – in Brussels, too. It is good to think globally and to act locally, but it is better to act together across borders.

3. European Monetary Union Size is the only important power factor in the globalized economy. The overcoming of monetary

fragmentation through a common currency, the euro, could set right the relationship of forces between the money markets and the countries of Europe. Exchange rates could be stabilized, and the value of European products in other currencies could be negotiated with overseas partners instead of remaining at the mercy of the US central bank and money-dealers in London, New York or Singapore. If the euro managed to become the leading currency, the EU would acquire sufficient economic strength to press for an end to the tax havens and to restore the tax liability on private income from interest and dividends.

4. Extension of EU tax law Fiscal policy is the key to the democratic steering of economic development, without *dirigiste* bureaucratic interference in the market. Europe's economy is now so integrated, however, that taxation can serve this end only at an all-European level. This is the only way to end competition within the EU over which country has the lowest corporate taxation and can woo the largest number of affluent taxpayers.

5. A tax on currency dealings (Tobin tax) and on euro-credits to non-European banks The economic damage caused by speculative exchange-rate fluctuations can be considerably reduced through a tax on currency dealings and loans such as that proposed by the American economist James Tobin. Movements into and out of individual currencies on the basis of interest-rate differentials would become less worthwhile, so that the European central bank would gain the freedom to adjust interest rates to the economic situation in Europe and would not have to follow the American lead. A currency tax would also bring in badly needed revenue to support countries in the South unable to keep up in the global markets.

6. Minimum social and ecological standards for world trade Governments in developing countries which provide a tiny upper layer with profits from world-market trade – through child labour, ruthless environmental destruction and starvation wages that depend on repression of trade unionists – are plundering their country's human and natural resources. If the World Trade Organization imposed sanctions on countries whose rulers were found (and were confirmed by the UN) to be breaching basic democratic and economic rights, the most undemocratic elites of the South would be

forced to conduct a development policy that really helped their nations to advance.

7. A Europe-wide reform of ecological taxation The taxation of resource use may promote labour-intensive economic activity, and limit the ecologically destructive growth of goods transport over ever larger distances. Human labour would be more highly valued, and energy-intensive automation would be less profitable. Restructuring of the tax burden would also offer a chance to separate the funding of the welfare state from the income of employees.

8. A European tax on luxury goods Capital gains on the part of companies cannot be taxed beyond the world average without having a negative effect on international competitiveness. It would only raise prices for Europe's products and services and drive investors out of the country. To ensure that the winners from globalization nevertheless pay their fair share in funding state expenditure, a higher rate of value-added tax on luxury goods would be an appropriate substitute. This would apply, at a level of 30 per cent, to everything that rich people enjoy: the purchase of property over and above a primary residence, luxury limousines, ocean-going yachts, private aircraft, expensive jewellery, cosmetic surgery, and so on.

9. European trade unions The great failing of Europe's trade union officials has been their neglect to build a powerful organization at the level of the EU. This is the only reason why there are no functioning European enterprise councils, and the only reason why company workforces in different countries can be played off against one another. If employees' representatives were to end their small-state ways of behaving, the efficiently organized corporate lobbies would lose their superiority in the legislative process in Brussels and it would become possible for EU social policy to take real shape.

10. An end to deregulation without social protection The removal of state communications and energy monopolies, as well as the opening up of previously protected sectors of the market to international competition, are having a disastrous effect on the labour market. If it cannot be guaranteed that at least roughly as many new jobs are created as are lost through liberalization, any opening of the market should be postponed until there is a fall in unemployment.

Notes

The translator regrets that in a small number of cases, where the original English of a quotation could not be located in London, it has been necessary to translate back from the version in the German text.

1. The 20:80 society

1. From Gorbachev's dinner speech, 27 September 1995, San Francisco.

2. Three journalists were allowed to attend all the working groups in San Francisco from 27 September to 1 October 1995. Hans-Peter Martin was one of them.

3. *Wirtschaftsblatt*, 14 June 1996; 'Wifo-Prognose', *Die Presse*, 30 March 1996.

4. *Die Woche*, 26 January 1996.

5. *Die Zeit*, 12 January 1996. In Sweden, too, the unemployment figures have been steadily rising. Officially 8.8 per cent in January 1997, the true figure is closer to 20 per cent if all those currently on training schemes, as well as in early retirement or demoralized withdrawal, are taken into account. For the last four decades, there has been no net addition to the number of private-sector jobs. See *The Economist*, 22 February 1997; *Profil*, 24 February 1997.

6. *Frankfurter Allgemeine Zeitung*, 29 January and 30 April 1996.

7. *Neue Kronenzeitung*, 14 May 1996.

8. *Frankfurter Rundschau*, 22 March 1996, and *Frankfurter Allgemeine Zeitung*, 4 June 1996.

9. *Der Spiegel*, no. 4, 1996.

10. Karl Marx, 'Wages, Price and Profit', in Marx and Engels, *Selected Works* (London, 1970), p. 225.

11. *Der Spiegel*, no. 4, 1996.

12. This term was first used in 1995 by the American economist Edward Luttwak.

13. *Financial Times*, 30 April 1996.

14. According to research by Timothy Egan ('Many Seek Security in Private Communities', *New York Times*, 3 September 1995); see also Lester Thurow, *The Future of Capitalism* (New York, 1996).

15. *The Economist*, 11 October 1930.

2. Everything is everywhere

1. Involuntary stopover, April 1994.

2. Visit in January 1995.

3. Visit in April 1993.

4. Visit in March 1992.

5. From a recent trip in February 1996.

6. Bertrand Schneider, interview in Paris, 27 October 1996.

7. *New Perspectives Quarterly*, Fall 1995, p. 3.

8. Ibid., p. 9.

9. Ibid., pp. 11–17.

10. Ibid., p. 2.

11. *Die Welt*, 2 February 1996.

12. *Der Spiegel*, no. 22, 1996, p. 99.

13. *Süddeutsche Zeitung*, 12 April 1995.

14. RTL, 22 May 1996.

15. Curt Royston, in interviews since October 1986, the last being in New York on 23 July 1996.

16. Gallery visits in Tomsk (April 1994), Lisbon (November 1993), and Vienna (exhibition *Young Art from Austria*, at the Museum of Modern Art, 11 June to 15 September 1996).

17. Interviews with Peter Turrini between December 1994 and August 1996 in Vienna, Retz and Bregenz: first extracts in *Der Spiegel*, no. 18, 1995, pp. 192ff.

18. Concert visits on 13 July 1996 in Vienna, and 20 July 1996 in New York.

19. *Manager-Magazin Special* (quoting *The Economist*), no. 1, 1996, p. 9.

20. Visit in July 1996.

21. João Havelange, interview, Rio de Janeiro, February 1991.

22. *Der Spiegel*, no. 21,1996, p. 191.

23. Ivan Illich, interview, Bremen, November 1992.

24. *IDC-Deutschland Info*, 17 January 1996.

25. *New Perspectives Quarterly*, Winter 1995, p. 21.

26. *Business Week*, 24 April 1995.

27. *Business Week*, 22 January 1996.

28. *Welt am Sonntag*, 25 June 1996.

29. Visit to Atlanta from 19 to 21 July 1996.

30. Barbara Pyle, interview, Atlanta, on 20 July 1996.

31. *World Resources 1996–97, The Urban Environment* (New York and Oxford, 1996, p. 3).

32. Speech at the UN Social Summit in March 1995.

33. UNDP, *Human Development Report 1996*, New York, July 1996.

34. OECD data base, research in Paris, July 1996.

35. Dinesh B. Mehta, interview Berlin, 20 March 1996.

36. OECD data base, research in Paris, July 1996.

37. *New Perspectives Quarterly*, Fall 1994, p. 2.

38. ORF Teletext, 10 August 1996; *Frankfurter Rundschau*, 26 June 1996.

39. Study by the causes-of-war working group at the University of Hamburg, cited in *Frankfurter Allgemeine Zeitung*, 26 June 1996.

40. Robert D. Kaplan, 'Die kommende Anarchie', *Lettre*, Spring 1996, p. 54.

41. Ibid., p. 58.

42. Samuel P. Huntington, 'The Clash of Civilizations?', *Foreign Affairs*, Summer 1993.

43. Timothy Wirth, interviews, Cairo, 12, 13 and 14 September 1994.

44. *Der Spiegel*, no. 23, 1996, p. 158.

45. *World Urbanization Prospects: The 1994 Revision* (New York, 1994).

46. *Frankfurter Allgemeine Zeitung*, 4 June 1996.

47. *Der Spiegel*, no. 23, 1996, pp. 156ff.

48. *The Economist*, 29 July 1995.

49. Klaus Töpfer, interview, Bonn, December 1992.

50. *Foreign Affairs*, March–April 1996, pp. 86–7.

51. *Public Papers of the Presidents of the United States, Harry S. Truman*, Year 1949, 5 (United States Government Printing Office, 1964) (January 27), p. 115.

52. *UNDP Report 1994*; UN Research Institute for Social Development, *States of Disarray*, 1995.

53. Ibid.

54. *World Resources 1996/97* (New York and Oxford), 1996.

55. *Der Spiegel*, no. 23, 1996, p. 168.

56. *Der Standard*, 14 June 1996.

57. *Foreign Affairs*, January–February 1996, p. 65.

58. *World Resources 1996/97*.

59. *World Watch*, no. 2, 1996, pp. 24ff.

60. Ibid., p. 28.

61. *Der Spiegel*, no. 2, 1993, p. 106.

62. *World Resources 1996/97*.

63. *Newsweek*, 9 May 1994.

64. Visit in April 1994.

65. *Newsweek*, 9 May 1994.

66. ORF Teletext, 13 June 1996.

67. Thilo Bode, interview, June 1996.

68. Ernst Ulrich von Weizsäcker, interview, Vienna, 19 October 1995.

69. E. V. von Weizsäcker, A. B. Lovins and L. H. Lovins, *Faktor vier – Doppelter Wohlstand, halbierter Naturverbrauch* (Munich, 1995).

70. World Resources Institute, *The Crucial Decade: The 1990s and the Global Environmental Challenge* (Washington, DC, 1989).

71. Thomas Lovejoy, interview, Washington, DC, June 1989.

72. Interviews with Lester Brown, Chris Flavin and Hilary French of the Worldwatch Institute during the UN conference on the environment in Rio de Janeiro, June 1992.

73. Bertrand Schneider, interview, Paris, 27 October 1992.

74. Most recently, Lester R. Brown, *State of the World 1996* (New York and London, 1996).

75. Lester Brown, interview, San Francisco, 27 September 1995.

76. *Frankfurter Allgemeine Zeitung*, 7 May 1996.

77. Ibid.

78. Jack Lang, interview, Paris, December 1991.

79. *Frankfurter Allgemeine Zeitung*, 9 December 1995, p. 15.

80. Myron Weiner, *The Global Migration Crisis* (MIT, New York, 1995).

81. Ibid.

82. Bertrand Schneider, interview, Paris, 27 October 1992.

3. Dictatorship with limited liability

1. Michael Camdessus, interview, Washington, DC, 6 February 1996.
2. *International Herald Tribune*, 16 January 1995.
3. *Financial Times*, 26 January 1995.
4. Michael Camdessus, interview, Washington, DC, 6 February 1996.
5. *Financial Times*, 16 February 1995.
6. *International Herald Tribune*, 2 February 1995.
7. Norbert Walker, interview, 29 January 1996.
8. *International Herald Tribune*, 2 February 1995.
9. *International Herald Tribune*, 3 April 1995.
10. Ibid.
11. *The Economist*, 7 October 1995.
12. The latest BIS figures for daily business, based on surveys conducted in 1994, amounted to 1.25 trillion dollars. Finance experts have since observed growth of 15 per cent a year, so that the 1.5 trillion barrier has probably been reached by now.
13. Peter Thomas (Reuters spokesman), interview, London, 25 January 1996.
14. *Der Spiegel*, no. 12,1994.
15. This figure is given by the Eurocurrency Standing Committee of the G-10 Group at the BIS. Quoted from Edgar Meister (member of the Bundesbank board of directors), 'Derivative aus der Sicht der Bankenaufsicht', lecture manuscript, 29 January 1996.
16. This figure is mentioned by Wilhelm Nölling, former president of the Hamburger Landeszentralbank, in 'Die Finanzwelt vor sich selbst schützen', *Die Welt*, 5 November 1993.
17. Steve Trent, interview, Washington, DC, 31 January 1996. The name has been changed at the interviewee's request.
18. The following account of the attack on the EMS is essentially based on Gregory J. Millman's excellent *The Vandal's Crown: How Rebel Currency Traders Overthrew the World's Central Banks* (New York, 1995).
19. Figures from Steven Salomon, *The Confidence Game: How Unelected Central Bankers are Governing the Changed World Economy* (New York, 1995).
20. Vereinigte Wirtschaftsdienste, 16 October 1993.
21. *Frankfurter Allgemeine Zeitung*, 3 February 1996.
22. See Deutsche Bundesbank, *Auszüge aus Presseartikeln*, 28 September 1995.
23. *The Economist*, 7 October 1995.
24. See Erich Dieffenbacher, *Organisation Business Crime Control, Die Off-shore-Bankenplätze*, text of a lecture given at the conference on money-laundering at the Friedrich Ebert Foundation, Berlin, 7 October 1993.
25. *Frankfurter Allgemeine Zeitung*, 17 November 1995.
26. Michael Findeisen, interview, Berlin, 8 January 1996.
27. Eidgenössisches Justiz- und Polizeidepartment, *Bericht der AG 'Lagebild Ostgelder'*, October 1995.
28. According to internal documentation of the German Federal Ministry of Finance, dated summer 1995.
29. Jean-François Couvrat and Nicolas Pless, *Das verborgene Gesicht der Weltwirtschaft* (Münster, 1993).
30. *Newsweek*, 3 October 1994.

31. Vincent Truglia, interview, New York, 1 February 1996.

32. *Handelsblatt*, 25 January 1996.

33. *New York Times*, 27 February 1995.

34. One point = 0.1 per cent. *Financial Times*, 24 January 1996.

35. According to a statement by the Federal Ministry of Finance in answer to a question from the SPD in the Bundestag: *Frankfurter Rundschau*, 10 September 1995.

36. Commission of the European Communities, *Report of the Committee of Independent Experts on Corporate Taxation* (the Rüding Report) (Office for Official Publications, Luxembourg, 1992).

37. *The Economist*, 7 October 1995.

38. Deutsche Bank research, according to the *Frankfurter Allgemeine Zeitung*, 15 March 1996.

39. *The Economist*, 29 April 1995.

40. *The Economist*, 7 October 1995.

41. Deutsche Bundesbank, *Auszüge aus Presseartikeln*, 11 January 1996.

42. Klaus-Peter Möritz, interview, London, 31 January 1996.

43. *International Herald Tribune*, 22 April 1995.

44. *Wirtschaftswoche*, 20 April 1995.

45. Wilhelm Hankel, interview, Berlin, June 1995.

46. Reuters, 19 February 1996.

47. The Negara episode is told in detail in Millman, *The Vandal's Crown*, pp. 225ff.

48. *The Economist*, 18 November 1995.

49. *Frankfurter Allgemeine Zeitung*, 19 January 1996.

50. *Berliner Zeitung*, 8 March 1996.

51. *Frankfurter Allgemeine Zeitung*, 2 September 1996.

52. *The Economist*, 3 February 1996.

53. James Tobin, 'A Proposal for International Monetary Reform', *Eastern Economic Journal*, nos 3–4, July–October 1978.

54. The US economist David Felix, for example, estimates that at a level of 1 per cent the taxable turnover would still be 72 trillion dollars a year – which would mean a fiscal revenue of 720 billion dollars.

55. Jörg Huffschmid, 'Funktionsweise, Nutzen und Grenzen der Tobin-Tax', *Informationsbrief Weltwirtschaft & Entwicklung*, special issue, no. 8, 1995.

56. Hans-Helmut Kotz, interview, June 1995.

57. Alexander Schrader, 'Devisenumsatzsteuer: Scheitern programmiert', *Deutsche Bank Research Bulletin*, 26 June 1995, quoted from Jörg Huffschmid, footnote 55.

58. Quoted from Millman, *The Vandal's Crown*, p. 231.

59. *Süddeutsche Zeitung*, 21 March 1995.

60. Barry Eichengreen, James Tobin and Charles Wyplosz, 'Two Cases for Sand in the Wheels of International Finance', *Economic Journal*, no. 105, 1995.

61. *Frankfurter Allgemeine Zeitung*, 17 March 1995.

62. See *Wall Street Journal*, 16 September 1993.

63. Vereinigte Wirtschaftsdienste, 30 September 1993.

64. Millman, *The Vandal's Crown*, p. 255.

65. This is the estimate of Roland Leuschel, chief strategist at the Banque Lambert in Brussels. Interview, Brussels, 30 January 1996.

66. See Julia Fernald et al., 'Mortgage Security Hedging and the Yield Curve', Federal Reserve Bank New York, Research Paper no. 9411, August 1944.

67. *Der Spiegel*, no. 12, 1994.

68. Ibid., no. 12, 1994.

69. *Wirtschaftswoche*, no. 47, 1994.

70. Wilhelm Nölling, 'Die Finanzwelt vor sich selbst schützen', *Die Welt*, 5 November 1993.

71. Felix Rohatyn, 'Globale Finanzmärkte: Notwendigkeiten und Risiken', *Lettre Internationale*, no. 46, autumn 1994, and 'America in the Year 2000', talk delivered at the Bruno Kreisky Forum in Vienna, 8 November 1995.

72. *Handelsblatt*, 13 April 1995.

73. *Deutsche Presse-Agentur*, 27 January 1995.

74. *Frankfurter Allgemeine Zeitung*, 13 December 1995.

75. Meister, 'Derivative aus der Sicht der Bankenaufsicht'.

76. Thomas Fischer, interview, Frankfurt, 21 January 1996.

77. David Thomas (Euroclear spokesman), interview, Brussels, 21 January 1996.

78. *International Herald Tribune*, 5 February 1996.

79. *The Economist*, 17 February 1996.

80. *International Herald Tribune*, 4 June 1996.

4. The law of the wolves

1. *The Economist*, 7 January 1995.

2. Quoted in *Die Zeit*, 24 November 1995.

3. *Financial Times*, 28 March 1996.

4. *Financial Times*, 3 July 1996.

5. *International Herald Tribune*, 29 August 1995.

6. All quotations from Thomas Fischermann, 'Mitleid für die Erste Welt', *Die Zeit*, 3 November 1995.

7. According to calculations made by the Federal Labour Institute, quoted in *Die Zeit*, 24 November 1995.

8. Until 1990 the Paris-based Organization for Economic Cooperation and Development (OECD) comprised only the twenty-three 'classical' industrial countries of the former 'West': the United States, Canada, Japan, Australia, New Zealand, Germany, France, Great Britain, Italy, Spain, Portugal, Netherlands, Denmark, Greece, Ireland, Belgium, Luxembourg, Sweden, Norway, Finland, Iceland, Austria and Switzerland. Since then five economically weaker countries bordering on the twenty-three, and economically bound by treaty to the European Union or the North American Free Trade Area, have also been admitted. These are Turkey, Mexico, Hungary, Czech Republic and Poland.

9. *Die Woche*, 12 September 1993.

10. *Wall Street Journal Europe*, 12 March 1993.

11. Edzard Reuter, 'Wie schafft bessere Erkenntnis besseres Handeln?', text of a lecture delivered at the Alfred Herrhausen-Gesellschaft, June 1993.

12. *Der Spiegel*, no. 4, 1996.

13. World Trade Organization, *Trends and Statistics 1995* (Geneva, 1995).

14. David Ricardo, *The Principles of Political Economy and Taxation*, 3rd edn, 1821 (London, 1973), p. 83.

15. UNCTAD, *World Investment Report 1995* (New York and Geneva, 1995).

16. Paolo Cecchini et al., *Europa '92: Der Vorteil des Binnenmarktes* (the Cecchini Report) (Baden-Baden, 1988).

17. *Financial Times*, 26 February 1996.

18. Based on a report in *In These Times*, 26 December 1995.

19. Information from the *Los Angeles Times*, 5 December 1995.

20. *Business Week*, 16 October 1995.

21. *Frankfurter Allgemeine Zeitung*, 29 April 1996, and *Der Spiegel*, no. 15, 1996.

22. Data from the US Bureau of the Census, *Current Population Reports*, quoted in Lester Thurow, *The Future of Capitalism* (New York, 1996).

23. Figures quoted from Simon Head, 'Das Ende der Mittleklasse', *Die Zeit*, 26 April 1996.

24. Thurow, *The Future of Capitalism*, p. 180.

25. According to a calculation made by the *New York Times*, based on US Labor Department statistics. *International Herald Tribune*, 6 March 1996.

26. See Philip Cook and Robert Frank, *The Winner-Take-All Society* (New York, 1995).

27. *International Herald Tribune*, 17 November 1995.

28. Ibid.

29. *Frankfurter Allgemeine Zeitung*, 29 April 1996. Cf. Robert Reich, *The Work of Nations: Preparing Ourselves for 21st Century Capitalism* (New York, 1991).

30. Thurow, *The Future of Capitalism*, pp. 126, 165–6.

31. Quoted (and retranslated) from Silvio Bertolami, 'Wir werden alle durch den Fleischwolf gedreht', *Die Weltwoche*, 31 August 1995.

32. Quoted (and retranslated) from *Frankfurter Allgemeine Zeitung*, 29 April 1996.

33. See Head, 'Das Ende des Mittleklasse'.

34. Stephen Roach, 'America's Recipe for Industrial Extinction', *Financial Times*, 14 May 1996. In January 1997 the billionaire speculator George Soros, of all people, created an enormous stir with an essay in which he denounced the 'excessive individualism and competitors' built into the neo-liberal model. See his manuscript 'The Capitalist Threat'.

35. *Financial Times*, 14 May 1996.

36. According to company information quoted in *Focus*, no. 45, 1995.

37. *Frankfurter Allgemeine Zeitung*, 29 May 1996, and *International Herald Tribune*, 29 February 1996.

38. Based on Heinz Blüthmann, 'Abschied auf Raten', *Die Zeit*, 8 September 1995.

39. *Der Spiegel*, no. 16, 1996.

40. *The Economist*, 14 October 1995.

41. *Le Monde Diplomatique*, October 1995.

42. Reuters, 19 March 1996.

43. *Die Zeit*, 22 July 1996.

44. *Der Standard*, 25 May 1996.

45. *Tageszeitung*, 6 March 1996.

46. *Bloomberg Business News*, 18 March 1996.

47. *Frankfurter Allgemeine Zeitung*, 3 June 1996.

48. *Frankfurter Rundschau*, 2 December 1995.

49. *Frankfurter Allgemeine Zeitung*, 13 October 1994, and *Frankfurter Rundschau*, 16 October 1994.

50. *Frankfurter Allgemeine Zeitung*, 30 October 1993.

51. *Der Spiegel*, no. 16, 1996.

52. *Frankfurter Allgemeine Zeitung*, 27 June 1996.

53. For greater detail, see H. Schumann, 'Selbstentmachtung der Politik. Die programmierte Krise des EG-Systems', *Kursbuch*, no. 107, 1992.

54. Figures of the Association of European Airlines.

55. *International Herald Tribune*, 3 July 1996.

56. Spain, Portugal, Greece and Ireland have secured transitional arrangements until the year 2003.

57. *The Economist*, 1 June 1996.

58. *Der Spiegel*, no. 8, 1996.

59. *International Herald Tribune*, 23 April 1996.

60. *Der Spiegel*, no. 2, 1996.

61. *Le Monde Diplomatique*, no. 1, 1996.

62. *Financial Times*, 24 April 1996.

63. *Frankfurter Rundschau*, 2 May 1996.

64. *Die Zeit*, 24 May 1996.

5. Comforting lies

1. Silvio Bertolami, 'Kater nach dem Tequilarausch', *Die Weltwoche*, 12 January 1995.

2. Figures from Anne Huffschmid, 'Demaskierung auf mexikanisch', *Blätter für deutsche und internationale Politik*, no. 6, 1995.

3. *Newsweek*, 18 March 1996.

4. Huffschmid, 'Demaskierung auf mexikanisch'.

5. *Frankfurter Allgemeine Zeitung*, 25 July 1996.

6. The account here leans upon the article by Frédéric Clairmont in *Le Monde Diplomatique*, June 1995.

7. According to calculations made by Gerard Laffray, economic adviser to the French government and Professor of Economics at the University of Paris. *Die Zeit*, 12 April 1996.

8. The main difference between the Western and the Asian development strategy is precisely analysed by the ILO economist Charles Gore in 'Methodological Nationalism and the Misunderstanding of East Asian Industrialization', UNCTAD Discussion Paper no. 111 (Geneva, 1995).

9. *International Herald Tribune*, 29 July 1996.

10. *International Herald Tribune*, 18 March 1996.

11. *Der Spiegel*, no. 39, 1995.

12. *Frankfurter Allgemeine Zeitung*, 16 December 1993.

13. *Financial Times*, 20 June 1996.

14. *International Herald Tribune*, 28 February 1996, and *The Economist*, 13 April 1996.

15. *Tageszeitung*, 28 February 1996, and *Frankfurter Allgemeine Zeitung*, 21 May 1996.

16. John Evans, interview, October 1993.

17. *Le Monde Diplomatique*, 18 February 1996.

18. Adrian Wood, *North–South Trade: Employment and Inequality* (Oxford, 1994).

19. UNCTAD, *World Investment Report* (Geneva, 1995 and 1996).

20. The latest product from the ideological factory, in which all the old theses and theories are rehearsed once again, is the book by the Harvard economist Robert Lawrence: *Single World, Divided Nations? International Trade and OECD Labor Markets* (OECD Publications, Paris, 1996).

21. Figures exclude Eastern Germany and are taken from the monthly report of the Bundesbank, July 1996, as reported in *Frankfurter Allgemeine Zeitung*, 19 July 1996.

22. In an interview broadcast by ARD television on 11 April 1996.

23. *Frankfurter Allgemeine Zeitung*, 4 June 1996 and 17 June 1996.

24. *Frankfurter Allgemeine Zeitung*, 12 June 1996.

25. *Tageszeitung*, 10 June 1996.

26. According to figures of the Federal Ministry for Labour and Social Affairs, quoted in Heiner Geißler, 'Es droht ein neuer Klassenkampf', *Berliner Zeitung*, 4 January 1996.

27. Figures taken from the fine analysis of the welfare state funding crisis. Wolfgang Hoffmann, 'Risse im Fundament', *Die Zeit*, 15 December 1995.

28. According to figures given by the chairman of the Federal Insurance Institute for Employees (BfA), Hans-Dieter Richardt, at a press seminar held on 22 February 1996.

29. Heiner Flassbeck and Marcel Stremme, 'Quittung für die Tugend', *Die Zeit*, 1 December 1995.

30. *Handelsblatt*, 19 July 1996.

31. See *Frankfurter Allgemeine Zeitung*, 19 June 1996.

32. *Stern*, no. 46, 1995.

33. Michael Wortmann, *Anmerkungen zum Zusammenhang von Direktinvestitionen und der Wettbewerbsfähigkeit des Standorts Deutschlands*, unpublished manuscript, Berlin, 1966.

34. *Frankfurter Rundschau*, 4 May 1996.

35. *Der Spiegel*, no. 19, 1996.

36. According to calculations made by the WSI Institute of the DGB trade-union federation, quoted in *Frankfurter Allgemeine Zeitung*, 14 July 1996.

37. A DIW team under Michael Kohlhaas projected the effects over ten years of a general energy tax rising by 7 per cent a year on the structural evolution of the German economy, with 1995 as the base year. By 2005 revenue would amount to 121 billion marks, to be offset against social contributions and income tax. In accordance with the distribution of charges, the DIW team suggested that 71 per cent of the receipts should be used to reduce workers' social security contributions (thereby lowering wage costs), while the rest should be credited to taxpayers as an eco-bonus of 400 marks per head. See the report in *Die Zeit*, 10 June 1994.

38. In Klaus Backhaus and Holger Bonus (eds), *Die Beschleunigungsfalle oder der Triumph der Schildkröte* (Stuttgart, 1995).

6. Sauve qui peut

1. Peter Tischler, interview aboard the flight from Vienna to Berlin, 21 June 1996.

2. Lutz Büchner, interview in Frankfurt, 24 July 1996.

3. Glenn Downing, interview in Reston, Virginia, 1 October 1995.

4. Allison Downing Fox, interview in New York, 21 July 1996.

5. Fax communication from Justin Fox, 20 August 1996.

6. Estimates of the economics professors Roy C. Smith and Ingo Walter from New York University. Interview, New York, 2 February 1996.

7. Ted C. Fishman, 'The Bull Market in Fear', *Harper's Magazine*, October 1995, p. 55.

8. *New York Times*, 1 February 1996.

9. *New York Times*, 21 January 1996.

10. *Die Zeit*, 31 May 1996, pp. 9–11.

11. *Die Woche*, 28 June 1996, p. 6.

12. *Publik-Forum*, 14 June 1996, p. 12.

13. *Tageszeitung*, 16 February 1996, p. 13.

14. *Frankfurter Rundschau*, 22 June 1996, p. 4.

15. Hans-Peter Martin, 'Bedingungen für irdisches Glück', *Der Spiegel*, no. 33, 1989; last visit on 1 March 1996.

16. Günter Schmidt, interview, Heiligendamm, 11 August 1996.

17. ORF-Teletext, 19 August 1996. In the event Perot won only 8 per cent of the vote in November 1996, but this time he was denied participation in the extremely important TV debates.

18. ORF-Teletext, 20 August 1996.

19. *International Herald Tribune*, 17 and 18 August 1996.

20. William Greider, interviews in Washington, DC, 23 January 1995, 2 October 1995 and 31 January 1996.

21. ZDF, *Auslandsjournal*, 19 August 1996.

22. Claus Leggewie, interviews, New York, 2 February 1996, and Lädenburg, 21 March 1996.

23. ORF-Teletext, 18 August 1996.

24. Thomas L. Friedman, in *International Herald Tribune*, 8 February 1996.

25. Peter Marizzi, interview in *Der Standard*, 21 August 1996. The first placards were seen on 30 August 1996. Interviews in Vienna, 30 August 1996. The election results later confirmed these fears. Haider's Freedom Party won 27.9 per cent of the vote in Vienna, and in the simultaneous elections to the European Parliament it stood nearly level with the Social Democrats and the Conservatives.

26. Quoted from *Falter*, no. 31, 1996, p. 9.

27. ORF, *Zeit im Bild*, 2 August 1996. Despite, and because of, such threats, both the Freedom Party and the Liberals considerably increased their share of the vote in the October elections. Yet the Social Democrats responded by virtually ending the immigration of relatives and of workers from outside the EU. And in February 1997 the new chancellor, Viktor Klima, offered Balkan refugees money to return home.

28. Quoted from Los Angeles Times Syndicate International, June 1995, printed in, *inter alia*, *Welt am Sonntag*, 25 June 1996.

29. *Die Weltwoche*, 31 August 1995.

30. Quoted from Los Angeles Times Syndicate International, June 1995, printed in, *inter alia*, *Welt am Sonntag*, 25 June 1996.

31. Ibid.

32. Robert Weninger, interviews, Vienna, 22 and 23 August 1996.

33. Ehrenfried Natter, interview, Vienna, 8 July 1996.

34. Franz Köb, *Innehalten. Von der Verlangsamung der Zeit* (Bad Teinach, 1996), and *Doppelfant Presse* (Bad Teinach, 1996).
35. Tyll Necker, personal letter, 24 July 1996.

7. Perpetrators or victims?

1. Observations made at various UN conferences in New York, most recently in January 1996.
2. Visit to New York, 22 July 1996.
3. Klaus Töpfer, interview, Bonn, 30 July 1996.
4. Al Gore, speaking at the UN World Population Conference, Cairo, 5 September 1994.
5. Timothy Wirth, interviews, Cairo, 12, 13 and 14 September 1994, and New York, 26 and 27 January 1995.
6. The traditional extension of the UN secretary-general's term of office was later vetoed by the United States, and Boutros-Ghali was replaced by Kofi Annan from Ghana.
7. Michael Camdessus, interview, Washington, DC, 5 February 1996.
8. Michael Snow, interview, New York, 2 February 1996.
9. Steve Trent, interview, Washington, DC, 31 January 1996.
10. Vincent Truglia, interview, New York, 1 February 1996.
11. Ferdinand Lacina, interviews, Vienna, 29 June 1995 and 21 November 1995.
12. Mikhail Gorbachev, interview, San Francisco, 29 September 1995.
13. Ted Turner, conversations in San Francisco, 29 September 1995, and Atlanta, 20 July 1996; see also *New York Times*, 2 August 1996.
14. Tyll Necker, personal letter, 24 July 1996.
15. Hermann Franz, interview, Munich, 9 November 1993.
16. Anton Schneider, interviews, Vienna, 13 May 1995, and 5 and 11 August 1996.

8. Who does the state belong to?

1. *Der Spiegel*, no. 11, 1996.
2. *Handelsblatt*, 26 March 1993, and *Frankfurter Rundschau*, 24 February 1995.
3. *Frankfurter Allgemeine Zeitung*, 9 July 1996, and *Der Spiegel*, no. 12, 1996.
4. *Frankfurter Rundschau*, 27 March 1996.
5. *Financial Times*, 13 October 1994.
6. *Die Zeit*, 25 June 1993.
7. *Die Woche*, 3 November 1995.
8. *Der Spiegel*, no. 12, 1996.
9. *Der Spiegel*, no. 26, 1996.
10. Commission on International Investment, *Incentives and Foreign Direct Investment*, background report by the UNCTAD Secretariat (Geneva, 1995).
11. *Frankfurter Rundschau*, 15 December 1996.
12. Markus Dettmer and Felix Kurz, 'Ein Gefühl wie Weihnachten', *Der Spiegel*, no. 20, 1995.
13. Deutsche Presse-Agentur, 22 May 1996.

14. *Incentives and Foreign Direct Investment.*

15. According to calculations made by the German Institute for Economic Research.

16. Council of Competitiveness, 'Charting Competitiveness', *Challenges*, October 1995; quoted from Lester Thurow, *The Future of Capitalism* (New York, 1996).

17. *Wochenpost*, 2 September 1996.

18. Figures from Will Hutton, *The State We're In* (London, 1995), and *Independent*, 16 June 1996.

19. *Frankfurter Rundschau*, 29 June 1996.

20. *International Herald Tribune*, 30 August 1995.

21. Financial Action Task Force Working Group, *Status Report* (Paris, 1990).

22. *Time*, 24 August 1994.

23. Quoted from Klaus Wittman, 'Perfekt, blitzschnell und dreist', *Die Zeit*, 3 May 1996.

24. Susan Strange, *The Retreat of the State* (Oxford, 1996).

25. During the special conference 'Plenty of Money?' organized by the Locuum Evangelical Academy, 12 May 1996.

26. Deutsche Presse-Agentur, 8 July 1996.

27. According to the Anti-Mafia Commission of the Italian Parliament, 3 June 1996.

28. *Frankfurter Rundschau*, 19 April 1996.

29. Kenichi Ohmae, *The End of the Nation State* (New York, 1995).

30. 'Does Government Still Matter? The State is Withering and Global Business is Taking Charge', *Newsweek*, 26 June 1995.

31. See *Frankfurter Allgemeine Zeitung*, 15 May 1996.

32. Commission on Global Governance, *Our Global Neighbourhood* (Oxford, 1995).

33. *Frankfurter Rundschau*, 9 February 1996.

34. For further details, see Harald Schumann, 'Europas Souverän', *Kursbuch*, 117 (Berlin, 1994).

35. Niall FitzGerald, 'A European Nightmare', *Financial Times*, 5 June 1996.

9. An end to disorientation

1. Karl Polanyi, *The Great Transformation* (1944) (Boston, 1957), esp. pp. 67ff.

2. Ulrich Beck, 'Kapitalismus ohne Arbeit', *Der Spiegel*, no. 20, 1996.

3. *Financial Times*, 30 April 1996.

4. Tyll Necker, personal letter, 24 July 1996.

5. *Die Woche*, 26 April 1996.

6. *International Herald Tribune*, 1 February 1996.

7. A good example is the attempt of the German and French labour ministers to flout all the rules of the European single market through minimum wage legislation that would banish cheap building-workers in Portugal or England from construction sites in their own country. Similarly, Saxony's Prime Minister Kurt Biedenkopf was in violation of EU subsidy law when he dished out grants to Volkswagen that were in essence a protectionist measure 'distorting' competition in Europe.

8. This demand is supported by a growing number of economic experts – for example, at the UN trade organization UNCTAD, at the German Institute for

Economic Research in Berlin, or by Wall Street banker and US presidential adviser Felix Rohatyn. See UNCTAD, *Trade and Development Report 1995* (Geneva, 1995), pp. 4–9; Heiner Flassbeck and Rudolf Dressler, *Globalisierung und nationale Sozialpolitik* (Berlin and Bonn, 1996); Felix Rohatyn, *America in the Year 2000*, manuscript of a talk given at the Bruno-Kreisky Forum in Vienna, 8 November 1995; and Roger Boorle, *The Death of Inflation* (London, 1996).

9. Two university economists, Stepan Leibfried from Bremen and Elmar Rieger from Harvard, also resolutely defend this prognosis in 'Fundament des Freihandels', *Die Zeit*, 2 February 1996.

10. *Berliner Zeitung*, 13 April 1996.

11. *Der Spiegel*, no. 32, 1996.

12. Ethan Kapstein, 'Workers and the World Economy', *Foreign Affairs*, May 1996, p. 18.

Index